DISCARD

THE COMPLETE GUIDE TO
SCULPTURE, MODELLING
AND
CERAMICS
TECHNIQUES AND MATERIALS

THE COMPLETE GUIDE TO
SCULPTURE, MODELLING
AND
CERAMICS
TECHNIQUES AND MATERIALS

CONSULTANT EDITOR
BARRY MIDGLEY

A QUANTUM BOOK

Published by Grange Books
An imprint of Grange Books Plc
The Grange
Kingsnorth Industrial Estate
Hoo, nr. Rochester
Kent ME3 9ND

ISBN 1-85627-971-5

QUMSCU

This book is produced by
Quantum Books Ltd
6 Blundell Street
London N7 9BH

Printed in Singapore by Star Standard Industries (Pte) Ltd

Consultant editor
Barry Midgley

Contributing editors
John Calcutt
Trevor Crabtree
Andrew Fyvie
David Harper
Dan King
Liz Lydiate
John Maine
David Morris
Rod Murray
David Nash
Sean Rice
Janet Rudge

Art director **Alastair Campbell**
Production director **Edward Kinsey**
Editorial director **Jeremy Harwood**
Senior editor **Kathy Rooney**
Editors **Nicola Thompson, Judy Martin, Catherine Carpenter,
Elbie Spivack, Carol Cormack**
Designers **Caroline Courtney, Nick Clark**
Illustrators **Chris Forsey, David Mallot, Simon Roulstone, Lorna
Turpin, Sally Kindberg**
Special photography **Jon Wyand, Paul Sawyer**

Filmset in Great Britain by Tradespools Limited, Frome, Somerset
Colour origination in Hong Kong by Hong Kong Graphic Arts Limited

Quarto would like to thank the many individuals and companies who
have given invaluable help during the preparation of this book. Particular
thanks go to Alec Tiranti Ltd for supplying materials for photography. We
would also like to thank the following: Candle Maker's Supplies Ltd,
London; Ruth Franklin and Sally Somerville, Barbican Arts Group; Fry's
Metals Ltd, London; BL Pattern and Foundry Co; Mr Shelton of Podmore
Ceramics; Pitt and Scott Ltd; and Dufylite Developments Ltd; and the
Stone Firms, Portland, Dorset.

CONTENTS

FOREWORD

An understanding of materials and a respect for their qualities is as relevant to sculpture today as it always has been. This book is intended to introduce the reader to techniques commonly employed by sculptors — some traditional and others firmly anchored in the twentieth century.

Craftsmanship cannot be seen as an end in itself and a poor or ill-considered idea will not be rescued by good craftsmanship. But knowledge of techniques and materials will help the reader to explore ideas and so begin to understand the relationships involved in the creative processes of sculpture, modelling and ceramics.

Barry Midgley

December 1981

PRINCIPLES OF SCULPTURE

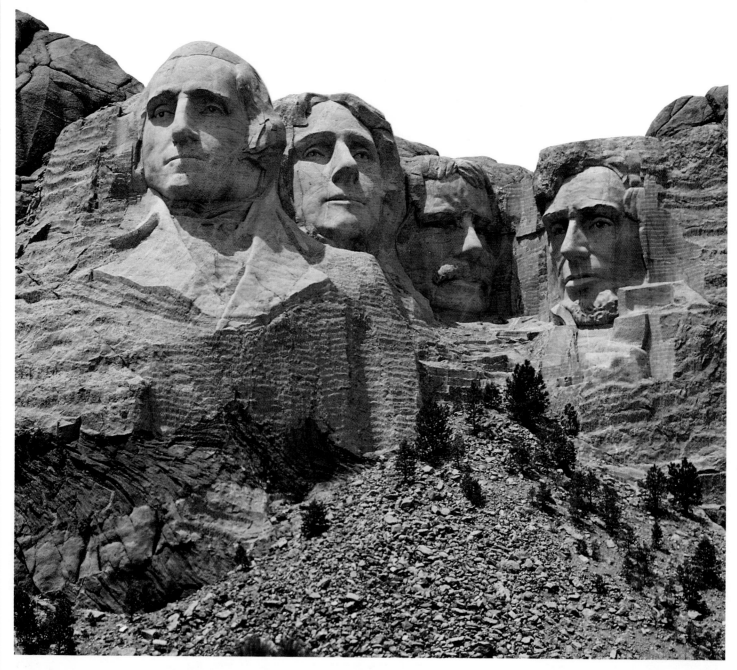

Above The rugged stone carvings at Mount Rushmore in South Dakota can be seen from miles around. The huge sculptures took many years to complete, and were indeed finished by the son of the artist Gutzon Borglum, who began the work. One of the fascinations of sculpture is that it can encompass works on a very large and very small scale.

MAIN TECHNIQUES

Sculpture is an art form which deals directly with real space, unlike painting which creates fictive space on a single plane. Sculpture, being three-dimensional, must occupy, interact with or enclose actual space. A form may be compact and solid or armed with projections intruding into the surrounding environment. It may be hollow, linear or pierced, giving access to its own internal space. Because sculpture has to have a real existence, however temporary, in a complex and cluttered world, a sculptor must be able to match perception and imagination with practical, technical skills.

Sculpture in the round demands a coherent combination of many different design elements, as it will be seen from several different viewpoints, and ideally each view should be equally worked out. Relief sculpture presents quite different design problems, since a complicated series of actual spatial relationships may have to be indicated within a relatively shallow depth of material. The particular challenges to a sculptor's capabilities may be overcome by learning or by instinct, but, inevitably, it is only in practice, not in theory, that the solutions are found.

The three basic methods of creating sculpture with raw materials are carving, modelling and construction. Carving and modelling are the oldest methods, and the basis of sculptural traditions, whereas construction has only been fully exploited and accepted in the twentieth century. Casting is a fourth basic technique, but this is a process of reproduction, not of original shaping.

CARVING

Carving is a subtractive process. This means that a solid mass of resistant material is shaped by cutting, chiselling and abrading the exterior to reduce the mass and create a particular form.

The outer limits of a carved sculpture are set by the shape and size of the mass of raw material. Wood and stone can be used for small- or large-scale work, and blocks of these materials can even be joined together if the form so demands. Carvings in ivory and precious stones are always small-scale.

The texture and substance of the material determine certain characteristics of the sculptural form. A soft stone may be too crumbly to be carved with any delicacy. Exhausting physical work is required to shape quite simple forms in a hard stone such as granite. Marble is relatively hard, and can be shaped into detailed forms, but could splinter during the carving process. Because of the lack of tensile strength—or the ability to withstand stress—in stone, the carving of slender, projecting forms is extremely precarious, since an ill-judged blow can fracture the whole piece. In many figurative stone carvings, arms are carved close to the body, and where a shape narrows, at the ankles for instance, there is often a supporting weight of stone, disguised as drapery, a tree trunk, or some other detail suitable to the subject. The instinctive confidence of Michelangelo (1475–1564) and Bernini (1598–1680) in handling their medium is evident from the intricacies of formal detail and their widely different approaches, which can be seen clearly in many of their works.

The fibrousness of wood gives it rather more tensile strength. Openwork designs and fragile, detailed forms are more commonly seen in wood carvings, such as beautiful Gothic altarpieces. A modern approach is that of the British sculptor Henry Moore (born 1898) who uses juxtapositions of space and mass in both wood and stone carvings.

MODELLING

Modelling is an additive process—the form is directly built up in a soft, malleable material, such as clay or wax, over a minimal supporting structure of rigid material. Modelling provides the sculptor with a greater freedom of expression than carving. The modelling material can be moulded and formed at every stage of the sculpture, giving complete control of both the inner and outer structure of the form, and if the work is unsatisfactory, part or all of the material can be pulled off and the process started again.

The size, shape and extension of forms in modelling is also more variable than in carving. Providing the supporting armature is strong and well balanced, no external supports are needed for the forms.

Hollow building in terracotta is a different type of modelling technique. There is no inner support, so the form must be more compact and self-supporting. Hollow-built terracottas are dried and fired to make the material more durable, and can be decorated with coloured glazes for surface detail and shine.

Models in wax or clay are often cast in metal, to give a finished, unbreakable version of the sculpture. Casting gives perfect reproduction of the form, but obviously alters the surface texture and colour of the original material.

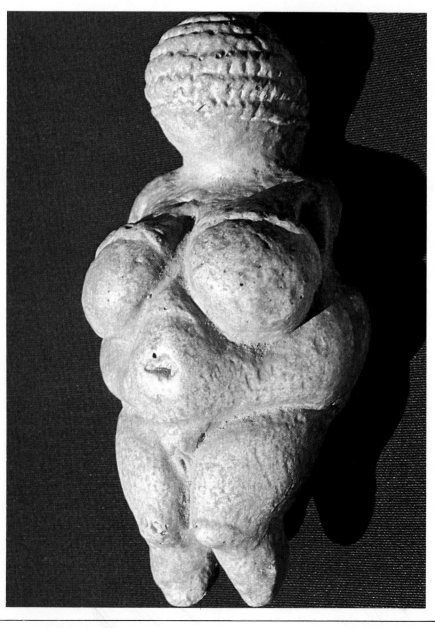

Below The *Venus of Willendorf* probably dates from 27000 BC. Carved with crude and clumsy tools, the roughly hewn generalized forms, especially the swelling breasts and belly, nevertheless convey an impression of sensuality and fecundity. The figurine was probably used as a fertility symbol.

Stone quarrying

Regardless of the area of sculpture which you are working in, it is important to remember the origins of the materials you are working with. For instance, the natural fibres of wood have a bearing on the ways in which the material can be used. Similarly, the fact that resins and glass fibre are synthetic materials affects how they are employed by the sculptor. Stone is a natural material. But, unlike wood, it has to be hewn out of the ground. Unless the sculptor is working on a very small scale, it is likely that the stone will have come from a quarry. Marble has traditionally been one of the most popular types of stone for sculpture.

One of the most famous marble quarries in the world is at Carrara in Italy. This is where Michelangelo obtained his stone. Here stone workings at the top of Monte Altissimo (1) can be seen. The exact methods of quarrying may vary according to the type of stone. At Carrara a network of wires which are used to cut the stone can be guided into position by pulleys. The stones are cut into large blocks (2). The huge size of the blocks can be judged by the tiny figures of men standing on top of them using drills to split them into smaller pieces. Another way of splitting blocks of stone is using wire in conjunction with carborundum stone which acts as an abrasive (4). In this instance, granite is being cut. Water is used to lessen both the heat caused by the friction and the amount of dust created. Holes have to be made in the stone so they can be lifted and transported (5). Here the nip holes are being made, before lifting, while other stones are being lifted in the background. Most quarries have their own large stockpiles. The blocks of stone are heaped on top of one another. For this, heavy gantries and lifting gear are essential (6). The blocks of stone (9) are stacked in the stockyard to await sale. Like most stockpiles, the marble stockyard at Carrara (8) contains pieces of stone of many sizes. When selecting a piece of stone to work on, make sure you assess its possible structural weaknesses as well as whether the shape and texture suits the effect you wish to achieve. Drills are used to split the stones (7) even when they are very

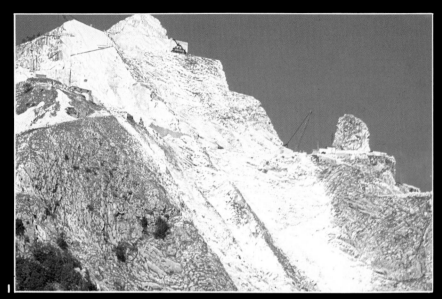

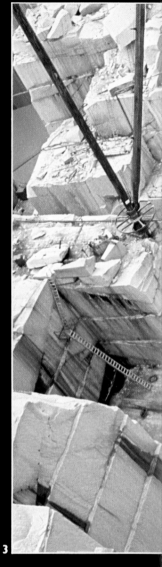

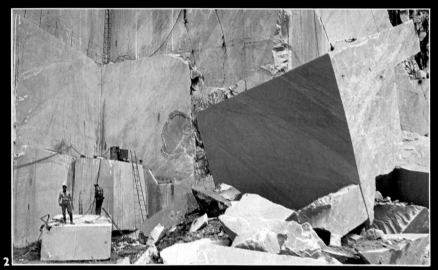

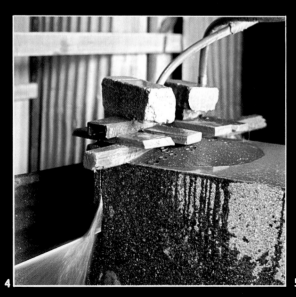

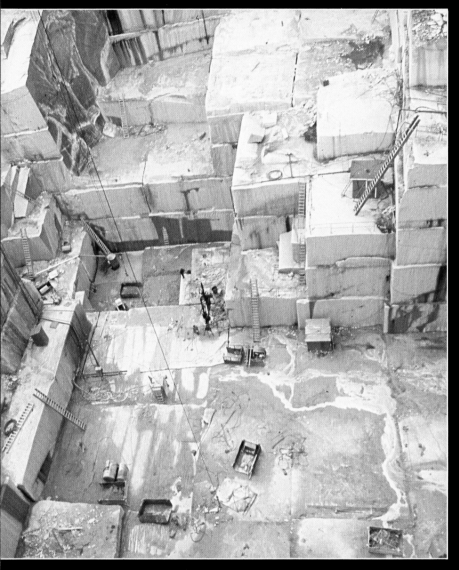

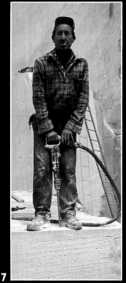

7

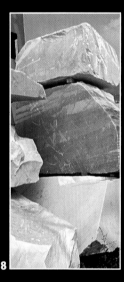

8

large. Wedges and pressure may also be used. Stone has poor tensile strength and so will split reasonably easily if pressure is exerted through it, by means of wedges, for example. Stones come from many different parts of the world. This spectacular picture (**3**) shows the Rock of Ages quarry in New York State, in the United States. The stones are piled to a great height. Granite is one of the hardest stones to work on and requires special tools. Sculpture with stone is one of the oldest sculptural media. Some of the earliest relics of artistic achievement include small stone carvings which may have been used as religious fertility symbols. Although the techniques of stone sculpture may have changed little over the centuries, the subjects and treatment by the sculptor have constantly changed to ensure that stone sculpture is one of the most popular and enduring areas of sculpture.

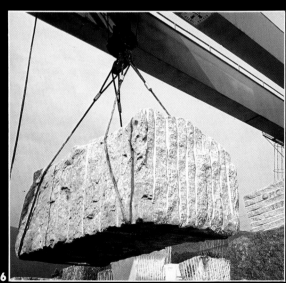

6

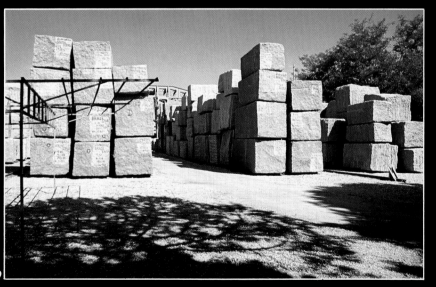

9

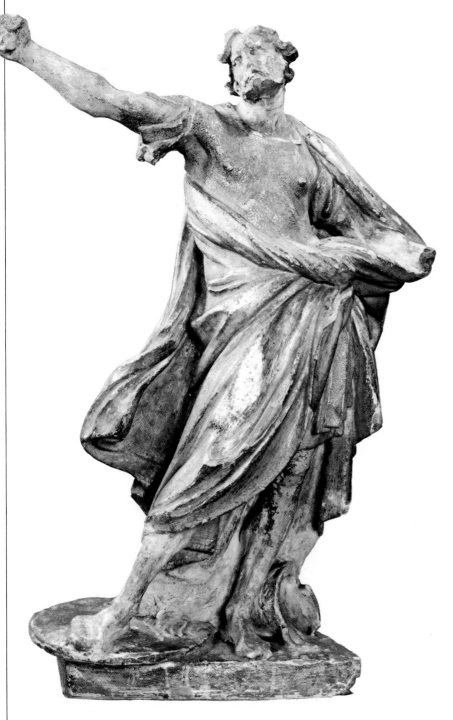

Above Gianlorenzo Bernini was one of the greatest Italian sculptors. This statue of St Longinus is made from terracotta which was later covered with gesso and gilded. This was a smaller version of Bernini's marble statue of St Longinus which stands in St Peter's in Rome. Bernini worked in many different sculptural media.

Modern techniques of lifting, joining and supporting heavy materials have removed some of the traditional restrictions on sculpted forms, and opened the way to very different descriptions of the relationships between space and mass. Transparent plastics give access to the internal space of a sculpture, even if it is enclosed. Industrial welding techniques are used in metal sculptures which thrust out huge, heavy projections, unsupported in space.

Preformed shapes and whole found objects can be joined together and combined with raw materials to function in a new context. Motor mechanisms and electrical circuits are incorporated in works that move through space or cast out light. The scope offered by new materials and techniques has also prompted artists to re-examine the possibilities of natural materials, even reshaping them in their own environment to form giant earthworks.

CASTING

Casting processes are for reproducing a sculpture in a different, usually more durable material from that of the original. With some methods, the original work perishes during the casting process and, again depending on the technique, it may be possible to produce several copies of the original, or only one. A mould or impression is built up around the original form, and used as the pattern into which the new material is set.

The traditional technique of casting is the lost wax method for casting bronze. Small models may be cast solid, but larger ones are usually hollow. Metal has considerable tensile strength, so that fragile and extensive forms can be cast which would be impossible to work in stone, or liable to fracture in either stone or hardened clay. Since bronze is poured into a mould in liquid form, it settles into every detail and sets in a completely faithful copy in which all the intricacies of form in the original are preserved. Complex compositions can be cast in several sections and later constructed into the whole. The qualities of bronze have always been highly regarded for their own sake—the rich, reflective surface, its natural colour and the heavy patination which it forms are all elements which can be held in mind when the original model is made.

Plaster is a cheap and readily available material for casting, but is somewhat crude for finished work. Glass fibre resin is a relatively new material which can be used to cast both modelled and constructed forms. Special pigmentation enables the sculptor to cast directly in bright colour, or even produce a surface imitative of bronze. A great advantage of the material is that, when cast hollow, the sculpture is quite lightweight.

CONSTRUCTION

Construction refers to the process of building a whole sculpture from various component parts, which may be all of the same material or of different substances. This is largely a twentieth century development, brought about by the sudden increase in materials and techniques which have become available through scientific and industrial research. Constructions may incorporate traditional sculptural materials, such as wood, stone and metal, but these are used to develop quite new ideas, which may, perhaps, be combined with modern materials such as plastics and glass fibre.

DEVELOPMENTS

Many of the tools, materials and forms of sculpture have changed little through centuries of activity. The earliest evidence of a deliberate carving process is the tiny *Venus of Willendorf*, dating from about 27000 BC. The simple curving shape of the figure indicates the problems of fashioning a form with primitive stone tools. Early artefacts were usually made from small lumps and fragments of material which could be easily carried and worked.

Small bone and stone sculptures, as well as clay figurines and pots, survive from the Paleolithic periods, but wood sculptures appear to have perished. Much evidence exists to prove that the impulse to create decorative and expressive form in natural materials was a very early feature of human development.

The significant early development in the history of sculpture was the discovery of metal working techniques. This at once provided a new material for sculpture, and far more efficient tools for cutting and carving. Abrasion techniques, equivalent to sandpapering wood, were well established, but these were laborious and imprecise. Metal tools were a much quicker and more accurate means of shaping, making possible delicate detail and intricate decoration.

The basic principles of carving, working in clay and bronze casting in use today were known in ancient Greek and Roman civilizations, and neither the tools nor the techniques have greatly changed. Their particular use has been subject to fashion and personal preference, and this has had considerable bearing on the developing styles of sculpture through the ages. In carving, for instance, each different tool gives a characteristic mark. The relatively deep holes formed by a punch, used in much decorative detail on Egyptian sculpture, set a very different style from that of the criss-cross texture and curving surfaces formed by claw chisel work. Although many of Michelangelo's sculptures are highly finished and polished, his mastery of chisel work is often clearly visible.

The marks on a clay model are an extremely personal expression of individual skill, since they are often formed with the fingers in a very direct engagement with the material. Although much clay sculpture was smoothed and neatened in the pursuit of 'perfect' form, the work of the modern French sculptor Auguste Rodin (1840–1917), with its massive forms and craggy, organic texture, clearly illustrates the vitality of the medium.

The task of a sculptor is to cooperate with the material to achieve his or her ideas, rather than impose a predetermined form upon it. For instance, it is senseless to try to imitate the plasticity of clay in rigid stone. The finest sculptors have always controlled their medium while paying due respect to its own inherent qualities. This can be seen in a traditional view of carving which holds that the sculpture lies already imprisoned within the block, and the sculptor works to recognize and reveal the true form.

The human figure was the primary subject for sculpture until the twentieth century. Ancient and medieval sculpture was created mainly for religious or celebratory purposes, to portray gods and goddesses, figures from myth and legend, and ordinary mortals in pursuit of a higher plane of living. Animals also appear frequently, with particular significance in pre-Christian, Eastern and tribal cultures. In relief sculpture, where quite different rules of space and form apply, some elements of architecture and landscape are shown in a rather condensed view.

Below This glazed figure of a mounted drummer is an example of Tang dynasty ware. This time—from AD 618 to 906—was one of great excellence in ceramic wares. The modelling on this figure is very detailed. The colour of the fired clay can be seen in places where the glaze has chipped off.

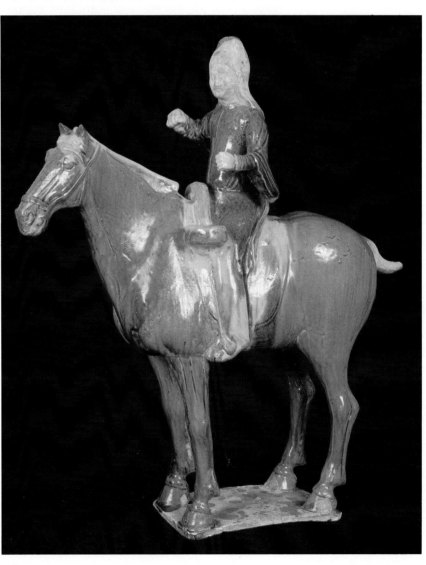

The twentieth century has seen many changes which have revitalized sculptural activity. Industrialization has produced man-made materials and mechanized tools which sculptors have eagerly grasped and put to their own uses. Communications are so efficient that virtually an international conversation has occurred between artists, resulting in an unprecedented and rapid evolution of ideas.

From tentative beginnings, pure abstraction came to be the dominant mode of artistic and sculptural form in a space of only 50 years, after centuries of figurative tradition. Picasso (1881–1973) was a remarkable innovator in both painting and sculpture. His analysis of form in his Cubist paintings introduced a new concept of volume, mass and space in visual terms. Reducing a form to a series of basic planes and angles, and combining several viewpoints simultaneously, he examined the interior and exterior structure of solid mass, without regard to its 'realistic' surface appearance. Picasso also first introduced the use of found objects and humble materials as appropriate components of sculpture.

The French artist Marcel Duchamp (1887–1968) went further, exhibiting everyday, functional objects, unaltered, as works of art. The lofty plane of sculptural tradition was questioned in the context of commercialism, industrial design and the immense social, political and philosophical upheavals occasioned by the First World War. The Dada and Surrealist movements investigated futility and fantasy, illustrating their visions as artistic form. Futurism and Constructivism attempted to define an art appropriate to the age of machines and urban development. Abstract art after the Second World War declined to grapple with social or political messages and concentrated on the full expression of the physical qualities of artists' materials, and pure visual sensation.

The images of Pop Art in the 1950s and 1960s entered into direct combat with the images and products of a consumer society, placing the forms in a fine art context. Minimal sculpture returned to pure form, allowing the characteristic qualities of the materials full reign, and artists even took to the land, working natural materials in their proper environment, and importing contrasting man-made elements.

Lightweight man-made materials, such as plastics and glass fibre resin have reintroduced colour as an important feature of sculpture, as have paints developed for industrial and commercial use, which can be applied to metal and plastic. Heavy metal sculptures by the American David Smith (1906–1965) and the Briton Anthony Caro (born 1924) gain vibrancy from their bright colour which matches the impact of the innovative forms. The whole basis of Smith's technique was learned directly in the workshops of a car factory. The celebration, by Pop and Superrealist sculptors, of the vigour and vulgarity of modern life would be far less effective if they did not use the very materials invented by the consumer society.

Mechanized tools and lifting gear have banished restrictions on sculpture originally imposed by the weight and substance of the materials. A new attitude to scale, both real and symbolic, has emerged. The human figure has been ousted from its dominant place in the subject matter of sculpture by the rapid adoption of abstract styles and concepts. Sculpture has achieved architectural scale in constructions and inflatable forms, and rivalled the immensity of landscape by treating it as both studio and gallery. For instance, the *Wrapped Coastline* in Little Bay, Australia, project of the sculptor Christo (born 1935), could only be a twentieth century feat, a redefinition of the natural form of the oldest sculptural material, stone, by literally packaging a coastline in plastic sheeting. On a smaller scale, sculptures have been produced which, in different forms, examine the space within which they exist. The *Corner Reliefs* by the Russian sculptor Vladimir Tatlin (1885–1953) are simple wooden constructions fitting into a 90° angle in a studio or gallery, from which curving metal rods reach out and touch the walls to create the sculptural area. *Palace at 4am* by the Swiss artist Alberto Giacometti (1901–1966), made in glass, string and wooden rods, defines the whole space of a building on a small scale by means of an open linear framework.

Below One of the most exciting breakthroughs in sculpture this century has been the advent of plastics as a sculptural medium. This work by the Italian artist Gino Marotta is entitled *Rhinoceros*. It is made from acrylic sheet. Acrylics are often used in conjunction with light because of their translucent qualities.

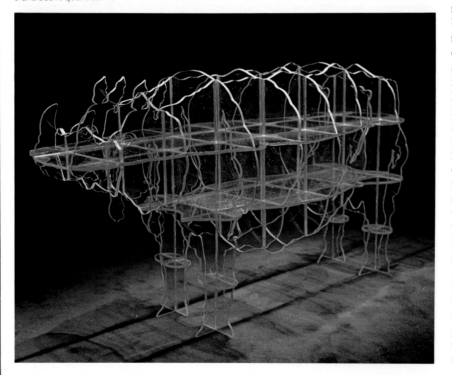

PREPARATIONS
DRAWINGS

Drawing is the common medium of all visual artists, and a common purpose is shared when drawing is used as a means of noting visual impressions quickly in a sketchbook or on a rough sheet. In many ways, however, the drawings of a sculptor may differ from those of a painter or graphic artist. Sculptors are not bound to two-dimensional space and need not spend time developing complex systems of perspective, immense vistas of landscape or crowded figurative scenes. Studies for a sculpture are quite likely to be self-contained images within the picture plane, and may be anything from a minutely careful examination of form from life, to a broadly sketched impression of the basic idea for a particular work. Colour plays a less important role, since the immediate problem is to define three-dimensional structure, as in an architect's drawing. Many sculptures use the natural colour of the material, and, if not, ideas about surface finish may arise directly from the form.

Many beautiful line and hatched ink drawings exist which demonstrate the preoccupations and working methods of major artists such as Michelangelo, Leonardo da Vinci (1452–1519) and the German wood carver Veit Stoss (c1450–1533). Small, broken studies of anatomical detail, the outline for an equestrian statue or an intricate design of a whole altarpiece, show how drawing records the progress from original research to a vision of the completed form.

The lovely wash drawings of Rodin indicate the massive, vital forms of his models by means of delicate overlapping tones. The modern sculptors David Smith and Alexander Calder (1898–1976) made bold abstract drawings with brush and paint, which are not necessarily a plan for a particular work, but provide the essence of their approaches to sculptural form. Christo and American Claes Oldenburg (born 1920) both combine collage with drawn images to describe huge outdoor projects, whether in town or landscape. Some of Christo's collages are like shallow reliefs, and Oldenburg sometimes adds photographs to suggest the three-dimensional reality.

Constructed forms, such as kinetic sculpture with motor power, or a transparent plastic sculpture with internal lighting, cannot be thrown together. Accurate drawings are needed which plan out both the aesthetic form and technical detail. In figurative work, disciplined objective studies of human form are made, to observe and understand the structure before the sculptural medium is approached.

In any artist's work, no theory or formula can provide an adequate substitute for careful and continual observation, and drawing is the quickest way to record this experience. In sculpture, however, the usefulness of drawing is limited as the final form of the work will depend upon the different experience of the physical qualities of the material, which cannot be accounted for entirely in advance.

This being said, it is also true that drawing media—like pencil, charcoal, pastel, ink or gouache—have characteristic material qualities of their own which may themselves suggest visual properties for the work. The importance of drawing for sculpture is often overlooked in the emphasis on three-dimensional form, but the sculptor's range can extend to cover the materials of both painting and sculpture, giving a very broad area of visual expression to be explored.

MAQUETTES

Drawing alone may be inadequate as a preparation for sculpture, since the crucial question is what the work will look like in a solid form, in real space and from all viewpoints. A useful way of checking the balance and volume of a sculpture is to make a small-scale model in which all the ideas for the larger work can be tried and tested. This is known as a maquette. It is a traditional aspect of carving and modelling work and, with drawing, has historically served the purpose of demonstrating the sculpture not only to the artist, but also to the patron who may have commissioned the work. In modern techniques of construction, the practice is not always suitable, since the forms are often arrived at through work in progress, suggested by the shape, texture and scale of each component piece. The ideas may be developed in small-scale sculptures which are important works in their own right.

Clay, wax or plaster can be used to make a maquette for a carved or modelled sculpture. A maquette can be scaled up mechanically to match a stone block by a technique known as pointing. This involves taking careful measurements of the forms and transferring the proportions to the stone via a metal structure with adjustable arms. This does not always produce a good result, since the large work may be a dull copy of the model, exhibiting no real relationship between the carver and the material.

The emphasis on direct engagement with materials, which has been a feature of twentieth century art, somewhat outmoded this academic tradition. Nevertheless, it may provide the means of understanding a form more completely than is possible in drawing, without the danger of wasting expensive materials.

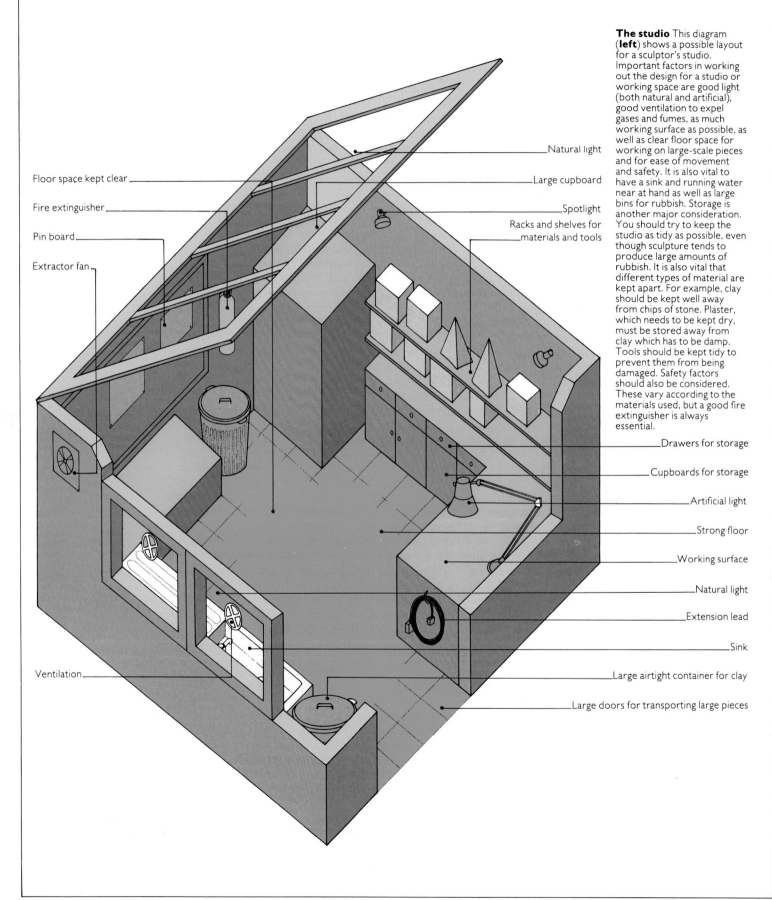

The studio This diagram (**left**) shows a possible layout for a sculptor's studio. Important factors in working out the design for a studio or working space are good light (both natural and artificial), good ventilation to expel gases and fumes, as much working surface as possible, as well as clear floor space for working on large-scale pieces and for ease of movement and safety. It is also vital to have a sink and running water near at hand as well as large bins for rubbish. Storage is another major consideration. You should try to keep the studio as tidy as possible, even though sculpture tends to produce large amounts of rubbish. It is also vital that different types of material are kept apart. For example, clay should be kept well away from chips of stone. Plaster, which needs to be kept dry, must be stored away from clay which has to be damp. Tools should be kept tidy to prevent them from being damaged. Safety factors should also be considered. These vary according to the materials used, but a good fire extinguisher is always essential.

Natural light

Large cupboard

Spotlight

Racks and shelves for materials and tools

Floor space kept clear

Fire extinguisher

Pin board

Extractor fan

Drawers for storage

Cupboards for storage

Artificial light

Strong floor

Working surface

Natural light

Extension lead

Sink

Large airtight container for clay

Large doors for transporting large pieces

Ventilation

THE STUDIO

The social role of the sculptor has changed considerably over the centuries, and, in addition, the conditions in which sculpture is produced have also changed. Medieval and Renaissance sculptors worked closely with other craftsmen, and the links between sculpture and architecture were particularly strong in church building and decoration. The workshop was a busy place, where apprentices helped to carry out the more mundane aspects of the physical work, while the master sculptor added refinements of form and detail. In the Renaissance, secular patronage from a ruling elite at first widened the scope for grandiose sculptural projects. However, developments in trade and commerce and subsequent urban development caused gradual social changes, which ultimately stifled many opportunities for sculptors. Sculpture has never found much of a home in small-scale domestic interiors, and, during the nineteenth and twentieth centuries, the sculptor has been gradually forced into isolation, depending upon an audience created through public and private galleries and relatively few commissioned civic projects. Many contemporary sculptors must continue to work without immediate benefits from exhibitions or sales. Studio space is vital, and, since a well-equipped, large workshop may not be an economic reality, the next best environment must be found.

PRACTICAL STUDIO REQUIREMENTS

A garage, loft, basement, spare room or disused warehouse can be equipped to form a suitable studio space. The basic necessities are good lighting, storage space for tools, materials and finished work, and access to running water for cleaning and mixing.

The ideal studio for large-scale work would be at ground floor level, with large doors to give easy access, a strong, solid floor and equipment for lifting and moving heavy weights. More realistically, the architecture of a room or basement will probably restrict the scale of work and possibly even the type of materials which can be used.

Sculptural processes involving solid materials inevitably make some mess, whether fine dust from cutting plastics, crumbly chips of stone, wood shavings, drips of plaster or the clutter of raw materials gathered for a construction. Different activities must be segregated or the materials may be spoiled. Fragments of stone or plaster, for instance, must be kept away from an area where fresh clay is modelled or stored. Used materials, which cannot be recycled, need not be kept lying around. Fresh materials must be stored in the proper conditions—wood or plaster, for example, can be ruined by damp, whereas clay must be kept moist.

Tools and equipment stored tidily on shelves or in a cupboard are more likely to stay in prime condition and can be found quickly when needed. Sharp tools should be kept well out of the way when not in use, in wall racks or a cupboard. This is for safety reasons, and to avoid blunting them with unnecessary wear. If a jumble of materials is kept in a studio for construction work, valuable tools may be easily mislaid.

A heavy wooden bench or table is very useful for most types of work. According to the materials being used, a modelling stand, a banker or a well-supported plastic or metal worktop may be additional necessities. Each material has characteristic properties which dictate the range of equipment needed, so the studio can either be made into a versatile workshop with a place for everything, or specially equipped for a particular medium.

Good, general lighting is a minimum requirement, and can be supplemented with spotlights if a particularly strong, angled beam is needed. The studio should be well ventilated whatever the type of work, but some materials, such as glass fibre resin, give off extremely unpleasant fumes and an efficient extractor is essential. Electric wall sockets, conveniently placed, are also vital if power tools are used frequently. An extension lead is a useful item, but wires which trail across a room are a hazard, and the lead should be coiled when not in use.

Particular safety requirements, as for resin or electrical equipment, must be carefully noted and observed. The same basic safety precautions must be taken in a studio as in any home or place of work, with due reference to the tools, equipment and processes used in the area.

Below This picture shows the artist Henry Moore at work in his studio. He is working on *Interlocking No 10*, a two piece sculpture. He is using plaster and has a variety of tools at hand – riffler, brush and an ordinary household grater.

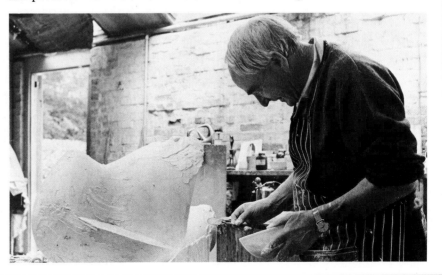

CLAY

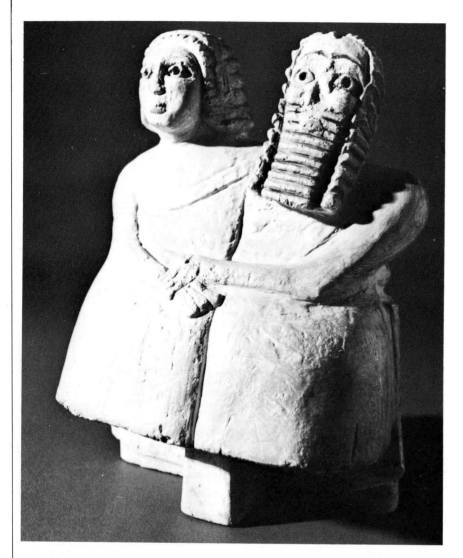

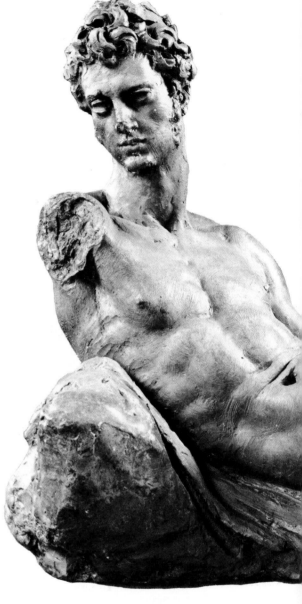

Above This Sumerian clay sculpture dates from between 2750 BC and 2600 BC. It was discovered in a temple at Nippur in Iraq. The image and the modelling techniques are fairly simple, although the image is, nevertheless, expressive. It is noticeable that more attention was devoted to the heads and faces than to the lower part of the work.

Above right This figure of a recumbent man was modelled by the sixteenth century Italian artist Vicenzo Danti. The marks of the modelling tools can be detected on the surface. The hair and face are quite well developed. Contrasting techniques have been used on the hair, flesh and drapery. Danti worked for most of his career in Florence.

HISTORY

Clays, in common with materials for carving, have been used for sculptures since earliest times. Most cultures have adopted pottery techniques for making sculptures. Sculptural objects are usually made up hollow from coils, slabs or tubes of clay which are then fired. Sometimes the outside surfaces are decorated either with clay modelling or by colours and glazes. Clay sculptures have also been formed by the technique of press-moulding, in which fresh clay is pressed into previously fired clay moulds. Whichever technique is used, the final material of the work is clay, and objects modelled in this way are referred to as 'terracotta' work. This term means 'baked clay'.

As early as the third century BC, the Greeks made their now famous Tanagra press-moulded terracotta figurines, which they painted with non-ceramic colours. During the Tang Dynasty (618–906), the Chinese made decorated and glazed press-moulded terracottas, whose excellence owed a great deal to the qualities peculiar to the ceramic techniques of their time and place. The potters of Pre-Columbian America, before the sixteenth century, and those in China and Greece made terracotta vessels or sculptures often decorating them with non-ceramic colours. In the fifteenth century, the Italian della Robbia family revived the use of press-moulding to create decorated and glazed sculptures. However, the most eloquent and successful sculptures, like the portrait of Giuliano by Andrea Verrochio (c 1435–1488), does not depend on great technical sophistication for its effectiveness. Even though this portrait may not have been possible without the Tuscan knowledge of earthenware, it is not embedded in the potter's practices with clay and glazes in the same way as, for example, Tang sculpture was.

Right This is one of the 7000 life size terracotta warriors found in the excavations at Mount Li of the mausoleum of the First Emperor of Ch'in. The figures were made in about 200 BC. The heavy clay found in the region of Mount Li enabled life size portraits to be made, and a striking feature is that no two warriors have the same face. More standardization is evident in the making of the torso, where moulds were probably used. Individual details were probably sculpted in afterwards, and the final statue brightly painted.

During the early Renaissance in Europe a new emphasis on visual naturalism developed. Bronze casting technology was revived. This, in turn, changed the way in which clay was used. It now became a transitional medium and no longer the end product of sculptures. It was used to model sculptures, which would later be cast in another medium like metal and, in more recent times, concrete or plastic resins. It was also used to make moulds for ceramic press-mouldings or simply as a material for preliminary studies. This second tradition of clay sculpture ran parallel with that of terracotta.

The sculptures made by contemporary sculptors who have used clay as a transitional medium, like the Italian Giacomo Manzù (born 1908), owe much of their liveliness in bronze to the qualities of clay, but nothing at all to ceramic technique. However, there are signs that sculptors are beginning to use ceramic techniques once again in new and creative ways.

Reconditioning clay
1. Unfired clay is broken down into pieces and dropped into a shallow bath of water. From time to time, it is stirred around until it absorbs water and softens to a thick sludge.

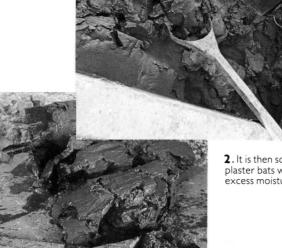

2. It is then scooped out onto plaster bats which absorb excess moisture.

Storing clay Keep clay in a large dustbin, covered with a damp sack and polythene. Keep the bin airtight with a well fitting lid.

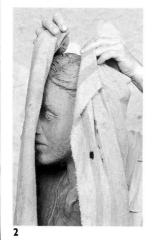

Keeping work damp 1. If the model is left overnight or for any long period during the work, spray it with water.

2. Wrap a damp towel around the model, taking care not to damage the modelling work already done.

3. Cover the whole thing in a large plastic bag and tie it tight around the base. This will keep the clay workable.

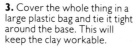

2
3

CLAY AS A TRANSITIONAL MEDIUM

In this way of using clay, the sculpture is treated just as if it were to be the final object. However, after the modelling is completed, it is used as the source for moulds of different types, depending on whether the final object is to be a casting in metal, concrete, plastic resins, press-moulded in terracotta, or a plaster cast. The clay is never allowed to dry out, and when mould-making is completed, it is stripped away from the internal supports, reconditioned and stored for reuse.

MATERIALS

Clay is one of the most commonly available materials, and if you happen to have access to deposits of suitable clay, you could dig your own. But few naturally occurring deposits yield clays that are sufficiently uniform, plastic and finely textured for sculpture purposes, so most sculptors buy the cheaper varieties of clay sold by potter's suppliers. Clays can be smooth or rough, depending on whether or not the clay contains sand and grog—clay that has been fired and ground up. For modelling rather than ceramic purposes, the choice is largely a matter of personal preference. The smoother varieties are better for small, finely detailed work, but grogged clays are easier to reprocess, because of their greater porosity, and have a ruggedness and resistance in handling that the smooth clays lack.

Clays are most conveniently bought already mixed, rather than as dry powder, and, since they are usually sold in plastic bags, they can be bought in any quantity and stored for long periods provided the bags remain airtight. Most sculptors use large galvanized bins with improvised airtight covers to store large quantities of clay for immediate use. Since these can be very heavy when full, it is useful to have them on small, wheeled dollies or trucks for mobility. A separate bin should be kept for clay which is being reconditioned. To recondition clay, chop or break it into small lumps and wet it down.

Modelling clay in optimum condition should be sufficiently plastic to be modelled easily, but not so wet that it becomes sticky. To maintain clay in this condition, a plaster of Paris slab of the sort made and used by potters for wedging (kneading) clay is best. These slabs or bats usually measure about $20 \times 20 \times 4$in ($50 \times 50 \times 10$cm). When dry, the porosity of the bat will soon dry out any over-wet clay which is kneaded and left in contact with the bat. Bats are also useful for kneading clay to

which plenty of water has been added to make it more plastic, since the wet clay will not stick to the plaster for long. Bats are best supported on strips of wood, 2–3in (5–7.5cm) above the surface they rest on, so that air can circulate.

Modelling stands, important for working with clay, come in a variety of sizes and shapes. They normally consist of a turntable or a top which can be rotated. The heavier tripod types sometimes incorporate a means of using the platform at an angle for small relief work, and the tops are adjustable for height. For larger, heavier work, fixed-height turntables called bankers are used.

The easiest way to maintain the dampness of clay during periods of working is by using a household water sprayer. Between sessions, the sculpture should be draped with a damp towel and wrapped securely in plastic sheeting.

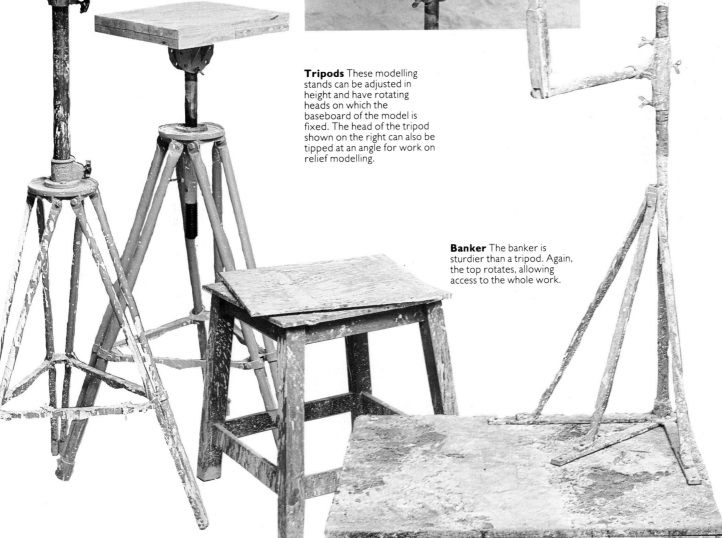

Back iron for quarter life-size figure The construction of this back iron is similar to the larger one but it is small enough to be used on a tripod.

Back iron for life-size figure A large support such as this must be firmly screwed down on a heavy wood base. As it will take some time to model the figure, the stand may be mounted on wheels and moved around.

Tripods These modelling stands can be adjusted in height and have rotating heads on which the baseboard of the model is fixed. The head of the tripod shown on the right can also be tipped at an angle for work on relief modelling.

Banker The banker is sturdier than a tripod. Again, the top rotates, allowing access to the whole work.

ARMATURES

There are few hard and fast rules for making armatures, since their configuration must vary with the job in hand. The simplest type is that used for heads or busts, called a bust peg. Another simple armature is the sort used for modelling reliefs. It need only consist of a rigid board studded with round-headed galvanized nails driven a short way in. For larger reliefs, it is advisable to provide a grid of galvanized wire running from the top of one nail to the top of another, giving more support to the additional weight of clay.

Most figure armatures are based on similar principles, and the larger the work, the sturdier the metal supports must be. These armatures usually have a strong, rigid wooden base, somewhat larger than the area to be occupied by the sculpture. The base is battened on two opposite sides of its bottom surface to make it easy to handle, and, if appropriate, the battens are spaced so that the base fits snugly over the top of a modelling stand. This base is the foundation onto which 'back irons', cranked, mild steel bars furnished with flanges, are screwed or bolted. This main support must be sturdy enough to

remain perfectly rigid after all the clay has been added. Further main sections of armature can be made either from screwed piping or welded steel. The advantage of the pipework type is that it can be dismantled from inside a waste mould, providing the threads are packed with heavy grease before the clay is added, but the welded type can sometimes be more convenient, and is more easily adapted to follow the centre of the modelled forms.

Fastened to the main support are secondary supports, which can be made of flexible materials. Most commonly used is square-section aluminium wire, which is available in various sizes. Secondary supports must be fixed to the main irons as firmly as possible, since armature pieces that rotate around one another are useless. The extremities of the supports should be fixed down wherever possible to avoid whipping and to give firm support to the clay.

In designing armatures, there is no real substitute for experience and common sense. After a while you develop an intuitive sense of where strength or flexibility will be needed for making a sculpture.

In the case of large sculptures, one of the functions of the armature is to provide a skeleton onto which bulking materials can be securely wired. These can be blocks of wood, polystyrene foam, or any suitable non-absorbent material, such as cork. To help the clay to stick to these materials, the surface can be studded with galvanized nails or enclosed in a layer of chicken wire. A useful device for supporting the weight of clay between major armature members is called a butterfly. This is a small X-shaped object, usually made by crossing and binding two short wooden laths. The butterfly is suspended by a wire from the nearest point of the armature. Because of the tendency of clay to sag, it is helpful, when working on a large scale, to start in the centre of the form with clay which is slightly harder than usual, and build up to the outer layers with progressively softer clay.

Learning to model with clay can be difficult and frustrating, as the clay has no resistant form of its own, and because its tendency to sag can lead to distortions. Its very responsiveness can yield spontaneous and delightful effects which may turn out to be irrelevant for your purposes. Thus it is vital to get to know the material, to gain experience in the ability to work out clear sculptural forms, to find out when to exert control and when to exploit the happy accident. One of the keys to developing control of clay is the practice of building outwards from the armature with fairly definitely shaped rolls, strips or blocks of clay, working outwards towards the final surface gradually and all over.

Relief modelling A special armature is needed for relief work. Drive round-headed nails into a wooden board at regular intervals. If the work is quite large, link the nails with wire to support the weight of clay.

The armature provides a rigid skeletal structure inside a modelled sculpture. It should follow the main axes of the sculpture and is especially crucial if there are projections of the form which are otherwise unsupported. Twisted wire forms the basic lines of the armature and the component parts must be securely bound at the joints so they cannot slip. If a particularly heavy weight of clay is to be applied, the structure is bulked out with blocks of wood or polystyrene, bound to the wire. The armature should be firmly fixed to a heavy wooden baseboard so that it cannot topple over.

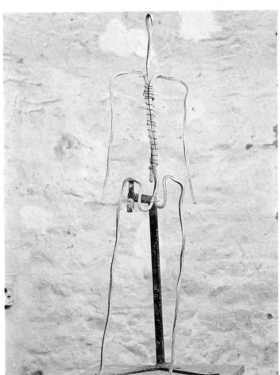

Construction of an armature 1. Pieces of square-section aluminium wire are bent into shape and bound together with galvanized steel wire.

2. The armature is secured to a back iron for support, again tied tightly with wire.

3. The bottom of the armature should be anchored to the base with nails hammered in and bent over the aluminium.

4. Small detailed shapes, such as hands, are constructed in wire and bound to the main armature.

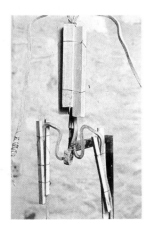

5. To reduce the weight of clay, the armature is bulked out with wood which should support long sections but leave the joints free.

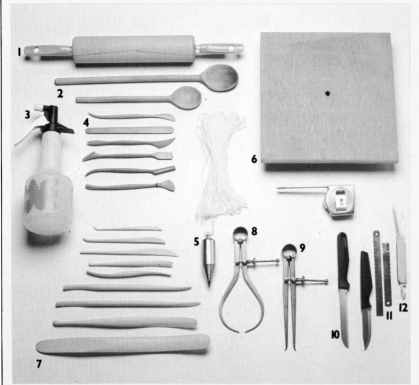

TOOLS

The main tools used for modelling are hands and fingers, and try to think of other modelling tools as specialized extensions of them. In selecting or making tools, a good rule is the fewer and simpler the better. A good assortment would consist of paddles or blocks for consolidating large masses, a variety of simply shaped wooden or metal modelling tools, and wire loop-ended tools. A useful cutting tool for dividing large lumps of clay can be made by twisting two strands of fine brass wire together and fastening a short stick or dowel to each end of the resulting 'wedging' wire. Most modelling is done with wooden tools, but metal ones can give a distinctly different quality. Metal tools are usually made of mild steel. The best wooden tools are made of boxwood or holly, but many sculptors make their own from any compact, fine-grained hardwood—particularly apple, pear or other fruit-woods. Experiment with wood and metal tools will show which suits your needs.

TECHNIQUES

Modelling is a complementary procedure to carving. Instead of removing stone or wood from the block in order to arrive at the sculpture's surface, the modeller works towards the surface from the core. The responsive nature of clay encourages a degree of flexibility in the sculptor's thinking that is not always possible in carving. But, whether modelling or carving, the work demands that the sculptor has a fairly definite concept in mind before beginning work on the final object. The degree of comfortable certainty will vary among sculptors, and the nature of the sculptural idea is usually the result of preliminary drawings, maquettes and studies on a smaller scale. When used on a large scale, clay needs good internal supports, which can put broad limits on the range of

Tools for clay modelling
Remember that modelling tools should be thought of as extensions of the hands and fingers. The effects produced by many of the tools pictured here closely resemble those which can be made by different parts of the human hand—finger tips, palms or the sides of the hands, for example. Tools come in a variety of sizes and shapes and most of them are made of wood, usually boxwood or holly (**7**). Plastic tools (**4**) are also available and are certainly valuable for the beginner.

The variety of tools to be found in craft shops can be overwhelming, so remember the principle that, in selecting or buying tools, the fewer and simpler the better. Experiment with as many tools as you can until you discover which best suit your personal needs. A sturdy baseboard (**6**), usually made of plywood or a similar material, is an essential for everyone—amateur or professional. It must be sealed to prevent water absorption. Purpose-made tools are not always preferable to items which

you can probably find around the house. A rolling pin (**1**), Wooden spoons (**2**), a plant spray (**3**)—vital for maintaining the moisture of the clay—kitchen knives (**10**), a penknife (**12**) and a plumb-line (**5**) will all prove to be invaluable. Broken hacksaw blades (**11**) are often used to create flat areas and as cross-scrapers to remove indentations. For measuring you will need a tape measure, as well as outside callipers (**8**) and inside callipers (**9**) for calculating exterior and interior measurements

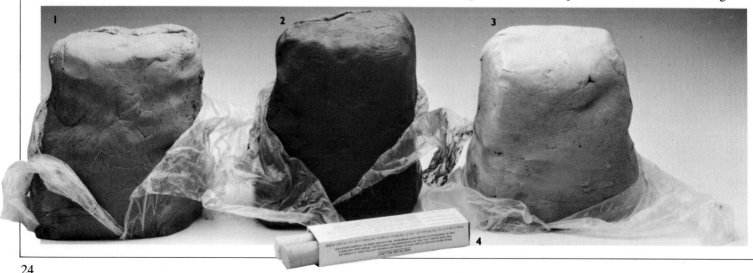

flexibility in the sculptor's thinking. It is possible, of course, to make a major change at some point during the final work, but this might mean dismantling the sculpture, altering the armature and beginning again—an uneconomic procedure.

In developing towards the final surfaces, the importance of good lighting cannot be overstated. Both a good general level of lighting and portable, directional light sources are needed. The varying play of light over modelled surfaces has important effects on how the form is perceived, and work in progress should be studied frequently under different lighting conditions. Lighting conditions are particularly crucial in the way relief sculpture is perceived, and, for this reason, any relief modelling must always be done, as nearly as possible, with the clay in the same relationship to the eye as in the final siting.

How the final qualities of form and surface are treated is a matter to be resolved by experience. However, there are some important factors to bear in mind. Firstly it is useful to have a knowledge of and, where possible, first-hand acquaintance with as many examples as possible of what has already been achieved. Secondly, it is important to consider the particular qualities of the underlying form and what seems most appropriate to reveal them at the surface. The visual traditions and uses of the material in which the sculpture will be cast should also be considered. A further important factor is what is appropriate both to the subject and to the sculptor's perceptions of it as these emerge in the working process. Above all, the artist should always use new possibilities as they emerge during the development of specific works or sculptural interests.

In a sense, clay used as a transitional material contains few particular instructions or guides to how it should be used, apart from those mentioned. However, the sculptor should constantly bear in mind the qualities of the material of the final cast—whether bronze, lead or plastic resins.

Types of clay The type of clay (**left**) chosen for modelling depends upon the nature of the finished work. When clay is used as a transitional medium, in a model which is to be cast in a more durable material, a grey clay body (**1**) or natural clay (**3**) may be used. It should be of a suitable texture and plasticity to be worked into the required form. A model in terracotta (**2**), a dark red clay, is finished by firing, and it is important to keep the clay free of impurities. Sticks or blocks of modelling clay which harden without firing (**4**) are also available.

Right Arturo Martini's *Clair de Lune* was made in 1932. It is an example of terracotta modelling and shows how Martini tried to recreate aspects of classical art in a modern idiom. The figures convey an impression of stillness and calm. Martini was trained as a goldsmith and a potter before he took up sculpture in 1906. In 1945, shortly before his death in 1947, he gave up sculpture in favour of painting. He felt that sculpture was no longer a living medium.

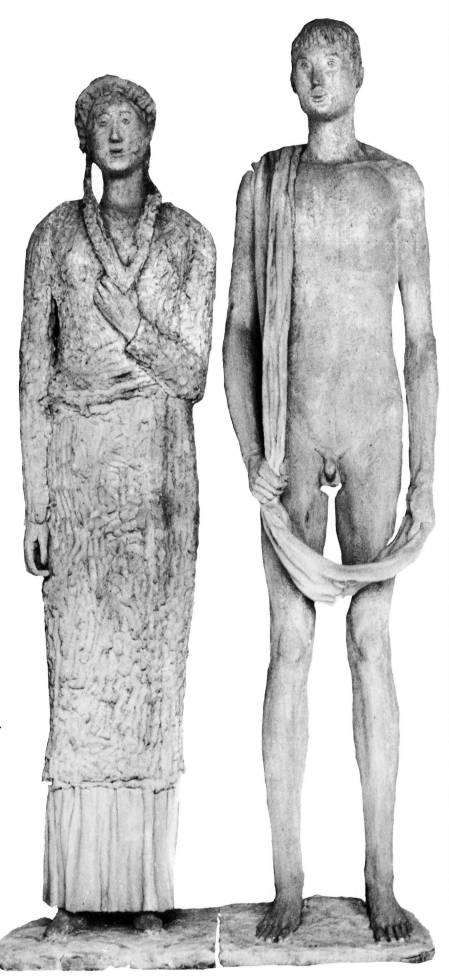

Modelling with clay 1.
Construct a suitable armature for the model. Here a bust peg with central butterfly is used.

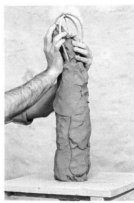

2. Build out the armature with large lumps of clay pressing firmly around the stem and filling in the rounded head.

3. Give the model volume and basic form by patting on thick rolls of clay, rounding out the shape.

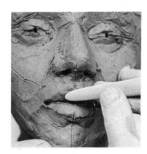

4. Work over the surface with your fingers drawing the clay rolls together into a single mass.

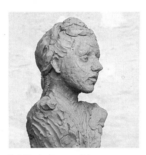

5. Continue to rough out the model with your fingers before adding detail. Develop the rhythm and contour of the form.

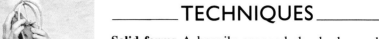

TECHNIQUES

Solid forms A heavily grogged clay body can be made into a sculpture which can be fired solid, without hollowing out, provided that adequate time is allowed for the drying process and firing is carried out very slowly. The drawbacks are the weight of the sculpture and the long drying time. But the real hazard is the danger of cracking, and the greater the contrast between thicker and thinner forms, the more likely it is that the clay will crack in the drying process. As a general rule, then, terracotta sculpture should be made as uniform in thickness as possible.

Another rule is that the clay should contain as few air pockets as possible, particularly in the case of smooth-textured clays. For this reason, and also to ensure that all the clay to be used for the sculpture is of about the same consistency, it is necessary to wedge or knead the clay in the way that potters do, using a plaster bat as a kneading surface.

Hollow forms A form with a large, flat bottom surface can be modelled directly and later hollowed out with a wire-loop tool when the clay has nearly reached the leather-hard stage and can be handled safely without distortion. Other forms can be prepared by forming a slab of clay over a

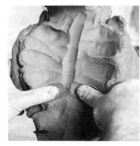

6. Add more clay to the surface and start to define features on the head and face.

7. Use a modelling tool to work into the shapes of eyes, nose and mouth, adjusting the forms by scraping off or adding clay.

8. Work the model to a stage where a basic representation of the subject is achieved.

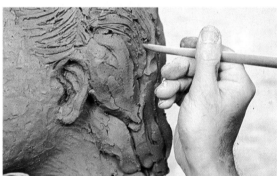

9. Draw into the clay surface with a modelling tool to develop texture in the hair.

Observe the subject closely as you work.

13. There are no hard and fast rules in clay modelling. The skills are best acquired with practice, adapting techniques to suit the final result you wish to achieve.

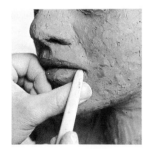

10. Work continuously over the whole form, adding detail to the portrait and bringing up the characteristic lines and shapes.

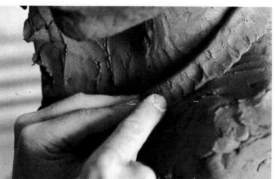

11. Develop details of clothing or drapery by patting on small rolls of clay and modelling them into the broader shapes.

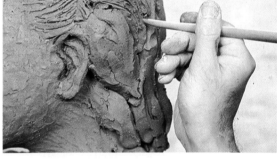

12. Add small dabs of clay and model them into the surface. Keep the texture active without losing coherence in the form.

mound of sand and later joining the slabs together with clay slip. Slip is made by mixing powdered clay with water until it reaches a thick soup-like consistency. Another method is to model directly over a simply shaped armature, and, when the clay is leather-hard, cut it into sections with a wedging wire and carefully remove from the armature. The armature must be designed with this in mind, so that the clay is not trapped on rigid projections. Since some shrinkage will occur between the completion of modelling and the time when the clay is leather-hard, a rigid armature should be bulked out with a soft material such as newspaper, which is easy for the clay to compress slightly as it shrinks. After the sculpture has been cut and removed from the armature, the pieces are reassembled after roughening the surfaces to be joined and painting them with slip. The sculpture is wrapped up to protect it from drying out any further until the moisture from the slip has equalized with the general condition of the rest of the clay, after which drying can continue fairly rapidly. Any walls which enclose a cavity must be perforated to allow the air inside to expand during firing without damaging the sculpture. The thickness of the final walls can vary from ¼in (6mm) to 1in (2.5cm) or more, depending on the size of the sculpture and the coarseness of the body. But the sculptor must bear in mind

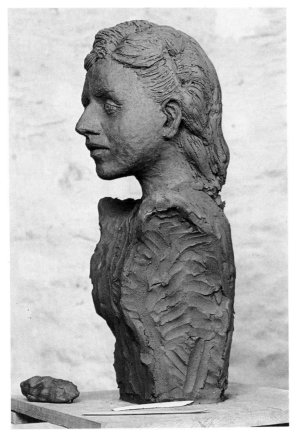

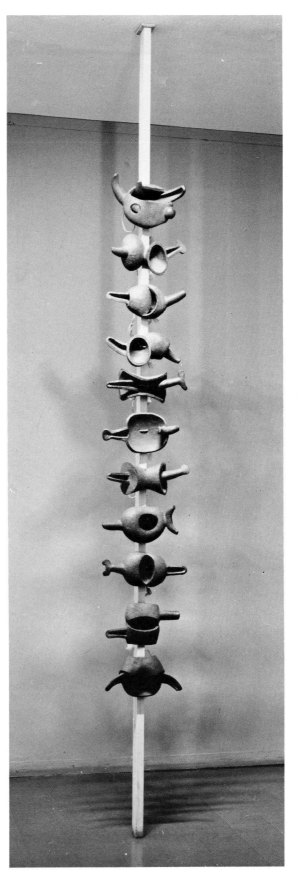

Left Isamu Noguchi's *Even the Centipede* (1952) consists of 11 pieces of Kasama ware, each approximately 18in (46cm) wide, mounted on a wooden pole 14 feet (425cm) high. It demonstrates Noguchi's individual contribution to the world of sculpture. Although born and trained in America, he spent his childhood in Japan, and this combination of influences gives a special quality to his work, which, as well as sculpture, includes theatre and costume design, garden plans and playgrounds. For Noguchi the essence of sculpture is 'the perception of space'.

Hollow modelling

Working with a hollow form is more satisfactory than modelling solid, especially where the work is so large that drying out would take too long or cause cracking. Hollow forms can be made directly and hollowed out when the work is leather hard. Other methods of forming include forming a slab of clay over a bed of sand or using a simple armature.

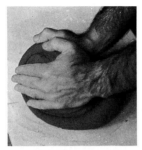

Hollow building 1. Wedge the clay thoroughly on a plaster bat or flat work surface covered with clean hessian or canvas.

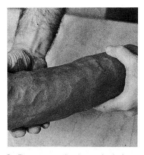

2. Draw out the kneaded clay into a long, thick roll.

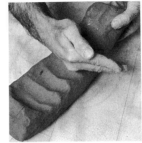

3. Place the roll on the hessian and hit it with the side of the hand along the length to flatten it out.

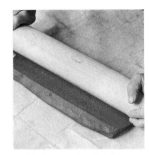

4. Work over the clay with a rolling pin to even out the thickness.

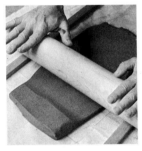

5. Guide the rolling pin over the wood battens placed either side of the clay. This ensures even depth to the rolled clay.

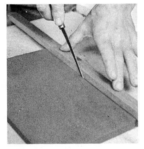

6. Pick up the clay pancake at one end and turn it over. Use the rolling pin again.

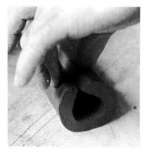

7. Cut the clay with a sharp knife guided along a straight edge. Make pieces of suitable size for the intended sculpture.

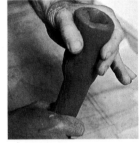

8. Curl the sheet of clay around to form a hollow tube, and model along the edges to form a seam.

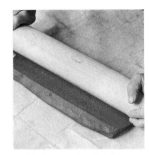

9. Hold the tube upright and draw it down with your other hand to narrow and lengthen it into the required shape.

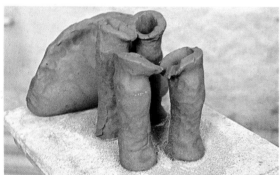

10. Make all the sections needed for the work in the same way and leave them to dry out on a bed of grog until they are leather-hard.

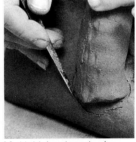

11. Hold the pieces in place and make marks on the clay with a knife to locate the joints.

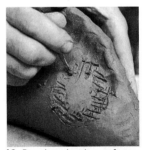

12. Roughen the clay surface by scoring with a knife. This provides a key for adhesion in the joint.

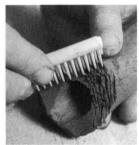

13. Roughen all the other surfaces which form faces of the joint. A plastic comb is useful for this.

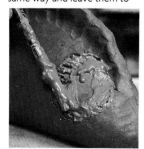

14. Paint clay slip over the roughened surfaces. This acts as an adhesive on the clay.

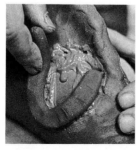

15. Lay a small roll of clay along the marked joint. This can be used to model around the seam lines.

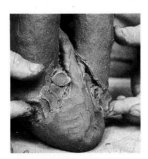

16. Press the preformed shapes into place and smooth clay over the joint to secure the sections.

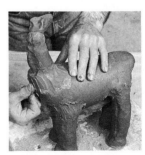

17. Use a modelling tool to work into spaces inaccessible to the fingers. Seal all cracks at the seams.

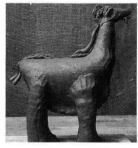

18. Fit all the pieces together in the same way to construct the basic shape of the model.

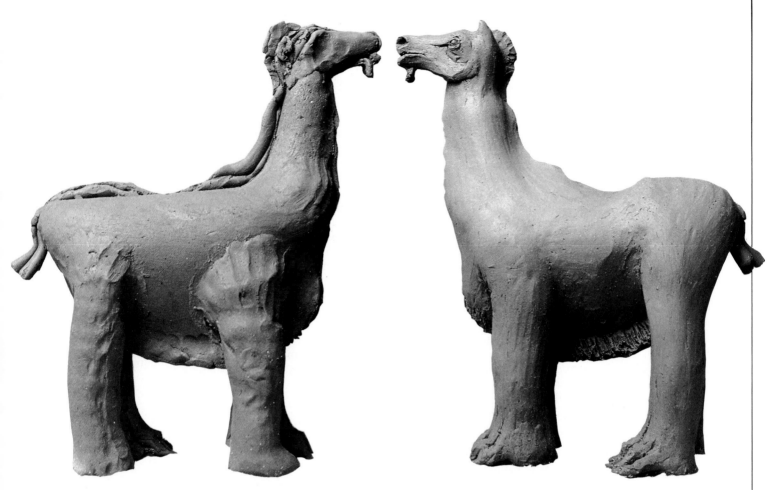

that uniform wall thickness is the key to minimizing the stresses that are set up in the clay during drying and firing.

Another important factor in working with hollow forms is timing. The clay must be kept in the optimum condition of dampness for each stage of work, and no part of the sculpture should be allowed to dry out to the leather-hard stage before any other. Working with quite large forms may prove to be an exception, as it may be necessary to start at the bottom and build upwards in stages. In this case, the lower sections must be allowed to dry enough to support the weight of the next stage or section, but not so much that joints might become insecure from too great a difference in moisture content. If cracking occurs at the leather-hard stage it can seldom be repaired successfully. A lower section can be allowed to dry out slightly without danger, if the top edge is kept damp with wet paper or cloths.

Hollow sculptures are usually worked and fired on a bed of sand or grog, so that the form can contract freely on its base or kiln shelf. From the completion of shaping through drying and firing, a terracotta will have shrunk by about 10 per cent. If size is critical, this will have to be allowed for by working on a slightly larger scale from the outset. If the sculpture is fairly large and is likely to be awkward to move or handle before firing, it can be worked on a grogged kiln shelf and placed directly into the kiln after drying.

In addition to the armature method, the main techniques for making ceramic sculpture are the same as those used by potters: building a form with coils or slabs; press-moulding; slip-casting (for quantity production); and throwing on the potter's wheel, all of which are covered in the section on pottery (pp 32–53). Each technique has its own particularly rich possibilities and vocabulary of forms.

There are some limitations on the size of terracotta sculptures which should be borne in mind. The problem of portability for firing can sometimes be circumvented by building a temporary kiln around the sculpture, if the time and effort are warranted. However, the size of available kilns should always be considered. This need not really be a limitation, providing that the sculpture is cut into sections at the leather-hard stage. Since the sections will then shrink and distort independently, a slight mismatching of form along the joints must be taken into account. Another consideration is that, after firing, the rejoining will have to be done using adhesives or cement grouts, and this too must be taken into account, since such joints will almost always be visible.

There is one important aspect of ceramic technique which is not often mentioned in relation to sculpture. It is in the nature of clay-working and ceramics that objects are made in quantity, and rejects are common. The lesson for the sculptor is clear: until you know the medium well through personal experience, it is a good idea to make more than one of a sculpture, or at least several variations on a theme.

19. The hollow form is now ready for surface modelling and decorative detail. These pictures show the sculpture half finished, one side in the rough jointed state, the other fully modelled.

TERRACOTTA

The term terracotta simply means baked clay and is used by most sculptors to mean any sculpture in which clay is used as a final material, which is fired to achieve permanence. There is also a more specialized usage, where terracotta specifically means fired clay sculpture, characteristically made in red earthenware bodies, which are comparatively soft and usually not fired to over 2332°F (1277°C). Today, however, much ceramic sculpture is also made in stoneware clays. These are harder and typically lighter in colour, sometimes as light as pale buff, and fired at temperatures which are much higher. Pure white porcelain clays and bone chinas are also used by a small number of specialists. The technical scope of ceramic sculpture can be as vast as the ceramics field itself, whether in the matter of shaping techniques, surface treatments, colourings, glazes or firing methods, and anyone approaching it from a sculptor's viewpoint is well advised either to cultivate the friendship of an experienced potter, or to take the time to become one.

The workplace in which clay is to be worked and fired must be kept very clean, as must the clays, tools and materials. Any foreign materials, especially plaster, must be stored and used elsewhere. If any bits of plaster are present in a clay sculpture during firing, they will cause small explosions of steam, which will mar or destroy the work, and can even damage the kiln.

MATERIALS

The clays available for terracotta sculpture are the same as for pottery, ranging from the red earthenwares through the salmon or pinkish mid-temperature clays to the paler, toast-coloured or buff stoneware bodies. The texture of any of these can be varied by the addition of sand and grog up to about 25 per cent, and this has the effect of reducing the amount of shrinkage and warping that all clay undergoes during drying out and firing. If a coarse texture is not desired, however, some increase in the stability of even a very smooth clay can be obtained by wedging in some sand or grog, which has been passed through a fine sieve. Although this will reduce the plasticity of the clay somewhat, it need not necessarily increase its roughness. Beyond this, the technically minded might become interested in the enormous range of possible colours and textures that can be produced by adding special texturing materials and colouring oxides.

Ceramic materials and techniques, of all those available for sculpture, provide probably the most varied and wide-ranging field of artistic pos-

sibilities. However, simplicity and directness should be the sculptor's aims until enough experience of the technical possibilities for any immediate sculptural purposes has been achieved.

In beginning, it is wise to choose either a smooth or textured earthenware body, sometimes called earthenware sculpture clay, or a textured stoneware body, called a 'crank mixture'. The choice may depend less on individual preference, which should always be determined by looking at fired samples, than on the type of firing facilities available. Clays should normally be fired to their correct maturing, or vitrifying, temperatures, and some kilns are designed for higher operating temperatures than others. The two fundamentally different types are oxidizing and reducing kilns, and each has characteristic effects on the colour of fired clays and glazes.

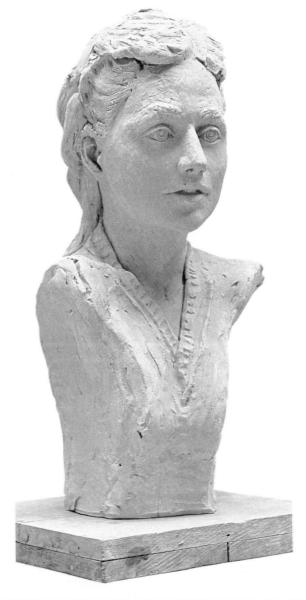

Right This picture shows the fired model. It is considerably lighter in colour than the unfired clay. It is important to fire the clay at the right temperature. It is very important to check the type of kiln and the temperatures to which it operates before firing any work.

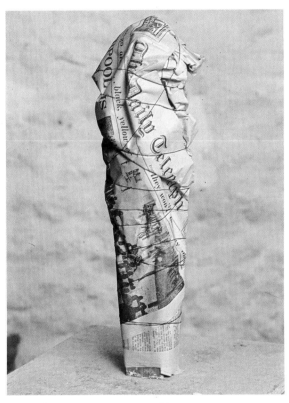

Hollowing a terracotta model 1. The armature used for this model was padded with newspaper to reduce the weight of clay.

2. Model the form in the usual way. When the model is leather-hard cut it loose from the base with a long knife.

3. Mark a seam line over the model and cut it into sections, preferably two. Pull them away from the armature.

4. Hollow out inside the form with a wire-loop tool. The clay must be firm but not too dry.

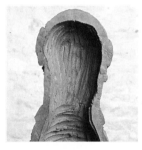

5. Work on each part of the model in this way, leaving even clay walls of about 1–1½in (2.5–3.8cm) in thickness.

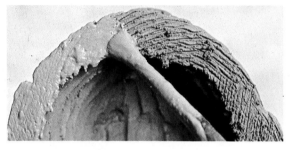

6. Roughen the seam lines with a comb or knife, and paint them with clay slip.

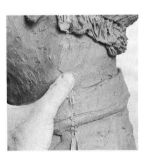

8. Wipe away surplus slip and model fresh clay over the seam to conceal it.

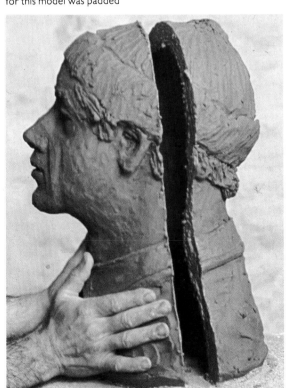

7. Place the sections of the model on a bed of grog and press them together, matching the seams exactly.

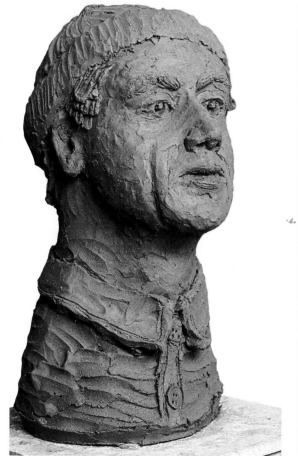

9. Once the seams are covered, finish the model to its original state. It is now ready for firing.

POTTERY AND CERAMICS

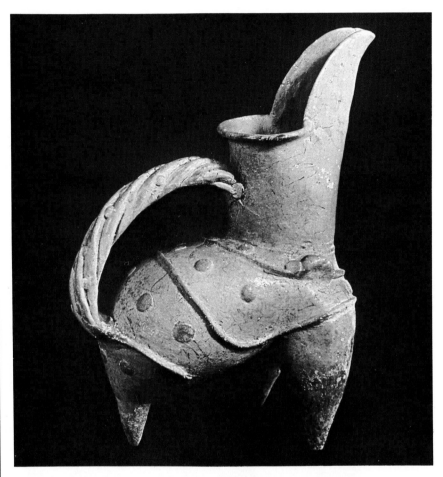

Above This earthenware tripod jug dates from the second or third millenium BC. The handle is made from twisted strips of clay. The other decoration is simple, consisting of raised strips or circles of clay. Pottery has been a popular craft since earliest times, and there are many fascinating traditions from all over the world. The development of glazes and kilns around 4000 BC made it possible to create durable, glazed ceramic vessels.

HISTORY

Pottery is one of the oldest and most widely practised crafts; it is unique and exciting. It is a tradition that has come through time with man and ranges from the purely ornate to the truly functional. Clay has unique characteristics and the beginner needs to understand some of these to be able to work with the clay intelligently. The term ceramics covers pottery and anything made from clay which has been hardened by firing.

Clay in its fired state is fragile and easily broken, yet is imperishable and it does not corrode or rot. For this reason, ceramic artefacts remain as a continuous record of man's development from earliest times. The museums of today are full of ceramic objects showing a rich profusion of styles and techniques.

The earliest ceramic objects date back to 6000 BC. These were no more than modelled clay images of men and animals baked hard in the sun and probably used for magical or religious purposes. Clay occurs over most of the earth's surface and many different societies possessed the basic knowledge and techniques needed to use it. It is not known when man first discovered that,

when clay was fired, it became permanent and durable, but it is thought that man's involvement with fire and its maintenance helped, perhaps by accident. Pottery making developed when man stopped the wandering nomadic life of a hunter and started to cultivate and farm. This explains why the parts of the world that first developed identifiable social patterns, such as Egypt, India, China and the Middle East, should be places where the earliest known ceramics come from.

Around 4000 BC potters in these countries developed kilns which allowed them to produce high quality pottery with glazed surfaces. This coincided with the development of metal smelting. Even at this early date, the practice of borrowing forms and decoration from other media was common, and, as early bronzes were rarer and more valuable than pottery, it was only natural that they were copied. As pottery developed into an industry, trading contacts increased and so helped spread new ideas and techniques rapidly. The rise of warfare between nations played a role in this too.

When Greece became a new centre of power and wealth, pottery forms produced were classical and owed little to the natural quality of clay but more to aesthetic ideals. The subject matter for decoration was superb illustrations of warriors, gods and classical myths, carried out in a style called *terra sigillata*, which involves applying coloured slip—liquid clay—over the ware and scratching the design through from the base. Later the Romans, much influenced by Greek art and culture, helped to change the simple pottery of Europe to a more sophisticated style and quality. When the Roman Empire collapsed, much of the technology they had introduced lapsed.

China also possessed a long, unbroken tradition in ceramics. But the Chinese found enjoyment in the spiritual rather than the physical, and this quality is evident in much of their pottery. The Chinese also buried ceramic models and vessels with their dead—the figures and animals which date from the Tang period (AD 618–906) and Sung period (AD 960–1279) are renowned for their excellence and demonstration of superb skills and techniques. China's greatest single contribution to the advancement of the craft is a more purely technical feat—the invention of white translucent porcelain probably during the Tang dynasty.

The spread of Islam from the seventh century marked a new phase in the cultures and arts of Asia, North Africa and parts of Europe. In pottery, Islam readily accepted the traditions and techniques of Near Eastern potters. However, trade and cultural contacts with China provided influences that can be seen in the ceramics of both

cultures, one being the use of copper-blue to decorate ceramic wares. Persian influence was evident in Spain due to the invading Moors from North Africa. It was through Spain that the Near Eastern techniques passed on to the European potters, tin glaze being one technique, which, together with enamel painted decoration (in Italy called 'majolica'), was to dominate European ceramics until the eighteenth century.

Around the end of the fourteenth century another significant technical innovation took place in Europe—the discovery and development of saltglaze stonewares in Germany. This process involves throwing salt into a kiln during firing. The salt combines with chemicals in the clay body to form a glaze. The process is little used today for safety reasons. This is particularly because it produces dangerous fumes.

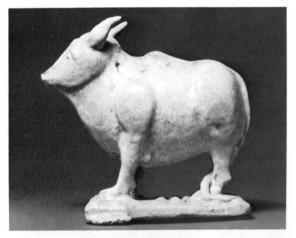

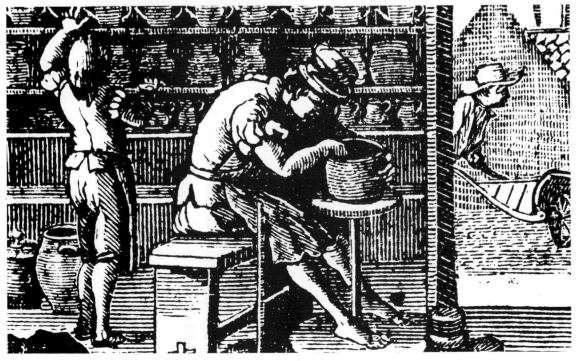

Above The development of ceramics in the Near East was greatly boosted by the spread of Islam after the seventh century. This charming figure of a bull (**left**) was made in Syria around AD 1200. Persia had several important ceramic centres. This earthenware bowl (**right**) dates from around AD 1000, and comes from Nishapur in eastern Persia. The geometric design and decoration with various colours of slip are typical for the culture and period.

Left The invention of the potter's wheel—probably in Mesopotamia between 3000 BC and 4000 BC— determined many of the working potter's practices for centuries after. This eighteenth century engraving by Thomas Bewick shows a potter's workshop. The wheel is being turned by the craftsman's foot.

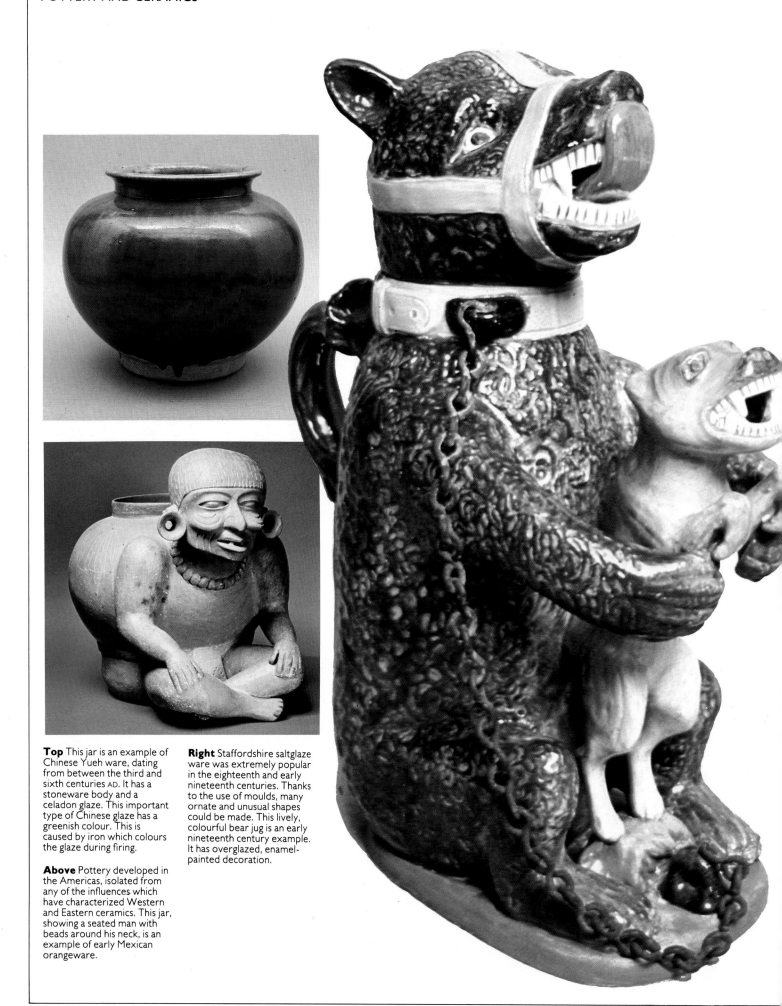

Top This jar is an example of Chinese Yueh ware, dating from between the third and sixth centuries AD. It has a stoneware body and a celadon glaze. This important type of Chinese glaze has a greenish colour. This is caused by iron which colours the glaze during firing.

Above Pottery developed in the Americas, isolated from any of the influences which have characterized Western and Eastern ceramics. This jar, showing a seated man with beads around his neck, is an example of early Mexican orangeware.

Right Staffordshire saltglaze ware was extremely popular in the eighteenth and early nineteenth centuries. Thanks to the use of moulds, many ornate and unusual shapes could be made. This lively, colourful bear jug is an early nineteenth century example. It has overglazed, enamel-painted decoration.

In the seventeenth century large quantities of Chinese porcelain were imported into Europe. The search for a match for this white clay body was to prove to be a great stimulus to innovation and technical advancement in the production of European ceramic wares.

Social and economic conditions began to change rapidly in the middle of the eighteenth century. The population expanded and demands for mass-produced products increased. In Britain the development was brought about by individuals, often sponsored by dukes or royalty. In this way Josiah Wedgwood (1730–1795) and his contemporaries helped to develop the manufacture of ceramics. These processes remain broadly similar today.

Far left This distinctively shaped vase is an example of Chinese Sung Lung ware. Towards the end of the Sung dynasty, invasions from the north by Tartars forced the Emperor to move south. This meant that the town of Lung Chuan became the centre of the production of celadon ware. Much Lung Chuan ware was mass produced, the lower quality articles being reserved for the export market.

Left This colourful ceramic jar is an example of Russian eighteenth century pottery. It has simple, stylized figurative decoration.

Below Willow pattern is one of the best known patterns on domestic china. It dates from around 1819 and became popular because the pattern could be transfer printed. This meant that the decoration process was both quicker and cheaper, and so the ware was accessible to a very large number of people. The process of transfer printing was a great success commercially in the nineteenth century. Willow pattern china has been made by many manufacturers, this example comes from Wedgwood.

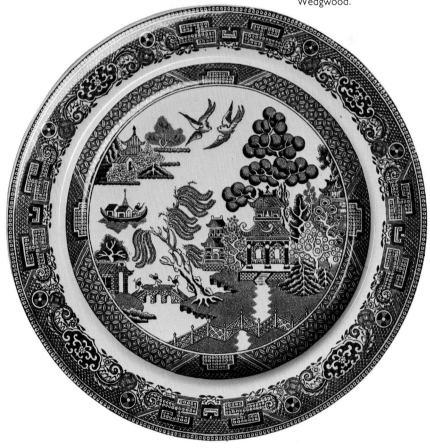

MATERIALS

Clay is a material difficult to define accurately, as all clays are mixtures of minerals. In general terms, clay is the natural result of the decomposition of granite and igneous rocks. There are two main types of clay. 'Primary' clays are found where they are formed and are therefore whiter and purer than the other 'secondary' clays. Secondary clays have been moved by water, wind or glacial activity. This movement reduces the particle size and increases the plasticity of the clay. Plasticity refers to the ability of a clay to be malleable and yet to retain its shape when it has been modelled. It is a major consideration in selecting clay and the degree of plasticity varies from type to type. However, impurities are picked up as the clay moves and these affect shrinkage and drying. They also tend to give the clay a darker colour.

Above *Ceramic Head* by Glenys Barton is an excellent example of the use of mould-making in ceramics. The stark, simple shape and intricate figures, which form an integral part of the image, produce a striking effect.

Right Elizabeth Fritsch, one of Britain's leading ceramicists, acknowledges the influence of music on her work. *Optical Pot with Swinging Counterpoint* (1978) is an example of what can be achieved using coiling.

Far right Another hand-building technique which contemporary potters are exploiting is pinching. This delicate, crackle glazed pot was fashioned by Mary Rogers, who uses natural forms as one of her main inspirations.

TYPES OF CLAY

Natural clay This is clay that has been mined, cleaned and can be used without additives.

Red earthenware This is also known as terracotta and is normally an iron-bearing, secondary clay. It is red in colour, quite soft and has good plasticity and strength. Red earthenware is excellent for modelling, hand building and throwing.

Ball clay This secondary clay is blue or black in colour and has a high drying and firing contraction. Ball clays provide a high plasticity and strength to clay bodies. A clay 'body' is a type or mixture of clay.

China clay or kaolin China clay or kaolin is a primary clay. It is a washed kaolin formed from decomposed granite and has very little plasticity, is less vitreous than ball clay and has a low firing contraction. It turns white on firing. China clay is used to provide the necessary working properties of the body and to act as a bond. China clay is the main source of whiteness used in preparation of most bodies and may be used as a glaze source of alumina and silica.

Fireclay Fireclay gets its name from its heat resistant nature. Its physical characteristics vary, some are plastic while others are coarse and granular. Fireclays generally contain some iron and are associated with coal deposits. They are used for insulating brick, hard fired brick, kiln furniture and also as additives to stoneware bodies to give a certain plasticity and the ability to withstand high temperatures.

Stoneware clay Smooth plastic sedimentary stoneware clays withstand high temperatures. They usually appear light buff, grey and light brown in colour. Stoneware clay needs additives before being used.

Bentonite This is an extremely fine plastic clay of volcanic dust origin. Bentonite is added to clay bodies to improve plasticity.

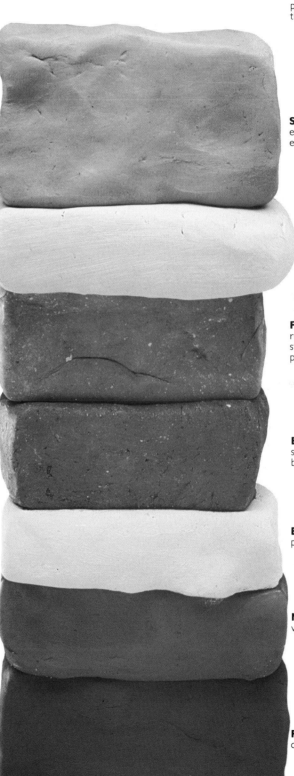

Types of clay
These are some of the clays which will prove useful to the potter—many because of their good plasticity.

Stoneware clay withstands extremes of temperatures, even very high ones.

China clay acts as a bond and is the main source of whiteness.

Fireclay is extremely heat-resistant and is often added to stoneware to increase plasticity.

Blue ball clay is used to add strength and plasticity to clay bodies.

Bentonite also adds plasticity to clay bodies.

Natural clay can be used without additives.

Red earthenware is usually called terracotta and is soft.

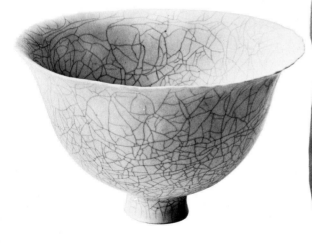

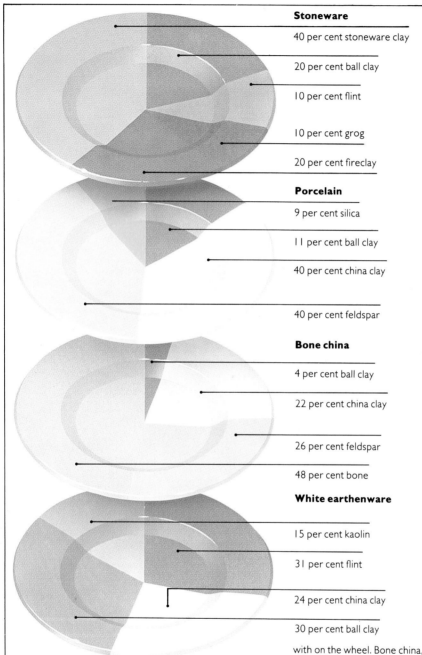

Stoneware

40 per cent stoneware clay

20 per cent ball clay

10 per cent flint

10 per cent grog

20 per cent fireclay

Porcelain

9 per cent silica

11 per cent ball clay

40 per cent china clay

40 per cent feldspar

Bone china

4 per cent ball clay

22 per cent china clay

26 per cent feldspar

48 per cent bone

White earthenware

15 per cent kaolin

31 per cent flint

24 per cent china clay

30 per cent ball clay

CLAY BODIES

A body is a mixture of clays or a mixture of clay with other ceramic materials to give a working basis for the type of pottery required.

The important qualities of all clays as far as the potter or sculptor are concerned are plasticity, texture, colour and durability, both when green— or unfired—and during and after firing. Clay bodies can be dug up and mixed by the potter or can be purchased from pottery suppliers. These suppliers stock most types of clay bodies or will mix a body according to personal requirements. It is important for the potter to choose the right clay for his or her needs and to understand the physical and aesthetic qualities of the material involved.

The main types of clay body on the market are stoneware, porcelain, bone china, white earthenware and red earthenware.

Stoneware A basic stoneware body consists of 40 per cent stoneware clay, 20 per cent fireclay, 20 per cent ball clay, 10 per cent flint, a mixture of ground flint, china clay and quartz, which helps to stiffen the body. Stoneware also contains about 10 per cent grog. Grog is clay which has been biscuit fired—fired just enough to dry it out—and then ground up. It adds texture to the clay mixture and helps give strength during firing. This combination gives the stoneware body its buff colour and high plasticity, which makes it very suitable for hand building and throwing. It has a low temperature of about 1832°F (1000°C) for the first or biscuit firing, and around 2336°F (1280°C) for the second, high gloss firing. When fired at this higher temperature, the body is very strong.

Porcelain The main ingredient of porcelain is china clay. A typical porcelain body might contain 40 per cent feldspar, 9 per cent silica, 40 per cent china clay and 11 per cent ball clay. This mixture gives the body a blue-white colour and translucency when fired at a high temperature, but its plasticity is low. It can be difficult to work with on the wheel, and so practice is needed to work well with this clay. This mixture has a fairly low biscuit-firing temperature of 1940°F (1060°C) and a gloss firing temperature of about 2336°F (1280°C).

Bone china This type of body is normally used in the industrial manufacture of ceramic wares. The mixture of about 48 per cent calcined bone, between 25 and 30 per cent feldspar, about 22 per cent china clay and up to 4 per cent ball clay gives a pure white, translucent body. When fired, it remains strong even if it is very thin, but it is brittle in its green—or unfired—state. Its plasticity makes it difficult to handle.

White earthenware This is a second type of clay

Clay bodies Clay, always a mixture of minerals, is basically the natural result of decomposition, usually of igneous rocks and granite. A mixture of clays or a mixture of clays with other ceramic materials is referred to as a 'clay body'. These bodies can be obtained in one of two ways: they can either be purchased directly from pottery or craft supply centres or be dug up and mixed by the potter. The latter method will of course be quite difficult for the amateur. An understanding of the qualities and characteristics of the material to be used is of paramount importance before work is begun. Four of the main types of clay body in general use are broken down into their component parts above. Stoneware bodies have a very high plasticity and are suitable for hand-building and throwing. Porcelain has a low plasticity and it therefore tends to be difficult to work with on the wheel. Bone china, although the chief body used in industrial manufacture of ceramics, has a plasticity which makes it difficult to handle. It is very brittle before it is fired. White earthenware is also frequently used for industrial work; it is often avoided by the amateur because it is difficult to hand-build and to throw. Texture, colour, durability and plasticity must be considered when choosing a clay body with which to work. Bear in mind that these bodies can be mixed according to personal specifications.

body predominantly used in industry. A mixture of ball clay, china clay and flint, it has good whiteness, but is not translucent. It is difficult to throw or hand build, but suits industrial processes.

TOOLS

The range of tools used in the production of ceramic forms is vast and the variety endless. Some can be made without much difficulty or adapted from household utensils, while more specialized tools for specific skills or techniques can be purchased from pottery suppliers. They fall broadly into two categories—shaping or modelling tools and cutting tools.

The modelling tools can be made in wood, metal or plastic and also come in a variety of shapes and sizes. They are used for a wide range of functions from texturing clay to smoothing it or serving as extensions of the fingers. Cutting tools cut the clay in one form or another. These include wires which are used for cutting forms off the wheel-head or slabs from a pancake of clay.

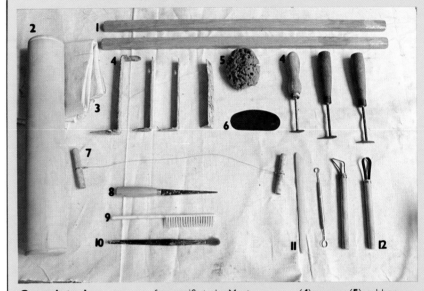

Ceramic tools
A small array of some of the vast range of tools used in the production of ceramics is shown here. They range from ordinary household utensils to those designed for specific tasks. Most ceramic tools falls into one of two types: those used for modelling and those used for cutting. Included here are: battens (**1**), rolling pin (**2**), hessian (**3**), turning tools (**4**), sponge (**5**), rubber kidney (**6**), cutting wire (**7**), knife (**8**), plastic comb (**9**), brush (**10**), wooden spatula (**11**), and various wire-loop tools (**12**).

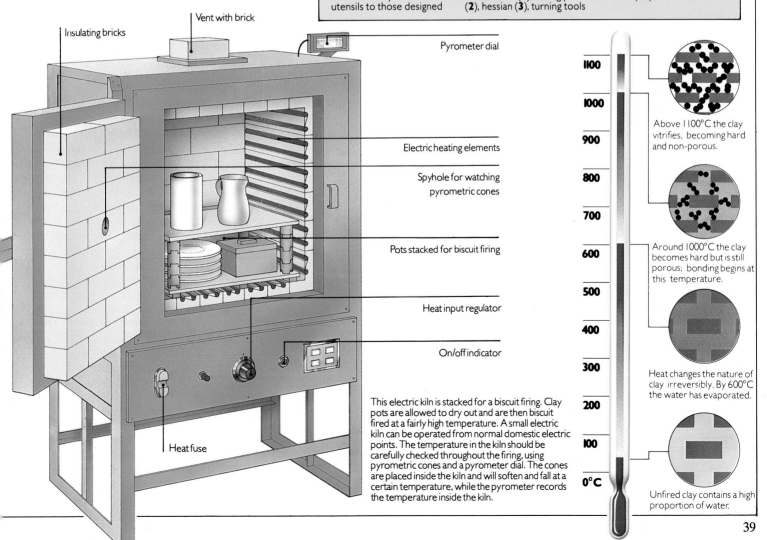

Insulating bricks

Vent with brick

Pyrometer dial

Electric heating elements

Spyhole for watching pyrometric cones

Pots stacked for biscuit firing

Heat input regulator

On/off indicator

Heat fuse

This electric kiln is stacked for a biscuit firing. Clay pots are allowed to dry out and are then biscuit fired at a fairly high temperature. A small electric kiln can be operated from normal domestic electric points. The temperature in the kiln should be carefully checked throughout the firing, using pyrometric cones and a pyrometer dial. The cones are placed inside the kiln and will soften and fall at a certain temperature, while the pyrometer records the temperature inside the kiln.

1100
1000
900
800
700
600
500
400
300
200
100
0°C

Above 1100°C the clay vitrifies, becoming hard and non-porous.

Around 1000°C the clay becomes hard but is still porous; bonding begins at this temperature.

Heat changes the nature of clay irreversibly. By 600°C the water has evaporated.

Unfired clay contains a high proportion of water.

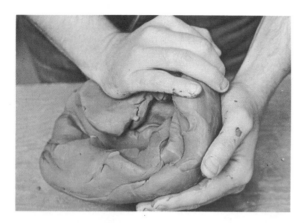

Spiral wedging Knead the clay on a flat worktop. Pull it up and around with one hand, while wedging it down with the other.

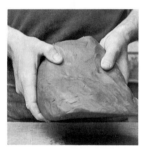

Wedging 1. Form the clay into a large loaf and slam it down onto the workbench to remove any pockets of air.

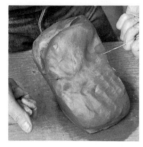

2. Draw a cutting wire through the clay loaf to cut it into two pieces.

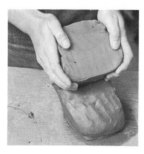

3. Pick up the top half of the loaf and turn it over. Throw it down onto the lower half. Repeat the process a few times.

Wedging Before working with clay make sure that it has the same consistency throughout. Wedging is the name of the technique for achieving this. It involves shaping the clay into a loaf and slamming it repeatedly on a table.

Protective clothing such as an apron is useful to avoid any mess.

Use the full weight of your body when pressing down.

The surface should be lower than the height of a normal table, and must be slightly absorbent.

Keep your feet well apart so that you can rock back and forth, adding weight to your work.

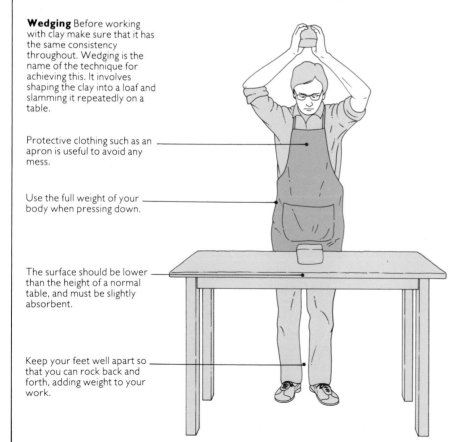

TECHNIQUES
PREPARATION

Both pre-mixed, purchased clay and clay that you have mixed yourself must be thoroughly prepared. The importance of this cannot be stressed too highly. Only with correct preparation will the clay give the results you desire. The preparation may seem rather laborious, but it is well worth the time and effort which it takes.

Wedging Wedging is a technique of mixing or kneading moist clay in order to make sure that the clay has the same consistency throughout. Wedging can be done in several ways. A simple method is to form the clay into a loaf-like shape by slamming it repeatedly on a table or bench. Then, using a wire, cut the loaf in half. Turning one half, slam it down onto the other until the two halves are combined. The continual cutting and slamming will eliminate lumps, inconsistencies and air bubbles.

A more difficult way used by professionals is spiral wedging. Clay is again formed into a wad or loaf which is then kneaded; both hands lift and move the clay from the outside of the mass towards the centre. The left hand rotates and guides the clay while the right hand does the kneading. The squeezing and turning forces the clay into a spiral pattern.

It is important to realize that wedging is done not only with the hands but with the entire body. Your feet should be planted firmly apart, so that you can rock back and forth, using the weight of your body when pressing down. The time taken for wedging depends on the condition of the clay. When the clay feels dense and tightly structured it has been wedged sufficiently. Wedging should take place on a slightly absorbent surface, lower than a normal table height. The surface should be wood for clay which is already of the right consistency and plaster slab for wet clay.

Clay that has become hard to work with can be collected in a plastic tub and then covered with water. The clay absorbs the water and softens after a day or two, and it can then be piled onto a plaster slab to be air dried before wedging again to get the correct consistency. If large amounts of clay are to be processed, a machine such as a pug mill can help take the hard work out of clay preparation.

Storing clay Clay should be stored in a damp atmosphere if possible. Clay can keep for months wrapped in plastic and stored in an airtight container or plastic bin. The plasticity of freshly blended clay improves if it is left to age for a week or two. Never allow clay to freeze, as this breaks down the fibres.

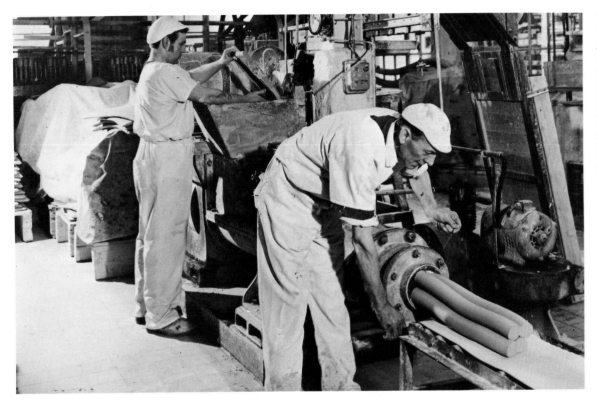

Left The pug mill is a machine used in the preparation of clay. The pug mill removes all traces of air from the clay, leaving it ready to work. The pug mill is only practical when large amounts of clay have to be prepared, and so is common in industry. Wedging is the best method for small amounts of clay. Careful preparation is very important with clay, because, without it, the clay will fail to hold its shape or will crack when it is being worked and fired.

Keeping clay moist

When working with clay, pay attention to its moisture content. Clay should be kept damp before work begins and while work is in progress. Dustbins (**1**) and plastic buckets with lids (**2**) are useful for keeping clay damp and storing it in its raw state. It can be kept for months in this way, but it must be wrapped in plastic before being stored in these airtight containers. While work is in progress, many potters find plant propagators (**3**) to be a useful means of keeping clay damp. A damp cupboard with a plastic or nylon curtain which zips shut (**4**) provides a slightly more sophisticated method of maintaining moisture levels for work in progress.

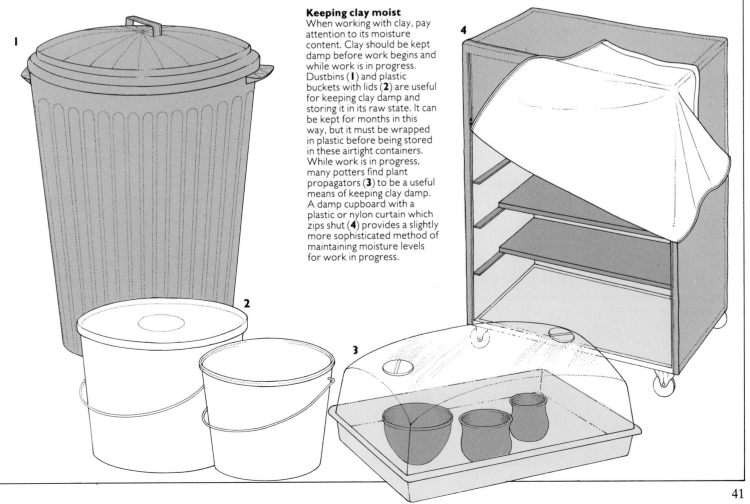

FORMING TECHNIQUES

Hand building Hand-made forms have a character that is determined by the irregularities of form and surface. There are no great problems to overcome in making a pot by hand, because clay is pliable and stays where it is put and also because it can be easily added to and extended. The techniques of hand building are essentially simple and easily mastered.

Pinching Small pots may be formed directly from one ball of clay. Roll the clay into a ball about the size of a fist and insert your thumb into the centre. Then apply pressure with the thumb of your right hand, if you are right-handed, and left hand, if you are left-handed, on the inside and fingers on the outside. Squeeze the clay thin, as your other hand rotates the pot. If this procedure is repeated rhythmically taking care not to make one area thinner than another, delicate forms can be made. The scale of pinched pots is rather limited by the length of the fingers. For beginners, the most common fault is small cracks which develop on the edge of the pot. Damping your fingers or turning the pot upside down on to a damp cloth until it regains moisture will help prevent this.

Pinching I. Pick up a lump of clay and shape it into a ball by patting and rolling it between both hands.

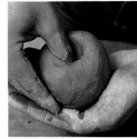

2. Insert one thumb into the centre of the clay ball and press down firmly.

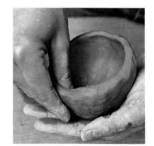

3. Support the pot in your palm and draw the walls out and up with the thumb and fingers of the other hand.

Below These ceramic figures by the British sculptor Ruth Franklin show a way of using ceramic techniques in a decorative rather than practical way. The shapes for the two figures were suggested by the shape of the clay when it was initially rolled out. The figures were glazed and fired in the usual way.

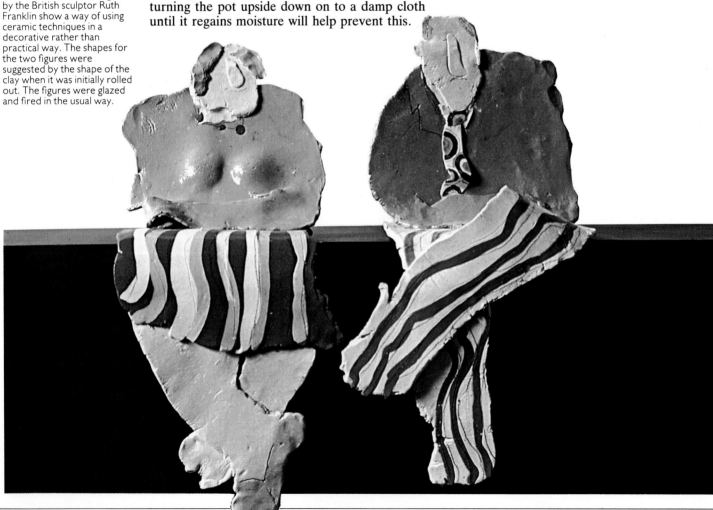

Coiling Coiling is one of the most basic methods of clay construction. Its main advantage is that practically any shape can be made. Coiling is a technique using long coils or ropes of plastic clay, approximately the thickness of a person's thumb. However, the thickness of the coil is determined by the size of the form. These coils are formed by rolling a piece of clay on a table using the palms and fingers, gradually extending it to the desired length and diameter. The rolling should start at the centre of the sausage of clay, sliding your hands outwards along the clay as you roll. Try to prevent the coil from flattening by letting the coil roll free after each rolling motion and by keeping your fingers slightly arched upwards. Several of these coils can be made at a time and covered with a damp cloth until you are ready to use them.

To make a coiled form, first cut out a circular base from a slab of clay the correct thickness for the size of the form. Score and moisten the edge of the clay disc with water and position the first coil. Work clay down from the coil into the base with a modelling tool or the tip of your finger. Lay the next coil in the same manner. To curve a form outwards, each coil should be slightly offset towards the outer edge of the coil beneath. To make a form curve inwards, each coil should be set on the inside of the coil underneath it. Continue these processes until the form is complete. It is best to build large forms in stages, allowing each stage to dry, and also preventing the piece becoming distorted or collapsing. But always ensure that the top coil remains damp, so that it will bond to the subsequent layers. It is important to work the clay of each coil firmly and smoothly into the coil beneath.

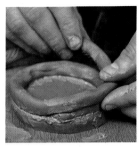

Coiling 1. Make small sausages of clay and roll them out thinly. Use the palms of your hands and keep fingertips turned upwards.

2. Make a base for the coil pot. This can be cut from a slab of clay or formed by making a flat spiral of coils.

3. Put the base on a turntable. Roughen the edges and coat with slip. Place the first coil around the base.

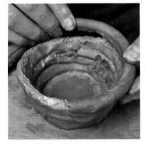
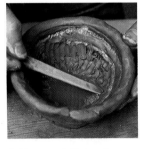
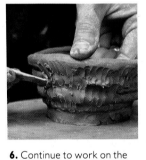

4. Add more coils to build up the walls, keeping an even thickness. Set the coils to slant in or out as required.

5. Use a modelling tool to draw the coils together and blend them down into the base.

6. Continue to work on the surface of the clay, supporting the walls of the pot with your free hand.

7. A coil pot has not the smooth, even finish of a thrown pot, but it is a simple and satisfactory process without use of machinery.

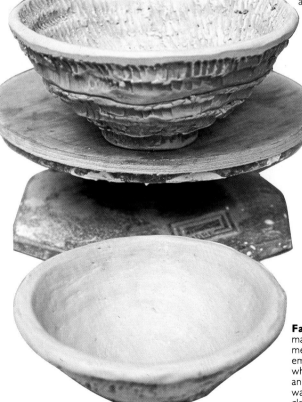

Far left This lamp stand was made using the coiling method. The grooves are emphasized by cobalt blue, which was rubbed into them and then sponged off. The pot was finished with a clear glaze.

Slabbing Slabs are sections of clay that have been pounded, rolled or cut into flat pancakes. Working with slabs can be very exciting, and this is one of the most versatile of all clay processes. Some potters work with templates or paper patterns of the forms they are about to make, while others use a totally spontaneous approach, however this needs detailed knowledge of the process.

The first basic method of slabbing is to roll out clay using a rolling pin onto a wooden board covered with hessian or powdered, fired flint. This helps prevent the clay from sticking. For this process, it is best to use wooden guides which will help give an even thickness of clay. The slabs should all be made at the same time and allowed to stiffen, retaining just enough moisture so that they are firm to handle yet capable of being stuck together. The required shapes can now be cut out of the slabs and joined together. To do this, roughen the edges with a fork in a cross-hatch pattern, coat them with slip and press together. The joints can be further strengthened by pressing a roll of clay into the inside joints or by beating them carefully to ensure a perfect bond. The joints are the weakest points in slab-built forms and must be watched for cracks and warping as the clay dries out.

Slabs can also be used at the plastic stage, the plasticity allows it to be bent and formed in different ways. However, in this state, the clay is prone to tearing and cracking, but with careful use of supports these problems can be overcome.

Below Alison Britton makes inventive use of slabbing. *Caged Stork* is an example of a slabbed earthenware jug. In slabbing, it is possible to use both patterns or templates and to work freely. It is an extremely versatile process which can be used to good effect by potters of all standards.

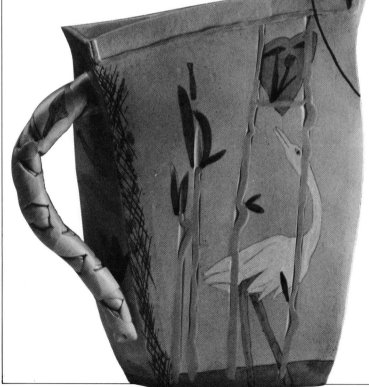

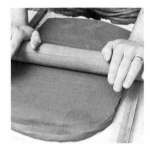

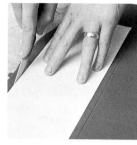

Slabbing I. Place a thick roll of clay on hessian and beat it with a rolling pin. Roll it out to an even thickness.

2. Make paper templates of the shapes required for each side of the pot. Lay them on the clay and cut around them with a knife.

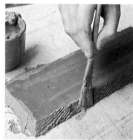

3. Chamfer each edge of the slabs to form a neat joint. If preferred, the edges can be left flat and a butt joint made.

4. Roughen the edges by scoring across them with a knife and paint them with clay slip to act as adhesive in the joint.

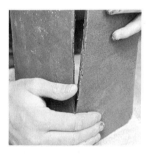

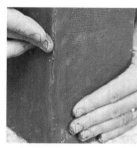

5. Press the edges together to form the first joint, holding the slabs upright.

6. Smooth down any slip which has escaped from the joint. Then clean and seal the outer seam.

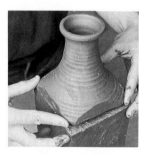

7. Reinforce the inside of the corner seam by pressing in a small roll of clay along the joint. Model it to the walls.

8. Repeat the process to form the whole shape of the pot. A thrown section may be added to create a neck on the pot.

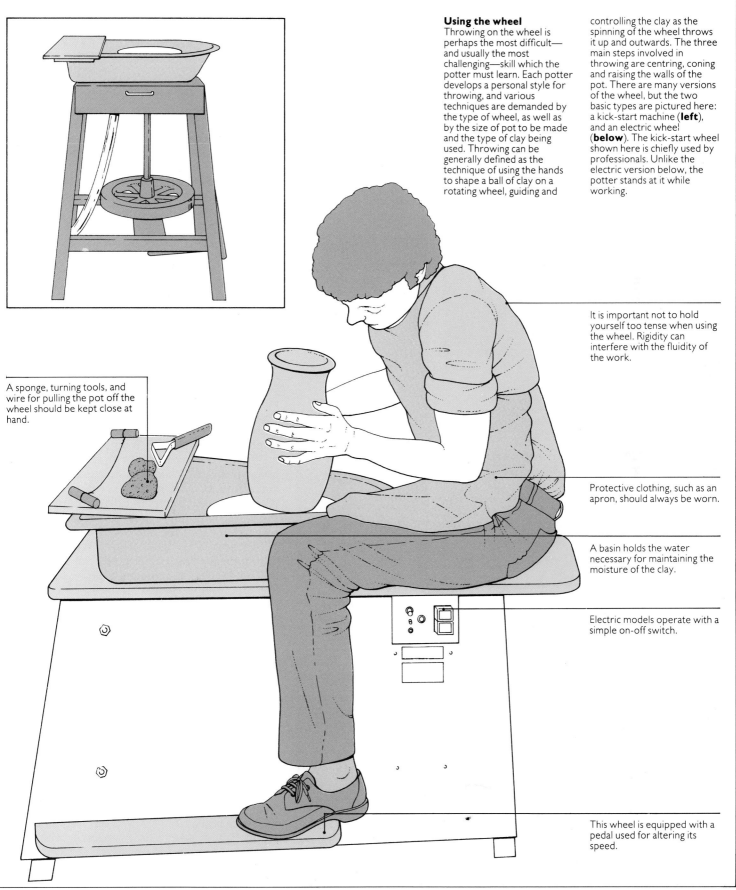

Using the wheel

Throwing on the wheel is perhaps the most difficult—and usually the most challenging—skill which the potter must learn. Each potter develops a personal style for throwing, and various techniques are demanded by the type of wheel, as well as by the size of pot to be made and the type of clay being used. Throwing can be generally defined as the technique of using the hands to shape a ball of clay on a rotating wheel, guiding and controlling the clay as the spinning of the wheel throws it up and outwards. The three main steps involved in throwing are centring, coning and raising the walls of the pot. There are many versions of the wheel, but the two basic types are pictured here: a kick-start machine (**left**), and an electric wheel (**below**). The kick-start wheel shown here is chiefly used by professionals. Unlike the electric version below, the potter stands at it while working.

A sponge, turning tools, and wire for pulling the pot off the wheel should be kept close at hand.

It is important not to hold yourself too tense when using the wheel. Rigidity can interfere with the fluidity of the work.

Protective clothing, such as an apron, should always be worn.

A basin holds the water necessary for maintaining the moisture of the clay.

Electric models operate with a simple on-off switch.

This wheel is equipped with a pedal used for altering its speed.

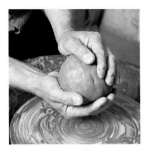

Throwing on the wheel 1.
Make a lump of clay into a smooth tight ball, patting it between both hands.

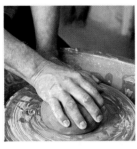

2. Throw the ball down hard onto the centre of the wheel, so that the base flattens and adheres to the wheel.

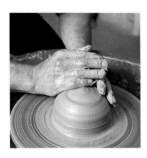

3. Start the wheel and keep hands wet. Draw the clay to the centre of the wheel, pressing with both hands.

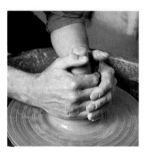

4. Cup hands around clay and draw it up into a cone. Keep arms braced against the wheel tray throughout the process.

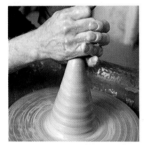

5. Cup hands over the top of the cone and press it back down. Repeat the coning until the clay is smooth and centred.

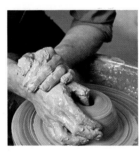

6. Press one thumb slowly down into the centre of the clay and move it outwards to form the base and walls of the pot.

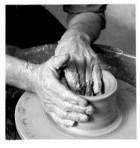

7. Support the outer walls with one hand and raise the walls from the inside, drawing them up with the fingers.

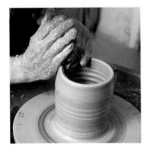

8. Continue working in the same way until the pot is the width and height required.

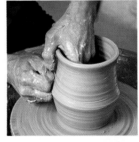

9. Curve the walls of the pot by applying finger pressure inside against the knuckles of the other hand outside.

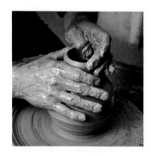

10. Narrowing or collaring the neck prevents the top from splaying out under pressure from movement of the wheel.

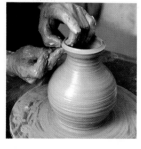

11. Shape the neck and rim between the fingers. Apply pressure gently and keep hands steady.

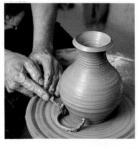

12. Hold a turning tool lightly against the rotating base to trim it. Stop the wheel and cut under the base with wire.

USING THE WHEEL

Throwing Throwing on the wheel is the most difficult challenge facing the amateur potter or ceramicist, and it requires considerable patience and practice. There is no one way to throw, each person develops his or her own style, while the type of wheel, clay and size of pot may also call for variations in technique.

Throwing is basically the technique of using the hands to shape a ball of soft clay on a rotating wheel. The hands guide and control the clay as the spinning action of the wheel throws it up and outwards. The process is restricted to making round or symmetrical forms.

Clay for throwing should be plastic and not too dry—or 'short'—or it may crack. It should also not be so finely grained as to prevent it from supporting itself. The clay must be well wedged. Take small lumps of clay and pat them into balls between 4in (10cm) and 6in (15cm) in diameter. Take one ball and cover the rest with plastic while you practise. Throw or press the ball of clay with force as near to the centre of the wheel as possible. When the clay is in position, pat it into a cone shape and squeeze sufficient water to act as a lubricant between hands and clay. Set the wheel spinning fairly quickly. With arms firmly resting on the edge of the tray or braced against your body, press your hands onto the clay ball. The aim is to coax the clay into the exact centre of the wheel. This first step is called 'centring'. It is extremely important, as no forms can be thrown successfully until the clay is correctly centred.

The next stage is 'coning'. With arms still resting on the tray, both hands can be enclosed around the clay, the thumbs opposite each other. Pressure from the hands causes the ball of clay to rise into a cone which is then pressed down with the palm of the hand. The coning should be repeated several times to achieve an overall consistency. The final press down leaves the clay running smoothly, perfectly centred on the wheel.

Once this has been achieved, place your right thumb onto the centre of the clay and press down to about ¾in (1.8cm) from the wheel-head. The thumb is then forced slowly outwards. This forms the bottom of the pot.

The next step is to raise the walls of the pot. This is done by using the thumb on the inside and fingers on the outside. Keeping an even pressure between the two, a ridge of clay can be drawn up from the bottom of the pot leaving behind the thickness required. This method is fine for small cylinders and bowls which—together with centring and coning—are the most useful forms for the beginner to practise. To check the quality of your

throwing, cut the pot in half longitudinally using a wire. The section should be fairly thick at the bottom tapering towards the top.

Care must be taken to relax the hands as you reach the top of the form, as the spinning action of the wheel has a tendency to flare out and split. This can be countered by 'collaring' the clay, which is done by closing cupped hands around the clay, constricting it back into shape. When the form is finished, it can be cut off the wheel-head with a taut wire drawn under the pot from the back to the front. It should then be possible to lift the pot carefully off.

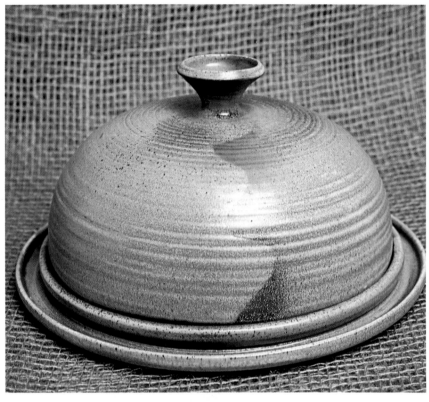

The technique of throwing— shaping a ball of clay on the wheel using the hands—is one of the most important techniques for the potter to master. With practice, a wide variety of shapes and forms can be made. The visual effect of thrown pots can be enhanced by the use of glazes. The cheese dish (**above**) was thrown and then glazed with an off-white glaze with iron sprayed on. Metallic colours are used in glazes, and they react in various ways according to the type of glaze employed. The teapot (**left**) has a thin Tenmoku glaze. This is a dark brown type of glaze. The vase (**far left**) is an example of the technique known as agate, in which two different coloured clays are mixed and thrown. The glaze is clear, in order to enhance the colours of the clay.

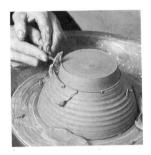

Turning I. Trim the base of
the pot when it is leather-
hard. Centre it upside down
on the wheel, wedged with
damp clay.

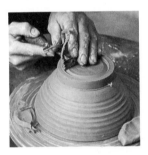

2. Hold a turning tool inside
the base to cut a foot ring on
which the pot will stand.

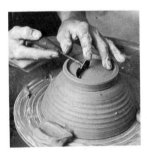

3. Use a broad turning tool to
pare down the weight of clay
in the base centre.

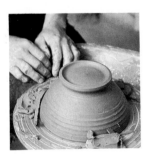

4. Complete turning so the
base is neatly shaped. Clear
the trimmings from the wheel
and remove the pot for firing.

Turning Turning is the trimming off of the
excessive thickness of clay from a thrown form,
usually from the base, while it is held in a chuck
or fixed with clay directly on to the wheel-head. It
generally sharpens and gives more definition to
the form and can be used to add texture.

Standard turning tools, such as steel profiles
and wire loops, can be purchased from pottery
suppliers. However, with a little thought and
imagination, it is possible to make your own.
Turning must take place when the clay is near to
leather-hard, as the trimmings should come off in
long, unbroken ribbons. The pot must be centred
onto the wheel by tapping. This is a skill in itself
and takes considerable practice. It is important to
study the inside of the pot carefully before
turning, in order to determine how much to turn
off relating the outside to the inside. The thick-
ness can be gauged by tapping the pot with your
finger and noting the tone. In fact this aspect of
ceramics—like so much else—in the end depends
on developing touch, which can only come with
practice.

MOULDS AND MOULD-
MAKING FOR POTTERY
AND CERAMICS

Mould-making is generally recognized as an in-
dustrial technique, and in most studio potteries it
is considered too time-consuming to produce
moulds, unless at least a dozen identical pieces
are required. It is, however, an underestimated
technique which can be used as a means to an end
by the craftsperson and which, with imagination,
can be utilized and exploited to create interesting
and varied forms.

The basic material for mould-making is plaster
of Paris. This is an incompletely hydrated calcium
sulphate produced by heating or boiling gypsum
stone, after it has been ground. When mixed with
water usually in the proportions of about 2 pints
(1.1 litres) water to 3lb (1.5kg) plaster, to a thick
liquid, the plaster will set fairly quickly in about
20 minutes. After drying, it will be absorbent.
The plaster needs to be contained round the
object or model being moulded. This can be done
with any strong non-porous material, such as
plastic, wood or soaped plaster slabs, that will
easily release from the plaster when it has gone
off.

Basic mould-making The mould is made from a
master or model which is the shape or form finally
intended from the cast. The model is usually solid
and has to be longer than the finished size because
of shrinkage. It is usually made from clay or
plaster, but could be made from almost anything
or any material. Designed forms can be turned in
plaster from a block on a lathe or mechanical

wheel. However, it is best for the beginner to
start by making a simple model with plastic clay.
All these models except the clay ones need to be
coated with a releasing agent to prevent the
plaster from sticking to the model. Common
releasing agents include soft soap for plaster and
varnish or wax for wood.

The simplest and most common type of mould
is the one-piece variety which releases the forms
without the need for divisions in the mould.
However, the more complicated the model, the
more complex the mould. The main problem is
one of undercutting which should be avoided if
possible. If not, it is necessary to make sure that
each piece will withdraw freely. These pieces
must be notched together so that they will key
together once the model has been removed. For a
more detailed examination of moulds and mould-
making see pp 64–75.

Press-moulding This can be done in several ways,
but the most efficient and widely used is to fill the
press mould with a slab of evenly rolled clay.
Having rolled the clay onto canvas or hessian, lift
both together and turn, supporting the clay so
that it lies down in contact with the plaster.
Remove the canvas and gently ease the clay into
the shape of the mould. When in position, the
clay can be pressed more firmly. Trim off any
unwanted clay with a knife and, when the clay is
leather-hard, it can be removed.

If the clay has been pressed over a mould, care
must be taken to avoid letting the clay shrink onto
it, as this will crack the form or prevent releasing.
Many variations of this technique exist and any
number of pieces can be stuck together to make
more complex forms.

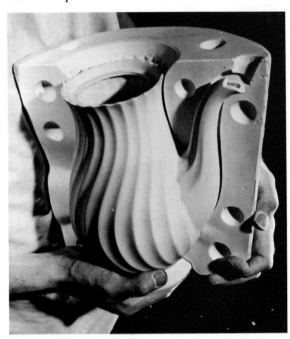

Slip casting In slip casting, like press-moulding, moulds are used to reproduce forms. For this process, the clay should be in a liquid form. This is done by mixing dry or plastic clay with water and deflocculants in given proportions. Deflocculants usually consist of sodium silicate or soda ash, also known as electrolytes. These separate the clay particles from one another and, in so doing, keep the slip fluid.

The slip, clay made liquid by mixing with water, is poured into a plaster mould. As the mould is absorbent, it gradually draws water off the slip leaving a clay skin on the inside of the mould. The thickness of this layer of clay depends on the time the casting slip is left in the mould. It is possible to see when the deposit is the correct thickness by tilting the mould slightly. The excess slip can be poured back into the container. The mould should be inverted and tilted slightly to prevent drips from forming on the inside. When the cast has lost its sheen, trim off the surplus clay while the cast is still in the mould. This helps to prevent distortion. The cast should be taken out of the mould when it is firm enough to keep its shape; additions can be made at this stage using casting slip or water. At the leather-hard or green stage, the seam marks or unwanted parts can be fettled or scraped away and sponged. The cast is then ready for firing.

Press-moulding 1. Roll out a large sheet of clay onto a clean piece of hessian.

2. Lift the hessian keeping the clay supported and turn it down onto the press-mould.

3. Start to ease the clay into the shape of the mould with palm and fingers. Press gently to avoid tearing the clay.

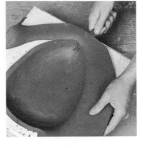
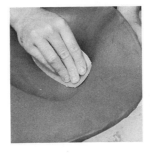
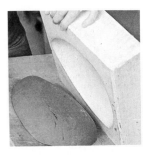

4. Press the clay firmly into the mould and smooth it against the cavity with a rubber kidney.

5. Hold a knife flat across the top of the mould and trim off surplus clay, leaving a clean edge around the shape.

6. When the clay has dried, hold a board flat over the top of the mould and turn it over carefully, releasing the cast.

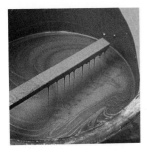
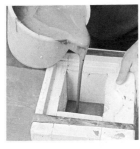
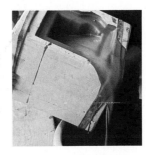
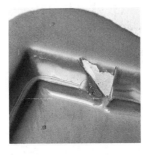
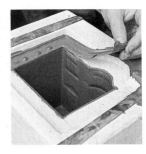

Slip casting 1. Slip is liquid clay made by wetting it down with water. Make a suitable quantity to fill the mould.

2. The slip should be of a thick, creamy consistency. Pour it in to fill the mould right to the top.

3. Leave the slip for about 20 minutes. Tilt the mould and check that a thick skin of slip has formed on the inside walls.

4. Pour out excess slip and let the mould stand until the clay skin loses its shiny surface.

5. Trim the cast and strip away surplus dried slip, so that the shape has a neat edge.

Left Mould-making is a frequently used industrial ceramic technique, as it is an excellent way of producing multiple pieces. The mould, from which this coffee pot is being removed, is made of plaster of Paris. This vessel required a two-piece mould.

6. Carefully dismantle the mould to extract the finished cast. It is quite thin and will sag if not sufficiently dry.

7. Here are the three stages of a slip cast—the plaster mould, the green clay cast and the glazed version.

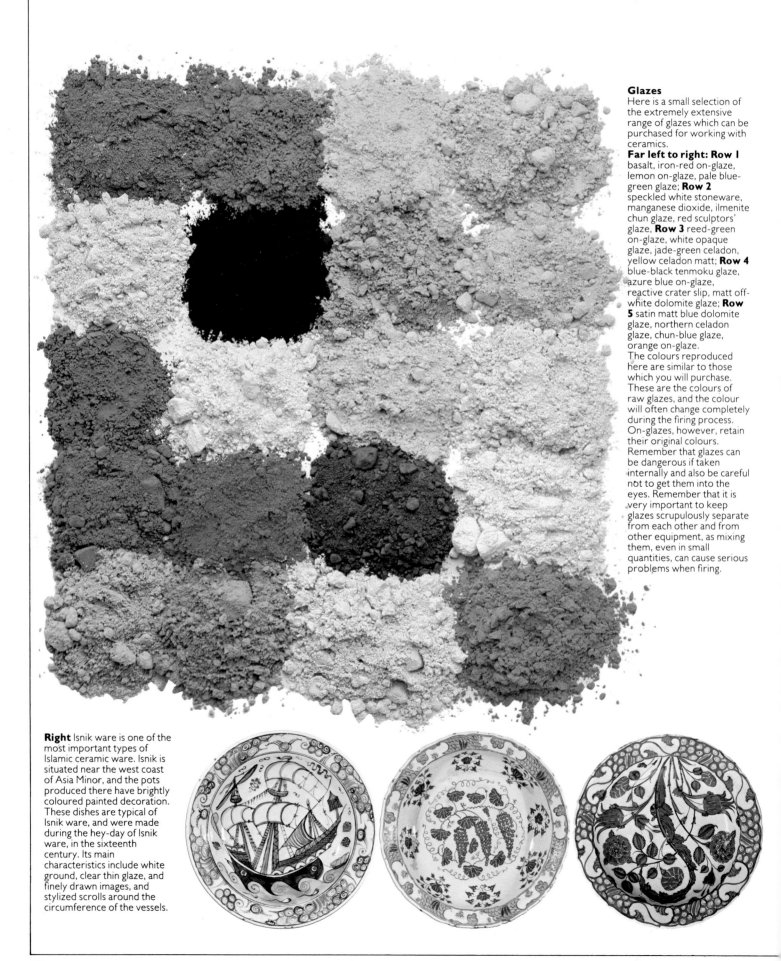

Glazes
Here is a small selection of the extremely extensive range of glazes which can be purchased for working with ceramics.
Far left to right: Row 1 basalt, iron-red on-glaze, lemon on-glaze, pale blue-green glaze; **Row 2** speckled white stoneware, manganese dioxide, ilmenite chun glaze, red sculptors' glaze, **Row 3** reed-green on-glaze, white opaque glaze, jade-green celadon, yellow celadon matt; **Row 4** blue-black tenmoku glaze, azure blue on-glaze, reactive crater slip, matt off-white dolomite glaze; **Row 5** satin matt blue dolomite glaze, northern celadon glaze, chun-blue glaze, orange on-glaze.
The colours reproduced here are similar to those which you will purchase. These are the colours of raw glazes, and the colour will often change completely during the firing process. On-glazes, however, retain their original colours. Remember that glazes can be dangerous if taken internally and also be careful not to get them into the eyes. Remember that it is very important to keep glazes scrupulously separate from each other and from other equipment, as mixing them, even in small quantities, can cause serious problems when firing.

Right Isnik ware is one of the most important types of Islamic ceramic ware. Isnik is situated near the west coast of Asia Minor, and the pots produced there have brightly coloured painted decoration. These dishes are typical of Isnik ware, and were made during the hey-day of Isnik ware, in the sixteenth century. Its main characteristics include white ground, clear thin glaze, and finely drawn images, and stylized scrolls around the circumference of the vessels.

GLAZES AND FINISHES

A whole range of materials, glazes, colours and techniques are available to the amateur potter. These can be purchased from the pottery suppliers in dry or liquid form, however some knowledge and understanding of them is necessary, as well as the means of application and firing treatment. There are several good books on the chemistry of glazes which go into greater detail.

Glazes are glassy materials used to cover ceramic forms, either to make them impervious to moisture and dirt or to change their appearance decoratively. The glazes and colours are fused on to or into the article by the action of heat. When cooled, they should have a thermal expansion similar to that of the clay. They are a mixture of minerals, oxides and chemical compounds and, like clay, contain substantial amounts of silica. Fluxes are added to help lower or give more control to the temperature at which these glaze materials will fuse and melt. The most common method of classifying glazes is by their maturing or firing temperatures. Majolica has a low maturing temperature range of 1492°F to 1922°F (900°C to 1050°C). Earthenware glazes have a firing range of 1832°F to 2102°F (1000°C to 1150°C). Fireclay or sanitary glazes mature at 2192°F to 2282°F (1200°C to 1250°C), while porcelain or stoneware glazes mature at 2282°F (1250°C) and over. With reference to glazes the term 'maturing' means that the glaze has melted and flowed smoothly over the surface of the article.

There are many ways of applying a glaze and these vary according to the size of the work and amount of liquid glaze available. Glaze can be applied to unfired or greenware, but this practice has many disadvantages and therefore should be avoided by the beginner. The most practical and common procedure is to glaze in the biscuit state. The amount of glaze put onto the ware is critical. Too little will result in starving the ware, while too much will make the glaze run off the ware and stick to the kiln furniture.

Dipping Dipping is the most popular method of glazing. Its main drawback is that a large amount of glaze is needed. The pot is held by hand or a pair of tongs and totally immersed in the glaze for a second or two. It is then taken out and left to dry, and excess glaze cleaned from the base.

Pouring Take the article, pour glaze into the inside and then quickly empty it out. Next, stand it over a large container and pour the glaze over the outside. This should be done with speed and precision. Make sure the article is evenly covered. The advantage of this method is that only a small amount of glaze is required.

Spraying Spraying has two disadvantages. Firstly, large amounts of glaze are wasted and, secondly, some form of fume extraction is needed to avoid inhaling toxic substances. Its advantages are that the glaze coating is easily controlled, using small quantities of glaze, and larger and more complicated articles, such as figurines, can be glazed. Spraying does, however, need time, skill and patience to know exactly how much glaze to apply.

Brush application Painting on the glaze can prove to be very difficult, as getting an even thickness is almost impossible using this technique. However, it is useful for repairing areas which may have been missed, and for decorative purposes.

All methods of glaze application can be used together on one pot. For example, on one vessel it is possible to combine pouring the inside, spraying the outside and using a brush decoration on top of this.

Colours Colours for glazing are metallic in origin and react differently in different glazes. Basic oxides and carbonates can be used, although pottery suppliers sell prepared body or glaze stains and enamel colours for under-glaze or on-glaze painting for the various types of bodies. These are the main types of colour application in glazes. In under-glaze painting, the colour is applied directly to the unfired vessel, while, for on-glaze work, the additional colour is applied to the glazed ware. A third method, in-glaze, involves applying colour to raw or gloss fired material which is then fired or refired so that the colour actually blends into the glaze.

Pouring I. The inside of a pot may be glazed by pouring glaze into the pot up to the brim.

2. The glaze is poured out to leave an even coating over the inner walls of the pot.

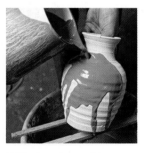

3. To glaze the outside balance the pot on battens over a bucket and pour on glaze from a large jug or bowl.

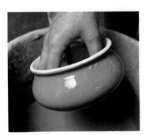

Dipping The outside of a pot can be evenly covered with glaze by dipping it into a large bucket of glaze right up to the rim. Brace the fingers inside the neck to hold it firmly.

Spraying glaze This requires special equipment—a compressor and paint spray-gun—and must be done in a spray booth which has a fume extractor.

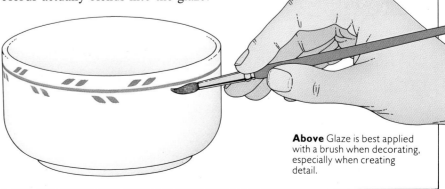

Above Glaze is best applied with a brush when decorating, especially when creating detail.

Kiln furniture
Biscuit firing
It is important to stack ware correctly in the kiln, so that the maximum amount can be fired at one time. Kiln furniture is used to support and separate the objects in the kiln. Biscuit and gloss firings have different loading requirements. Useful pieces of kiln furniture include tile cranks (**1**), props (**2**), props with castellated tops (**3**), stilts (**4**) and saddles (**5**). Kiln furniture is made from refractory body, so that it can withstand the very high temperatures inside the kiln.

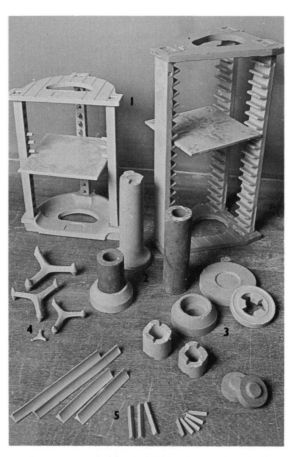

SAFETY

All pottery suppliers are greatly concerned about the danger to health arising from the use of certain ceramic materials and have eliminated or controlled their use. However, most materials used in pottery should be considered harmful, but the danger can be minimized if the materials are used properly. There are some basic rules which should be followed and which will lessen any dangers to your health and safety.

Dust Dust is probably the greatest hazard. Always clean up spillages as soon as it occurs. Clean all equipment and utensils after use. All work surfaces, walls and floors should be thoroughly cleaned. Take care not to generate airborne dust, so use a wet process rather than dry wherever possible.
Conduct Do not eat, drink or smoke while working.
Clothing Wear suitable protective clothing at all times.
Storage Hazardous materials should be clearly labelled and stored.
Heat Take particular care when using kilns, because of the great heat generated. Follow all maker's instructions totally.

FIRING AND KILNS

The kiln is the most vital piece of equipment in the potter's studio. It is possible to make a variety of ceramic pieces by hand, but a kiln of one type or another is needed for the ware to be permanent and functional. There are various types of kilns and each has its limitations and uses. Cost of fuel is one of the main factors when deciding on the type of kiln to instal. The main types used today are electric and gas, but oil and solid fuel kilns can be bought or built.

Electric kilns The electric kiln usually takes the form of a steel box lined with refractory bricks, with a door at the top or front. The heat is radiated from wire elements not unlike those of an electric heater. They are set in the walls, floor and sometimes doors of the kiln. Its advantages are more evenness of control together with greater safety and greater cleanliness in firing.

The atmosphere in an electric kiln is neutral, and there are usually oxidizing ventilation holes in the roof and door, which allow steam to escape and enable the inside of the kiln to be observed. The input of current to the elements is regulated by switches which control the rate of increase in the rising temperature.

Gas kilns Gas kilns are generally favoured by studio potters because of their wide range of firing techniques they will cover, from earthenware to porcelain, through to oxidizing to reduction. They are reasonably cheap to run and require little repair. The kilns are usually brick structures with a steel box, unless built on site, where only a framework is needed. The main disadvantages are the initial cost and the need for adequate flue ventilation to carry away the burnt gases. Burners provide the heat source, these are fed by gas pipes fitted with regulators.

Oil fired and solid fuel kilns Kilns using oil for fuel are generally similar in design to gas kilns, only different burners are required. Solid fuel kilns, burning fuels such as wood, consist basically of a chamber into which clay articles are placed to receive the heat which is generated in fire mouths situated around or beneath the chamber. Constant attention and care in stoking is essential throughout the firing, making it a long and arduous task.

Control of firing It is advisable for the kiln to have some form of temperature indicator or control, so

Right Pyrometric cones are used to indicate the temperature inside a kiln. They are made from clays, which melt at specific temperatures, thus enabling the temperature inside the kiln to be judged. Most kilns also have a thermocouple and pyrometer. The temperature, gauged by the thermocouple, is indicated on the outside of the kiln by the pyrometer.

that the temperature of the kiln can be determined at any time. The most common is the thermocouple and pyrometer. The thermocouple protrudes inside the kiln while the temperature is indicated on the pyrometer. Pyrometric cones are also used inside the kiln. These bend at certain temperatures and by constant observation the temperature of the kiln can be gauged. The packing and firing of the kiln is an important operation, as a little carelessness can spoil all previous efforts.

Biscuit firing It is not unusual for most ceramic articles, whether functional or ornamental, to have several firings. The reason for these firings is to allow different changes to take place at certain temperatures.

Once the clay articles are dry, they are placed in the kiln to be biscuit fired. This process is to harden the clay so that it may be easily glazed. Normally the biscuit is fired to a temperature below that of the gloss. Bone china is an exception, receiving a higher biscuit than gloss usually around 2208°F–2264°F (1220°C–1240°C). Care must be taken at this stage because the water in the clay is being driven off by the heat. This generates steam which must have a means of escape, otherwise the work may explode. Shrinkage takes place during all periods of drying and firing.

In stacking a biscuit kiln, pieces of work can come into contact with each other without the danger of them sticking together. The aim, when packing a biscuit kiln, is to fill the kiln to the maximum capacity which will ensure an even firing. Ware can be stacked inside or upon one another. However, it is important to take care not to put too much strain on the bottom objects. Flat ware can be placed on small supports, while cups are placed with their rims together and lidded objects fired with lids in place.

Gloss firing In the second or gloss firing, great care must be taken to avoid ware touching each other, as they will stick together when the glaze melts. The foot rings or bases of pots should be totally clear of glaze, as should the kiln shelves or batts. The batts are best coated with a batt wash, which contains flint or alumina, to protect them from drips of glaze. Again an evenly packed kiln helps towards a better heat distribution. Care in placing batts and props is essential, placing props so that the weight is evenly distributed and warping prevented.

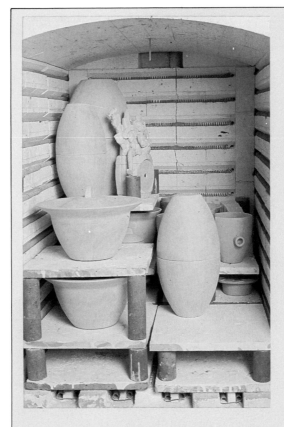

Biscuit firing
This is the first firing which dries and hardens the clay so that it can be glazed. For the biscuit firing, this three-phase electric kiln heats to a temperature of between 1140°F and 1160°F (610°C and 625°C). Pieces can come into contact with one another during the biscuit firing, as they will not stick together. As shown here, lidded pieces can be biscuit fired with the lids in place. However, it is important to give each object the support it requires. Here the bottom pieces are stacked on small supports, while the extended leg of the figure, a vulnerable part of the piece, has its own support.

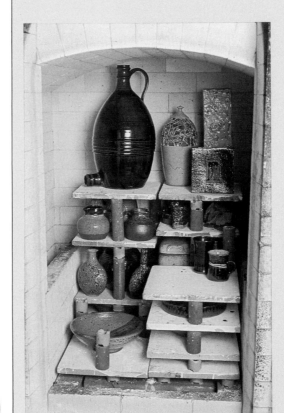

Gloss firing
The ware is stacked differently for the gloss firing. The temperature in the kiln is higher than for the biscuit firing. During this firing, it is vital that the pieces do not touch one another, otherwise they will stick together when the glaze melts. This ware is stacked on kiln shelves, which have been covered in batt wash. This helps to protect the shelves from drips of glaze. This picture shows the pieces after firing. For both firings, even packing the ware will help ensure that the heat is distributed evenly.

WAX

HISTORY

Wax has been used for modelling effigies for thousands of years and was certainly in use long before the advent of bronze. During the Italian Renaissance many sculptors made small wax maquettes as preliminary studies for larger works. Some wax maquettes by Pietro Bernini (1562–1629), Benvenuto Cellini (1500–1571) and Giambolgna (1529–1608) still survive today. Wax modelling developed to a high level for miniature portraiture during the seventeenth century, and was an invaluable aid to anatomists in recording dissection. The anatomical waxes of the Italian sculptor Gaetano Giulio Zumbo at La Specola in Florence and later those of Joseph Towne (1808–1879) at Guy's Hospital in London were of particular interest, realizing a remarkable standard of natural interpretation. The development of pigmented wax brought new directions in wax modelling and inspired, among others, the Swiss

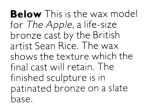

Marie Tussaud (1760–1850) to make wax like-
nesses of famous people; the museum she founded
is still a popular attraction in London.

During the nineteenth century artificial wax
fruit was made which reached disconcerting levels
of naturalism. In the twentieth century, Roy
Herbert, working in the department of botany at
the National Museum of Wales in Cardiff has
created some astonishing wax models of botanical
specimens.

Artists have used this medium in a number of
ways, sometimes mixing additives to it to soften it
or make it more flexible. Sometimes they have
added substances like animal fats, oils, tallow or
gums, making the wax more malleable. Apart
from being a modelling medium in its own right,
wax for the past 4000 years has played a vital part
in the process of casting metals, such as bronze.
The wax model, inside a refractory mould, is fired
out in a kiln at a high temperature. This leaves a
void, which may be filled with molten metal. This
is known as the *cire perdue* or lost wax process.

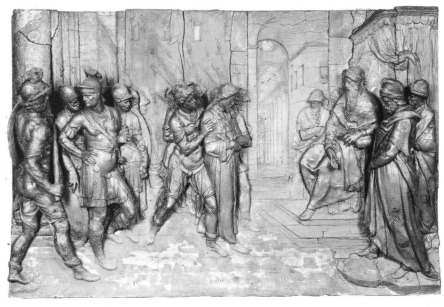

Above This is a rare example of a wax which has survived intact. By the sixteenth century Italian sculptor Giambologna, it shows Christ before Caiaphas. Although the wax is cracked in places, the great detail can still be seen on the surface.

Tools for modelling wax
The tools pictured here include all those that are necessary when working with wax: a surface of either glass or marble (**1**), a small wax scraper (**2**) or a large one (**3**)—depending on the size of the work to be done—nails (**4**), a craft knife (**5**), pencils (**6**), a scriber (**7**), and various dental instruments (**8**). These are used for working in detail.

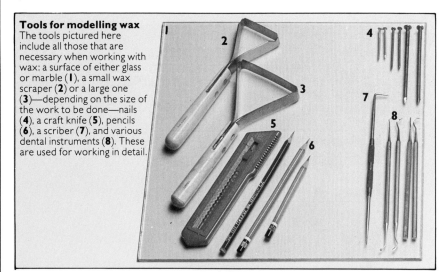

MATERIALS AND TOOLS

Until recently bee's wax was used for modelling, however, this has now become very expensive and has largely been superseded by cheaper microcrystalline waxes. These new types of waxes are by-products of the oil industry and are produced in various blends, providing the sculptor with hard, soft and ductile waxes for various types of modelling.

Few tools and equipment are needed for wax modelling. As with modelling in clay, the hands are the most important 'tool', especially when working in soft wax. However, steel rifflers and wooden or metal spatulas can also be useful. A spirit lamp or candle may also be needed for heating the blade of metal spatulas.

Polystyrene can be used for building up the initial masses for large works—thus cutting down on the amount of wax needed. Copper wire is important for making armatures. A soldering torch or low brazing flame can be used to 'weld' wax edges together. A saucepan for melting wax is a vital piece of equipment, as are brushes for applying molten wax and wax rods for use as runners and risers. Surforms or files are useful for finishing surfaces off. A runner cup or gate will be needed for pouring metal into the moulds. The best shape for this is a cylinder with a curved base. This basic shape can be cut from polystyrene and smoothed with a surform or file; it should then be covered with soft wax and the surface worked to an even finish.

Types of wax
Many different types and blends of wax are available for modelling and each is specially constituted to have particular properties and uses. They may be suitable for modelling only, or for casting techniques, some are hard and some soft. In addition there is a range of different

colours. Red modelling wax (**1**) is a hard wax, and, as it is particularly suitable for casting, it is usually modelled over an armature of core. A general purpose modelling wax (**2**) is used like clay, to build up a mass layer upon layer. It can also be used to

form the original model in lost wax casting. The white wax (**3**) shown here is purely a modelling medium and is not suitable for casting processes. It is formulated to provide exceptionally fine detail and can be very accurately shaped. Beeswax (**4**) is a

natural substance with a long history as a sculpture medium. It was traditionally used for models to be cast in bronze. The more recently developed micro-crystalline waxes are less expensive than beeswax and have largely superseded it for general sculptural purposes.

Wax modelling 1. The first step in wax modelling is to prepare a sheet of wax. Begin by spreading oil evenly over a marble slab.

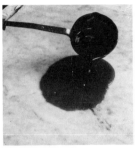

2. Heat the wax until it is liquid, and scoop some out with a ladle. Pour it quickly and evenly over the oiled marble surface.

3. The wax must be allowed to cool slightly, but not too much, so that it remains malleable. Meanwhile, brush oil over the palms of the hands.

4. Lift the wax carefully with a broad, flat knife, so that it lifts as a whole skin from the marble without cracking.

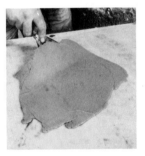

5. Turn the wax over with the knife, so that the other side cools flatly against the slab. The wax should still be warm and flexible.

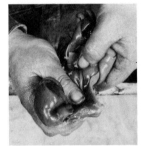

6. Knead the wax into a malleable ball. Work it vigorously until it is the correct texture.

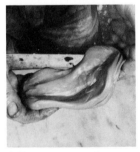

7. The wax is ready for modelling when it is in a pliable lump with a texture similar to soft toffee. If it hardens too much, it will crack.

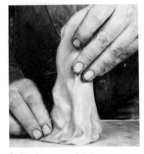

8. Begin to model the wax into the basic shape required. Gradually extend the modelling process with hands and tools.

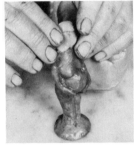

9. Corrections or repairs can be made to a wax model with fresh wax. Mould the soft wax on to the model with the fingers.

10. Tools for wax modelling can be heated in a flame. It is important to check whether the tool can be left in the flame or just passed through it briefly.

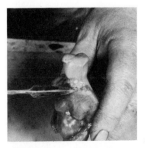

11. The hot tool melts the wax and gently moulds the forms together. First work up the basic shape of the form required.

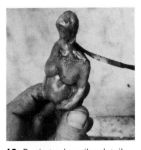

12. Begin to describe details of form and surface finish with the heated tool. This type of modelling is used for small models.

MODELLING IN WAX

Wax is used to model small scale sculptures directly, as well as to form an outer shell over a core or armature for a sculpture which is to be cast. Wax does not harden fully and is therefore a vulnerable and relatively impermanent medium. A solid wax sculpture must be treated with care and not subjected to excessive heat or placed in a position where it can be knocked or eroded.

However, modelling in wax can be very rewarding, both in the practice and the result. It is especially suitable for making small figurative sculptures.

In order to model with wax, it must be kneaded into a malleable mass. Some waxes are composed in such a way that they are constantly pliable, and the heat of the hands renders them more so. A mass of wax for modelling can also be made by pouring melted wax on to a flat, cold surface so that is solidifies into a sheet. The sheet is picked up and rolled and kneaded while still warm to form the solid ball. The form can then be manipulated with the hands and fingers and fine details added with heated modelling tools.

Modelling techniques are largely a matter of personal style and preference and are best developed in practice. No particular rules can be stipulated, as the essence of a successful modelled sculpture lies in the interaction of the sculptor's dexterity and the natural qualities of the material. Both for solid wax models and those with a core or armature, the wax can be added in small lumps or strips and coaxed into shape with fingers or tools. Wax can also be melted into the existing surface with heated metal spatulas.

The surface qualities of wax are its characteristic sheen, which can be enhanced by passing a flame over the surface, and a slight translucency. The outer form of the model can be smoothed to form a cohesive, unbroken surface, or left to show the activity of modelling, with craggy texture and half melted lumps of wax adding to the vitality of the form.

When the model is on a large scale especially for subsequent casting, it is easier to maintain the vigour of the surface texture than on a small scale, where too much detail may obscure the form. However, wax is a most responsive medium and on any scale encourages a full expression of the art of modelling.

If any corrections need to be made to a wax sculpture, such as when it becomes damaged or needs modifying, these can be carried out so long as the wax is still quite fresh and has not become too hard. To mend a broken piece of sculpture, melt down some new wax and gently mould it onto the model with your fingers.

ARMATURES FOR SMALL WORKS

Unless the projected model is a very simple one, then a wire support or armature will be needed on which to form the wax. Make this out of copper wire and braze the wires together where they intersect. Brazed copper wire will withstand the wax firing and is also the most readily absorbed metal when molten bronze is poured into the mould. Steel wire should not be used as it is a bad conductor of heat and will chill the molten bronze, causing bad misrunning. When misrunning occurs, the molten metal hardens too fast in places, and this results in slight fissures on the surface of the sculpture. These have to be repaired with a welding torch and bronze rod. Another reason for not using steel is that it rusts easily.

Soft and ductile modelling wax can be formed into its final shape entirely by hand. Harder waxes can be modelled and drawn together with steel rifflers or wooden modelling spatulas in a similar way to modelling clay surfaces. Metal spatulas can also be used, and a spirit lamp or candle may be used to heat the blade. The advantage of using a candle is that the black sooting that it leaves on the steel tool transfers during the modelling process and enriches the colour of the wax. This also helps to reduce the natural translucency of many waxes, making it rather easier to develop the form. When working on a small scale, it is also possible, with care, to 'flame' the model. This can reveal the very fluid and plastic characteristics of the material.

ARMATURES FOR LARGER WORKS

For larger wax sculptures, a larger and stronger internal armature is needed which can, eventually, be removed during the moulding process. As this armature will not be left inside the mould, it can be made of any suitable strong material. In order to economize on the amount of modelling wax needed, initial masses can be built up with sections of polystyrene which are attached to the armature by brushing the surfaces with molten wax. When this preliminary build-up has reached a suitable size, it should be sealed with molten wax, forming a good basis on which to apply the final thickness of wax. Mould sections are taken from a finished wax model such as this.

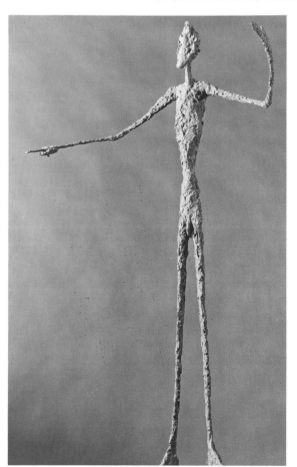

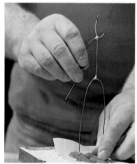

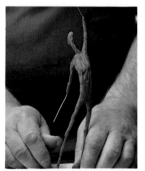

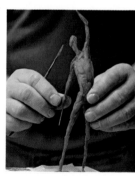

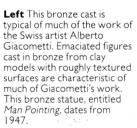

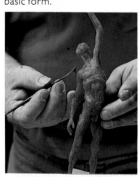

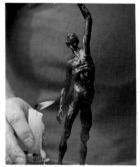

Wax modelling on an armature 1. Use copper wire with brazed joints to form the armature. Set it into a wax base.

Left This bronze cast is typical of much of the work of the Swiss artist Alberto Giacometti. Emaciated figures cast in bronze from clay models with roughly textured surfaces are characteristic of much of Giacometti's work. This bronze statue, entitled *Man Pointing*, dates from 1947.

2. Press small pieces of wax onto the armature, modelling with your fingers to build a basic form.

3. Continue to add wax to the model, developing the volume and structure of the figure in a gradual process.

4. Apply tiny pieces of wax with a metal modelling tool to model surface detail and delicate forms.

5. Pass a candle flame lightly over the wax to weld and harden the surface. This also enriches and darkens the colour.

HOLLOW BRONZE CASTING

In order to make a wax model for casting hollow in bronze, it is important firstly to build a core which is the shape and likeness of the intended design; keep it slightly reduced in size. Ideally, it should be about ¼in (6mm) under the actual size. This can be done using a refractory compound—one which can withstand heat—either modelling direct onto a support armature, or modelling it in clay, producing a flexible mould, and casting a refractory core. The core should be left to cure and then dry before any wax is applied. Curing is the process in which the material dries. It goes through various stages in setting and needs to be left for at least 24 hours to mature completely.

It is easier to apply the initial coat in the form of liquid hot wax and, once this has set, to continue modelling the surface with a soft wax. The modelling is done in the same way as already described. If the final surface is gently flamed it will produce a harder and more resilient outer skin, making the wax less vulnerable to damage when it is handled later on.

THE LOST WAX OR _CIRE PERDUE_ PROCESS

This process involves making a flexible or plaster mould from the original clay model, pouring wax into it, thus creating a wax casting. After preparing the wax cast, a second mould is formed around the wax in a refractory material to form an 'investment mould'. This mould is then baked to a high temperature in a kiln, to remove all traces of wax. The baked mould is referred to as a 'ludo mould'. Molten metal is then poured into the ludo mould to fill the void left by the wax, which was melted out during the earlier baking. This loss of wax during baking gives the process its name.
Making runners and risers Runners and risers must be made out of wax when using this method. Runners are channels in the mould through which the molten metal runs to fill the mould. Risers are also channels in the mould but their function is to allow air and gases to escape. The best way to make runners and risers is to use steel rods which will be covered by wax. The basic sizes of rod that will be needed are 30in (76cm) lengths in diameters of ⁵⁄₁₆in (8mm), ⅜in (10mm) and ½in (1.25cm). To make the wax runners and risers, cut two slabs of clay about 3in (7.5cm) by 1in (2.5cm) by 1in (2.5cm), and place them onto a clean, smooth surface, preferably metal. Embed the end of the steel rods into these at either end so that the clay blocks are supporting the steel rods approximately ½in (1.25cm) from the work sur-

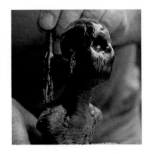
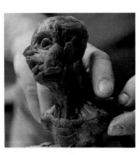

Modelling on a core 1. Model or cast a core slightly under the size for the finished work. Make it from refractory cement.

2. The core should be quite dry before adding wax. Brush on a layer of melted wax to about ⅛in (3mm) thickness.

3. Build up the basic structure of the form with small pieces of wax modelled onto the waxed core.

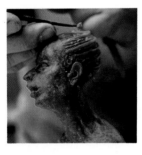
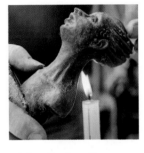
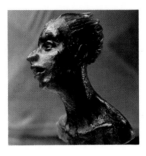

4. Develop the surface of the model and add detail with more wax pieces, shaping them with fingers or modelling tools.

5. When flaming with a candle, keep the model moving so that the wax softens and seals, but does not melt out of shape.

6. In addition to colouring and finishing the model, the candle flaming strengthens it for subsequent casting work.

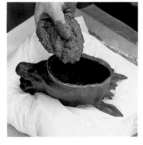
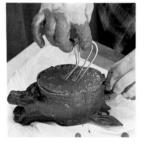
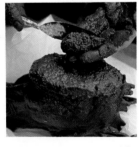

Coring a hollow wax 1. Support the wax on a soft cushion bed. Mix up cement coring material and drop it inside the wax.

2. Insert galvanized wire through the centre of the core. This should have been previously measured and bent into shape.

3. Build up the core material above the top of the wax. This will increase its stability during the casting process.

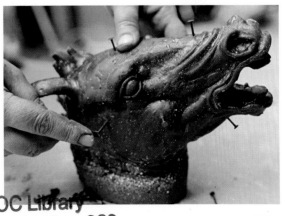

4. Push long pins through the wax and into the core to hold it in place. Leave the pin heads standing above the wax surface.

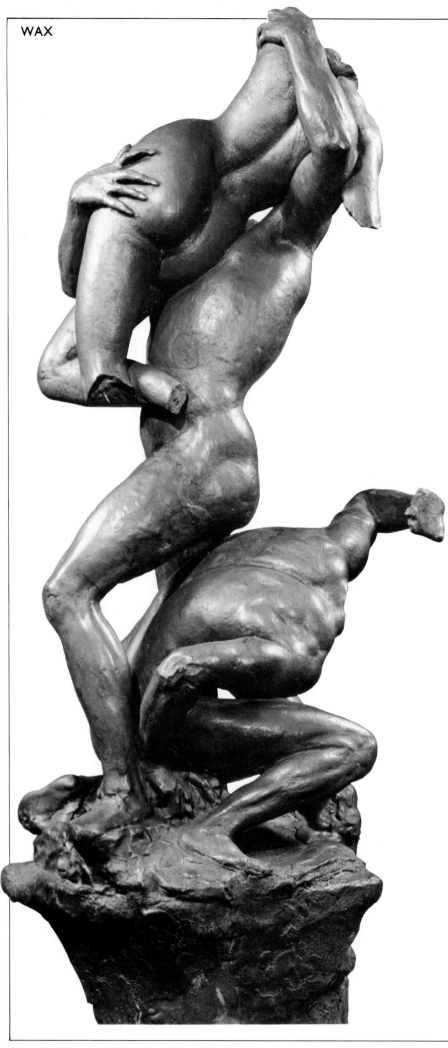

face. Next, build shuttering around the outside, allowing at least ½in (1.25cm) gap all round. A mould is made using a vinyl moulding compound. This is made from PVC (polyvinyl chloride), a strong, flexible substance which has superseded gelatin in mould making.

Pour the hot vinyl mould into the shuttered area until the steel rods and the clay are covered by at least ½in (1.25cm) of the moulding compound. When cold, remove the shuttering and turn over the mould, revealing an oblong mould with two oblongs of clay set in it. Remove the clay so that the end of the steel rods show through. Using a very sharp knife and metal straightedge, cut along the top of each steel rod with a single clean cut. When this has been done, the steel rods and any residual pieces of clay can be removed. The best wax to use for rods is a flexible but strong type which has a low melting point. The rods often need to be bent, so brittle wax is not suitable as it would make the rods snap.

Pouring the wax into the mould at a gentle slope, which allows the wax to run more easily along the narrow channels in the vinyl mould. When nearly all the wax has been poured into the mould, place it on a flat surface to complete the pouring. Never use very hot wax on a vinyl mould, as it will damage the mould. To complete the rodding system in the lost wax casting process, a runner cup—or gate as it is sometimes—called will be needed. The size of the runner cup is dependent upon the size of the wax to be cast. Note that after the bronze has been poured into the mould, the running system often uses the runner cup as a storage tank of molten metal. This helps to eliminate shrinkage in the casting as the bulk of the cup keeps some metal semi-molten for up to 10 minutes after it has been poured. The bronze has to be poured into the runner cup and, if the surface is rough, the bronze will break off small pieces of the mould which will find their way into the casting. If this happens, pitted areas will occur, and there will be a lack of detail in these areas. As the bronze is poured into the mould it fills the areas previously occupied by the wax.

Left *The Rape of the Sabines* by Giambologna is one of the great achievements of sixteenth century sculpture. It is a highly complex figure composition. This wax sketch model was one of the artist's preliminary versions. It shows the careful positioning of the figures and the attention paid to the exact placing of the limbs. Because wax is mainly used as a transitional medium, relatively few waxes have survived.

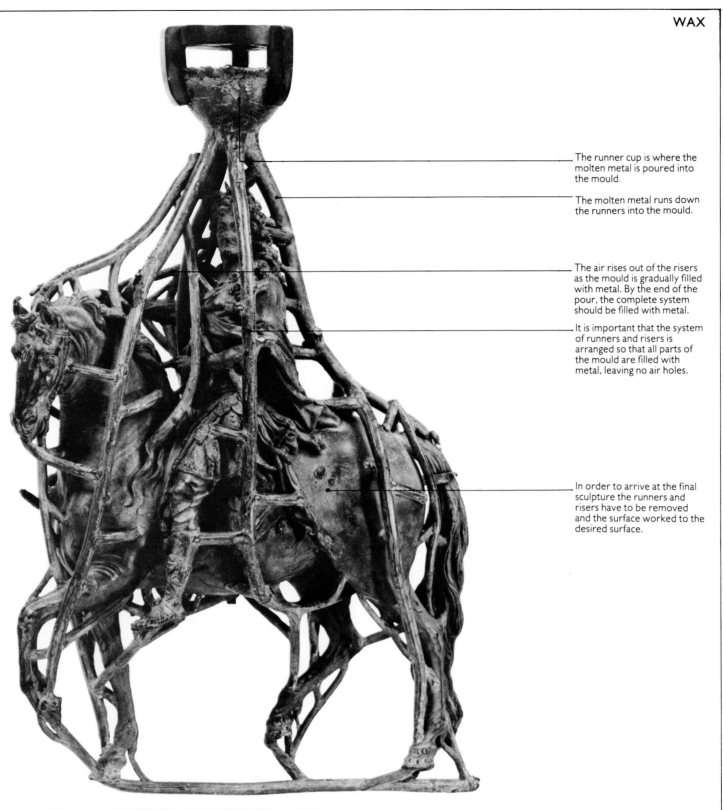

The runner cup is where the molten metal is poured into the mould.

The molten metal runs down the runners into the mould.

The air rises out of the risers as the mould is gradually filled with metal. By the end of the pour, the complete system should be filled with metal.

It is important that the system of runners and risers is arranged so that all parts of the mould are filled with metal, leaving no air holes.

In order to arrive at the final sculpture the runners and risers have to be removed and the surface worked to the desired surface.

Left These moulds show a simple piece with the runners and risers in position. The wax at the top of the mould is the runner cup into which the molten metal is poured.

Above It is unusual for a cast to be preserved with the runners and risers intact. However, this bronze of a mounted figure by the seventeenth century Dutch sculptor Martin Desjardins still remains as it was immediately after being cast. The work is fairly small – about 22in (56cm) high. But it still requires a very complex network of runners and risers to ensure that no air pockets are trapped because of the complexities of the composition.

MAKING HOLLOW WAXES

A hollow wax can be produced using a flexible mould in two ways. For the first method, the mould is first tied up tightly and aligned internally. Wax is then melted in a pan over a low heat until it is liquid. Never leave a pan of wax which is being heated. If it heats too fast, it can explode. Leave the melted wax until a 'bloom' appears on the surface, it is then ready to be poured into the mould. A wax with a 'bloom' looks clouded and has lost its shine. A small quantity of the melted wax is poured into the mould, rolled around the inside and then poured out. This is left to cool until set and the process is repeated until the wax casting is about ¼in (6mm) thick. When the completed wax casting has cooled, a core of refractory cement, reinforced by some galvanized wire, can be poured in. When this has set, the cored wax can then be removed from the mould and left for 24 hours for the core to cure. The wax can then be worked on if necessary before being cast into metal.

In the second method, the mould is left open, the wax is melted in a pan over a low heat until liquid and brushed onto the mould surface. This is a delicate process which must be repeated. Care must be taken to brush all over the surface of the mould each time the wax is applied. When the pieces have reached the desired thickness, and the edges cleaned, the mould is carefully re-assembled and securely tied up. The seam inside can be sealed by brushing it with liquid wax if there is access; if not, wax can be poured in and rolled. When it is cold, the core can be poured. It is easy to see the build-up of wax using the brush method, and it is more easily controlled. However, the pour and roll method is faster, more efficient and does not leave any seams.

USING THIN SHEETS OF WAX

Drapery and abstract sections can be fabricated and modelled by using precast thin sheets of wax. These sheets may be smooth or can have texture cast into them when the wax is poured. When the sheets are set and firm they may be cut into the required shapes, curved or manipulated by hand and assembled by using a heated spatula to spot weld the edges. If great care is taken it is possible to use a soldering torch or low brazing flame to actually 'wax weld' edges together using wax rods as a form of filler rod for the seams. Once the model has developed some structural strength, it will then be possible to continue where appropriate with modelled inclusions. However, attention should be paid to the consistency of the wax.

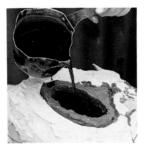

Making a hollow wax by pouring and rolling 1. Pour a small quantity of melted wax into the assembled mould.

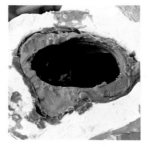

2. Roll the wax around the inside of the mould and pour it out. Repeat this process to build up an even layer.

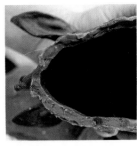

3. This picture shows the completed hollow wax. It should be thick enough to stand up to subsequent work for casting.

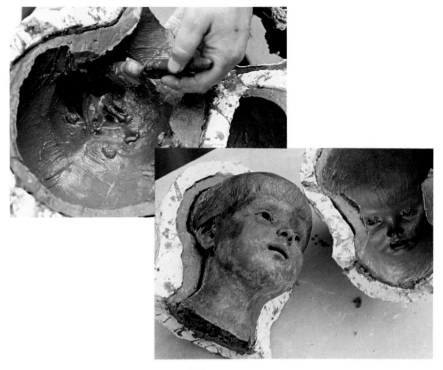

Brushing a hollow wax cast Brush melted wax into both halves of a mould. Build up thickness with several layers of wax, covering the whole surface each time. To join the two pieces assemble the mould and seal the outer seams, then brush more wax into the inside seams. Let the wax set completely before opening the mould.

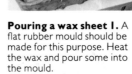

Pouring a wax sheet 1. A flat rubber mould should be made for this purpose. Heat the wax and pour some into the mould.

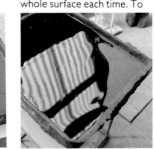

2. Tilt the mould gently to spread the wax across the flat surface. Allow it to set into a thin, malleable sheet.

3. Manipulate the wax sheet into the shape required. Weld it onto a wax model using the heated tip of a metal tool.

MAKING A SOLID WAX MODEL

A solid wax can be taken from a flexible mould, by simply pouring the mould full of wax with a bloom on the surface and leaving it to set. A wax casting can be taken from a plaster mould if required. This is often useful for simple relief casting where any undercuts are minimal. The plaster mould should be left to soak in water for at least one hour or until it is thoroughly saturated. The molten wax can then be brushed on in the same way as brushing wax onto a flexible mould. When the wax is about ¼in (6mm) thick, leave it to cool and harden. The whole mould should then be immersed in water and, with a little help, the thickened wax casting will float away from the master. This process is unsuitable for detailed work because the surface is not as· crisp as a rubber moulded surface. Also, fractures in the plaster mould surface can occur very easily if any wax adheres to it.

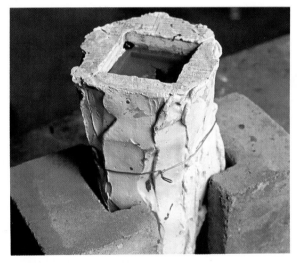

Casting a solid wax model
1. Assemble the vinyl moulding compound in its plaster jacket. Tie it with wire and prop it upright.

2. Melt a quantity of wax in a pan, enough to fill the mould. Pour it smoothly into the mould.

3. Wait for the wax to set and then dismantle the mould. Ease the wax model out carefully, peeling back the rubber mould.

SAFETY

Clothing Always wear protective clothing. Asbestos or other types of heat-resistant gloves are vital. Cover your arms so that they do not get burnt by molten metal or wax and always wear stout shoes, ideally, steel-capped boots. Trouser legs should be tapered and not flared. When casting, wear a foundry mask to protect your eyes from the glare of the metal.

Fire Both vinyl moulding compound and wax are potentially explosive, so melt them slowly and always keep an eye on them. Always have a fire extinguisher to hand and insure against fire. If possible, make sure that there are always two people in the working area when pouring metal, so in the event of a fire one of them can try and extinguish it.

Ventilation Good ventilation is essential in a studio, since the fumes from vinyl moulding compound can be an irritant if inhaled too deeply in an unventilated space.
Tidiness A further precaution is always to keep the floor space clear to prevent tripping up when carrying molten substances.

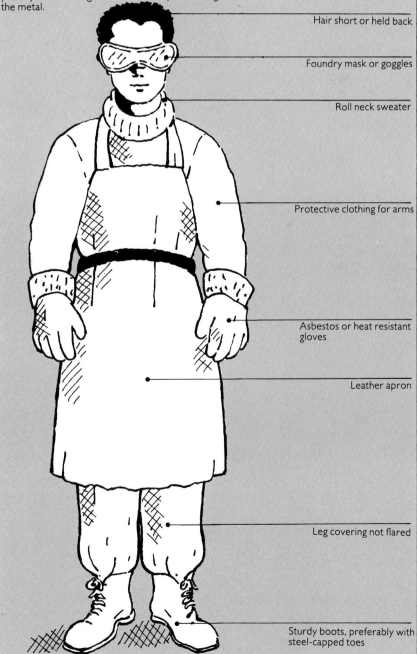

Hair short or held back

Foundry mask or goggles

Roll neck sweater

Protective clothing for arms

Asbestos or heat resistant gloves

Leather apron

Leg covering not flared

Sturdy boots, preferably with steel-capped toes

MOULD-MAKING

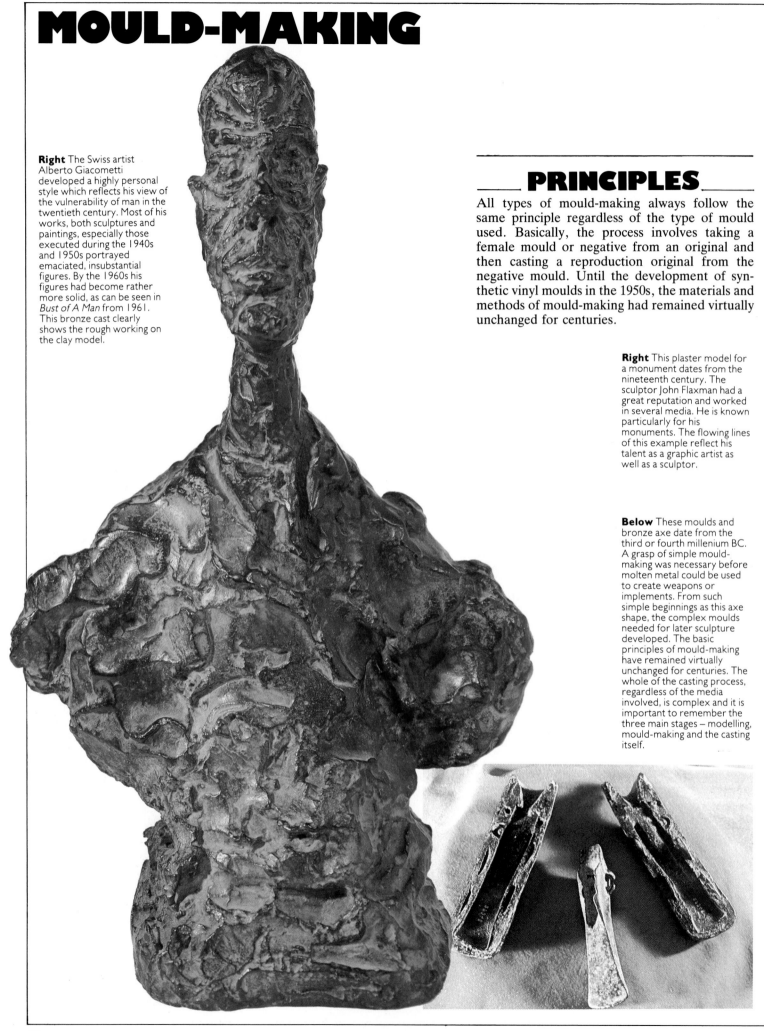

Right The Swiss artist Alberto Giacometti developed a highly personal style which reflects his view of the vulnerability of man in the twentieth century. Most of his works, both sculptures and paintings, especially those executed during the 1940s and 1950s portrayed emaciated, insubstantial figures. By the 1960s his figures had become rather more solid, as can be seen in *Bust of A Man* from 1961. This bronze cast clearly shows the rough working on the clay model.

PRINCIPLES

All types of mould-making always follow the same principle regardless of the type of mould used. Basically, the process involves taking a female mould or negative from an original and then casting a reproduction original from the negative mould. Until the development of synthetic vinyl moulds in the 1950s, the materials and methods of mould-making had remained virtually unchanged for centuries.

Right This plaster model for a monument dates from the nineteenth century. The sculptor John Flaxman had a great reputation and worked in several media. He is known particularly for his monuments. The flowing lines of this example reflect his talent as a graphic artist as well as a sculptor.

Below These moulds and bronze axe date from the third or fourth millenium BC. A grasp of simple mould-making was necessary before molten metal could be used to create weapons or implements. From such simple beginnings as this axe shape, the complex moulds needed for later sculpture developed. The basic principles of mould-making have remained virtually unchanged for centuries. The whole of the casting process, regardless of the media involved, is complex and it is important to remember the three main stages – modelling, mould-making and the casting itself.

TECHNIQUES

TOOLS AND MATERIALS

For making plaster moulds of any type, the same tools and materials are needed as for working with plaster (see pp 140–159). There are two types of flexible mould-making compounds – cold and hot melt. These are readily available from sculpture suppliers.

Materials needed for mould-making include brass shim, hessian or sacking, brushes for painting on the mould-making compound and a vessel in which to melt the flexible mould compound.

SIMPLE PLASTER CASTING

A simple plaster cast can be made for a relief if it has few or no undercuts. Undercuts are, quite literally, areas of a sculpture or mould where the material has been cut into horizontally, for example, on a female nude sculpture the area under the breasts is formed by an undercut. The finished clay original should be walled around the edge with clay and the wall sealed into place. Next, a coat of creamy plaster should be 'thrown' by hand over the surface, making sure no air is trapped anywhere. Throwing plaster involves mixing a bowl of plaster, and, when it thickens, throwing handfuls of it onto the sculpture using an action similar to sowing seed. When this layer of plaster has set, pour ½–1in (1.25–2.5cm) of plaster into the relief and add some form of reinforcement, such as iron rod or fire wood, to give added strength. This simple mould can be used for wax casting, if it is soaked well with water before use.

The rest of the clay figure should then be treated in the same way as the main front section. If the mould is to be filled with plaster, it is possible to make large back sections as the plaster can be poured into the mould, but if the mould is to be used for glass fibre or reinforced ciment fondu, numerous sections must be made as the seams of the cast will need to be filled as the mould is built up during the final casting.

Realignment of the mould sections for final casting is important. This can be done easily by making a zigzag in the brass shim wall in simple areas of the seam, which will act as a key. A clay wall can be used instead of brass shim, but only one piece of mould can be done at one time. The clay wall should be removed and clay wash applied to the seam before the next section is done. Locating keys can be cut in the seams on a clay-walled mould as the moulding process progresses. These small conical holes form a crude type of male-female joint, which help join the parts of the mould correctly.

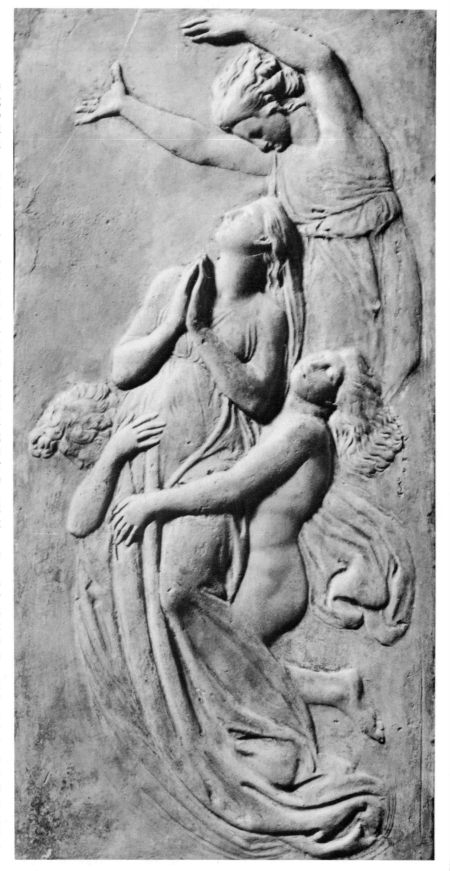

Plaster waste mould I.
Divide the model into sections for the mould. Place a wall of brass shim along the seam lines.

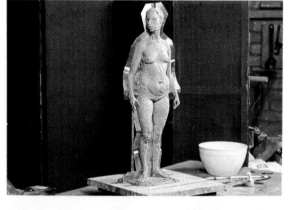

2. Set the shim so that each section of the mould will be easily detached. Pad out the back iron support with clay.

3. Make small zigzags in the shim at intervals, so that location keys are built in as the mould is constructed.

4. When mixing the first coat of plaster, add a little colour by first dissolving pigment in the mixing water.

PLASTER WASTE MOULDING

A plaster waste mould can only be used when no more than one cast is required from an original clay model, because the mould is chipped away when the cast is made. The cast can be made of a variety of materials ranging from plaster, glass fibre with resin to ciment fondu and glass fibre matt.

To make a plaster waste mould, first split the clay into 'piece' areas and build a wall out of 30 gauge thin brass shim—a type of brass foil—along the seam lines chosen. There is usually one large section, for example, the complete front of a figure, and depending on the choice of the final casting material, numerous back pieces. Two simple pieces may suffice if a solid plaster cast is going to be made from the mould.

When the brass shim dividing wall is in place 'throw' a coat of plaster at the largest section of mould. This initial coat of plaster is often coloured with powder paint so that, when the mould is removed from the final cast, it is easy to tell the difference between the external plaster, the colour coat and the cast inside the mould. Each time a mix of plaster is applied to the mould, the edges of the shim seam must be cleaned. A old spoon is ideal for this. Once about ¼in (6mm) of

5. Throw a smooth coat of plaster over the whole model to ⅛in (3mm) depth, flicking it on with the back of your hand.

6. When the colour coat is complete and no clay remains visible, clean the edges of the shim with a spoon.

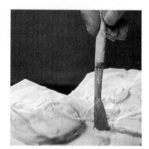

7. Paint high and rough areas of plaster with clay wash, before continuing to make the mould.

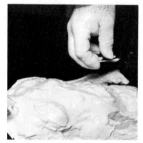

8. Throw on a thick layer of plaster over the colour coat and add to it until it is about 1½in (3.8cm) deep.

9. Build up a heavy layer of plaster against the brass shim, but keep the seam edge clean as it must be clearly visible.

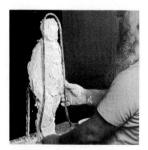

10. Bend reinforcing irons into shape to fit onto large sections of the mould. Make them continuous to support the weakest points.

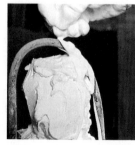

11. Flick wet plaster onto the points of contact between iron and plaster.

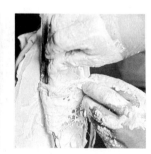

12. Use scrim soaked in plaster to attach the irons, winding it round the iron and against the plaster surface.

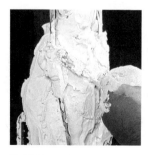

13. Thicken plaster on the mould where necessary, and make sure the irons are firm. Leave the mould to dry for one hour.

14. Damp the seams and ease in a chisel to separate the mould sections. Pull away one section of the mould.

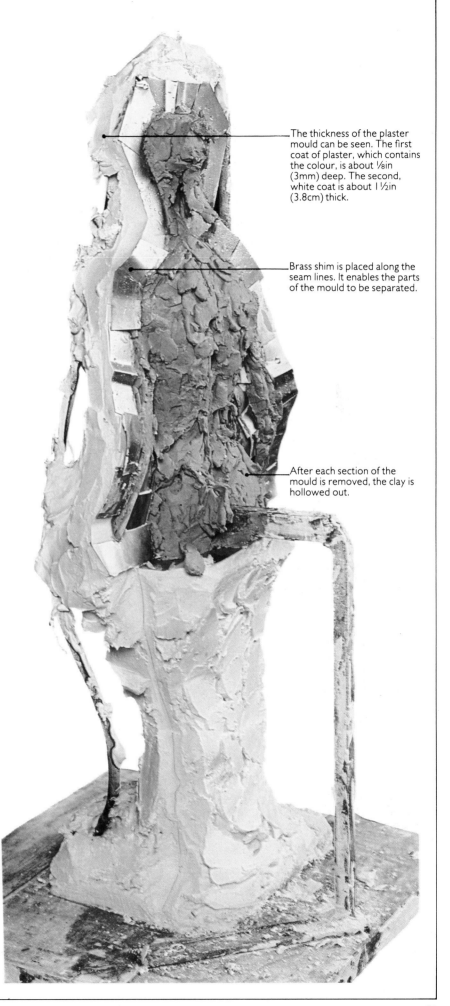

The thickness of the plaster mould can be seen. The first coat of plaster, which contains the colour, is about ⅛in (3mm) deep. The second, white coat is about 1½in (3.8cm) thick.

Brass shim is placed along the seam lines. It enables the parts of the mould to be separated.

After each section of the mould is removed, the clay is hollowed out.

colour coat has been applied and allowed to set, then clay wash the high points of the coated section. A clay wash is made by filling a soft clay thumb-pot with water, this will produce a slip-like substance which can be applied by brush onto the coated sections. This clay wash allows for easy separation when chipping out the final cast from the mould, as it separates the back-up plaster from the colour coat.

Next, back up the colour coat with more plaster until it is about 1–1½in (2.5–3.8cm) thick. To strengthen the mould, apply section irons externally, attaching them to the outer mould surface with scrim, a type of open-work sacking, and plaster, taking care not to cross any seam lines with the scrim or reinforcement. The strength given by the irons reduces the need for excessive back-up plaster and prevents movement in the mould sections when left to dry in preparation for being used with glass fibre or other materials.

PIECE MOULDING

Piece moulding in plaster has now mainly been superseded by rubber moulding compounds. However, it is still practised by some artists and is still used extensively in ceramic reproduction.

To use this process, first bed the original into clay up to the half way mark, this must be done

15. As each part is removed, clean out clay from the inside and remove the brass shim. Reassemble the mould.

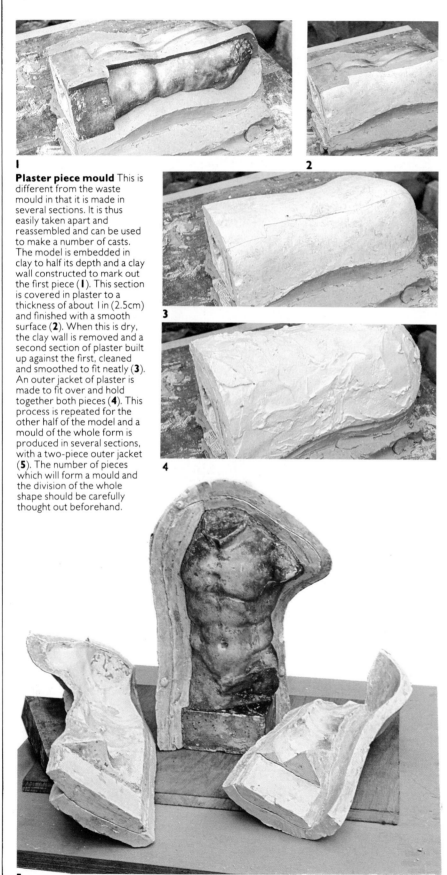

Plaster piece mould This is different from the waste mould in that it is made in several sections. It is thus easily taken apart and reassembled and can be used to make a number of casts. The model is embedded in clay to half its depth and a clay wall constructed to mark out the first piece (**1**). This section is covered in plaster to a thickness of about 1in (2.5cm) and finished with a smooth surface (**2**). When this is dry, the clay wall is removed and a second section of plaster built up against the first, cleaned and smoothed to fit neatly (**3**). An outer jacket of plaster is made to fit over and hold together both pieces (**4**). This process is repeated for the other half of the model and a mould of the whole form is produced in several sections, with a two-piece outer jacket (**5**). The number of pieces which will form a mould and the division of the whole shape should be carefully thought out beforehand.

exactly as the piece sections have to pull off with ease and must have no undercuts. Next, build a clay wall along the exact halfway mark of the section left above the clay bed. All of this work must be clean and accurate, as the efficiency of the piece mould depends upon it. Build up the first piece in plaster to a depth of about 1in (2.5cm) and finish it to give a smooth, clean exterior. A day later, when the plaster is cured, remove the clay wall, take off the piece, check it for ease of removal and replace it in exactly the same position. Then clay wash the seam, and build up the second piece in the same way as the first.

There are now two piece sections covering the original above the clay bed. Any roughness on the outer surface of these pieces should be smoothed down with sandpaper or a surform. After this, clay wash the piece sections and build a one-piece exterior jacket over them using scrim and plaster. When this has cured, it can be removed, checked and replaced. The clay bed is removed and the original with its two piece sections and plaster jacket in place, turned over and the whole process repeated on the other side of the original. Always check that the seams and the exterior of the piece sections have been clay washed, as failure to do so will result in a useless mould. When the complete mould has cured, it can then be carefully opened. Remove the exterior jackets first and then the piece sections. The piece sections are chamfered or bevelled along the outer seam edges so that a V-shaped seam is made, which provides a grip to pull on when the pieces are removed from the cast taken from the piece mould.

RUBBER MOULD-MAKING

Rubber moulds can be made from cold cure or hot melt rubber moulding compounds. The most popular cold cure compounds are latex and silicone rubber, both of which give excellent detail. However, hot melt rubber moulding compounds are used most commonly. These provide a flexible, durable rubber mould that can be reused. They are economical, as after use they can be re-melted and used again. Hot melt rubber comes in different hardnesses and different degrees of flexibility; this is denoted by different colourings. The most commonly used one is a red hot melt rubber moulding compound, made from polyvinyl chloride.

SIMPLE RUBBER MOULDING

A simple rubber mould can be made from a small object using a clay wall instead of a plaster retaining jacket. The original should be placed on a clay bed. If it is porous, it should be sealed with

shellac or a suitable sealant. Shellac is a varnish which is made from the resinous secretion of an insect, the lac. Build up a clay wall around it with about ⅜–½in (1–1.25cm) gap between it and the original, making the final height 1in (2.5cm) higher than the highest point of the original. Check that the wall is well supported and that it is well sealed at the base to the clay bed. Melt some vinyl mould in a pan and pour it in. Leave to set, and, when cold, remove the clay wall. It may be necessary to build a simple two-piece plaster jacket around the set vinyl mould. This can be done by placing a strong thread along the proposed seam line, covering the whole mould with one mix of plaster until it is about ½in (1.25cm) thick. When the plaster starts to set, pull the thread from one side (putting your finger on the other end) to the other side, and it will cut the setting plaster.

The state of the plaster has to be just right for this process. If it is too soft, the seam will rejoin, if it is too hard the thread will break. When the plaster jacket has cured, remove it from the flexible mould. Using a sharp knife, cut the mould and remove the original. When cutting the mould choose where you cut carefully, so that, if possible, the mould is kept in one piece. Make as few cuts as possible. When the original has been removed, clean the mould thoroughly and return it to the plaster jacket. It is now ready for use.

ONE-PIECE RUBBER MOULDING

Firstly, secure the original in a safe position and, if porous, seal it well with shellac or some other type of sealant. Then cover it carefully with strips of wet newspaper. Extra care should be taken if a soft clay original is being covered, as any damage done will have to be remodelled before the mould is poured. Strips about 1in (2.5cm) wide and 4in (10cm) long are the most efficient as they can be wrapped around the forms. When this is finished, roll out soft clay into sheets about 6in (15cm) square by ⅜in (1cm) thick. Cover the newspaper with the clay sheets until the whole model is covered in a smooth clay skin about ½in (1.25cm) thick. Draw a seam line on the surface of the clay skin, following the simplest, straightest areas, but dividing the clay skin in half. Check that the final plaster retaining jacket will pull away from the vinyl mould and will not trap itself on an undercut. If undercuts have been created in the clay skin, then build up with more clay until the right form is achieved.

Next choose your running and rising points. Runners and risers are solid cylinders of clay; runners are usually 1½in (3.8cm) in diameter and risers ¾–1in (1.8–2.5cm). With the running point

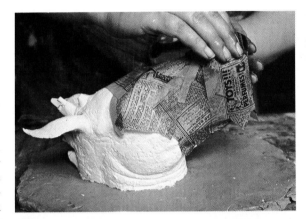

1. Place the original model on a clay bed and cover the whole surface with strips of wet newspaper.

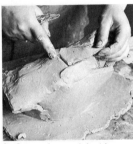

2. Cover the model with sheets of clay about ½in (1.25cm) thick, pressing the clay firmly around the form.

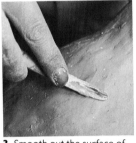

3. Smooth out the surface of the clay jacket. The vinyl moulding compound will later take the exact shape of this clay layer.

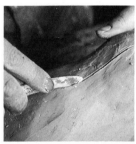

4. Draw a seam line along the centre of the clay coat around the whole form, marking it out into two halves.

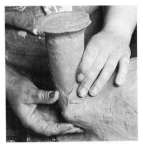

5. Set a thick roll of clay to stand vertically from the lowest point of the clay jacket. This will form the runner.

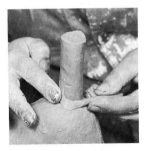

6. At the highest point set a thinner roll of clay to make a riser. Model it smoothly into the jacket at the base.

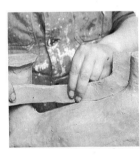

7. Extend the seam line up the sides of the runner and riser, and build a clay wall about 1in (2.5cm) deep along the line.

8. Mix a quantity of plaster to a creamy consistency and throw it onto one side of the form, covering the clay completely.

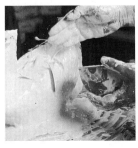

9. When the first thrown coat of plaster is complete and free of air bubbles, throw a second thicker coat over it.

10. Keep the top edge of the clay wall clean by scraping it down with a spatula.

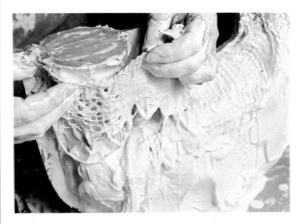

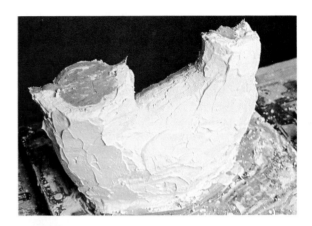

11. Reinforce the jacket with scrim soaked in plaster. Do not let it cross the edge of the clay wall.

12. Build up the plaster to form a thick, even coat. It must be particularly strong at the seams, against the clay wall.

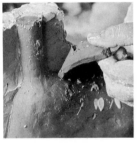

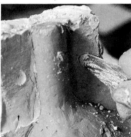

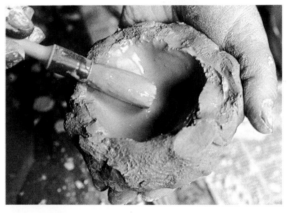

13. When the plaster is dry, peel away the clay wall leaving the seam edge exposed.

14. With a spatula, gouge small holes in the plaster seam to provide location keys for when the jacket is later reassembled.

15. Make a small pinch pot of wet clay and fill it with water. Brush around inside, dissolving clay into the water.

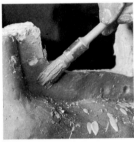

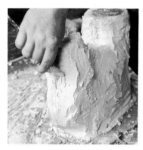

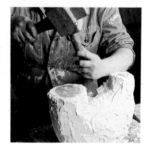

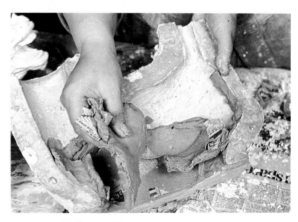

16. Paint the clay wash over the whole plaster seam edge. This will seal it to separate the plaster jacket halves.

17. Build up the second half of the jacket in the same way as the first. Do not allow plaster to obscure the seam line.

18. When the plaster has dried, tap a chisel into the top seam and ease another into the side seams to separate the halves.

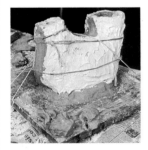

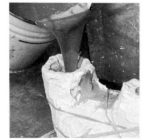

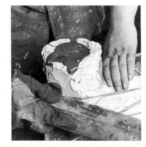

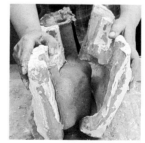

19. Pull the plaster jacket apart and clean out clay and newspaper from this and the original model.

20. Reposition the original and plaster jacket on the clay bed. Seal seams and base with clay and tie firmly with string.

21. Melt a sufficient quantity of vinyl moulding compound and pour it into the jacket through the runner, filling it to the brim.

22. Tap the plaster with a wooden paddle to release air bubbles in the rubber. Leave the mould to cool completely.

23. When the rubber has set, untie the string and pull the plaster jacket apart to reveal the vinyl moulding compound.

do not allow the hot vinyl mould to pour onto the original, as it will skin upon contact. Set the runner to the back or the side of the model or use an exterior tube to pour down, which can be removed when the moulding has been completed. Build the runner in clay so that it is approximately 2in (5cm) higher than the highest point of the clay skin. It is best to make it cylindrical in shape, as it has to be removed from the plaster jacket, first in clay and then secondly in the flexible mould. Next add the riser on the highest point of the clay skin. As the name suggests, it makes the vinyl moulding compound rise by allowing the air to escape when the mould is poured into the plaster jacket through the runner. The riser should be the same height as the runner. Make sure that the runner and riser are well joined to the clay skin and run smoothly into it. If they do not, build up with more soft clay until they blend in satisfactorily.

Build the clay wall along the line which was originally drawn, making it about 1in (2.5cm) deep. Mix the plaster to a creamy consistency and throw the initial coat, making sure that a complete cover is achieved and that there are no air bubbles around the intersection of the seam and clay skin. Back up with jute scrim and plaster and introduce exterior irons if the jacket is more than 18in (45cm) high, to give it extra support. During this process, keep the clay wall edge clean and do not cross it with scrim or irons.

When the half plaster jacket is cured, remove the clay wall and cut three or four conical key location points in the plaster jacket seam. Clay wash the seam thoroughly. Build up the other half of the plaster jacket in the same way as the first half, again being careful not to cross the seam line with plaster, scrim or irons. After each coat of plaster or plaster and scrim make sure that the seams are scraped down and well cleaned, so that eventually the sections of the plaster jacket can be easily separated.

After the plaster jacket has cured, open it using blunt chisels and a mallet. Place the chisel blade on the seam and tap lightly. Do not try to open it in one go or from one side, but try gently from all sides and from the top, so that the stress on the plaster jacket is spread over the whole. The jacket after a certain amount of light tapping will split up the seam and can be removed easily. Take care not to disturb the original, as the jacket will need to be relocated later. The plaster jacket may pull away some or all of the clay skin when it is removed. Clean out all of the clay from the jacket and off the original and clean off all the newspaper.

The original should now be clean, and, if it is made of clay, mend any surface damage which may have occurred. Check the plaster jacket and if there are any small holes, fill them with clay. Next reassemble the plaster jacket around the original, making sure that it is replaced in exactly the same position. If it is not put back together correctly, the mould will be thick on one side and very thin or non-existent on the other side. Tie the plaster jacket together securely using string or for even better results, wire. Also secure the mould down so it cannot ride upwards. Bear in mind that the case has to withstand the pressure of the molten vinyl mould when it has been poured in.

Seal the seams around the base with soft clay. The mould is now ready for the hot moulding compound to be poured in. When this has been done, leave the mould until it is cold. Untie and remove the plaster jacket. The runner and riser may make this difficult, so use a sharp knife to cut through these at their base, being careful not to cut into the main rubber mould. Next cut the rubber mould open with a sharp knife, always remembering the shape of the original. Keep away from detailed areas, keep the cut clean, it is very easy to make a jagged cut in a rubber mould. Try to keep the mould in one piece, if it has to be split in two, make sure that both pieces are well supported by the plaster jacket. When the original has been removed, reassemble the flexible mould and plaster jacket. The mould is now ready for use.

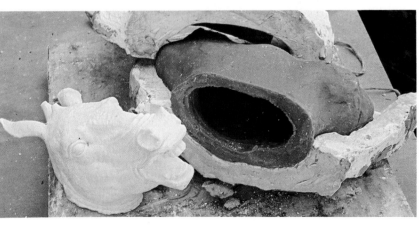

26. Having released the original, reassemble the rubber mould in the plaster jacket ready for casting.

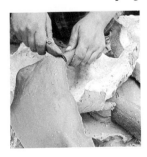

24. Use a sharp knife to cut off the runner and riser just above the outer surface of the mould.

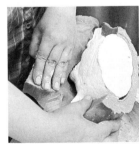

25. Partly slit open the mould with a knife to release the original, but leaving the mould itself in one piece.

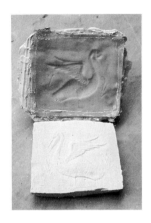

Latex rubber mould Latex is brushed onto the original in successive thin coats. Each layer should be allowed to dry out to a transparent film before the next is applied. Latex is very flexible so should be supported in a plaster jacket which is laid on before the mould is lifted from the original.

PIECE RUBBER MOULDING

Piece rubber moulding is similar to one-piece rubber moulding as newspaper and clay skin are both used in the same way. The seam line is drawn, but instead of just one line splitting the mould jacket in half, one side of the mould jacket is complete, but the other side is split into sections transversely. Check for any undercuts and build up with soft clay until each mould section will 'pull' cleanly. Build a runner and riser on either side of the main seam line and blend in. Next build the main clay wall about 1in (2.5cm) deep around the clay skin and plaster jacket on one complete side of the mould in the same way as for one-piece rubber moulding. When this is finished remove the clay wall, cut location keys, clay wash the exposed seams and build the next clay wall across the remaining area to be covered. This area can be split into as many pieces as wanted, but the pieces should be kept simple.

As each plaster jacket piece cures, remove the clay wall, cut location keys, clay wash any exposed seams, and repeat the process until the clay is completely covered. When the final plaster piece has cured, open the mould using a chisel and a mallet. Since only one side of the jacket needs to be removed, this is best done by two people. As soon as the seam shows signs of opening, one person should hold down the pieced side of the mould while the other removes the main piece of mould. Clear all of the clay from this piece and tidy up the remaining clay and newspaper, so that it is flush with the jacket seam. Try to seal any small points that might allow the hot rubber mould to seep onto the other side.

Reassemble and tie together sealing all seams with soft clay. Next, pour the hot rubber moulding compound into the cleared side. Leave to cool. Remove all of the pieces on the other side, trim away any mould that has seeped through, clear all of the clay and newspaper out and replace the bottom section. Tie together and pour hot vinyl mould carefully into the gap left up to the top of the section. Leave this to cool until set. Repeat until all of the sections have been filled.

When all the pieces have been poured and are cold, remove the plaster jacket and open the mould. The rubber mould will peel apart revealing the original. The pieces of mould should be placed back on the plaster jacket pieces, so that they are fully supported and retain their shape.

Melting hot rubber moulding compound Hot melt rubber is made from polyvinyl rubber. When melting it gives off toxic fumes that can be harmful especially to smokers and should not be inhaled. There are specially designed melters on the market for rubber moulding compounds, these are expensive but efficient. However, hot melt rubber can be melted in a saucepan over a gas ring—but not an electric cooker. The rubber should be cut into 1in (2.5cm) cubes and a little placed in a thick bottomed old saucepan. This should be put on an asbestos mat over a gas ring, keeping the heat low. As the rubber melts add a little more, stirring continually to prevent sticking and burning. Continue this process until enough rubber has been melted for the mould. Only enough rubber to make a small mould or a multi-piece mould, where each section is poured individually, can be melted by this process.

However, using a large specifically designed melter, up to 5 gallons (23 litres) of the moulding compound can be melted and kept hot for pouring. A quick melt attachment will handle large chunks of rubber and it is a reasonably quick process requiring little attention except for re-charging the quick melt attachment with rubber. The rubber mould should be poured when it is liquid, do not attempt to pour a lumpy melt as this will result in a poor mould. Pour the rubber slowly and evenly so that the level in the plaster jacket rises steadily, avoiding trapping air or chilling and thus solidifying, during the pour.

Rubber piece mould This is a similar process to the one-piece rubber mould, but, instead of constructing the plaster jacket in two halves, it is made in several sections over the clay coat. The clay is removed from one section and the hot rubber poured in and left to set. A second piece of the jacket is then cleaned out and replaced, then filled with rubber. This is repeated until the mould is complete.

SILICONE RUBBER MOULDING

Silicone rubber is a cold cure rubber moulding compound. It comes in two parts, a rubber solution and a catalyst. The catalyst is usually tinted and the rubber base is white. The two parts are mixed together and then poured into the mould. Silicone rubber is expensive and because of this can only be used economically for small moulds.

The preparation for using silicone rubber is the same as that for vinyl mould, the only differences being that the clay skin should be made no more than ¼–⅜in (6mm–1cm) thick, and the plaster case must be tied very tightly. Instead of claying the seam, it is better to seal it with thin plaster. Silicone rubber is extremely penetrating and leaks, seeping through even the smallest hole in the jacket, but it also gives excellent fine detail. Because it is a cold cure moulding compound, it can be used on originals that will not withstand the heat of hot melt rubber compounds. Mix the two parts of the compound together well, making sure that all of the rubber base is mixed in. Leave to stand for 15 minutes so the air rises out of it, and then pour slowly into the mould until it is full. Tap the sides of the mould occasionally as the rubber is poured, this releases any trapped air. Leave it until set, between 24 and 36 hours, depending upon the atmospheric temperature. Open and treat in the same way as a rubber mould. A silicone rubber mould can be used with a variety of materials and will withstand the heat of molten lead.

LATEX RUBBER MOULDING

Latex rubber is a cold cure moulding compound and can be used to make very flexible moulds. It can be brushed onto the original or sprayed on, but this requires special equipment. Do not use latex on porous materials like wood and plaster, unless they have been well sealed with shellac or another sealant first. When using latex always ventilate the room well.

First, secure the original in a safe position and dust it in French chalk (talcum powder) or graphite powder also known as plumbago. Then apply the latex all over with a brush. Allow each coat to dry thoroughly to a transparent film. Watch out for white patches, especially in undercuts, as these patches denote that the latex is not properly dry, and, if more latex is painted on, it will never set. The number of coats required is related to the shape of the original. If it is a simple shape, six coats will be ample, but if it has a lot of undercuts, up to 10 will be needed. Reinforce-

ment can be incorporated in the latex: cotton scrim is best and can be applied and brushed over with latex after the second brushed coat. This method of reinforcement requires no outer support, but is not as flexible as a pure latex mould with an outer jacket. A plaster jacket can be made for a latex mould in a similar way to a plaster jacket for a rubber mould. This should be done before the latex mould is peeled off the original, so that the case supports the latex in exactly the correct position. Often, latex moulds are filled with sand when placed in storage, to prevent the latex drooping inside the plaster case and thus losing its original form.

Silicon mould The preparation for a silicon mould is the same as that for vinyl moulding compound, but the clay coat over the original model is made only about ¼in (6mm) thick, this being the eventual thickness of the mould. Silicon is mixed and poured cold so it can be used to mould for instance, from a wax model, which would melt in the heat of liquid vinyl moulding compound. However, it is expensive and only really suitable for small works.

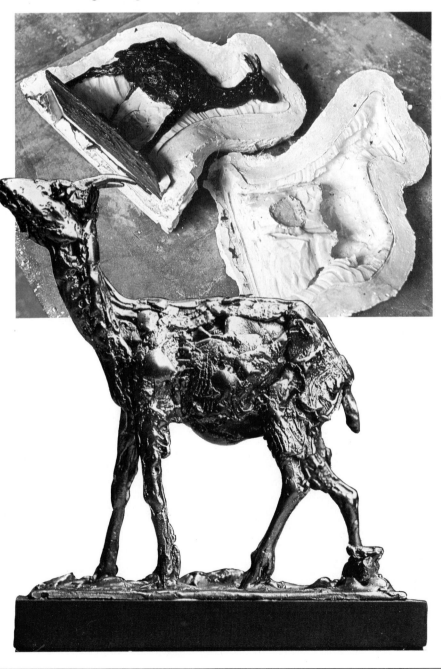

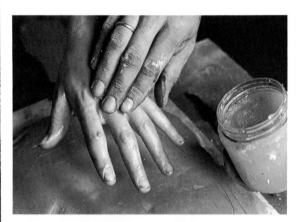

Taking a mould from a hand 1. It is essential to grease the hand thoroughly before starting mould-making.

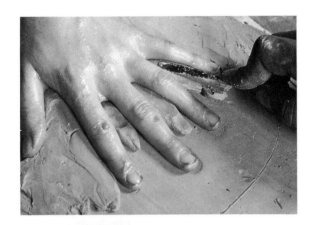

2. Place the hand on a clay bed and start to build clay around the contours.

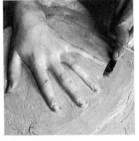

3. Work the clay into the outline of the hand until it is embedded in clay to half its depth. Smooth down the surface.

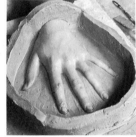

4. Build a continuous clay wall around the clay bed and up over the wrist. Seal any gaps.

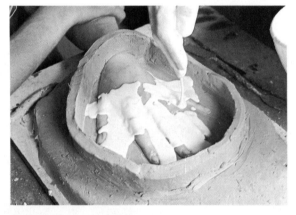

5. Mix a bowl of thin plaster, and drop it over the hand to form a smooth coating.

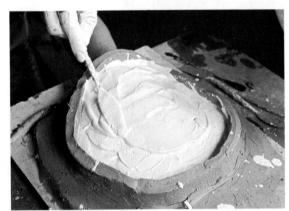

6. Build up with thickening plaster to fill the whole area inside the clay wall. Wait while the plaster sets.

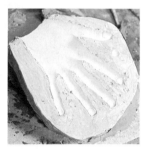

7. Strip away the clay wall and check at this stage that the hand can be easily released from the mould.

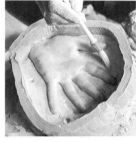

8. Turn over the hand and mould. Rebuild the clay wall and cut location keys in the plaster. Clay wash the mould seam.

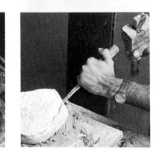

9. Build up the second half of the mould in the same way.

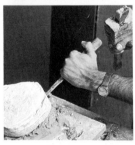

10. When the whole mould is dry, tap along the seam line with a chisel to separate the two halves.

11. The finished mould contains a highly detailed impression of the hand.

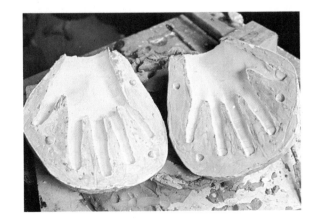

TAKING A MOULD FROM A LIFE FIGURE

This process is a particularly delicate one and should not be attempted by anyone inexperienced. Only simple moulds should be made, like, for example, a hand moulded from life.

The hand and arm to be moulded should be free from any cuts or scratches which could be irritated by the plaster and finger nails should, ideally, be short. Start by thoroughly greasing the hand and arm with petroleum jelly taking care to flatten any hairs on the arm so that they will not become entangled in the plaster mould. Then place the hand and arm on a bed of clay and build up the clay to the halfway mark on the fingers,

hand and arm. Plaster or plaster bandage can then be applied to build up the mould, but take care to keep the edges of the mould neat. This needs to be done quickly as the plaster bandage is light and fast setting. If only plaster is used, build it up to 1in (2.5cm) thick to give the mould strength.

When the plaster has set, the mould, hand and arm should be turned over, the seam clay washed and location keys cut. The whole process should be repeated, taking care to keep the seam clean. When the second piece of mould has been made, it should be removed gently from the hand, so as to preserve detail. If this is not done gently, the mould will shatter or crack. This is because the plaster will not have set all the way through or achieved its full strength.

Taking a mould from life
These plaster hands and the wax face were made from moulds of life figures. The outside of the mould which made the hands is fibreglass and the inside is vinyl, a useful material because it reveals very fine detail, such as fingerprints, in the moulded hands. The mould is screwed together and plaster is poured through the bottom of it. After about 20 minutes it can be unscrewed and the moulded hands are ready. The wax face mask was produced through a process requiring the face to be covered with petroleum jelly, followed by carefully placed plaster bandages. The wax mask is then made from the plaster mould. This can be extremely dangerous and should never be attempted without expert training or supervision.

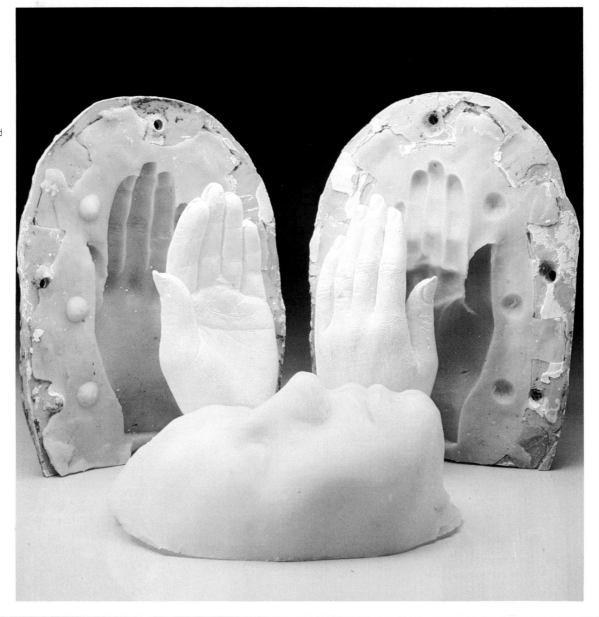

CASTING METAL

HISTORY

Metal casting and in particular bronze casting has evolved over a period of about 4000 years and has remained virtually unchanged in its principles to this day. The lost wax method of casting in bronze was known to the Sumerians in the Indus Valley around 2000 BC. It continued to evolve in the Middle East and was used in China around 1500 BC. Two basic methods of bronze casting emerged in the Ancient World, the direct and the indirect methods.

The direct method meant that the sculpture had to be modelled as a solid form in wax, over which a refractory material was formed. The wax was subsequently melted away and molten bronze poured into the resultant void to make a solid casting. Similarly, wax was modelled over a shaped refractory form, which, in the process, became a core. The core was then held in place by metal pins pressed through the wax followed by the application of an external coating of refractory material. After the wax had been melted away, then the resultant space between the core and mould could be filled with molten metal to produce a hollow section casting. This method in both instances results in the original modelled work being destroyed during the process.

The indirect method, introduced by the Greeks, required the production of a piece mould from the original model in order to produce a wax casting which could, if necessary, be cored and could then follow the same process already described. The mould could then be used to repeat the process if necessary. Both these methods are still used today. The lost wax technique is still the most satisfactory method of producing cast sculptures in bronze, although two important alternative developments in metal casting emerged in the eighteenth and nineteenth centuries—sand moulding and electrotyping.

Left This bronze of Alexander the Great is an example of the sculpture of the Greek Hellenistic period. It is difficult to link the names of over 500 known Greek sculptors with the work which survives, and equally difficult to date accurately any of the sculpture of this period. Here the thickness of the metal can be judged.

Far left Early Chinese bronzes, dating from the later part of the Shang dynasty (1300–1028 BC) could quite possibly have been made by the lost wax method, in use from about 1200 BC. Ceremonial vessels resembled their secular counterparts, in this case a *Ting* or type of cooker.

Below The bronze reliefs of Donatello (1386–1466) are renowned for their spatial complexity and dramatic effect, as exemplified by the *Miracle of the Birth* from the Basilica del Santo in Padua.

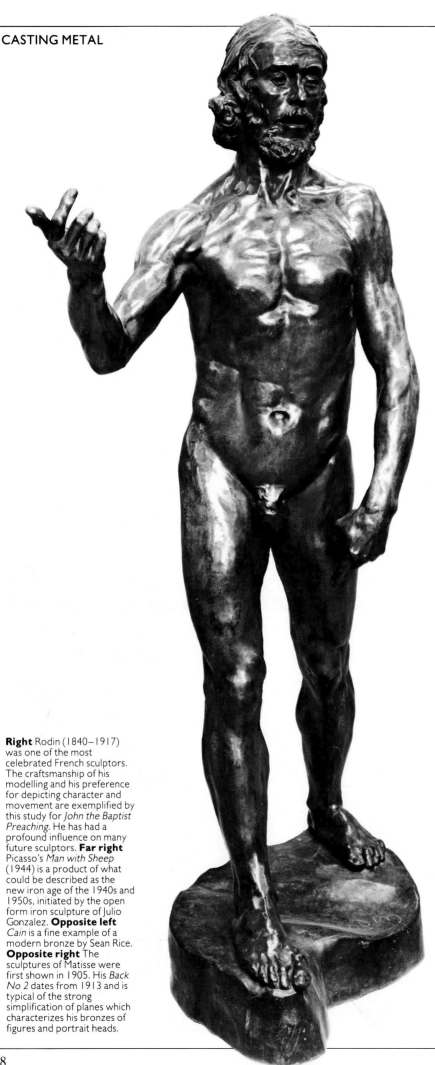

Sand moulding was developed during the eighteenth century. It involves finely graded sand, either slightly dampened with water or moistened with an oil binder, being rammed firmly over a sculptured form in a series of split sand moulding boxes. These boxes are 6in (15cm) deep and are made of cast iron; they are joined together by a sliding wedge. The boxes are separated and the original pattern removed to leave a perfect impression. Runners and gas vents are cut into the sand, the boxes reassembled and the metal poured. The advantages of such a process are mainly that it is cheaper than alternative methods and that the gases can escape very easily through the sand. However, this is a process developed by industry, largely for commercial castings, mostly in iron. It is best used for simpler lay forms, where the division of the sand mould is not too complicated and does not require unduly intricate draw pieces to overcome undercuts. Nowadays, even industry has turned to injection wax patterns for its complicated machine castings, using ceramic shell dip moulding as a refractory investment or mould.

Electrotyping, introduced in the nineteenth

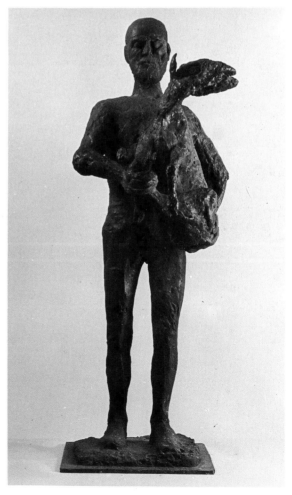

Right Rodin (1840–1917) was one of the most celebrated French sculptors. The craftsmanship of his modelling and his preference for depicting character and movement are exemplified by this study for *John the Baptist Preaching*. He has had a profound influence on many future sculptors. **Far right** Picasso's *Man with Sheep* (1944) is a product of what could be described as the new iron age of the 1940s and 1950s, initiated by the open form iron sculpture of Julio Gonzalez. **Opposite left** *Cain* is a fine example of a modern bronze by Sean Rice. **Opposite right** The sculptures of Matisse were first shown in 1905. His *Back No 2* dates from 1913 and is typical of the strong simplification of planes which characterizes his bronzes of figures and portrait heads.

century, gives a mechanical reproduction of an original model in bronze. An electric current is used to transfer particles of metal from a bar suspended in an electrolytic solution, to build up a deposit on the face of a mould until sufficient thickness has been established. The 'castings' are usually very thin and accurate, but tend to lack the surface vitality and character of a poured metal casting.

Many sculptors now form original patterns from expanded polystyrene which has unique properties at high temperatures. The polystyrene pattern can be simply rammed up in a box or sand pit with slightly dampened sand. Then an appropriate pouring channel and rising vents must be introduced. The molten metal can be poured direct into the retained pattern, which burns away instantaneously and allows for its replacement by the metal. Again this is a method best suited to relatively simple and undetailed forms and, on the whole, to solid castings. Hollowed sections of polystyrene can be cast in the same way using a supported core of rammed sand on the cavity side. Large sections should not be more than 1in (2.5cm) thick.

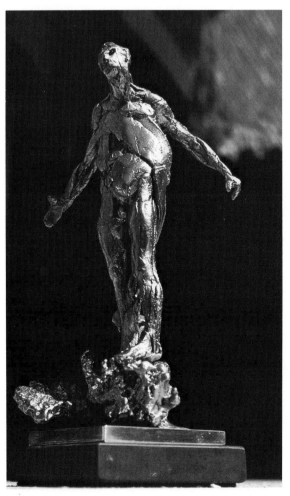

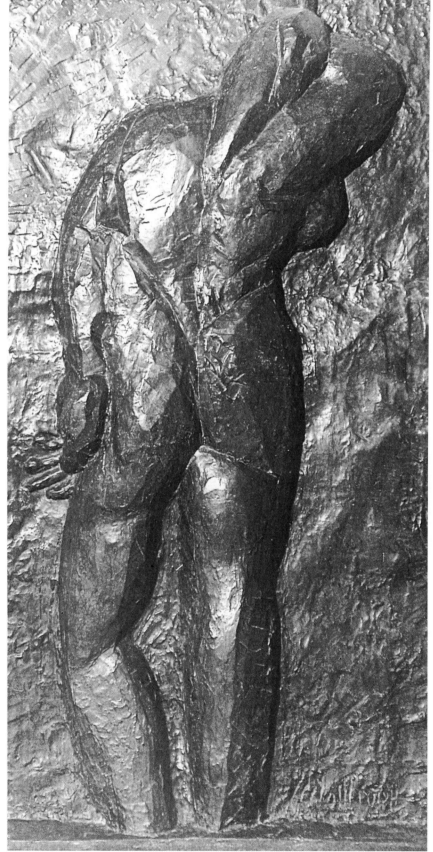

Aluminium Aluminium has the great advantages of being light, strong and relatively cheap. However, it does not weather well and cannot easily be coloured. After polishing, the surface of the metal will become very shiny, but it requires lacquering to ensure it will keep its shine.

Lead Lead is an interesting metal when used on a small scale. Large pieces tend to distort as it is very soft. Lead also has a low melting point.

Iron Iron has been used by sculptors, especially for architectural works. However, it is rather brittle, and not very popular with sculptors today.

Bronze Bronze is probably the most popular metal for casting. It is very hard wearing, will take a variety of finishes and has a pleasing natural colour.

MATERIALS AND TECHNIQUES

ALUMINIUM

Aluminium is a strong light metal with a much lower melting point than bronze and is comparatively cheap. It achieves a high silver polish, which can be temporarily retained with a good lacquer. However, it is apt to oxidize, particularly outside, weathers to a rather lifeless grey colour, and it is not readily responsive to colour treatments.

LEAD

Lead has been used for many centuries, particularly for garden sculptures, fountains and architectural details. It also weathers to a dull grey, but seems to retain more surface vitality than aluminium. However, it is very soft and prone to damage, and it is obvious from surviving examples of eighteenth and nineteenth century work, that over very long periods large pieces eventually tend to distort and compress under their own weight. It is an attractive material for using on small simple castings and, as it has a low melting point, affords most students and enthusiasts the opportunity to try metal casting in their own home.

IRON

Iron has been used sculpturally for fountains, lamp-standards and other architectural detailing since the development of sand casting for industrial purposes. However, it is rarely used by sculptors today.

BRONZE

Various metals have been used through the ages for the production of sculptured objects and its is evident that certain metals are preferred both for aesthetic and practical reasons. Bronze is naturally the most popular alloy due to its durability, natural colour and range of patination.

GOLD AND SILVER

Gold and silver are usually considered too expensive for most sculptural purposes and, although the lost wax method is usually employed, additional technical advances, such as vacuum assisted casting and centrifugal casting, have been introduced to achieve better mould penetration of the precious metal. This results in sharper definition.

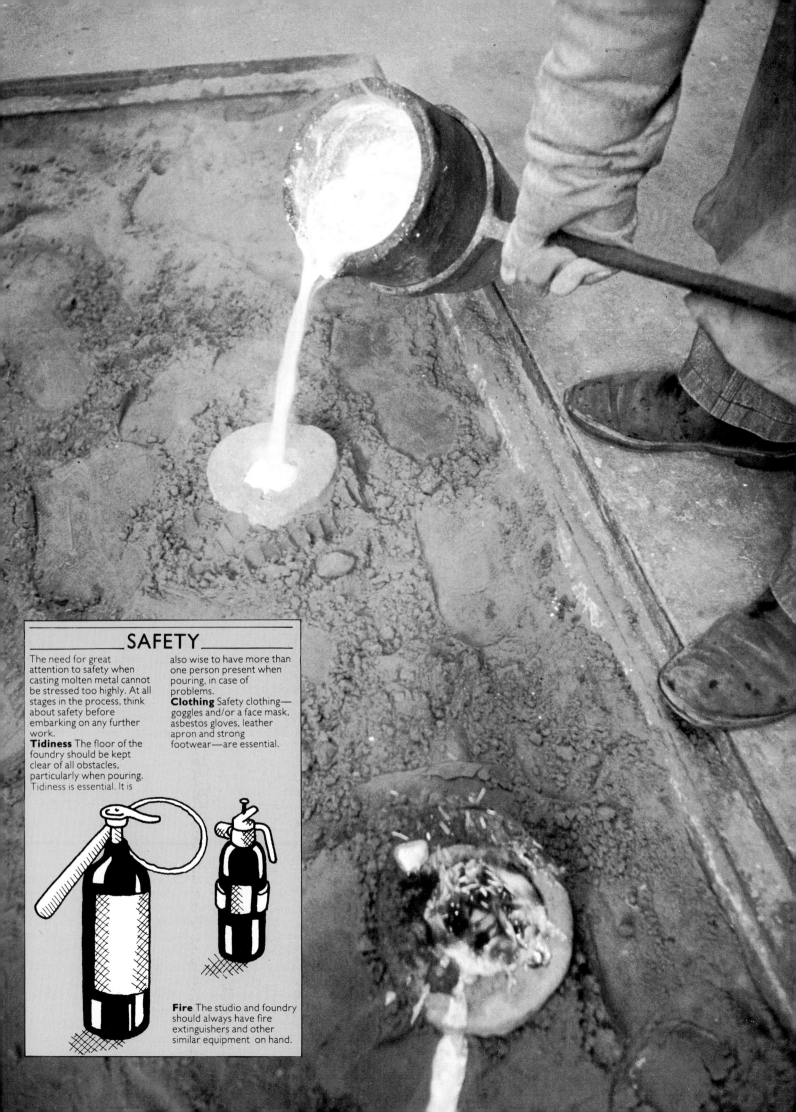

LOST WAX CASTING WITH BRONZE

The principles of casting bronze are broadly similar to those for other metals. There are two basic methods, direct and indirect, both solid and hollow. Solid castings are usually more limited in size due to the fact that a bronze casting should not be more than 1in (2.5cm) in thickness. Thicker sections will result in bad shrinkage, cracking and distortion, and cause difficulty in attempted repairs. Consequently, when considering casting a figure or figurine, the thickness limitations will prohibit a casting of much above 10–12in (25–30cm) in height and, if the figure is rotund, it may need to be even smaller.

For a small sculpture, take a rod of approximately ³⁄₈in (10mm) diameter down its full length with connecting rod sections and place horizontally to strategic simple areas of the figure. The main rod will probably stand about 1in (2.5cm) from the wax sculpture to enable sufficient space for ease of sawing when removing the rods in bronze. One or two rods, about ¼in (6mm) in diameter should then be similarly attached to high points and extremities as risers or vents. These should be attached by rods sloping upwards from the model to the outer rod in order that air and gases can escape with the rising metal. The runner first mentioned should be attached to the bottom of a runner cup which should be made from wax coated polystyrene for lightness placed above the casting. The cup will vary in size depending upon the size of the model, but should always be large enough to give a good head of metal during casting and allow for continued feeding to the bronze during cooling.

All rod attachments should be sealed firmly with a heated steel spatula and should only be applied as far as possible to convex surfaces and not hollow sections. This will permit easy removal of the rods when in the bronze.

Founders usually have their own preference for particular refractory investments, which are the moulding compounds applied to the wax and withstand the heat of prefiring and the thermal shock of the molten bronze. Most of these investment compounds have, traditionally, a plaster of Paris base binder, which has various grades of sand, fire-clay, brick dust and grog added in varying proportions. Moulds made of this type of material are usually quite large and heavy in relation to the object being cast and are also extremely fragile after the wax has been fired out of the mould. To help strengthen the mould—or ludo mould, as it is called—some founders strengthen the investment with metal rods or mesh. Alternatively, a refractory cement can be used as the basis of the investment.

Mix the first coat of investment or 'fine coat' of ciment fondu with dry sieved sand and plaster of Paris—to accelerate setting—in the proportions of one plaster, two ciment fondu and six sand. The second backing coat or coarse coat should consist of a prepared, commercially available, lightweight castable refractory cement. This type of preparation not only has the advantage of comparative lightness to volume, but is also very strong even when fired out, and seldom requires additional reinforcement.

The fine coat should be sieved and mixed dry. Then mix small quantities with water to form a creamy consistency and apply carefully with a soft brush to the rodded wax until ¼in (6mm) thick. When the first coat has set, the second coarse coat of lightweight cement and plaster (in proportions of 10 to one) can be built up to strengthen the mould. This should lead to a mould of a fairly simple shape extending to about 1in (2.5cm) outside the wax rodding. If suitable, the second coating may be poured to form a fully cylindrical mould by setting a former in some suitable material around the finely invested model. A hollow wax with a core of the coarse investment is handled very much in the same way as already described for solid casting. The essential difference is that steel pins should be pushed through the wax model to touch the core and still allow sufficient length outside the wax to be held by the external investment. These pins will keep the core accurately suspended within the mould and prevent it from falling. In order to ensure that the bronze will flow through the wall section of the hollow casting, which is usually ⅛–¼in (3–6mm) thick, more rods (two or three runners) will be needed and a more sophisticated network of feeders and vents will be necessary. The mould, when finished, should be left for about 48 hours in order to cure fully after which it can be fired out.

FIRING OUT

The process of firing out and baking lost wax ludo moulds is very important, and it must be stressed that, if this is not done correctly, then the consequences when pouring hot metal can be—literally—explosive. Consider carefully the type of kiln or furnace suitable for this process. Remember that in the first instance the wax contained in the mould will pour out and either fill the air with black smoke or ignite and burn up within the furnace. Some founders, particularly when firing out a number of moulds, find a suitable place and build a temporary kiln out of fire bricks and fireclay around the mould, producing a made-to-measure structure, as it were, and

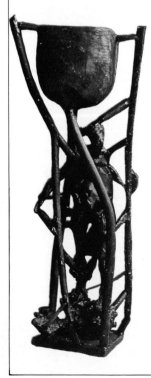

Below This picture shows the model with the runners, risers and runner cup in position. The arrangement of the runners and risers is very important, because it is vital that the bronze reaches all areas and details during pouring and that no air bubbles are trapped.

then introduce a gas or paraffin burner to supply the necessary heat. The Benin in Nigeria still use brushwood and timber stacked like a great bonfire around a heaped mound of their ludo moulds to get the necessary heat for a satisfactory firing of these moulds.

Try to find a means of firing which will allow you to work within your existing studio without the environment taking on too much of the appearance and character of a battlefield or brickyard. Important considerations are the necessity to regulate the flame when firing different moulds and the erratic and unpredictable dimensions of individual moulds. The completed and cured mould can be placed runner cup downwards in the kiln in such a way as not to be directly in line with the flame and so that they will not fall over.

Firing should be slow to begin with to allow water vapour to escape and to prevent sudden cracking. However, ciment fondu based refractory moulds can be fired more quickly than a plaster of Paris refractory mould. When the water vapour has cleared and the wax has melted, the moulds can be heated quite rapidly to a bright cherry red heat right through without any fear of structural breakdown. It is very important that the moulds are seen to be red hot all the way through to guarantee that any last vestige of wax is removed.

When the furnace has cooled down, the sections can be removed to reveal the baked mould. These must be removed carefully as a ludo mould is fragile and susceptible to sudden shocks or knocks. On turning the mould the right way up, the runner cup uppermost, it will then be possible to inspect the mould to check whether it is satisfactorily fired out. If the runner cup is clean and free from signs of sooting, then the mould is safe to receive molten metal. If, on the other hand, there is the remotest sign of black sooting even around the neck of the runner cup, or at the exits to the risers, the mould must be considered as possibly unsafe to pour. In this case there will at best be a turbulence during the pouring, and surface destruction on the face of any casting may be caused by the evident small residue of wax remaining within the pores of the mould.

If in doubt, it is far better to re-fire the mould rather than to risk a metal pouring. Assuming the mould is satisfactorily fired, it will now need to be lowered into a sand pit or suitable container and firmly rammed up with dampened sand, taking care not to allow anything to fall into the runner cup or risers. A cup cover is a good idea. The purpose of the compressed sand is to strengthen the resistance to the bursting pressure within the mould during the pouring of the molten metal. Also, should the mould crack under stress the

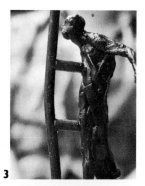

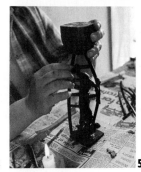

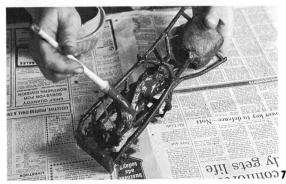
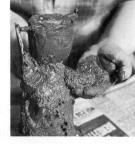

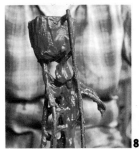
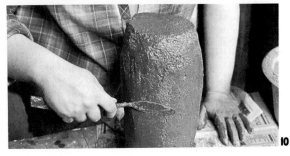

Lost wax casting with bronze This important method of casting is very complex and requires specialist equipment. Start with a wax model. Several wax rods are needed to prepare a model for casting (**1**). These are made in a vinyl moulding compound, originally formed around metal rods. Runners through which the hot bronze will pour are set on the model first (**2**). Small sections run out horizontally from the model and attach to vertical rods brought up from the lower part of the model to above the head (**3**). A runner cup is formed from polystyrene covered with wax (**4**). This is lost in firing out the model leaving a well in which to pour the bronze. The runner cup is attached to the top of the runners (**5**). Risers, which release air as the bronze is poured, are set at an upward angle from the model. They branch into vertical rods which stand to each side of the runner cup (**6**). The fully rodded model is then encased in a refractory compound up to the top edges of the runner cup. The first coat is a thin, smooth mixture of sand, plaster and cement which is brushed on and blown into the detail (**7**, **8**). Two coarser coats of cement are then applied (**9**), building up a smooth cylindrical shape around the model (**10**). This is referred to as a ludo mould.

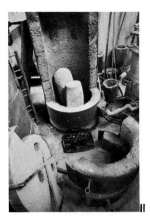

11

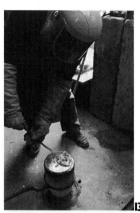

12

13

Breaking the investment
After pouring, the mould should be allowed to cool slowly. Do not be tempted to remove the mould too quickly. If the mould is removed before it is properly cooled, fractures in the cast and severe shrinkage can result. Once cool, the mould can be lifted out of the pit (1) and broken open with hammers to reveal the bronze cast (2, 3, 4,). This should be done with great care. Before starting further work, the cast should be firmly fixed. A small model can be clamped in a vice (5). All traces of the investment should be throughly cleaned off (6).

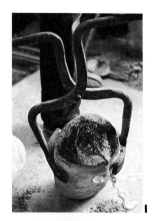

1

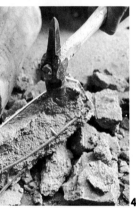

4

The ludo moulds are put in a burn-out kiln and fired to get rid of the wax. This process leaves a hollow impression of the rodded model inside the mould. (11). The kiln is sealed up and gas heated under pressure to achieve the right temperature. The wax runs out of the mould and through a hole in the base of the kiln. The mould must be fully cleaned out, otherwise problems may occur when pouring the bronze. The moulds are taken out and embedded in sand with the runner cup facing upwards. Sand must not fall into the mould. The bronze is melted down in a crucible and lifted out with lifting tongs (12). Asbestos gloves, goggles or protective helmet and a thick leather apron are minimum safety requirements for the person handling the hot metal. The crucible is then placed into a metal pouring ring. Impurities are skimmed from the top with a ladle (13). The metal is lifted (14) and poured smoothly into the moulds until they are quite full (15). Metal escapes from the risers at this point. A black powder thermal coating is thrown on the metal (16). This keeps the bronze molten in the runner cup so it will flow into all details in the mould.

Whenever molten metal is being used, it is extremely important to take great care over safety. Heavy duty shoes or boots should be worn to protect the feet from falling weights and heat. Asbestos or other fireproof gloves must be worn. In addition to thick trousers and sweaters with long sleeves, a protective leather apron should be worn for further protection. Above all, you should never try to deal with molten metal – however small the quantities – by yourself. Always have another person present.

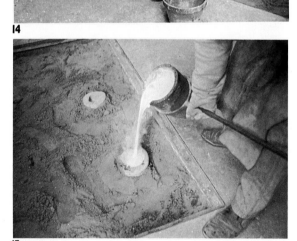

14

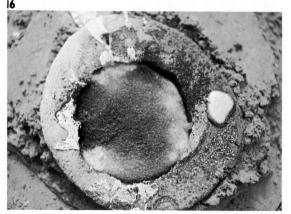

15

16

sand against the mould will immediately chill and arrest any escape of metal.

Crucibles for pouring molten metal come in various shapes and sizes. For pouring as a single operation, a crucible of up to 60lb (27kg) capacity must be considered a maximum. Around 40lb (18kg) of molten metal is about the most comfortable, bearing in mind the high temperature involved. A single pouring ring is recommended, slightly tapered to fit snugly around the crucible. The ring should fit all the way round so as not to exert undue pressure at just one or two points only.

When pouring hot metal, it is best, if possible, to have someone else at hand to help in case of mishaps. However, if working single-handed, shortened crucible lifting tongs can be made or adapted to help lift the hot crucible out of the furnace.

The crucible can then be placed in the pouring ring and the metal skimmed in order to remove floating dross. The metal should be poured slowly and evenly so as not to cause turbulence or chilling during the pour. It is better to let the mould cool down slowly after pouring since overenthusiasm and impatience to get the casting out can result in fractures and severe shrinkage in the castings. Casting is one sculptural process where patience pays great dividends.

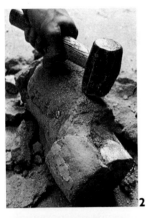

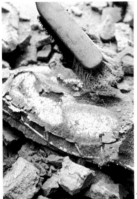

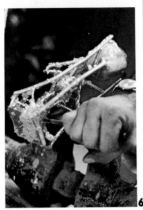

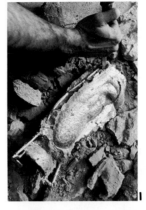

Chasing and fettling
Chasing and fettling are the terms used to describe the process of finishing a bronze or metal cast. The amount of finishing required depends firstly on the quality of the mould and the pour, and secondly on the artist's own wishes. Lost wax casting will generally produce a reasonably good finish. The initial finish will be improved if a good alloy of bronze is used and if the mould is of high quality. Chasing is the process of finishing or adding detail to the surface with tools. The first step is to cut the metal rods off the surface of the cast with a chisel (**1**, **2**) and hacksaw. (**3**). Finally, a file should be used (**4**).

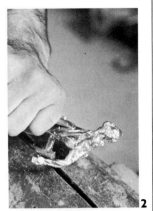

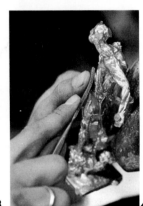

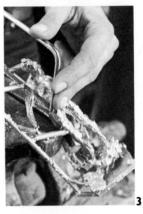

FINISHING

Chasing and fettling When the casting has cooled, the mould may be broken away with a hammer and chisel followed by the careful removal of the bronze rods that comprise the running and rising system. Care should now be taken to file and grind away the rod marks and to remove any metal flashing or small defects with sharpened cold chisels. Textured matting punches should be used to match up textured surfaces so that the casting is not covered in a rash of smooth filed patches. This process is known as chasing and fettling. The process of finishing a bronze cast takes both time and patience. It is worth devoting the necessary time to this, in order to achieve a good finished result.

Pin holes can be drilled out and tapped to take threaded bronze rod of the same colour metal. If the casting comprises a number of sections, as in a larger work, then the finished pieces will need to be welded together and the seam weld will need chasing and fettling. The completed bronze may be polished and then waxed or lacquered. It may be preferable to patinate and colour the surface with one of a number of chemical treatments to achieve a more subdued and subtler surface finish.

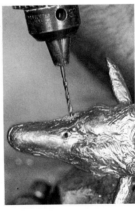

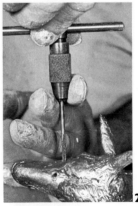

Tapping Holes in a bronze cast left by pins which held the core of the wax models must be filled to finish the surface. The holes are first drilled out (**1**) and tapped (**2**) to give them a thread. A bronze rod is also threaded and screwed into the hole (**3**). The rod is sawn off at the surface of the cast (**4**) and filed down to the correct finish (**5**). The process of finishing can be fairly extensive, depending on the type of finish the sculptor wishes.

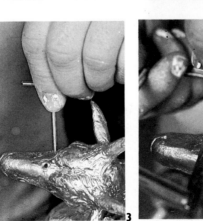

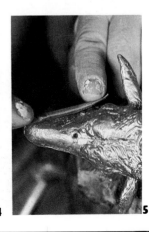

RESINS AND GLASS FIBRE REINFORCED PLASTICS

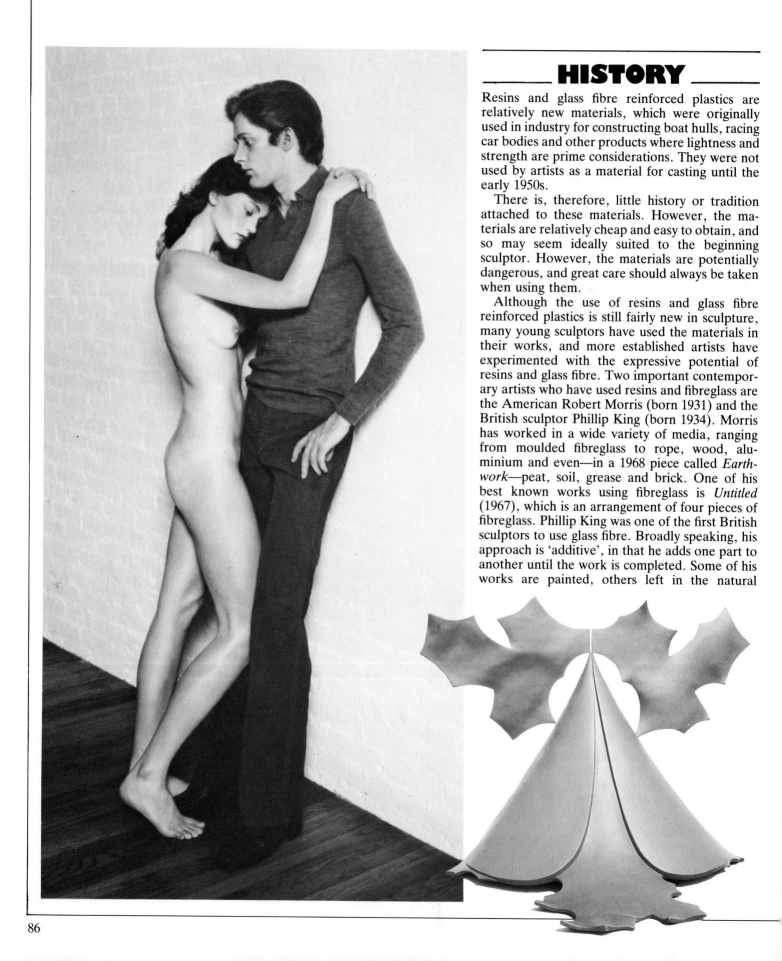

HISTORY

Resins and glass fibre reinforced plastics are relatively new materials, which were originally used in industry for constructing boat hulls, racing car bodies and other products where lightness and strength are prime considerations. They were not used by artists as a material for casting until the early 1950s.

There is, therefore, little history or tradition attached to these materials. However, the materials are relatively cheap and easy to obtain, and so may seem ideally suited to the beginning sculptor. However, the materials are potentially dangerous, and great care should always be taken when using them.

Although the use of resins and glass fibre reinforced plastics is still fairly new in sculpture, many young sculptors have used the materials in their works, and more established artists have experimented with the expressive potential of resins and glass fibre. Two important contemporary artists who have used resins and fibreglass are the American Robert Morris (born 1931) and the British sculptor Phillip King (born 1934). Morris has worked in a wide variety of media, ranging from moulded fibreglass to rope, wood, aluminium and even—in a 1968 piece called *Earthwork*—peat, soil, grease and brick. One of his best known works using fibreglass is *Untitled* (1967), which is an arrangement of four pieces of fibreglass. Phillip King was one of the first British sculptors to use glass fibre. Broadly speaking, his approach is 'additive', in that he adds one part to another until the work is completed. Some of his works are painted, others left in the natural

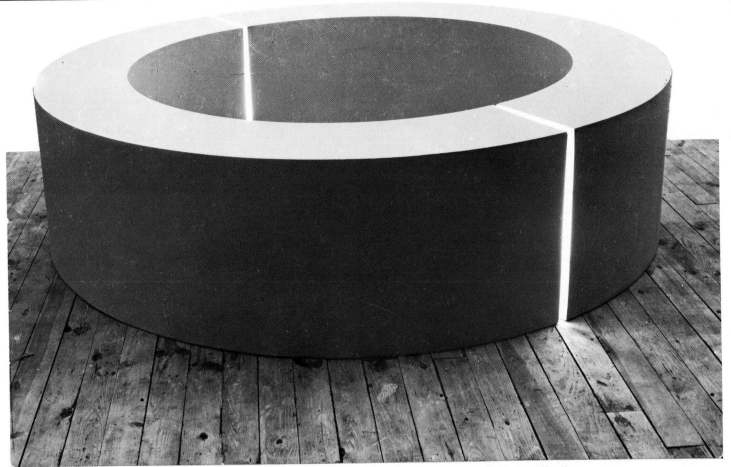

colour of the original material. In addition, many younger artists are using resins and glass fibre in new and exciting ways, and new approaches to the medium are still being developed.

MATERIALS

One of the main uses of resins and glass fibre is as a quick and relatively easy way of casting from moulds, in comparison with casting in metal. Fibreglass, as its name implies, is composed of thin filaments of glass, which are assembled with a bonding agent into various forms. The main forms of fibreglass are mats, which are flat pieces, tapes or strips, and loosely bonded strings of glass fibre, called rovings.

Resin itself is a by-product of oil. There are several types designed for different uses. Resins belong to the thermosetting group of plastics. The term 'thermosetting' means that the substances require some form of heat to enable them to be shaped or moulded. Unlike the plastics in the thermoplastic group, however, thermosetting plastics cannot be remoulded once they have set. The main resins used by sculptors are polyester resins and epoxy resins, the polyesters being the more popular.

RESINS

Polyester resin comes in a liquid form, which has the consistency of treacle. This is changed to a solid form by a chemical reaction, which is triggered by adding two other elements to the polyester resin. The first is called an accelerator and is usually the chemical cobalt napthanate.

The second is a hardener or catalyst, usually the chemical methyl ethyl keytone peroxide. Adding these two substances produces a chemical reaction, which, in about 30 minutes, changes the liquid into a gelatin-like substance. This period, during which the sculptor must work, is known as the gel-time. As the process continues, the material gradually becomes harder. Many factors control the setting time. These include the proportions of accelerator and catalyst, the bulk of resin involved and the amount of heat being chemically generated or applied. The change from liquid to solid is usually called 'curing'.

A wide range of polyester resins is available, but the most useful for sculpture are laminating and clear casting resins. Laminating resin is normally used in conjunction with glass fibre and built up in layers—laminated—to produce a shell-like cast. Clear casting resin, on the other hand, is usually poured into the mould to give a solid cast of resin without any laminated or layered reinforcement. Clear casting can be poured in bulk without the excessive heat build-up, cracking and discoloration which occur with laminating resin. This makes it more suitable for pouring into intricate moulds than laminating resin. Also, because of its transparent nature, clear casting should be used for embedding objects or specimens. Both types of resin can be used with inert powder fillers and pigments to give colour or texture. Powdered fillers tend to dissipate the heat, as well as strengthening the resin.

Cured resin is, by itself, rather brittle, but with the addition of glass fibre reinforcement, has a very good ratio of weight to strength. Its weathering properties are not, however, too good and so a filler, such as marble dust or slate dust, is

Above Robert Morris's *Untitled Work* in grey fibreglass made in 1965 has a diameter of 24in by 96in (60cm by 240cm). The clean lines of the moulded glass fibre follow his style of using each sculpture to embody a single, relatively simple plastic idea and his concern with primary structures. This sculpture both occupies and encloses space.

Far left John de Andrea's life-size couple (1978) uses cast vinyl polychromed in oil to achieve this very realistic and startling life-like effect. The vinyl provides the medium for a very literal expression by the sculptor and the colouring and tone of skin is carefully worked at to sustain the illusion of real life.

Bottom left *Modern Sculpture of Genghis Khan* by Philip King demonstrates the flexibility that can be achieved by working in resin and fibreglass. The thin head piece is balanced precisely on the conical form. The base projection manages to give an impression of molten liquid frozen in a moment of time. The work is painted in the bright primary colours that King often uses in his sculptures.

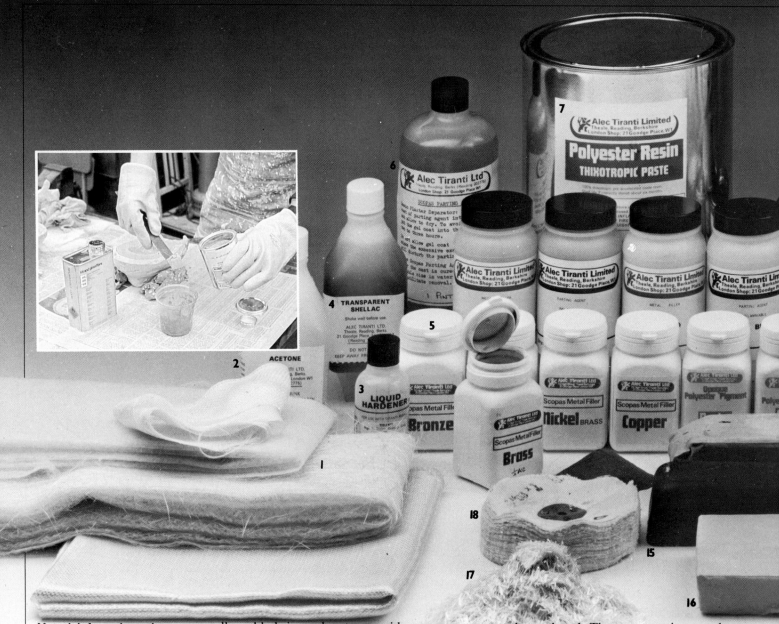

Materials for resin casting

Resin casting is a quick and relatively simple way of casting from moulds, but the attention to safety that must be exercised cannot be over-emphasized. When mixing resin solutions the manufacturers' directions must be followed exactly (**inset**). Failure to do so could be very dangerous. A wide range of the many materials necessary for the various stages of resin casting is displayed here: glass fibre mat (**1**), acetone (**2**), liquid hardener (**3**), transparent shellac (**4**), assorted metal fillers (**5**), parting agent (**6**), thixotropic paste (**7**), silicone mould rubber (**8**), wax parting agent (**9**), cleansing and barrier creams (**10**), curing agents (**11**), assorted powder fillers (**12**), tins of polyester resin (**13**), polishing compound (**14**), buffing compound (**15**), white wax (**16**), chopped glass fibre (**17**), polishing attachment (**18**).

normally added in order to provide a more resilient surface. Laminating resin is a greenish-grey colour in its natural cured state, another form of protection is to apply paint to it, which solves weathering and colour problems instantly.

Resin is resistant to most common solvents, but, before it is cured, it can be dissolved by acetone or hot water and detergent, although the latter demands vigorous rubbing. Once cured, resin stripper, which is a very strong, caustic-based, toxic substance, will dissolve it over a period of several hours. In general terms, resin and glass fibre are fairly permanent and resilient materials.

Most resins are already pre-accelerated, and therefore require only the addition of the catalyst to begin the curing process. The easiest method of estimating the amount of catalyst to be added is by judging weight and percentage. For a slow mix, 1 per cent of catalyst should be added giving a pot life—the period in which the mixture can be worked—of about half an hour. For a fast mix, this ratio can be increased to 2 per cent. A proportion of 1 per cent of catalyst is equivalent to 10cc per kilogram of resin. A graduated catalyst bottle or measuring device and a weighing scale will enable any amount of resin to be

correctly catalyzed. These proportions apply at a room temperature of 60°F (16°C). Changes from this temperature will slow or quicken the gel-time and pot life. The bulk of the resin involved also affects this, a thin layer will gel more slowly than a thick one.

The amount of resin needed for a particular cast can be estimated roughly. First, cut out glass fibre mat to cover the mould surface and weigh it. For the gel-coat, the weight of resin needed will be equivalent to one layer of 1½oz (42gm) glass fibre mat. For laminating, the amount needed will be twice the weight of the mat.

GLASS FIBRE

Glass fibre is produced in a variety of types, weights and forms. Rope, rovings and tapes are normally used for joining and reinforcing, chopped strand mat and woven mat are used for laminating. Whilst woven mat is normally stronger, chopped strand is more versatile for oddly shaped moulds. Different weights of chopped strand mat are available, the lightest being a surface mat, used for ensuring that sharp angles and corners, as well as intricate detail, are

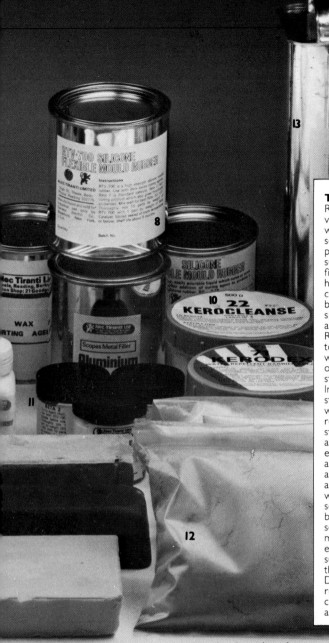

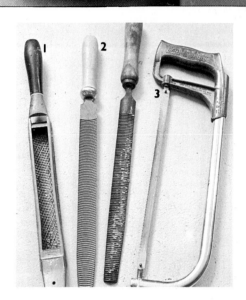

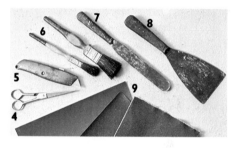

Tools for resin casting
Resin can be worked with a variety of tools, many of which are also used in other sculptural processes. Those pictured here are essential: surform (**1**), dreadnought files (flat and rounded) (**2**), hacksaw (**3**), scissors (**4**), craft knife (**5**), decorators' brushes (**6**), palette knife (**7**), spatula (**8**), tungsten carbide and wet-and-dry paper (**9**). Resin is easily removed from tools prior to gelation by washing in acetone. But once it has cured, a resin stripper must be used. Immerse tools in the stripper overnight and wash with water after the cured resin has dissolved. Resin stripper is caustic and toxic and so must be handled with extreme care. At the end of a casting session, wash out all brushes with hot water and detergent. A thin film of wax or oil applied to scissors, rollers and knives before use will help prevent seizure and clogging and make removal of resin easier. Clean casting surfaces daily and apply a thin film of wax to them. Dusting the interior of rubber gloves with French chalk will prevent them adhering to your hands.

impregnated. As a general rule, the heavier the mat, the more difficult it is to impregnate and the less flexible it is for bending around corners or over bumps. The mat is held together by a binding agent which dissolves during lamination, and most mats can be split to give thinner layers before casting, if required.

_ TOOLS AND THEIR USES _

Most tools needed for resin work are common to other sculptural processes, however several specialist tools may also be needed. A catalyst measuring bottle, made of plastic and calibrated, provides a clean, efficient and safe vessel for catalyzation and is relatively inexpensive. A casting table with a glass, melamine or galvanized steel top can be used for casting flat sheets or laminating geometric solids direct. It also provides a clean reuseable surface for general work. A thin layer of wax on the surface will enable cured resin to be cleaned off easily with a scraper. Specialist rollers can be purchased for laying up large, smooth flat areas. These consist of a set of round, washer-like units on a spindle which pushes the resin into the mat and forces out air.

Because of its smooth hard surface, resin is particularly suitable for spray painting. However, spray guns and compressors are expensive and, although useful for applying fast drying coats of cellulose primer and obtaining high gloss finishes, it also requires a great deal of experience and ability to be able to use them well.

Cured resin can be worked with a variety of tools, such as files, surforms, saws and abrasive papers. It is, however, a hard material and so direct working can be time-consuming. A metal hacksaw can be used for cutting straight edges, whilst a coping saw may be handy for irregularly shaped cuts. To avoid splintering when cutting, apply pressure and direction from the gel-coat side. Dreadnought files, abrafiles, surforms and other files suitable for metal work are all satisfactory for trimming and shaping. Filing at a slight angle will eliminate juddering and subsequent splintering. For finer shaping, coarse preparation paper and a range of wet and dry papers, which can be used with wooden or rubber blocks, are best. A sanding disc attached to an electric drill will swiftly remove surplus resin, but, for safety reasons, this work should be done outside or in an isolated place. It is also important to wear a mask during all these operations.

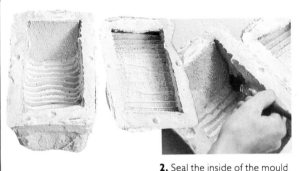

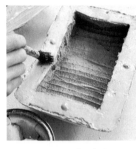

Using a plaster waste mould 1. First protect hands with barrier cream. Work on both halves of the mould as follows.

2. Seal the inside of the mould with two or three coats of shellac, giving it a tough, shiny surface.

3. When the shellac is dry, brush a thin, even layer of wax over the whole mould. Take care not to fill in the texture.

4. Apply a coat of separating agent over the wax shellac. The mould is now prepared for casting.

5. Measure a suitable amount of resin gel into a waxed paper cup. Stir in pigment and mix with a wooden spatula.

6. The percentage of catalyst to be added to the gel must be carefully calculated. Weigh the amount of gel in the cup.

Drilling can be done by hand or by power using bits suitable for metal. Solid resin may build up heat during drilling. Applying water will prevent this. On smooth surfaces, use a punch or a strip of masking tape to stop the bit slipping.

It is often necessary to join cured, moulded sections either permanently or temporarily. With a mould which has to be laid up in separate sections, the following procedure should be adhered to. Ensure that the seams of the cast are level with the mould seams, and that no resin or other deposits will prevent mould sections from meeting. If the interior of the complete mould is accessible when assembled, tie sections together and seal seams on outside with modelling clay. Fix a brush to a stick of suitable length. Pour a small amount of catalyzed laminating resin into the mould, and rotate it with the seam in a vertical plane. Apply pre-wetted pieces of glass fibre with the extended brush in order to strengthen the seam. If cast sections have to be removed from the mould, tape these together with masking tape around the seam and continue as above.

With a blind mould, where the interior cannot be reached, two choices are available. With small, compact moulds, mix up an appropriate amount of laminating resin and pour into one section. Fit onto the other portion of the mould, tie and seal quickly. Rotate the mould with the seam in the

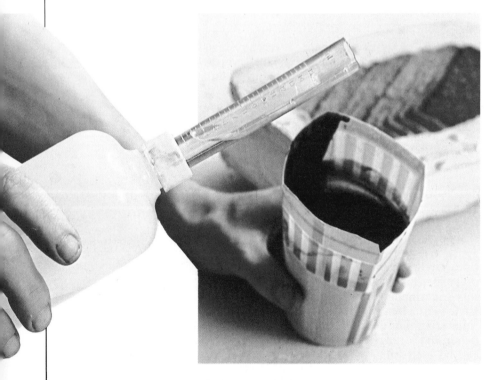

7. Measure catalyst in a marked bottle, 10cc per 2.2lbs (1kg) of gel. Pour it into the gel and mix it in thoroughly.

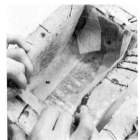

8. Apply gel coat all over the mould with a soft brush, making a thin, even layer. Leave for about half an hour to stiffen.

9. Apply fine surface matt to the gel coat while it is still tacky. Tamp the matt into all the mould surfaces.

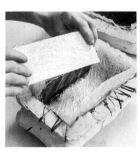

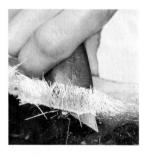

11. Lay in a layer of coarse chopped strand matt and press it into place. Wet it out with resin.

12. Allow the resin to harden slightly. With a sharp knife trim off matt standing above the edge of the mould.

vertical plane until the resin gels. To shorten the gel-time, use double the amount of catalyst. With larger blind moulds, the seams may require strengthening with glass fibre. This is achieved by cutting a strip of glass fibre about 1½in (3.8cm) wide and tacking the strip around the seam of one section, ensuring that only half the width of the strip is impregnated, while the other half stands above the seam. When the strip has adhered, follow the same procedure as for small blind moulds, ensuring that unimpregnated glass is pushed into the interior of assembled sections before they are tied and sealed. With more complex moulds, a combination of the above procedures may be needed. Try to anticipate possible joining problems when making and designing the mould.

Flat sections of resin can be joined by simply roughening the two surfaces, applying a layer of impregnated fibreglass and clamping them together until cured. With sections which join at a convex surface or where only a temporary joint is required, a bolting method should be devised. Bolts and other fittings are best located during the lamination process but may be added later. Special bolts known as 'big heads' can be purchased, or ordinary bolts with large washers, which disperse stress over as wide a surface as possible, should be used. Fix the bolts to the cured glass

fibre surface with several layers of fibreglass. A smear of wax applied to the threads will ensure that stray resin can be removed after curing.

Solid resin can be machined in much the same way as metal, turning on a lathe being perhaps the most common method. Excessive heat build-up may be dispersed by water or cooling fluid.

TECHNIQUES
PREPARING MOULDS

Moulds for casting resin can be made from a variety of materials. The mould must be moisture free, able to be sealed and prepared with separating agents, and capable of being removed from the finished cast. Plaster, wood, metal, glass fibre, cardboard, hardboard, vinyl mould compounds, glass and thermoplastics are all suitable materials. The choice of mould material depends on the nature of the mould required, and this, in turn, depends on the nature and numbers of the casts required to be made from the mould. Although individual moulds create individual problems, there are several basic types which should cover most eventualities.

Plaster Although plaster is convenient and quick, it has a high moisture content, is subject to warping, liable to breakage and very porous. The

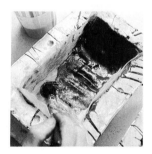

10. Catalyze laminating resin and brush it on, to wet out the matt. Eliminate any air bubbles in the resin.

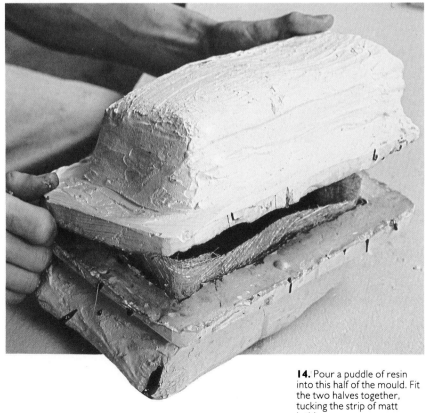

15. Tape up the mould and seal the seam. Revolve the mould so the resin inside wets out the remaining matt. Leave to cure.

13. Apply a strip of matt around one mould section half above and half below the top edge. Wet out the bottom half.

14. Pour a puddle of resin into this half of the mould. Fit the two halves together, tucking the strip of matt inside.

16. To release the cast from the mould, use a hammer and chisel to chip away the plaster. Clean off the finished cast.

Resin mould release procedure 1. Resin can be cast inside a resin mould. Wax and separator are applied before casting.

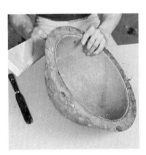

2. To release the cast first tap around the outside of the mould with a piece of wood to loosen the cast.

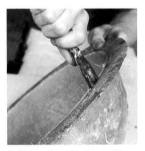

3. Slide a thin, flexible knife between cast and mould and work it around to free the edges.

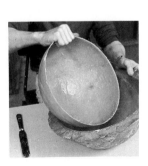

4. Following this procedure, you can grasp the cast and slide it easily from the mould.

construction and preparation of the mould are, therefore, of paramount importance. The mould should be as thin as possible in order to speed up drying, to minimize the possibility of reabsorption of moisture and to minimize the chance of warping. After removing the mould from the original, reassemble the sections and tie them together. Dry the mould until all the moisture has evaporated. To test this, scratch the mould with a fingernail, and, if the mould is dry, this will produce a dry powder and an irritating noise. The mould surface should be sealed with several coats of shellac, until a shiny surface results. Avoid any build-up of shellac in hollows, and ensure that the seam is also sealed. When dry, a layer of wax should be applied with a clean, dry cloth. If the mould is heavily textured, apply the wax with a brush. A coat of PVA release agent should then be applied with a sponge or brush to complete preparation. The release agent is water based, and, when dry, forms a thin covering like a plastic bag on the mould surface. Carefully applied, the shellac, wax and release agent should not affect the surface quality, even retaining fingerprints from the original. Polyester resin is a very efficient adhesive and, for example, penetration of sealer and separators will impair the final result.

Wood and metal moulds These are normally used to cast geometric shapes and are constructed directly as moulds. Care has to be taken that no undercuts occur, and that the mould is reasonably rigid. Complex moulds, which can be assembled and disassembled for access during lamination and for ease of removal of the finished cast, can be made using bolts. Any gaps should be filled with modelling clay. Wooden moulds require the same preparation as plaster, using shellac, wax and PVA. Moulds constructed from metal do not require sealing, and a layer of wax and PVA will effect a release. For larger moulds, which are to be used for repeated castings, it is best to construct compound moulds, using wood with metal surfaces.

Glass fibre and thermoplastics These require no sealing, and a release can be effected just using wax. However, if the casts are to be painted, a layer of PVA should also be used, as traces of wax on the finished cast create adhesion problems for most paints. Vacuum-formed thermoplastics usually require support during casting. Wooden cradles, to which the edge of the plastic can be stapled, prevent distortion and provide a firm mould surface.

Flexible moulds Any flexible moulding material can be used, providing it can withstand the heat

CASTING PROBLEMS

Condition	Reason	Possible cure
Shellac or plaster adheres to surface	Badly sealed mould. Damp mould. Uneven separator.	Immerse in warm water. Methylated spirit may dissolve shellac. Take down to surface with wet and dry.
Paint will not adhere to surface	Separator or wax on surface. Cast not fully cured.	Wash with water or acetone wet and dry surface. Leave cast to cure further.
Surface wrinkles	Laminate applied too soon. Gel-coat too thin.	Apply filler and work down.
Surface tacky	Mould not properly sealed.	Apply heat or wash down with acetone.
Surface blistered	Uneven setting of gel-coat due to uneven catalyst addition. Uneven wetting out of laminate, or damp brush.	Cut out affected areas, fill and work down.
Surface pin holes	Uneven or aerated gel-coat.	Fill and work down.
Surface cracks	Result of excess exotherm caused by over-catalyzation or too much resin.	Fill and work down.
Surface soft areas	Patches of dry laminate.	Cut out, fill and work down.
Surface colour uneven	Uneven mix of pigment and gel. Uneven application of gel.	Apply coat of pigmented resin to back of cast or paint surface.

MOULD PROBLEMS

Condition	Reason	Possible cure
Gel-coat not setting	No catalyst. Low temperature or damp mould.	Heavily catalyze and mix laminating resin into gel-coat. Apply heat.
Laminate not setting	No catalyst. Low temperature.	Remove and apply fresh laminate. Apply heat.
Gel-coat only slightly set	Too little catalyst. Low temperature or damp mould.	Laminate carefully, the exotherm from lamination should send off the gel-coat. Apply heat.
Laminate set but remains tacky	Over-catalyzation or too much pigment in laminate.	Clean with acetone, or apply coat of laminating resin.
Mould will not separate	Faulty mould, undercuts etc. Uneven separator or mould damp.	No problem with waste mould, with others cut mould to effect release. Immerse in warm water to dissolve separator and release vacuum.

generated during the gel period. The mould should be encased in a rigid jacket to prevent distortion during casting. No sealing or wax is required, but a thin coat of PVA will help prevent tackiness on the cast surface. These moulds are particularly useful for repetition casting of objects which involve complex undercuts or texture.

Cardboard and paper Moulds made from cardboard and paper should be prepared in the same way as plaster moulds. However, the nature of the material obviously limits the size for which these moulds are suitable.

Releasing the mould Plaster waste moulds are released in the usual manner, that is by breaking in some way. With plaster piece moulds, seams should be gently and evenly prised apart. If resistance is encountered, soak in warm water to dissolve the PVA. With wood, metal and fibreglass moulds, tap the exterior of the mould with a wooden mallet or stick to release the suction. Soaking in warm water may also help, as will a thin palette knife slipped between the cast and mould and then flexed. Flexible, glass and vacuum-formed moulds present no problems.

CASTING WITH LAMINATING RESIN

Before starting to cast, cut the mat to shape with scissors or a sharp knife, and place on one side. The first stage of the casting process is to apply the gel-coat to the prepared mould. This initial coat will form the surface of the cast, so great care must be taken. Estimate the amount of resin needed to cover the cast surface, and add fillers or pigments as desired, stirring gently but firmly until an even mix is achieved. Decant the amount to be used. Then estimate and add the appropriate quantity of catalyst. Stir the catalyst gently until it is thoroughly mixed. Violent agitation will cause the catalyst to splash and aerate the resin. Let the gel-coat stand for a minute to allow any air bubbles to disperse. Apply the gel-coat evenly to the surface of the mould with a brush, ensuring that undercuts are covered and no air bubbles are trapped. Disperse any pools of gel-coat with a brush, and leave to gel.

Wash brushes in acetone and dispose of excess resin. Check the mould during the gel process. If pools have reformed during gelation and heat build-up is occurring, a damp sponge on the area will help dissipate the heat, but remember to dry off any moisture before laminating starts. When the gel has set, lay the precut sections of glass fibre in place, overlapping the seam by around ½ inch (1.25cm). Estimate and catalyze the amount of laminating resin, and apply with a stippling motion of the brush until the glass fibre has

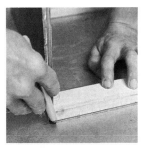

Laminating 1. Construct the frame to be laminated. Lay it on a waxed metal worktop and mark around the edge.

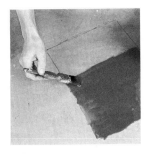

2. Mix up and catalyze resin gel. Brush the gel all over the marked area to form a thin layer. Leave it to harden.

3. Lay a sheet of chopped strand matt over the gel coat. Mix and catalyze resin and brush it into the matt.

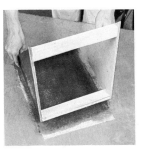

4. Place the frame squarely on the resin area and press it down firmly.

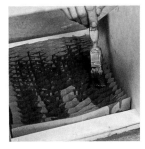

5. Add a reinforcing layer of expanded paper honeycomb, cut to fit into the frame.

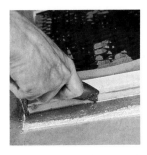

6. When the resin is partially cured, trim the shape with a sharp craftknife to make a neat, clean edge.

become transparent. Ensure that no air bubbles are trapped between the glass fibre and gel-coat, and that the mat has adhered to the gel-coat. If the mould has a heavy texture, small pieces of mat should be pushed into those areas. If the gel-coat has been left overnight, a thinly brushed layer of catalyzed resin will help the glass fibre adhere during impregnation. Successive layers of fibreglass may be applied without waiting for previous layers to cure, but care should be taken not to disturb or raise the initial layer.

Before the cast has completely cured, the excess glass fibre can be trimmed from the seam edge with a sharp knife. Reinforcing should be carried out at this stage using, for example, glass fibre roving, paper rope, honeycombed cardboard or prepared metal or wood structures. The cast should be left for as long as possible, but at least until the laminate surface is tack free. Premature removal will increase the possibility of distortion and warping.

Casting problems Most problems result from human error. Panics can be avoided by careful preparation. Ensure that tools, materials and solvents are assembled before casting is begun. Cut the fibreglass to shape before mixing any resin. Make sure that the casting area is clean, organized and well ventilated. Check that separation has been correctly completed, and ensure that the mould will not be stuck to the surface.

7. Leave resin to cure completely. When dry, slide a palette knife underneath to release it from the worktop.

8. A lamination of glass fibre resin is tough but lightweight and may be more suitable for smooth surface cover than wood.

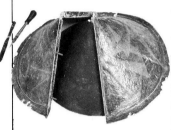

Bolted resin mould If a resin mould is constructed with an outer seam line standing away from the mould surface, it can be joined with small bolts through the seam. This makes it easy to release from the cast.

SOLID CASTING

Solid casting is sometimes a very good method of casting resin, especially if the mould is too thin or intricate for laminating or if a clear transparent cast is required. A thin or intricate cast can be achieved by impregnating the resin heavily with a powder filler, in order to dissipate heat and add strength, and by spooning and squashing the material into the mould.

For clear casts and moulds which require pouring, such as a waste mould of a quarter life-size figure for example, clear casting resin is preferable to standard laminating. The clear casting variety takes longer to gel and cure, and has been developed to produce less of an exotherm. This means that it can be used in quantities which with laminating resin would crack, smoke and discolour. The amount of catalyst added is, however, much more critical, and test pours should be tried first. The amount of catalyst can vary from 2 per cent for a peanut-sized object to 0.6 per cent for an object the size of a tennis ball. It should be possible to pour a resin block of about 22lbs (10kg) weight in one pour with the clear casting resins now on the market. Shrinkage of about 8 per cent in volume usually occurs, and exposed surfaces tend to remain tacky. This can be av-

oided by placing a melamine sheet over the surface after pouring.

Preparation of moulds is the same as for laminating resin, as are removal procedures. Pigments and powders can be added before catalyzation if required. Ensure that the prepared mould is level and firmly supported before starting to pour. Having poured the resin, agitate to help trapped air escape, and leave to cure. If excessive heat build-up is noticed after gelation, place the mould in water or in a fridge to reduce the heat.

With transparent casts, embedding objects or samples and so on, problems of cracks and discoloration may occur due to over-catalyzation or excessive volume. There is unfortunately no formula to guarantee perfect results, as each individual mould will present different problems. With larger volumes, pouring can take place over a period of time, allowing each layer to cure before the next is added, until the total mould capacity is reached. When cured, the resin can be treated in the same way as laminating resin, and transparent castings can be polished and buffed to give the same appearance as clear perspex.

BUILDING UP DIRECT

Although primarily a moulding material, resin and glass fibre shapes can be built up direct, using an armature covered with chicken wire, units made of wood, cardboard, expanded polyurethane or papier-mâché. Working direct involves reversing the order of the casting process. The fibreglass is applied first, the shape defined and finally the surface is resolved and finished. This method is generally best reserved for shapes where surface definition is not critical, as fibreglass in its cured form can be difficult to work. Sheets of material, cloth or hessian can be impregnated with laminating resin and draped or hung until cured. With areas over 1 foot (30cm) square, a supporting layer of fibreglass may be needed to add rigidity.

FINISHING

There are two main categories of finish—those applied before curing and those applied after. The first requires a decision before the casting process begins and is always integral to the gelcoat. Powder fillers such as chalk, china clay and talc can be used to apply a heavy gel-coat, which can then be worked and sanded back after curing. Slate powder, marble dust and other hard powders will give the gel-coat better weathering properties. All powder fillers must be inert, and, as a rule, require extra catalyzation. Metallic filler powders, such as bronze or aluminium, which are

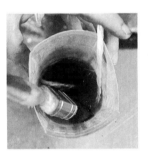

Reinforcing 1. Cut lengths of glass fibre roving and soak them in catalyzed resin.

2. Apply roving around the inner edges of a cast to add strength and rigidity. Use a brush to settle it in place.

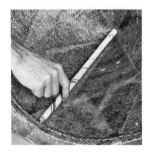

3. Additional support can be made using rolls of newspaper. Cut a thin tube of paper to length and lay it into the cast.

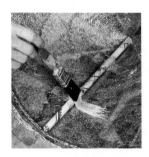

4. Put small strips of chopped strand matt across the paper. Wet it all out with resin and leave it to cure.

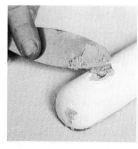

Finishing 1. Pick up filler on a spatula and smooth it into a hole or dent in the surface of the cast.

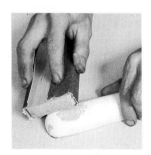

2. Allow the filler to dry and rub it down with coarse tungsten carbide paper. Finish it smooth with fine carborundum paper.

added to the gel-coat, give a metallic finish to the final cast. The amount of powder in the gel-coat will determine the degree of likeness to the real substance, and, because of the resulting density of the gel-coat, you should make sure that it is catalyzed throughout.

After removing the cast from the mould, the surface should be rubbed over with wire wool and then burnished to bring out the shine on the metal fragments suspended within the resin. Coloured metal flakes, available in a wide range and combination of colours, can be added to the gel-coat to produce a glittery surface on the final coat. Coloured pigments, both opaque and translucent, may be bought ready suspended in resin. These can be added to the gel-coat to give the cast inbuilt colour. This should be added to the resin in a proportion of 1:14 prior to catalyzation. Keep behind some uncatalyzed gel-coat for repairs after removing the cast from the mould. The cast can then be polished with rubbing compounds, colour-restoring car polishes and wax polish.

If a finish is to be applied after curing, the following general preparations should be followed. Remove all traces of the release agent with warm water and detergent, wash with clean water and allow to dry. Gaps and holes can now be filled with a plastic filling compound, and, when set, worked down to the cast surface. To ensure that the cast has a key, rub with fine wet and dry paper.

A vast range of paints is available, and most are suitable for use on resin. The type of paint should be chosen to give the desired finish. Generally for a high gloss finish, synthetic enamels, polyurethane or acrylic lacquers and cellulose car paint are the most common. For matt finishes PVA water-soluble paints, emulsions, matt cellulose or synthetic eggshell paints can be used. Gloss finishes can be taken down to matt by applying a matt polyurethane varnish. Having decided on the type of paint, a suitable undercoat can be applied and smaller holes filled and

worked down. For high gloss finishes, a cellulose primer can be applied with a spray gun, and pinholes filled with cellulose putty, prior to adding the top coat.

After the paint has set, the application of rubbing compound, colour restoring polish and wax polish will give a high gloss surface as on an automobile. For less high finishes, synthetic and water-based paints may be applied with a brush. The paint surface is only a thin skin and will faithfully reflect the surface underneath. Therefore, for a high gloss finish, a smooth surface is needed, usually achieved by working through several grades of wet and dry paper.

Above Eva Hesse's *Repetition 19, III* (1968) is a collection of 19 tubular fibreglass units. They are between 19in (48cm) and 20in (50cm) high by 11in (28cm) to 13in (33cm) in diameter. Unlike much of the sculpture in resin and fibreglass she is aiming at an organic effect, rather than the clean-cut precise lines often identified with this medium.

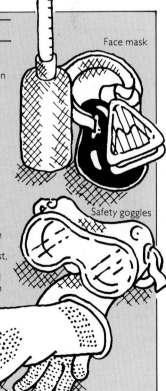

WOOD

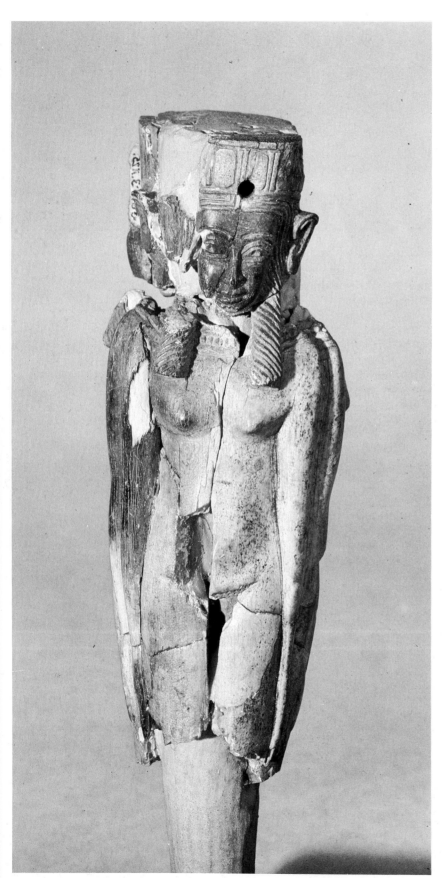

HISTORY

Accessible, light, easily worked and replaceable, wood is an essential element of basic survival—the weapon, shelter, fuel. As a substance, wood is part of man's history. With the discovery of metal and its subsequent development, tools for working wood became more sophisticated. These tools widened the range of structural possibility—stronger boats, bigger roofs, spoked wheels. With the availability of the material and the tools for shaping and joining it, the circumstances were ever present for their use in making images.

Wood and stone have always been the traditional materials of sculpture, owing to their natural abundance all over the world. Since wood carving is a less daunting task than stone carving, it has probably been more common, but few examples survive from early civilizations, since wood is not as durable as stone.

In areas where the climate is dry, wood carvings have been preserved. Several small sculptures have been found from Egyptian tombs, these either commemorate important people or

Left This figure of a woman with a crown made of wood and ivory is an example of an early wooden sculpture which has survived the ravages of time. Wood is a much less durable material than stone, for example. Some of the simple surface detail on the face, crown and hair is still visible.
Above The frozen tombs at Pazyryk in the Soviet Union have yielded many fascinating objects which are extremely well preserved. The tombs gave a picture of the life of nomadic peoples from the third millenium on. This small wooden table has roughly carved legs with some surface detail. It dates from the fifth century BC.

Far right Wood carving is one of the world's oldest sculptural practices. This carved figure of the Buddhist 'saint' Lohan shows great naturalism in the facial features. The belt and robe are also fairly sophisticated in their approach.
Right Tilman Riemenschneider was an acknowledged master of wood carving in Germany during the fifteenth century. This group of figures is entitled *Three Helpers in Need*. The relationships between the figures, the many different surface textures and the complex folds in the robes show the artist's great skill.

depict on a small scale the day to day occupations of the slaves of the dead person. The small carved figures are brightly painted to make them more complete and life-like. Their purpose was to ensure that the master or mistress received the same services in the after-life as he or she had been supplied with on earth.

Brightly painted wood sculptures are not a peculiarity of early or primitive civilizations. Until the Renaissance, it was customary to paint sculpture, and many of the early European masters of painting turned their hands to decorating a wide variety of carvings.

Some of the richest examples of wood sculpture come from the tribal cultures of Africa, South and North America, the Pacific Islands and Australasia, including various stylized carvings for use in religious rites and ceremonies. Masks, figures and totems exist from many historical periods, often heavily decorated or bearing traces of their original colours. The forms and design of the sculptures belonged to traditions handed down through generations. In Nigeria, terracotta heads have been found of a design which suggests that the style originated in wood carving and was translated into another medium.

The craft of wood carving has been widely used in making furniture and in association with building and construction techniques in many different cultures. The Mayans decorated the wooden framework of their temple buildings with intricate relief patterns. Simple wooden boats were carved by the Romans and a tradition of carved decoration has lasted through many modifications of design and function. Furniture such as tables, chairs, beds and storage chests have been beautified with much imaginative imagery, from scenes and figures to simple engraved patterns. Particularly fine examples come from China, a country with a great heritage of art and craft. Wood carving has often been combined with gold or silver inlays for a luxurious effect.

The close connection between sculpture and religious architecture gave rise to a period of outstanding sculpture in wood in Northern Europe during the fifteenth and sixteenth centuries. The German artists Michael Pacher (active c1465–1498), Tilman Riemenschneider (died 1531) and Veit Stoss (c1450–1533) carved the most beautifully intricate altarpieces and relief

Above The statue of St Mary Magdalene by Donatello was one of the artist's latest works. It is very expressive, combining subject matter and technique. The folds of the robe contrast starkly with those of the Riemenschneider piece.

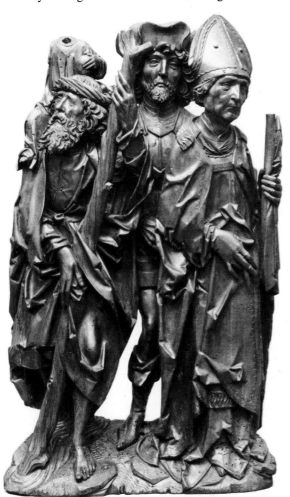

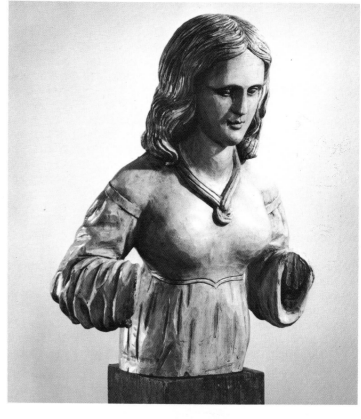

decoration for churches, as well as small figures of biblical characters. Some of these are extraordinarily complex compositions. Both Stoss and Riemenschneider eventually abandoned the tradition of painting wood and allowed the rich, natural qualities of the material to remain visible.

Without doubt, wood carving was widely practised in Europe in the centuries following the Renaissance, although many of the major sculptors of this period are best known for work in stone, or modelled forms. Much excellent work was done in decoration for architecture and furniture. Grinling Gibbons (1648–1721) worked in many locations in England on decoration for churches and private houses, and much of his work can still be seen.

The twentieth century has seen a number of artists favour wood as a material, despite the range of new possibilities in technique which has appeared in plastics, resin and metal welding. Constantin Brancusi (1876–1957) refined his carved sculptures into abstract shapes seeking the essential form of human and animal subjects, later moving into pure abstraction. In addition to using wood as a material for finished sculpture, he often mounted stone sculptures on specially designed wooden bases, and made wood prototypes for sculptures finally made in stone or metal.

The British artists Henry Moore (born 1898) and Barbara Hepworth (1903–1975) have de-veloped their monumental style of abstract sculpture in wood. Both artists have been occupied with the relation of space and mass, often on a grand scale, carving large, curving sculptures with deep depressions and holes passing right through the form. The rich colour and grain patterns of the polished wood give each sculpture a unique surface quality.

Wood readily lends itself to construction techniques, whether pieces are simply glued together, jointed with the traditional techniques of carpentry, or bolted in large sections. Artists exploring Cubist principles of form, such as Picasso (1881–1973) and Frenchman Henri Laurens (1885–1954) made wooden reliefs and free-standing sculptures with jutting, angular planes, interpreting a new vision of volumetric description. Surrealist artist Hans Arp (1887–1966) made a series of painted reliefs in wood, simple forms in vivid colours, based on the organic shapes of natural objects. The American sculptor Louise Nevelson (born 1899) creates reliefs like huge modern day altarpieces, often incorporating preformed wooden shapes, such as chair legs or banister rails. The simple idea of stacking wood, as in a builder's yard, forms the basis of large sculptures by the American artist Carl André (born 1935). Interlocking stacks of wooden beams form a satisfying, symmetrical form in which the true nature of the material is completely undisguised.

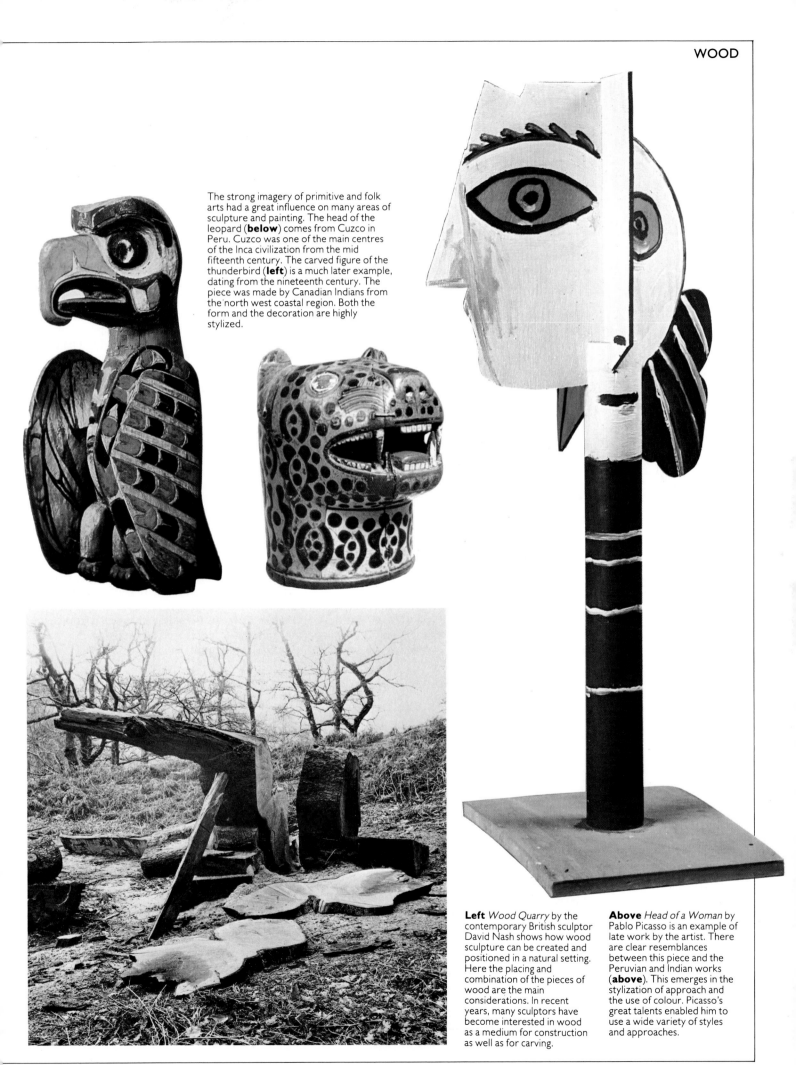

The strong imagery of primitive and folk arts had a great influence on many areas of sculpture and painting. The head of the leopard (**below**) comes from Cuzco in Peru. Cuzco was one of the main centres of the Inca civilization from the mid fifteenth century. The carved figure of the thunderbird (**left**) is a much later example, dating from the nineteenth century. The piece was made by Canadian Indians from the north west coastal region. Both the form and the decoration are highly stylized.

Left *Wood Quarry* by the contemporary British sculptor David Nash shows how wood sculpture can be created and positioned in a natural setting. Here the placing and combination of the pieces of wood are the main considerations. In recent years, many sculptors have become interested in wood as a medium for construction as well as for carving.

Above *Head of a Woman* by Pablo Picasso is an example of late work by the artist. There are clear resemblances between this piece and the Peruvian and Indian works (**above**). This emerges in the stylization of approach and the use of colour. Picasso's great talents enabled him to use a wide variety of styles and approaches.

MATERIALS
THE TREE

Before describing the ways and means of shaping wood, it is important to give an account of its origin—the tree. Each tree is peculiar to its particular species and location. Every year a tree covers its entire surface area with a new layer of fibre. The material for this fibre is produced by the paper thin cambium layer on the underside of the bark. The fibre gives wood its tensile strength and conveys water and nutrient from the earth to the leaves for photosynthesis and returns them as food to the cambium layer.

Trees growing on their own tend to spiral their fibre more than trees growing together where they develop a group strength against the wind. The timberman will watch for factors such as soil type and land drainage when selecting trees to fell and process.

Living wood is full of moisture. Once the tree is down and ceases to function as a living entity it begins to lose this moisture and shrinks. The extremely important process of controlling this drying out is called seasoning.

SEASONING

The purpose of seasoning wood is to produce timber of uniform and stable moisture content which will 'move' (crack or warp) as little as possible. Cracking, which is also—picturesquely—called heartshake, occurs along the grain of fibre when moisture is not leaving the wood evenly, but this cracking does not weaken the timber as it is 'with' the grain.

Other than pulping for paper, most wood is destined for the building and furniture trade and accordingly is sawn along the grain into planks of various thickness. Air dried or kiln dried, the timber is stacked with chocks separating each plank to allow air to circulate evenly. The stacks are sometimes weighted on top to prevent warping. When seasoning wood, which is planked or in the round (unplanked), allow a year for each inch (2.5cm) of thickness.

Air dried means that the wood should be stacked outside under a simple roof—a piece of corrugated iron supported on legs would do—somewhere where air circulates. When the wood is seasoned, store it inside an unheated shed. As a general rule, the bark should be removed, as bugs and fungus like to thrive in the damp area between the wood and the bark.

Even when seasoned, wood retains a certain amount of moisture and remains sensitive to its environment. Even centuries-old wood will open up in central heating. The cracks usually close up again in normal humidity. If kept in a moderate environment, wood will stabilize to that environment. Natural wood is not an inert substance and this must be accepted before using it in any way as a sculpture medium.

Right A tree grows thicker gradually by an annual process in which a new layer of fibre is laid down beneath the bark. Cells on the underside of the bark, known as the cambium layer, produce the new fibres. As the subsequent layers grow, the innermost section of the tree is subject to chemical changes, which may also change its colour, and forms the heartwood. The living wood, or sapwood, which is the most recently formed part of the tree, provides vitality by conducting moisture and nutrients through the fibres to the leaves and acts as food storage for the cambium layer. If the growth of the tree is uninterrupted, the process is hardly visible in the section of the wood. But if the tree is inhibited by unfavourable climatic conditions, in winter for example, growth rings appear which indicate the pattern of the successive layers of new fibre.

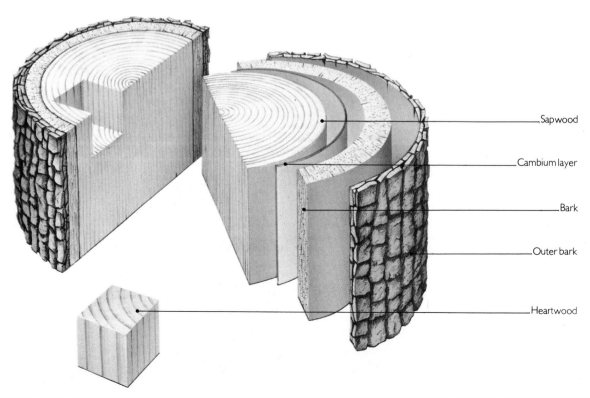

Sapwood

Cambium layer

Bark

Outer bark

Heartwood

Bark is sometimes enclosed between two limbs of a tree (**2**) which become merged as the new wood grows. In this close up picture (**3**) a dead section of bark is wholly encased in the more recent growth.

When a branch is pruned, it should be cut off close to the base. The small area of dead wood is covered by new growth in the fibres (**7,8**) and although this may form a bulge, the new wood is quite sound.

Crystalline deposits may occur in wood fibres (**6**). These are formed by the precipitation of mineral salts drawn up from the soil through the roots and fibres of the tree. The deposits are usually microscopic, but if enlarged, they can be a hazard when wood is sawn.

Growth of wood The fibres of wood tend to grow straight, in line with the vertical axis of the tree, and this forms the grain pattern. However, spiral grain (**1**) is found in many species. The twisting of the fibres causes the timber to split down the grain.

Knots form in timber at the base of a branch. The branch develops naturally from the wood fibres (**4**), distorting the grain. When a branch dies, the knot of dead fibres becomes loosely encased in the living wood (**5**), and may fall out when the timber is cut and dried.

___ SOURCES OF WOOD ___

Foraging in demolition sites, old houses, barns, and factories can provide you with heavy beams, floor boards, or banister ends. Furniture restorers often have good pieces in their junk heaps. Even fire wood stacks yield the odd piece of oak, cherry or pear.

Forage for unseasoned wood as well. If you see a fallen hardwood tree in a field, find out whose it is and ask for a piece of it. Tree surgeons who lop urban trees and local park departments are good sources. People handling and clearing such wood are usually sympathetic to the idea that it will be used creatively. Build up a stock, stack it so air can circulate around it and forget about it. It will season in time, and you can keep adding to the stock whenever you come across likely pieces.

Buying is another obvious way to obtain wood. Blockboard, plywood, chipboard and hardboard are made to be inert and consistent. Manufactured generally in standard sizes, these boards can be bought from timber merchants. 1in (2.5cm) to ½in (1.25cm) thicknesses make a rigid, flat plane. Thin ply and hardboard are good for a cladded, curved surface and for laminating a bend.

Oak, lime, beech and foreign hardwoods can be bought in the round from some timber merchants. Always try to talk to the foreman and say exactly what it is for, to ensure that you get a suitable piece. Building timber such as pine is widely available.

Left If the space is available, a stock of wood can be stored in the studio as it is acquired, giving greater scope for sculpture than ready-cut timber or boards. Lengths of wood should be stacked horizontally and not subjected to excessive heat or dampness.

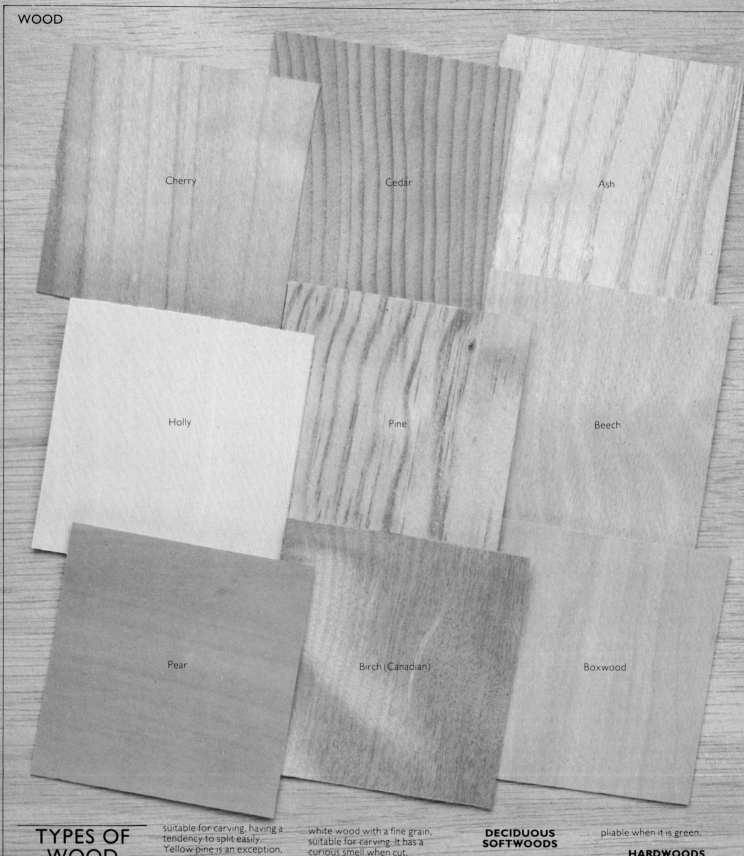

Cherry

Cedar

Ash

Holly

Pine

Beech

Pear

Birch (Canadian)

Boxwood

TYPES OF WOOD

CONIFEROUS

Cedar This close grained wood is light and easily worked, but is durable for outdoor sculpture.
Columbian larch, pine, spruce (deal) These are soft woods with a pronounced grain. In general use in the building trade, they are useful for construction work, but not suitable for carving, having a tendency to split easily. Yellow pine is an exception, and is a good carving wood.

FRUIT WOODS

Apple A close-grained hard wood, apple is white when fresh, but dries to a reddish colour. It is easily workable in carving.
Cherry Cherry is a traditional carving wood, used particularly for relief work. It has a lovely, red-brown colour.
Holly This is a smooth, hard white wood with a fine grain, suitable for carving. It has a curious smell when cut.
Pear Pear wood has a range of colours from light red to strong yellow. It is even-textured, close grained and moderately hard.
Plum The grain of plum wood is quite distinct and the colours range from pink to dark red. It is hard, but not difficult to work. All fruit woods are good for carving, but, since the trees are relatively small, they cannot be used for large-scale work in one piece.

DECIDUOUS SOFTWOODS

Alder The alder is a small tree and the wood is light and easily carved. It has a reddish colour and indistinct grain, but, because of its composition, is not suitable for splitting along the grain. It is used for making clogs.
Birch The bark must be removed when seasoning birch. It is a white wood with a soft, indistinct grain, and rots quickly outside.
Hazel The hazel is a small tree, and the wood is very pliable when it is green.

HARDWOODS

Ash Ash is a white wood which seasons very hard and is resilient in its length. It is easy to split when green and, being durable outdoors, it is excellent for constructions which take stress. It is also used for the handles of metal tools.
Beech This wood is soft when green and splits easily, but is quite hard when seasoned. It has a light brown colour. Beech, which is often

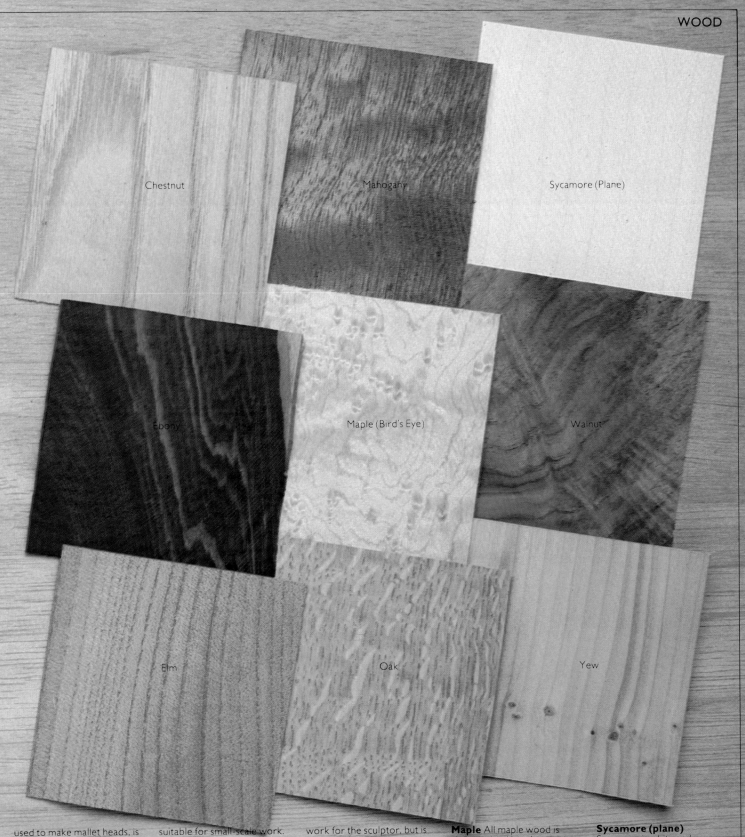

Chestnut

Mahogany

Sycamore (Plane)

Ebony

Maple (Bird's Eye)

Walnut

Elm

Oak

Yew

used to make mallet heads, is not suitable for outdoor sculpture.

Boxwood This is excellent for small, delicate works as it is very hard and dense with an indistinct grain. Boxwood is also the best choice for a chisel handle.

Chestnut A durable wood which splits well whether green or seasoned, chestnut is strong in the length but has a tendency to split. It is mid-brown, with distinct grain and takes a finish well.

Ebony Ebony is a very hard wood, black and dense,

suitable for small-scale work. It is hard to come by and the splinters can be poisonous, so it is not a good choice for a beginner.

Elm Elm is a dark reddish-brown wood with an interweaving grain. It resists splitting but tends to warp during seasoning. It is long lasting outdoors if wet—Roman drainage pipes of elmwood are still found intact and functioning.

Greenheart This wood is so dense it will not float and is used in the construction of dock piers. It is difficult to

work for the sculptor, but is very durable.

Lime (basswood) This is a very suitable wood for carving. It seasons well and has an indistinct grain and light yellowish colour. It is a particularly good choice for relief carving but is not tough enough for outdoor display.

Mahogany This wood has a low moisture content when seasoned and tends to splinter if carved across the grain. However, it is suitable for carving, if the tools are kept very sharp. It has a rich, reddish-brown colour.

Maple All maple wood is close-grained but the texture varies. The range of colour, from light to red-brown, gives a good finish.

Oak The heart wood of oak is durable in all conditions, seasoning hard and continuing to harden in time. The sap wood is usually removed before carving and must not be used in construction as it has no strength under stress. The sap wood is easily distinguishable from the heartwood as a yellow layer. The heartwood is suitable for both construction and carving.

Sycamore (plane) Sycamore is white and moderately hard. It resists splitting but rots quickly outside. It can be difficult to work but is obtainable in large pieces.

Walnut This is an excellent carving wood, dark brown in colour. It has a rich grain and is much sought after as a veneer, so it is expensive and difficult to obtain.

Yew Yew is hard and durable with a distinct grain. The colours vary from light yellow to strong reddish-brown. In carving, it gives a good finish.

TOOLS AND EQUIPMENT
CUTTING AND CARVING TOOLS

Tools for shaping wood are designed and used, observing the linear structure of the grain. Each has a particular function related to its shape, size and weight.

Wedge The wedge has a tapered edge and is designed for splitting lengths of wood along the grain. A heavy metal hammer (sledge or lump hammer) is used to drive in a metal wedge and a wooden maul or beetle for wooden wedges. Most unseasoned wood will split easily, but elm, sycamore and knotty pine are rather resistant. Oak, ash, beech and chestnut split readily.

Wedges should not be too sharp, they part the fibres rather than cut them. Wood shaping tools are all a development of the wedge.

Axe The axe is simply a sharp wedge with a handle. The weight applied is the weight of the tool itself multiplied by the length of the handle. The difference from the wedge is that the axe will cut across the fibre. The first cut is made diagonally down the grain, subsequent cuts are made sharply across.

There are different sizes, weights and styles of axe head and different lengths of handle. It is important to be comfortable with the tool and to be able to use it without tiring. Big felling axes are too heavy: it is better to use a trimming axe with a 3½lb (1.5kg) head and a 30in (75cm) handle, and a 2lb (1kg) hand axe with a 12in (30cm) handle.

Adze The adze is an axe with the cutting edge on a different plane. It was originally designed for boat building, shaping curved beams and boards. The craftsman stood astride the wood, skilfully shaving it to the required thickness. Do not attempt to use the heavy long-handled adze. Without proper apprenticeship, it is all too easy for a glancing blow to chop into your foot. The smaller short-handled adze, similar in size and weight to a hatchet, is very useful and much safer. It is a form of crude chisel striking into and shaving the wood. Gouge blades can be used. African sculptors use the adze almost exclusively.

Chisel The chisel is the most versatile and precise wood shaping tool. Carpenters' flat chisels are the most useful for general work, with cutting edges ranging from 2in (5cm) to ⅛in (3mm). The flat chisel is designed both to cut across and shave along the grain.

Do not attempt to remove too much wood with each chisel cut. The chisel can behave like its ancestor, the wedge, and split along the grain.

Gouge The gouge chisel has a curved blade and can do the jobs a flat chisel cannot, such as carving a concave surface or cutting a shallow surface line. For engraving a surface a V-shaped chisel is used.

Gouges come in a variety of curves and widths, with straight or curved shafts. Curved shafts are useful in cutting awkward surfaces round and through a hollow.

Plane The plane is a wide chisel blade held at a particular constant angle for shaving a flat surface, useful for construction work and for preparing pieces to be joined flush.

Draw knife This is a long, sharp cutting edge with a handle at right-angles to the blade at each end. The weight applied is the sculptor's own weight by drawing the tool towards the body. This is less dangerous than it might appear because the arms cannot pull back far enough to allow the blade to reach the body. The draw knife is for shaping, by shaving along the grain, and is especially useful for green wood.

Spokeshave A small version of the draw knife, the spokeshave is useful for cleaning and smoothing the surface of wood, as well as shaping it. It is quite a small tool and can be used on a flat or curved surface.

Files A file is a bar of metal with a roughened surface, attached into a smooth handle at one end. It is flat on one side and curved on the other. It is a heavy abrasive tool for evening and rounding the surface of the wood. A completely round file is designed for work on awkward or partially enclosed surfaces.

Rifflers Rifflers are essentially small files on long narrow shafts. They are shaped for work on delicate or complex forms. Rifflers are available in a wide range of sizes.

Sandpaper Abrasive papers come in various grades, from very rough to very fine, and are used to achieve a perfectly smooth finish.

Handles Metal tools have wooden handles for several reasons. As opposed to metal, wood is more comfortable, light and warm to hold. Ash and hickory are good for axe, adze, hammer and mallet handles, being resilient in the length. Beech and boxwood make good chisel handles. To give chisel handles a longer life put a metal ring round the wood, just below the end, so the mallet hits wood and not metal. A piece of narrow copper piping or a length of wire wrapped round and twisted tight will keep the grain of the handle together.

SAWS

The most effective way to cut across wood grain is with a saw. This effectively consists of a row of tiny chisels set at the edge of a plane of steel. This

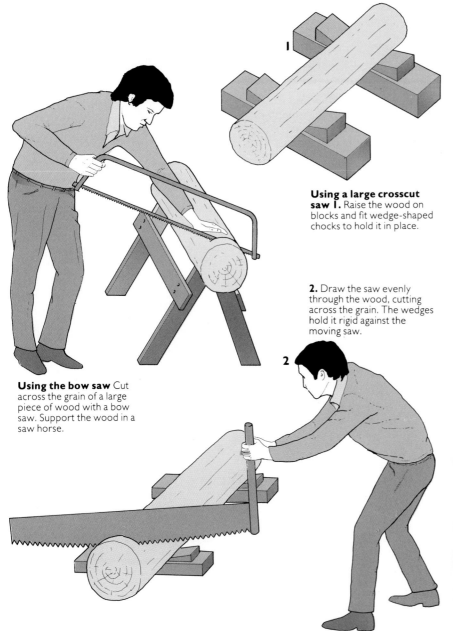

Using a large crosscut saw 1. Raise the wood on blocks and fit wedge-shaped chocks to hold it in place.

2. Draw the saw evenly through the wood, cutting across the grain. The wedges hold it rigid against the moving saw.

Using the bow saw Cut across the grain of a large piece of wood with a bow saw. Support the wood in a saw horse.

is set in a wooden handle, for manual use, or attached to a motor for extra power.

Long saw A saw with a long blade (5ft/1.5m) and a handle at each end is pulled, never pushed through the wood, and is used on heavy timber.

Bowsaw This is particularly useful for rough cuts. Hard-tipped replaceable blades are very sharp and give good service. Throw the blade away when it becomes blunt. The bowsaw is designed for unseasoned wood but cuts seasoned timber just as well.

Crosscut A seven-point crosscut saw in invaluable. A seven-point saw has seven teeth per inch (2.5cm). Buy a good one and it will last a lifetime. A crosscut is less effective on unseasoned wood, but is excellent for general construction work. The teeth are set and angled to cut across the wood grain.

Ripsaw The teeth of a ripsaw are set differently from those of a crosscut, as the ripsaw is designed for cutting down the grain.

Tenon saw This is a fine-toothed saw, 12 points to the inch (2.5cm), with a thick metal support along the top edge of the blade. The tenon saw has precision in cutting either across or down the grain.

Fretsaw The fretsaw is for cutting out curved or angular shapes from board. It has a narrow blade, set in a metal frame, and is easily manoeuvred through the wood.

Bandsaw This is a narrow, power-driven blade, fixed into a heavy, stable support. The bandsaw is able to cut through hardwood boards up to 4in (10cm) thick.

Jigsaw This is another power tool with a narrow blade fixed into a machine casing. The radius of

Saws The best way to cut wood across the grain is with saw. A useful selection for many different tasks would include a chainsaw (**1**), bow saw (**2**), ripsaw (**3**), crosscut saw (**4**) and a tenon saw (**5**). The teeth on saw blades are set for specific functions. This picture shows the teeth on a tenon saw (**6**), crosscut saw (**7**) and ripsaw (**8**).

Tools for wood

There are literally thousands of tools which can be used when working with wood. Their functions are always related to their weights, shapes and sizes. Modern power tools which made work much easier include the electric drill (**1**) and the electric jigsaw (**2**). Surforms (**3**), various files (**4**) and rifflers (**5**) are all used for smoothing surfaces. For combining materials, socket spanner sets (**6**), screwdrivers (**7**), wrenches (**8**), coach bolts (**9**), studding (**10**), screws (**11**) and coach screws (**12**) are often used. Wire nails (**13**) and oval nails (**14**), pincers (**15**), the ordinary hammer (**16**), the ball hammer (**17**), pliers (**18**) and claw hammers (**19**) are also used for this purpose. Construction work often involves the use of polyvinyl acetate adhesive (**20**), dowels soaked in linseed oil for outdoor work (**21**), natural dowels (**22**), a template for making dowels (**23**), and augers (**24**)—with handles fitted (**25**) or with a brace (**26**).

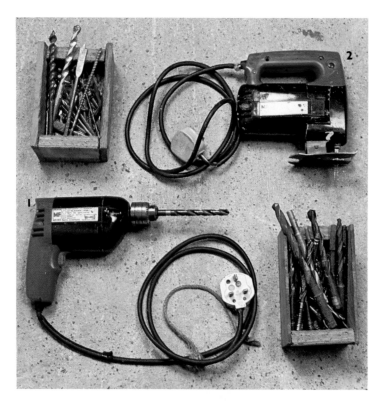

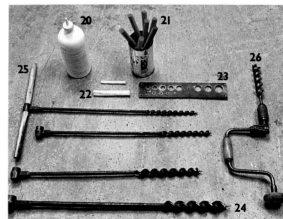

cut is not restricted by a supporting pillar as is that of the bandsaw.

Electric chainsaw The chainsaw is useful in the studio as it is relatively small, light and quiet. It must be used thoughtfully and carefully as a power-driven blade is always dangerous. It is used to remove large areas of wood quickly. The speed can lead to overzealous cutting and disrespect for the wood.

A petrol-driven chainsaw is used for cutting sections from a tree where it lies, in a field or wood. It can make certain cuts, such as boring through the wood, that other saws cannot, but it is noisy and dangerous, and gives off unpleasant fumes.

Bench circular saw A circular saw is power driven, and used for ripsawing along the grain. It is no use in carving, but helpful in construction work where wood is often used in its length rather than mass. It is set in a robust frame and has adjustable guides for angled cuts. Again, it is potentially very dangerous and should be used with care and respect. Attachments to convert a hand-held power drill to make a circular saw are sufficient for the home craftsperson, but no substitute for the fixed machine in the studio.

MALLET, MAUL AND BEETLE

These are important carving tools which will soon become close friends. Lignum vitae makes the best mallet, being a heavy oily wood with a close,

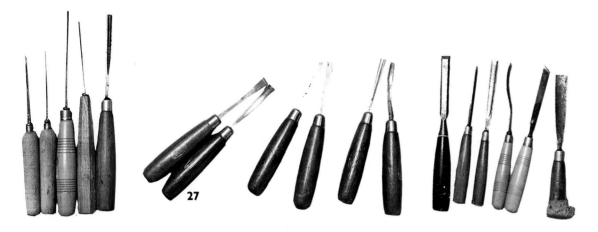

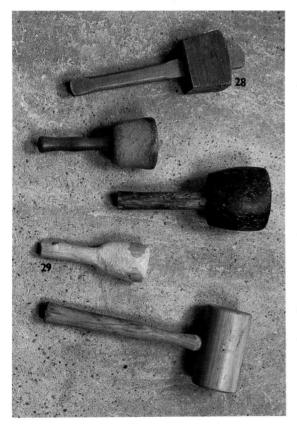

The most versatile wood carving tool, the chisel, comes in an enormous range of variations; the most useful have cutting edges which are flat, U-shaped or V-shaped (**27**). The shape and size of the cutting edges varies according to the purpose of the tool. Mallets, also available in a wide range (**28**), are also vital for carving work. Mallets are usually made from the very hard wood lignum vitae. A maul (**29**) is made from a single piece of wood. Planes and squares come in many types. Pictured here are squares (**30**), a plane (**31**), an adjustable square for setting angles (**32**) and a marking gauge (**33**). Axes are available in different sizes and weights, with various handle lengths and head shapes. Pictured here are a felling axe (**34**), a trimming axe (**35**), a hatchet (**36**) and a draw knife (**37**), used for shaping by shaving along the grain. It is certainly not advisable for the amateur woodworker to invest in the complete range of tools available. It is of much greater use to obtain a few tools of good quality. Pre-planning will help you to purchase those you are most likely to need for the type of work you are undertaking.

interwoven grain. Beech is the next best, but it gradually erodes with use.

A maul is made from a single piece of wood, from the base and root of a young tree. The knotty tangle of fibres in the root base make a resilient club. The beetle is a big wooden sledge hammer for driving wooden wedges. A steel ring around the handle gives it more weight and a longer life.

DRILLS

Auger This is a form of turning chisel for boring a hole across or down the grain. It has two cutting edges on either side at the end of a spiral shaft, which winds out the shavings, and an eye at the top to hold a wooden handle. When the auger is turned, the leading screw winds the tool into the wood. The turning blades shave the wood as they are pulled in by the screw thread.

The auger can make a long hole, much longer than the electric drill, hand drill or brace and bit, and wider, up to 2in (5cm) in diameter. The spiral can clear some shavings but after a few inches it may clog and jam the shaft. To avoid this take out the auger occasionally and remove the shavings. The auger is used in dowelling or bolting big timbers together. For smaller holes use a brace and bit, or hand or electric drill.

Electric drill This is very useful for making preliminary holes for screws and dowels especially when there are a lot to do.

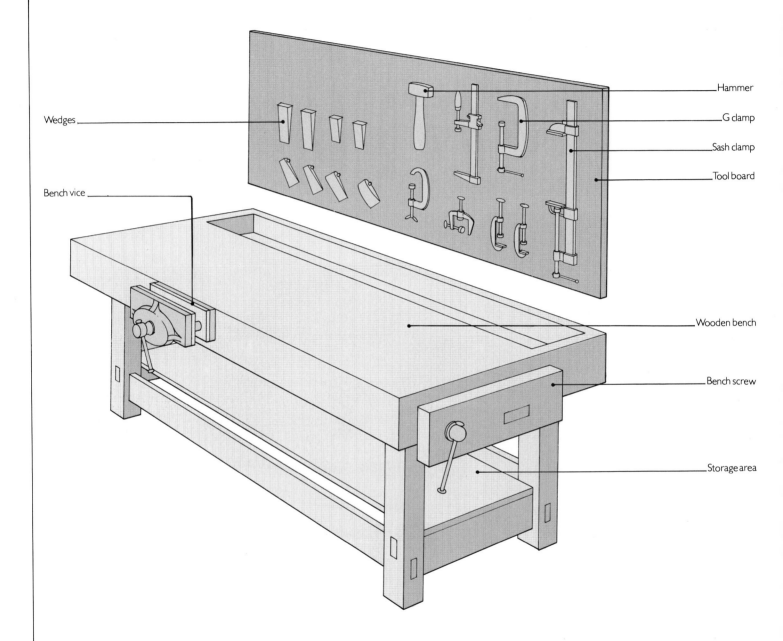

Wedges

Bench vice

Hammer

G clamp

Sash clamp

Tool board

Wooden bench

Bench screw

Storage area

Above A steady, solid work bench of comfortable height is a vital piece of equipment. The bench should be fitted with a vice and a bench screw, so wood can be held fast as it is sawn, drilled or carved. A low platform underneath the bench provides a handy area of storage space for materials or work in progress. To keep tools tidy and accessible, a tool board should be fitted to a wall close to the bench, on which clamps, hammers, and cutting tools can be hung.

HOLDING WOOD

To enable the sculptor to work comfortably and efficiently, the wood must be held steady. This is achieved largely by common sense. A steady, robust bench is an important tool providing a comfortable working height and a base for a vice and bench screw (holdfast). Large pieces of wood can be laid on the bench or leant against it for for carving, held steady by clamps, or chocks nailed to the bench or floor. Very large pieces can lie on the floor and need only chocks to stop them rolling. To move big pieces use levers and rollers. Any stout length will work as a lever and sawn lengths of scaffolding pipe make good rollers.

For lifting and suspending, use a block and tackle on a gantry—a beam supported by two tripods or on very sturdy tressels. For this, ideally an H-beam of steel should be set across the studio and into the walls.

Vice A strong vice attached to a solid workbench is an invaluable tool in all wood sculpture techniques. The vice should have short ½in (1.25cm) wood planks screwed inside the jaws, to give a better grip and prevent chisels from striking the metal.

Clamps G-clamps and sash clamps are vital in construction work, for temporary joining while the form is worked out, and for holding sections in place.

SHARPENING TOOLS

This is an essential activity, calming in its method, and it puts you in touch with the all important 'edge'. Sharpening your tools can be good preparation for your work.

The purpose is to give the cutting edge a well supported 'keenness'. A sound edge will last for some time and can be kept by the occasional run on an oilstone. Too fine an edge will break and takes a lot of work to restore.

When sharpening a flat chisel, what is important is the angle, correctly termed the 'ground angle', of taper from the main body of the shaft towards the tip. It should be neither too steep, which would clog in the grain, nor too shallow, which would weaken the cutting edge. The ground angle is best at 25° and the cutting edge 'honed angle' is best at 30°. Both angles should be flat and not curved.

For the ground angle use a grindstone. A 6in (15cm) diameter wheel, ¾in (18mm) thick will give good general service, either electric or hand driven. For the honed angle, use a flat carborundum oil-stone.

Be careful not to allow the tool to overheat on the wheel as this will damage the resilience of the metal. The edge turns blue when overheated. If it does overheat, grind it off and start again. Have a small container of water by the wheel and occasionally cool the edge.

Hold the chisel at the required 30° angle and push it along the oilstone. To stop the stone slipping about, put it against a batten nailed to a bench. A burr will form on the edge of the chisel, it is breaking off this burr that creates the sharp cutting edge. To do this turn the chisel over and move it once up the stone, holding it flat down on the stone. Then continue as before, alternating these procedures until the burr breaks off. Work all over the stone to avoid wearing a groove in the middle.

The gouge chisel appears more difficult to sharpen, but, once the rhythm of a figure of eight movement is mastered, it is as simple as the flat chisel. In this motion, rock the gouge edge from side to side as you move it over the stone. Remove the burr with a curved slipstone. Sharpen a V-shaped chisel like a flat chisel, removing the burr with an angled slipstone. It is as well to have one oilstone for flat chisels and another for gouges.

For sharpening an axe, use a file on the 'shoulders' and a stone for the edge. Secure the axe head in a vice and move the stone against the blade. The same procedure is used for sharpening a draw knife.

Saws need to be sharpened and 'set' to obtain the slight angle of each alternate tooth to the plane of the blade. This makes the cut slightly wider than the blade. If the saw is stiff in the cut, then it is not sufficiently 'set'. The setting is done with a saw setting gauge, the sharpening with a triangular file.

Put two strips of wood down either side of the saw edge and clamp it in a vice. The wood supports the thin plane of metal. Sharpen each tooth angled away from where you stand. Push the file evenly two or three times through each alternate valley. The file must be held horizontal. On a crosscut saw, where the blade is slightly angled from the handle, push gently against the cutting edge nearer the handle in each valley. On a ripsaw, file at right-angles to the blade. Start near the handle and work along to the end, then turn the saw round and do the same again. Both sides must be sharpened evenly or the saw will cut on a curve.

Sharpening tools It is vital to keep tools sharp, as blunt tools will not achieve the effects you desire. Useful tools for sharpening include a grind wheel (**1**), a file for saw teeth (**2**), a saw set (**3**), oilstone (**4**), slipstone (**5**) and oil (**6**).

Sharpening carving tools
1. Lubricate an oilstone with a thin trail of oil.

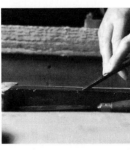

2. Hold a flat chisel with the honed angle of the blade flat on the oilstone. Push it up and down on the stone surface.

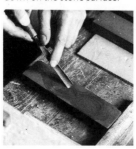

3. Sharpen a gouge by working in a figure eight motion on the stone, rocking

the blade from side to side around the curves.

4. Finish the gouge by removing the burr from inside the blade with a slipstone.

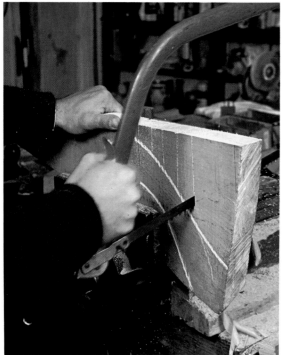

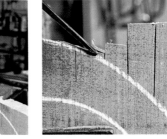

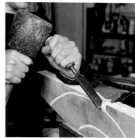

2. Use a chisel to remove the waste wood between the saw cuts, following the chalk line.

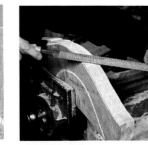

3. Hold the chisel with the flat side up, so the angled edge of the blade follows the curve without digging into the wood.

4. Smooth down the cut surface with a rasp. Use the flat side of the rasp on convex curves.

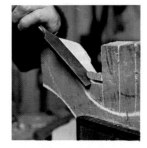

5. Turn the rasp and use the rounded side for working into concave surfaces.

6. When one side of the shaping is completed, turn the wood in the vice and repeat the process on the other edge.

7. Smooth down the second curve with the rasp as before. The shape is now cleanly formed.

Removing waste wood 1. Mark a shape on the wood with chalk. Clamp it in a vice and make vertical cuts along the width with a bow saw, down to the level of the chalk mark.

Splitting wood 1. Hold a metal wedge to the sawn end of a length of wood and drive it in with a mallet.

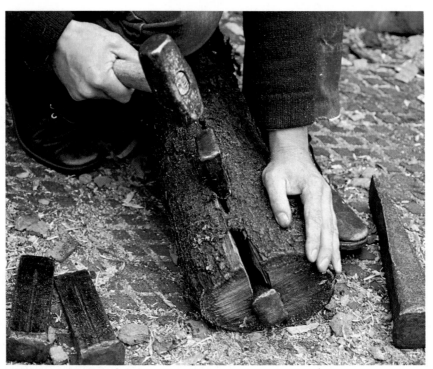

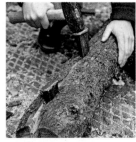

4. Take out the first wedge and place it behind the second. Hammer it in, to lengthen the split.

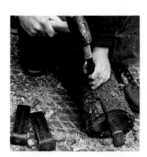

2. Place a second wedge in the top of the wood, aligned to the first along the length.

3. Drive both wedges in further to split the wood open. The first wedge is loosened as the second is fully embedded.

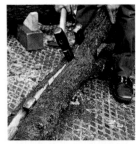

5. Repeat the process until the length of wood is split right along into two pieces. Cut any holding fibres with a hatchet.

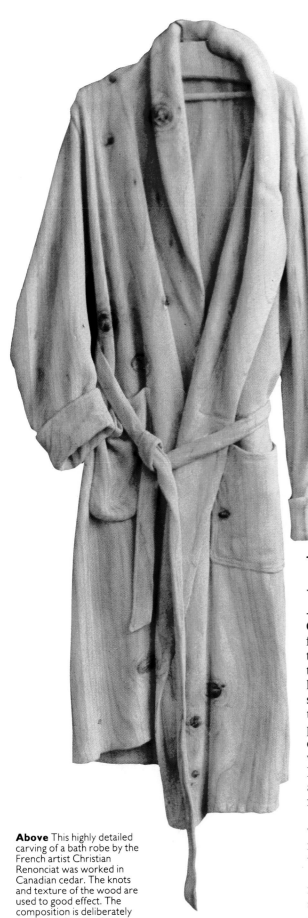

Above This highly detailed carving of a bath robe by the French artist Christian Renonciat was worked in Canadian cedar. The knots and texture of the wood are used to good effect. The composition is deliberately casual, heightening the naturalism of the piece.

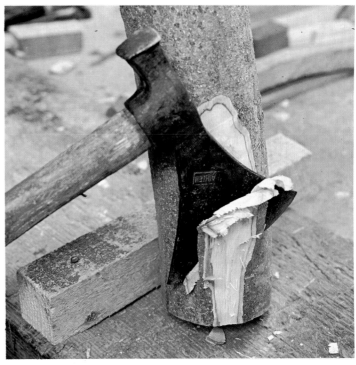

Using an axe Hold the top of the wood and steady the bottom against a bench chock. Chip away the wood gradually to form an angled cut, working with the grain.

Using a drawtool Grasp the handles of the tool at either end and draw it along the wood to strip away the bark.

Using a tenon saw The tenon saw may be used on small pieces of wood for accuracy in cutting across or down the grain.

TECHNIQUES
CARVING

Carving refers to methods of removing wood from a mass to achieve an image. It is important that the idea is appropriate to the material and that the behaviour of wood is considered. Use the linear structure to your advantage. Wood is stronger along its grain than across it. Mark out the first areas to remove with chalk. When possible use a saw to cut across the grain and chisel wood away towards the saw cut. Keep the wood well supported and cut towards the support. Mark it with the chalk at each stage, have plenty at hand. Keep turning the wood to approach the form from all sides. Start with the heavier tools— axe, saw, broad chisels and gouges—then work with more precise tools to shave and file until the related forms, planes and surfaces work together to make an image.

Wood can sustain many degrees of surface, and it is a mistake to assume that a smooth polished surface is automatically the surface that is required. All tools leave their own specific mark on the wood and these should not be disregarded.

Above This still life by Fred Watson was carved in ash. The work is virtually life size and was carved in different pieces which were then fitted together. The piece gives an impression of calmness, one of the effects the artist wished to achieve.

RELIEF CARVING

Light is the most important factor in relief work, and assuming the relief carving will be presented vertical on the wall then light will fall across the surface at an angle of 60° from above. The carving modulates this fall of light. The more refined tools are used for relief carving; engraver's tools, small V-shaped chisels, gouges and rifflers. Working at an angled bench is more comfortable than flat on a bench and the light articulation is also more accurate. Hardwoods, being close grained, are good for relief carving. Lime, cherry and walnut are particularly useful.

CONSTRUCTION

Wood is traditionally a material for construction—of roofs, furniture, barns and houses. Its linear nature is perfect for this practice. There are countless books describing basic carpentry but do not be conditioned by the traditions of joinery. Observe them and use them as expedient. Basically, for sculpture, you need only observe the linear structure of wood and use it to your advantage.

One of the contemporary concerns of sculpture is the way an object engages space. Constructions

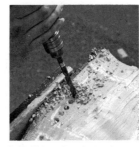

Roughing out 1. Make a drawing of the basic shapes required as a rough guide to carving. Mark up the block with chalk.

2. Drill into the block where it is to be deeply carved. This breaks the rigidity and forms a stop if the wood begins to split.

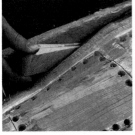

3. Keep the block firmly clamped in a vice while carving. Use wedges to support an irregularly shaped block.

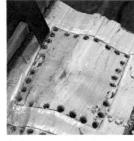

4. Cut along outlines with a flat chisel, making vertical cuts down into the wood.

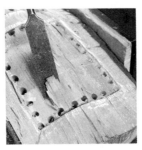

5. Start to clear broad areas of wood with the chisel. Work along the grain towards the outline of each shape.

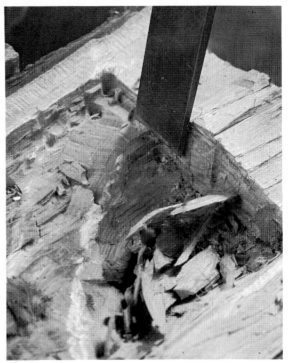

6. Use a gouge to give a clean, deep cut along outlines. Shave off the wood a little at a time.

7. The gouge is also used to cut across the grain. Avoid cutting too deeply in one stroke or the gouge may jam or split the wood.

8. Continue to work with flat chisels and large gouges, starting to define the shapes and planes within the block.

9. Roughing out gives the general form of the sculpture. It is then ready to be developed in detail with smaller chisels.

may involve space as much as material. It is worth making large constructions in such a way that they can be dismantled into smaller units. This is sensible for storing and transport.

Clamps are invaluable, as well as offcuts and batten lengths to prop and hold pieces in position while you try out angles and heights. Once the positions are certain, the methods of jointing can be decided, with consideration of the weight and stress involved. For permanent joins, a lap joint, butt joint, or mortise and tenon can be glued, dowelled, nailed or screwed.

If dismantling will be necessary, use coach bolts or screws, or pegs rubbed with soap which can be knocked out. If the presence of a bolt head or nut is distracting, it can be countersunk to disguise it, the nut being tightened by a box or socket spanner. There are many ways of joining wood, apart from traditional joinery, such as binding, wrapping, stacking, leaning, and plaiting.

Large shapes can be made by building a wooden frame and covering it with panels of composite wood which is flexible, such as hardboard or thin plywood. This is called cladding.

A mass can be built up by lamination. A bend is made in thin composition board, ply or hardboard, or with thinly sawn planks of wood. The pieces are bent and glued together, and held in position until set.

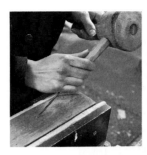

Relief carving 1. Fix the block in a vice. Draw up the design in pencil and start by lightly graving lines with a V-tool.

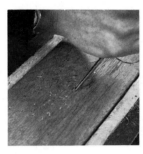

2. Guide the V-gouge carefully around the pencil lines, tapping it gently with a mallet.

3. Use a chisel with an angled tip to shave away and shape the surface. Push it with your hand, not with a mallet.

Rifflers 1. Rifflers are small tools with a filing head which come in a variety of shapes and with straight or curved shafts.

2. Use rifflers for delicate shaping and refining the surface. Guide the head into curves with the forefinger.

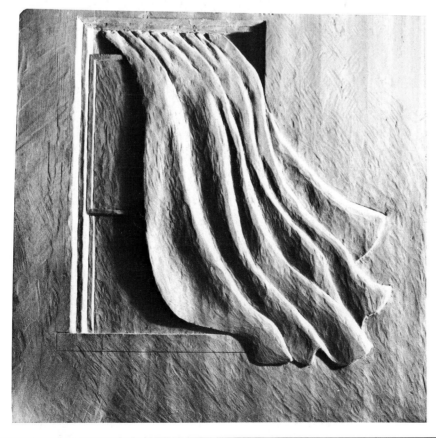

Left *Curtain Blowing* by Claire Langdown is a modern relief carving. The artist has chosen a simple, everyday image and created it effectively in her chosen wood, obeche. The folds of the curtain help convey the feeling of movement as the curtain blows in the wind.

Bolting two blocks together 1. Set the blocks in position, raised from the floor and held firmly together with G-clamps.

2. Position the auger and turn the handle until the cutting end bores right through the wood. Keep the shaft vertical.

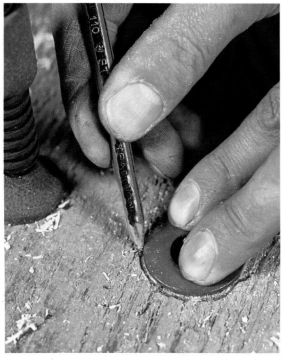

3. The bolts may be disguised by countersinking. Mark the circumference of the bolt washer around the drilled hole.

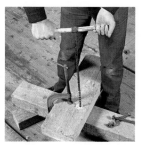

4. Using a small gouge, make vertical cuts around the marked circle to the depth required.

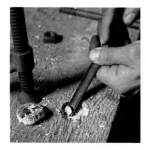

5. Clear away surplus wood inside the circle with a large gouge to form a small recess in the block.

6. Push the bolt up through the drilled hole and fit the washer and nut.

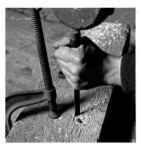

7. Tighten the nut with a socket spanner, screwing it down into the recess.

Squaring off a block 1. Clamp the block in a bench vice and use a square to mark the right-angle at one end.

2. Steady the blade of a crosscut saw along the thumb of your free hand. Draw the whole length of the saw through the wood.

Seasoned wood can be made pliable by long containment with steam, in a process called steam bending. The wood is bent to shape while pliable, and sets in that shape as it dries.

Constructing a mass to carve involves dowelling pieces together to gain a bulk. For consistency of mass, the timber sections should be of the same species and if possible the same age, and the dowels too. But interesting results can be achieved by mixing wood types. Construction with wood is an interesting technique, which can be of particular relevance to the beginner, who is trying to develop sculptural skills.

Pegging wood with dowels 1. Make dowels by cutting small lengths of wood and rounding them off by hammering them through a metal template.

2. Apply glue to the pieces of wood to be assembled and clamp them firmly together to form the construction.

3. Drill through the joints to make holes for the dowels. The dowels should be made of the same wood as the construction.

4. It is essential that the drilled holes pass through both pieces of wood at the joint. Pour in wood glue.

Left *Running Animals/ Reindeer* by the American artist Robert Stackhouse is a vast construction measuring about 12 feet by 6 feet by 66 feet (about 4 metres by 2 metres by 20 metres). The play of light and shadow through the slatted wood helps convey the impression of movement which the artist is trying to create. This shows how, in sculpture, light is often an important element in a work which is constructed from another medium.

Above This 1966 wood sculpture by the French artist Pol Bury shows an approach which contrasts with that of Robert Stackhouse. The combination of cubes and spheres makes a very restful work in which the viewer can compare shape and texture of the different types of wood. Many of Bury's works are mobiles or kinetic works in which the movement may be so slow as to be almost imperceptible.

5. Hammer in the dowels as far as they will go, to pass through the seam of the joint.

6. Use a tenon saw to cut off the dowels at the surface of the wood.

ADHESIVES

There are several types of glue which can be used in construction work, some stronger than others. No glue is effective on damp or unseasoned wood. Many adhesives will fill a gap in a joint, but the bigger the gap, the weaker the bond. The following are effective in general use.

A good type is glue derived from animal or fish skins, bones and sinews. It comes in solid bars or granules and must be warmed, but never boiled, before use. It is a basic, cheap glue for inside work but does not resist heat, damp or humidity.

Joints must be clamped while the glue is drying. Casein comes in powder form and is mixed with water. It will set at a low temperature, resists heat and humidity, weakens when wet but hardens again as it dries. It is good for joints which take stress. PVA glue is suitable for general woodwork inside. It sets in 20 minutes and dries hard in 2 hours. It is adequate for general use but not very strong under stress.

Epoxy glues are very versatile for indoor and outdoor work. They resist wet weather elements and hold firm under stress. Although more expensive than other glues, epoxies are more reliable.

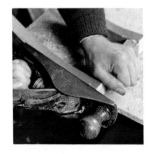

7. Work over the surface with a plane to take off any surplus dowel, leaving it flush with the outer surface.

Cutting down the grain
Clamp the wood and mark it down the length. Use a ripsaw to cut when working with the grain.

Cladding Thin plywood or hardboard may be used to cover a wooden framework and can be bent around curving forms. Put glue on the frame and fit the board. Secure it by hammering panel pins.

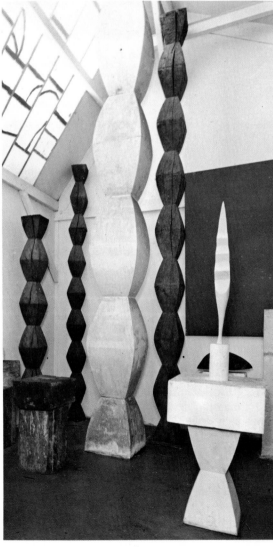

Right These two works demonstrate very varied approaches to wood carving. The late seventeenth century limewood carving of a cravat by the English artist Grinling Gibbons (**top**) shows the great intricacy and detail for which his works are renowned. Constantin Brancusi was one of the great innovators of twentieth century sculpture. These versions of the *Endless Column* (**bottom**) show some of his many approaches to this subject.

Shaping 1. Particular care must be taken in shaping fragile or unsupported wood sections. A riffler is suitable for this task.

2. A fine chisel may also be used, pushed only with the hand as the force of a mallet blow may break the wood.

Spokeshave Use a spokeshave to clean and smooth down wood. When drawn across the surface, it should not drag or stick.

Rubbing in linseed oil Apply linseed oil with a rag to act as stain and preservative. It always affects the colour, and a mixture of turpentine and wax may be better for light wood.

Contact glue is useful for joining perfectly flush surfaces. A contact glue is usually applied to each surface and left to go slightly tacky before the joint is made.

SURFACE TREATMENTS

A wood sculpture kept inside untreated or unpainted will gradually darken in colour and its richness will dull. The dry fibres will absorb an oil or polish which will keep the surface alive. Every form of surface treatment darkens the wood on application but in some cases the original colour will be restored as it soaks in. Raw linseed oil mixed with a little white spirit can be brushed on.

Polish A polish can be made of a mixture of beeswax and turpentine. Rub the mixture into the surface of the wood, which will gradually absorb the polish.

Painting Wood can be stained or painted. For painting proceed as you would when painting the woodwork of a house. Fill in any cracks, and paint in primer undercoat before the topcoat, or use gesso as a base for colour.

Gesso A mixture of rabbit skin glue, whiting and water, warmed but not boiled. Gesso needs a 'key' so the wood surface should not be too smooth. A surface filed or rubbed over with rough sandpaper is good. The gesso is brushed on

warm. Load the brush and apply it in rapid single strokes. Gesso fills in cracks and gives an excellent surface for paint, particularly water based. The paint should be applied in one fluid stroke, not worked over as with household paint. Coloured inks give translucent hues on a gesso ground. Gesso is not durable outside.

PRESERVATIVES

Outside, wood weathers to silver grey over a period of time. This depends on the amount of pollution there is in the air. The natural elements work at the wood; the ever changing humidity and temperature, fungus attack and wood-devouring insects all take their toll on the wood, destroying its structure. This natural process can be slowed down with wood preservatives.

Regular doses of tar-based creosote can keep a wood resilient and intact for a long time. It darkens the wood considerably when first applied, but weathers to grey in a few months.

There are many chemical preservatives on the market, some of them colourless. Soak the wood in preservative many times to saturate the fibre. It will not penetrate unseasoned damp wood. The wood will need an annual coat of preservative followed a month later by an application of linseed oil. Finally, to help give a wood sculpture a longer life outside, shape it so that rain water will run off the sculpture and away from its base.

Above *Hyphen*, created in 1980 and 1981 by the artist Paul Neagu shows the use of wood as a medium for shaping and construction. For this work, ash beams were bent and bolted onto elm bases.

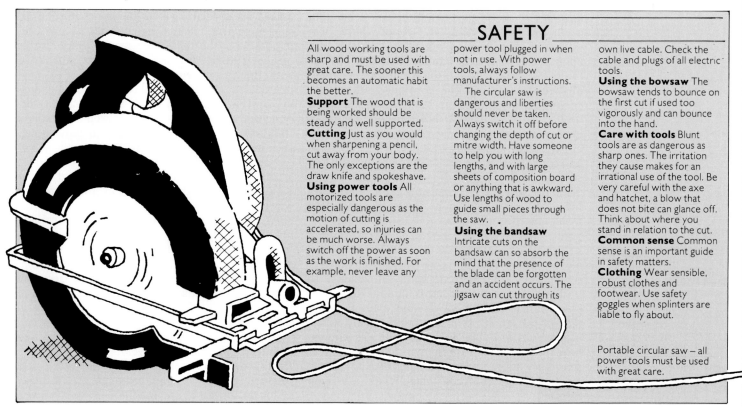

SAFETY

All wood working tools are sharp and must be used with great care. The sooner this becomes an automatic habit the better.

Support The wood that is being worked should be steady and well supported.

Cutting Just as you would when sharpening a pencil, cut away from your body. The only exceptions are the draw knife and spokeshave.

Using power tools All motorized tools are especially dangerous as the motion of cutting is accelerated, so injuries can be much worse. Always switch off the power as soon as the work is finished. For example, never leave any power tool plugged in when not in use. With power tools, always follow manufacturer's instructions.

The circular saw is dangerous and liberties should never be taken. Always switch it off before changing the depth of cut or mitre width. Have someone to help you with long lengths, and with large sheets of composition board or anything that is awkward. Use lengths of wood to guide small pieces through the saw.

Using the bandsaw Intricate cuts on the bandsaw can so absorb the mind that the presence of the blade can be forgotten and an accident occurs. The jigsaw can cut through its own live cable. Check the cable and plugs of all electric tools.

Using the bowsaw The bowsaw tends to bounce on the first cut if used too vigorously and can bounce into the hand.

Care with tools Blunt tools are as dangerous as sharp ones. The irritation they cause makes for an irrational use of the tool. Be very careful with the axe and hatchet, a blow that does not bite can glance off. Think about where you stand in relation to the cut.

Common sense Common sense is an important guide in safety matters.

Clothing Wear sensible, robust clothes and footwear. Use safety goggles when splinters are liable to fly about.

Portable circular saw – all power tools must be used with great care.

STONE

HISTORY

The history of sculpture in stone is closely connected with early architectural traditions, where many discoveries about the use of the material were made. Local geological conditions clearly influenced the way stone could be used, particularly the distinction between hard stones such as granite, and softer stones such as limestone.

EARLY TRADITIONS

Prehistoric uses of stone still interest sculptors today. There are three structural types of prehistoric stone sculpture—rock-cut, simple buildings and standing stones. Rock-cut forms imitate caves, carved out from bed rock. These occur more usually in soft stone areas, often as tombs, but occasionally as dwelling areas, which are created entirely by the removal of material. These interior forms were often very refined though simple. Good examples can be seen in Sardinia, and similar principles of rock-cut tombs and dwellings are seen throughout the prehistoric world. The tradition continued and flourished in historical times.

Early Indian architecture achieved sophistication in the carving of great temples from natural rock strata, while the early Christian church in Ethiopia produced masterpieces of controlled mass and space. In such cases, the whole building could be seen in sculptural terms. More traditionally, the facades of these buildings are identified as sculpture. Famous examples such as the giant cliff-cut figures of Rameses II at Abu Simbel demonstrate the possibility of *in situ* carving. The facades at the city of Petra in southern Jordan demonstrate how the tradition of bed-rock carving became overlaid by detailing derived from a building tradition where columns and capitals are elements essential to support the structure.

Simple stone structures may have developed from the rock-cut tradition. The notion of cutting a chamber down into the rock, then roofing the cavity with giant flat boulders is probably a structural ancestor of the simple henge monuments, where two or more vertical stones are spanned by a heavy stone lintel. Stonehenge in southern England, the most famous of these, shows great refinement in the ball and cup method of joining post and lintel. Many henge monuments or dolmens, as they are also known, have a balance and poise which show a great sensitivity to the selection and placing of the massive boulders from which they are constructed.

Cairn-like structures, where smaller boulders are overlapped to enclose a roughly domed space, were common in the prehistoric world. These 'corbelled' arches spanned huts and passageways before the true arch was devised. This method survived much longer in Mayan architecture as an important way of making doorways.

The third type of prehistoric structure, the many and varied standing stones, have a more obvious association with sculpture. The alignments of Northern Europe, particularly in Brittany and Scandinavia, have attracted great attention in recent years, but their true origin and purpose remains speculative. Although many are of local stone, their natural forms were often modified by carving. Examples include 'menhirs' in Brittany, many of which are made of granite. Sometimes the stones were transported great distances, when it was considered essential to site special stones in particular places.

While the traditions of carving are more clearly related to the practice of the Egyptians and subsequent great civilizations, the structures of prehistory established principles of essential form making by reduction, simple structural building and essential landscape placement, all issues which concern sculptors now.

Egypt still has a plentiful supply of good building stone of different types. For the ancient Egyptians, limestone and sandstone provided basic material, while harder stones such as granite, basalts and quartzites were also quarried and carved for special parts of the work. The hierarchic society of ancient Egypt, with its preoccupation with the after-life, meant that durable materials were directed to projects concerned with the permanence of the nobility. A high degree of organization and centuries of unchanging conventions led to highly sophisticated quarrying and masonry practices, as well as a refined tradition of carving, particularly in hard stone. Just as the society was strictly formalized, so carving played a constant role in relation to architecture, and the carved sculpture had a clear relationship with the cubic block from which it was reduced.

As in present-day masonry, Egyptian carving procedures depended on the known values of the front and sides of the block. However, this was due not simply to stylistic reasons, but also from conventions of Egyptian society, and from the structure of the material, which was quarried in cubic form following the parallel natural splits in the stone.

In ancient Mexico, a strong tradition of carved architectural sculpture developed, where, as in Egypt, the underlying form of the block was retained in the sculpture, although here the way of suggesting the figure or animal in the block was

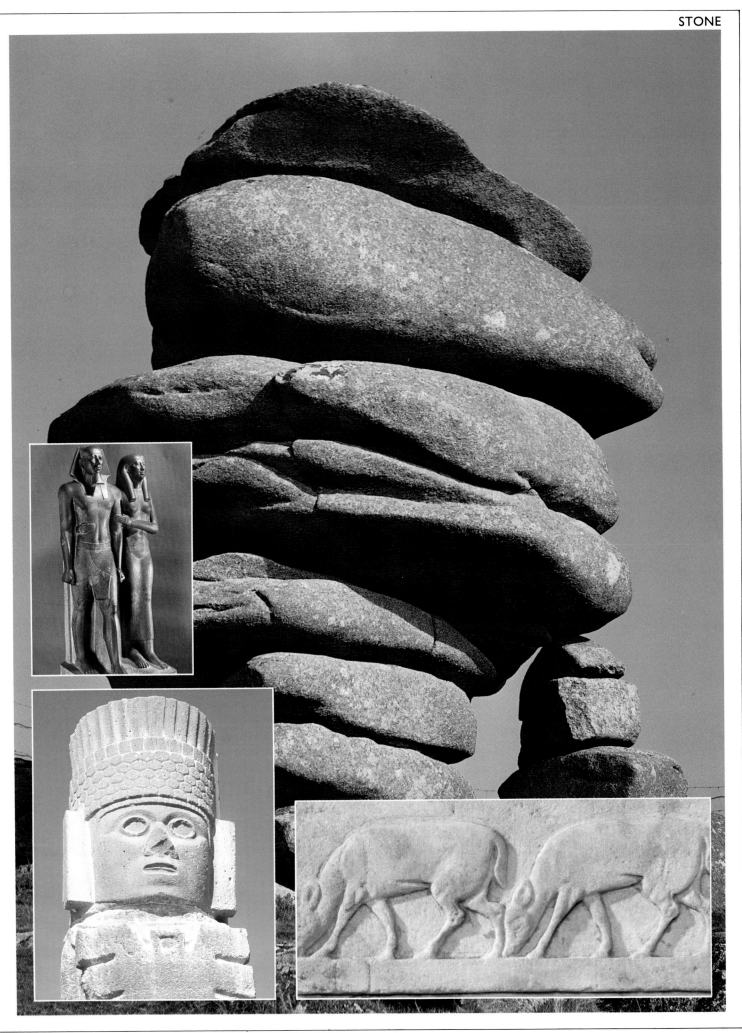

generally more abstract than in other traditions. Early figures, particularly the Toltec carvings at Tula, relate closely to elements of the building, suggesting a figure while hardly changing the form of a column. The extraordinary giant Omec heads from the Gulf coastal area seem to suggest that a giant boulder, rather than regular quarried block, was the original material.

The abundance of marble in the Mediterranean area strongly influenced the carving traditions of the ancient Greeks and centuries later provided the basic stone for the Renaissance masters. Unlike granite, which was so intractable in the face of ancient tools and methods, marble could be worked more freely. As attitudes towards the portrayal of the human form developed, forms became more extended, with holes being drilled through the material to free arms and legs in positions implying movement. The translucency of the material provided a close metaphor for the qualities of the figure and delicacy of draperies.

Although bricks and tiles were commonplace in Roman building, the use of marble for sculpture continued directly from the Greeks, and a highly organized industry quarried and masoned the marble dressings for the great Imperial buildings. Since the Romans could command the engineering skills that built the great aqueducts and roads of the Empire, it is ironic to see that structures such as the triumphal gates of Pompeii were built in brick and then disguised. The marble cladding formed a thin veneer, in much the same way as stone is finely laminated onto a concrete backing in many contemporary buildings, to provide a surface which no longer describes the underlying building structure.

Below Michelangelo's *Battle of the Centaurs* is an example of an early, although uncompleted, work in marble. Work on the sculpture probably ceased around 1492 when Michelangelo's patron Lorenzo de' Medici died. The general forms of the figures are well developed, showing the muscles and solidity of the forms, but the surrounding area reveals the marks of the tools and is still in an unfinished state.

MIDDLE AGES AND AFTER

The great period of structural innovation in stone was undoubtedly the Middle Ages, when the great Romanesque and Gothic cathedrals represented the most advanced raising of stone that had ever been known. Workshops were set up near the cathedrals, to which quarried stone was brought and worked by teams of masons, carvers and sculptors. This system of on-site work continued into industrial times, until eventually, with the arrival of heavy saws and other machinery, it became more economical for masons to work away from the site and nearer the quarries.

As far as possible, local stone was used, but sometimes supply was scarce or a particular stone was selected for detailed work. In these cases, the material was transported from afar by land or even by sea. For example, French stone is to be found in the southern English cathedrals, and the island of Portland in Dorset received a Royal Charter as early as 1078, when its famous limestone quarries were providing material for the Tower of London.

Apart from outstanding examples such as the twelfth century Giselbertus of Autun, most of the great medieval stone sculptors remain anonymous. However, the Italian Renaissance, which saw the emergence of marble sculpture independent of an architectural context, also gave rise to known individual masters. Pisano, Donatello, Michelangelo and Bernini each stand out in their own right as artists. The famous marble quarries, particularly those in the mountains near Carrara in Tuscany, had been founded by the Romans. During the rise of the Medicis, they became a plentiful source of marble for the Italian City States. The material was quarried high in the mountains, as it is today. The white marble used by Michelangelo (1475–1564) came from the mountain of Altissimo at the summit of the range, where zigzag tracks led upwards, and the blocks were lowered directly down the mountainside. The retaining ropes were wound around wooden pegs driven into the cliff. This acted as a brake. These precarious methods which took many human lives are now relieved by mechanized transport and lifting equipment.

Michelangelo used his technical mastery and his insights into figure and group composition to develop his powerful and expressive sculpture. He was capable of the finest, most sensitively finished surface, but, when his intentions were better conveyed by broad, rough shaping, the carving was left at an earlier stage. His work contains an intimate record of his procedures and techniques—from punching away the rough stone through claw chiselling to fine honing.

His successors were faced with the almost impossible task of taking these insights further. Inevitably, the most successful developments lay in other directions. The Italian sculptor Gianlorenzo Bernini (1598–1680) aimed at a different kind of rhythm and movement in his sculpture, using marble almost like a fluid material, achieving improbable transformations, as in *Daphne and Apollo*, where the rock first becomes a figure in flight and then changes through Daphne's fingertips into foliage.

Many Baroque sculptors produced carvings for the great gardens of Italy and France in particular. Much of the work is interesting when seen as part of the organization of these formal landscapes, but the purpose of sculpture in such a context seems less important than that of the Romanesque and Gothic periods.

The Neoclassical movement of the eighteenth century, especially in France, turned from the vigour of the Baroque back to a concern for harmony of form, proportion and simplicity. These values were nonetheless approached by sophisticated means. For instance, the calm figures of the Italian Canova (1759–1822) are defined with precision and sensuality. He delighted in the different treatment of skin, silk and soft materials, but kept the quality in keeping with the overall context of the sculpture.

Marble came to be seen as the basic material for carving, and, by the nineteenth century, the practice of reproducing a plaster original in marble had become commonplace. Whereas in bronze casting foundrymen reproduced the actual marks of the sculptor during casting, in marble pointing, the skilled carvers in sculpture factories remade the sculptor's forms, and the original artist was not necessarily involved in the quality of the final surface. Meanwhile the introduction of mechanized methods gave a new facility to these craftsmen. Although technical accomplishment was highly advanced, sculptural sense came second to showing skill and dexterity.

At the turn of the twentieth century, the pioneers of modern sculpture attempted to find new equivalents for volume and mass, and the Salon traditions of the nineteenth century were avoided in favour of new forms. For example, Constantin Brancusi (1876–1957) brought a sense of the simplified forms of ancient and folk carving to his highly sophisticated work. Sculptors such as Frenchman Henri Laurens (1885–1954), Russian Ossip Zadkine (1890–1967) and Jacques Lipchitz (1891–1973) introduced fragmenting planes which seem to question the solidity of their stone blocks. The Russian-born American Naum Gabo (1890–1977), although primarily a constructor, also found in small-scale carving a way of developing his abstract notions. The British artist Barbara Hepworth (1903–1975) reversed the Salon role by working primarily as a carver (of both wood and stone), and sometimes allowed bronze casts from her carvings. Both Henri Gaudier-Brzeska (1891–1915) and Jacob Epstein (1880–1959) produced major twentieth century works in stone, with a strong sense of the primitive and distant past.

All these artists preferred working directly into the stone—perhaps after some preliminary studies—rather than reproducing in stone, forms conceived by modelling and casting. Further examples include the British artist Eric Gill (1882–1940), who drew from the procedures of the medieval master carvers for his direct carving, and Henry Moore (born 1898), who, particularly in his earlier carvings, devised forms analagous to those of nature, which were suggested by the quality of his organic material. Swiss artist Max Bill (born 1908) carved geometric forms in granite, while the recent work of American Isamu Noguchi (born 1904), who worked for Brancusi, leaves a sense of scarcely touched nature, relating to the Japanese sensibilities behind the placing of stones in a contemplative garden.

Below *Sleeping Nymph* by Antonio Canova, the eighteenth century Italian sculptor, reveals the artist's delight in the treatment of skin and soft materials. The positioning of the figure and the facial expression indicate both sensitivity and sensuality.

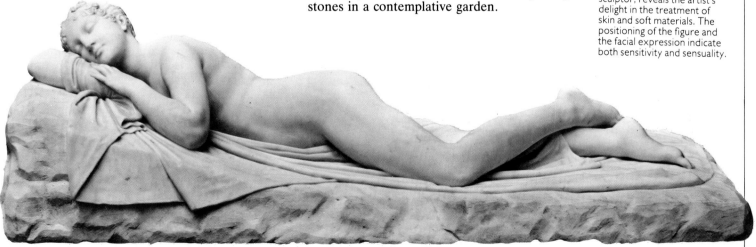

Igneous rocks The best known type of igneous rock is granite. Igneous rocks are the most weather-resistant, durable types of stone. All granites are very hard and will thus take a very fine polish. These rocks are extremely old and are formed by the solidification of molten material.

Sedimentary rocks The two principal types of sedimentary rock are sandstone and limestone. They are more porous than igneous rocks, and tend to give a textured finish. They are much easier to carve. Sedimentary rocks are produced by particles which have settled and become bonded by natural adhesives. They usually contain bone remains.

Metamorphic rocks are transformed igneous or sedimentary rocks. Pressure, great heat or chemical reactions in the earth's crust usually causes this transformation. Marble and slate are the metamorphic stones most frequently used in sculpture. But soapstone and alabaster are also stones which can be classified as metamorphic.

Cornish granite

Karin granite

Sandstone

Limestone

Marble

Slate

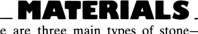

MATERIALS

There are three main types of stone—igneous, sedimentary and metamorphic—each resulting from a different geological process.

IGNEOUS ROCKS

Igneous rock is formed by the solidification of molten material. The best known type of igneous rock is granite, which is composed of crystals created during the cooling process. There are many granites, of all colours, which come from as diverse locations as Scandinavia, South Africa, Brazil, America and Britain. All granite is extremely hard and will take a fine polish.

SEDIMENTARY ROCKS

Sedimentary rocks are formed by the settling of particles of material which become bonded by natural adhesives. The two principal types of sedimentary rock are sandstone and limestone.

Sandstone Sandstone consists of grit particles, largely composed of silica, which adhere to one another. The particles are extremely durable, having been formed from other crystalline rock. When the bonding agent is tough, an extremely intransigent material results. Sandstone is widely distributed throughout the world.

The main colours tend to be the earth colours—ranging from red through to ochre, with some grey and blue-grey. The stone looks very porous and normally does not take a polish. The dust is very dangerous.

Limestone Limestone is formed from the settling of calcareous or chalky material, such as fragments of shell or the tiny skeletons of countless marine organisms. There are many types of limestone, which vary considerably because of the different possible components and how they were formed. Many organisms began on the sea-bed, and so limestone may even contain identifiable pieces of shell and fossil.

Although amalgamated into homogeneous stone, the different layers or strata—the grain of the rock—are still evident in many limestones. Limestone contains distinct horizontal divisions which define the 'bed' height. This is the height of stone available before a natural break. This restricts the size of limestone for sculpture.

There are many limestones which are suitable for carving, as they are relatively easy to cut and their weathering properties are reasonable for a soft type of stone. In fact, limestones 'case harden'. This means that the natural moisture—

or quarry sap—found in most newly quarried stone gradually moves to the surface of the carved form, eventually making a harder shell which will protect the rest of the stone. If this surface is subsequently broken, erosion of the softer interior can be rapid and harmful. Hence, reworked limestone weathers less well than does the freshly worked stone.

Most limestones range in colour from creamy white to brown. The main factor in determining colour is the presence or absence of iron. Most countries have their own deposits of limestone. For example, Portland and Bath stones are important British limestones, while Alabama and Indiana are major types from the United States.

Chalk is found naturally in rough pieces and can be worked easily. Quite large lumps are possible, but the stone will gradually break down if exposed to the weather.

METAMORPHIC ROCK

Metamorphic rock is formed through the effects of pressure, great heat or chemical action. These processes transform the basic structure of igneous or sedimentary stones. The best known types of metamorphic rock are marble and slate.

Marble Basically calcium carbonate, marble is formed in a vast range of colours and consistencies, ranging from the pure white marble of Carrara in Italy and the Pentelic marbles from Greece, to exotic veined marbles from Portugal, red travertine marbles from Iran and dense black marble from Belgium. Pakistan produces green marble, and Italy a wide variety of figured and plain marbles.

Generally, sculptors find the simpler types of marble most suitable, particularly the Carrara marble from Tuscany which comes in a range of whites and greys. Textured travertine marble is also popular. It is usually cream in colour and comes from near Rome. Different types of marble weather very differently, particularly in a corrosive atmosphere. One of the most reliable is 'Ordinario di Carrara'. It is a cold grey-blue colour, tending to white.

Alabaster Italian alabaster is considered a type of marble. It is translucent. However, most alabasters are strictly speaking not marble, but relate more closely to gypsum. They are soft and easily carved.

Slate This type of rock is formed by the metamorphosis of clay-like shale. The most significant characteristics are the strata, which make it easy to split the rock in one direction. Chunks of slate can be quarried, but generally this stone is most useful to the sculptor in slab form. It is extremely close grained and is often used for letter cutting. Colours range through grey-blue and green. Recently, sculptors have begun to use slate as a material for construction.

Soft stone For those beginning to work in stone, soft stones are normally preferred. However, it can sometimes be more difficult to make a form in very soft stone than in a stone with a little more resistance. Popular stones of this type are alabaster, soapstone, porphyry and some of the softer limestones, such as Bath stone.

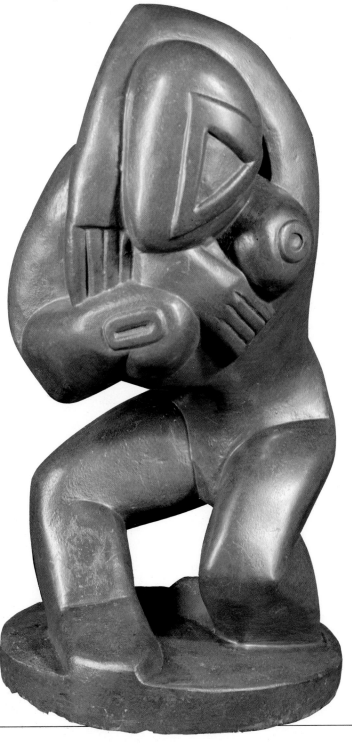

Below *Red Stone Dancer* by the French artist Henri Gaudier-Brzeska was completed in 1914. It is an example of his individual late style of carving in its energy and primitivism. Gaudier-Brzeska died in 1915 at the age of 24. His artistic career was brief but wide ranging.

TOOLS AND TECHNIQUES

Stone carving tools The varied point widths of the marble punches (**1**) are used in the different stages of roughing out the marble (broader points) and the removal of smaller masses and more delicate work (finer points). Round-ended chisels (**2**), known as bullnoses, are used for making channels in hard stone, while the scriber (**3**) is a fine metal tool which can be used for very detailed surface work. The hard lignum vitae mallet (**4**) can be used with any of these mallet-headed tools. The broad boaster (**8**) and wide spaced claw (**9**) are used at first to give a general form to the stone and are followed up by the forged flat chisel (**5**), the narrow tungsten flat chisel (**6**), the narrow spaced claw (**7**), and narrow tungsten tool (**10**) for definition work.

Stone rasps and files are abrasive metal tools used for finishing and fining down stone surfaces. Their surfaces have sharp projections or teeth which are formed by indentations in the metal while they are being made. The dreadnought file (**12**) is initially used for clarifying form, followed by a stone rasp (**13**), and the very small and delicate rasps (**11**), also known as rifflers. These are used for achieving a clear surface and with detailed work.

Stone carving hammers are made of untempered tool steel, and they usually vary in weight depending on their size. A small lump hammer (**16**), a small lead dummy hammer (**14**) and a slightly larger dummy hammer (**15**) are used to good effect with a range of fine claw chisels (**17**) and flat chisels (**18**). The pitching tool (**20**) is of value in removing large fragments during the early stages of blocking out the initial forms. When the heavy hammer (**19**) is used with the pitching tool and applied with force, the blows can remove considerable amounts of stone.

In order to reproduce a form according to its original dimensions the carver uses the method of 'pointing' using a compass (**22**). This is where, given two known points on the stone, a third can be found by using the distances from each of these points. Curved calipers (**21**) are used for accuracy of measurement when reproducing a shape in stone.

Long Portland punches (**23**) vary in length from 18in (45cm) down to thick waisted

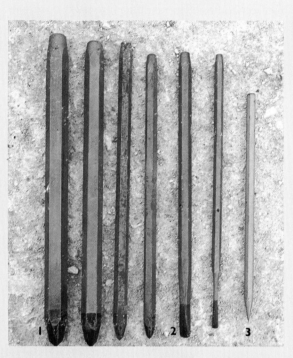

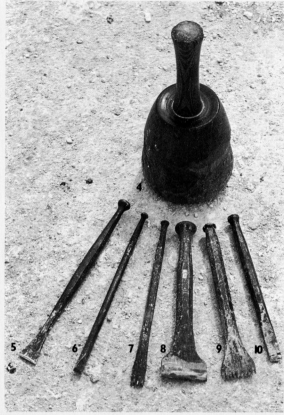

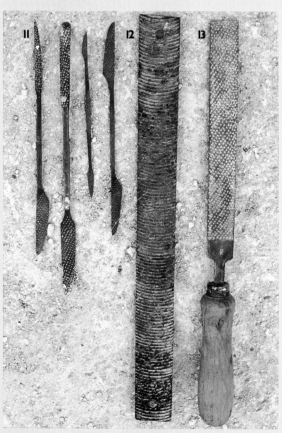

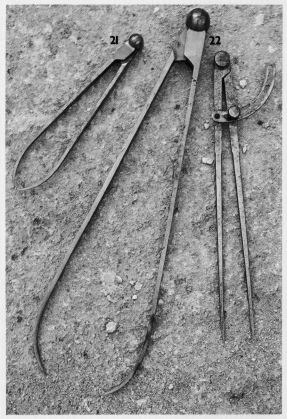

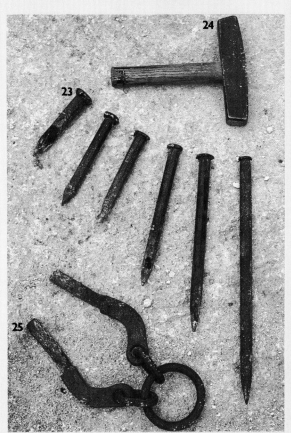

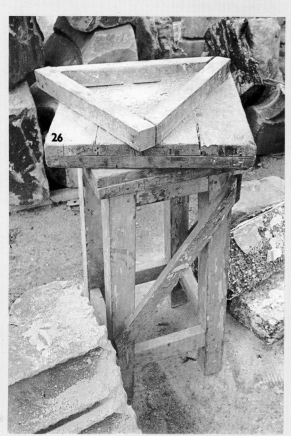

granite punches of about 4½in (11cm). Note the different lengths of the forged points. They are more drawn out for softer stone and stubbier for granite. They can be used with a long-headed hammer (**24**). A Lewis bolt (**25**), which is an expanding bolt, is inserted into particularly heavy stones prior to lifting them.

A revolving wooden bench or banker (**26**) provides a sturdy waist-high surface to work a stone on. Note that the two tops are both made of a double layer of planks glued together in opposite directions, so as to absorb the stress from hammer blows to the stone. The triangular frame delineates a rough enclosing border for the stone. This hammer can deliver a heavy blow and is used with granite (**27**). Note that the hammer head has a slightly curved top and ends angled downwards, the wood narrowing into the metal. Granite hammers have very delicate hafts with heads almost oval in shape. The hammer is held at the bottom to avoid vibration and jarring being transmitted to the hand. The stone carver who is beginning to work with different stones does not need to acquire all the tools shown on these two pages, but instead should concentrate on obtaining a few high quality tools from a reputable supplier.

This sequence of photographs shows some of the different stages in making a sculpture. The work, entitled *Expanded Column*, is shown while still in progress. The piece is by the British sculptor John Maine, who worked on the piece in Italy. The artist began working from a model made of Portland stone (**1**). The model should never be a prescription for work, but rather a starting point and guide for working with the stone. It is very important that, as the work progresses, the artist responds to the material, rather than simply trying to impose his or her ideas on it. In many cases, the work may change radically from the model, although, in this instance, the overall idea was, broadly, maintained as the work proceeded. Having selected the block of stone for the work, the next step was to position the stone so that work could begin (**2**). For heavy blocks of stone, lifting equipment and even cranes may be necessary. Before work starts on the stone, it is important to position the stone at the correct height. The most convenient height for a stone is probably about waist high, but it should not be lower than knee-high. The properly supported stone must also be placed so that it is not liable to topple over or move when work is in progress. The stone chosen by the artist was a block of Italian Trani marble (**3**). Once in position, it was then sawn into the basic cuboid shape from which the artist worked (**4**). When the initial material was removed, the angles in the work began to emerge (**5**). Power tools are a good way of removing large amounts of stone quickly. The chips of stone on the ground can be seen around the base of the work. Creating a stone sculpture involves a number of gradual processes which smooth away the excess stone until the desired surface is reached. These operations remain basically the same whether the sculptor uses power or hand tools. Power tools are more suitable for large-scale work, as they take much of the effort out of the basic shaping. However, they need to be used with great care and due attention to

1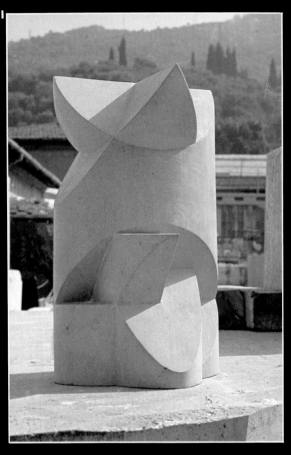

2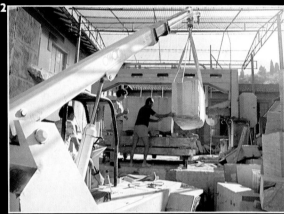

3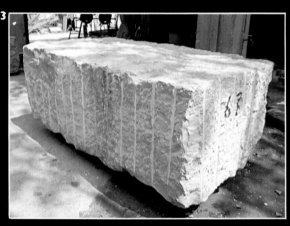

4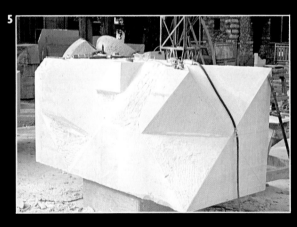

5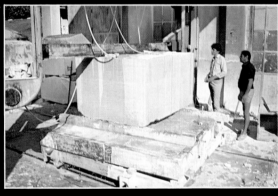

7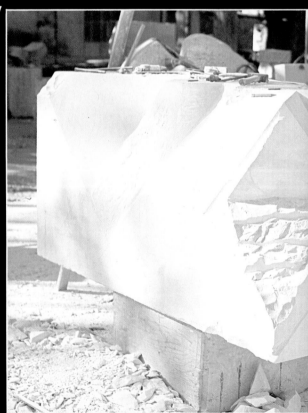

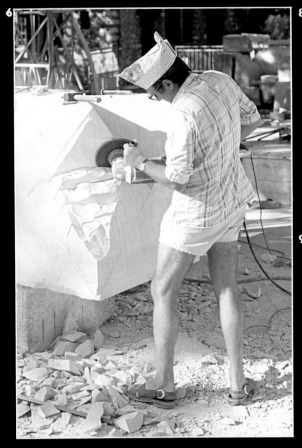

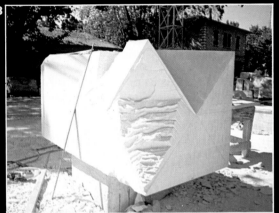

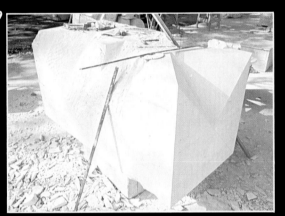

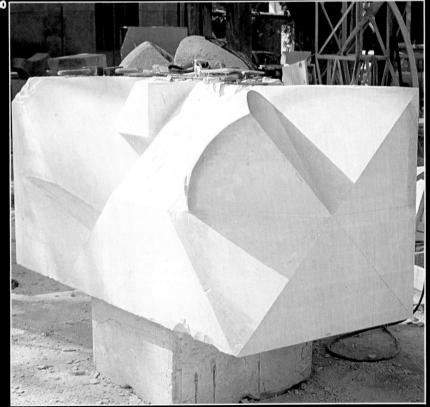

safety precautions. The next stage in the work was to remove more stone and produce the first outline of the final shape. Here a diamond disc saw is being used, and the operator is wearing safety goggles (**6**). The general view after the first shaping (**7**) shows the marking out on the surface of the stone. Marking out provides an outline for the shape. The first shaping establishes the overall angles of the final shape. Here the upper surface of the angle is much smoother than the lower. Further shaping then follows. The stone is gradually being worked away down towards the marks (**8**). The saw cuts are clearly visible, showing that vertical cuts were made into the stone to enable the sculptor to smooth the surplus stone away more easily. Once the marking out indications had been reached, the planes of the sculpture were defined more clearly (**9**). Finally, rounding out of the forms began (**10**).

This series of pictures shows the processes involved in working on one small part of a larger work. The same processes must be repeated for the other parts of the sculpture, before any final finishing can start. In this instance the sculptor was able to work in the open air. This is advantageous because it lessens problems of dust and ventilation which can present difficulties if working inside. *Expanded Column* is a fairly large-scale work, so it is obvious that work on the piece will take a long time, even if the sculptor has help from assistants. One of the great fascinations of sculpture with stone is how the final shape gradually emerges from the roughly hewn block of stone.

QUARRYING

Most stones used by the sculptor will have been quarried, so it is useful, even for the beginner, to understand the general principles involved in obtaining stone from the earth. Stone is quarried in various ways, depending on the nature of the material and where it is found. Certain principles apply to the removal of blocks, particularly the use of natural divisions in the bed rock. These arise from geological pressures causing cracks, or in the strata created when the rock was formed. These are then augmented by man-made divisions, such as sawing or splitting. Sawing applies generally to softer stones and marble, whereas splitting has been used for thousands of years for all types of stone and still prevails today. Most stone is obtained through open-cast quarrying, whenever possible using natural advantages, such as an outcrop of rock, cliff edge, or even a mountain top. Sometimes stone is mined, where good material lies deep below an overburden which cannot be removed economically.

Massive chain saws are used to remove soft limestone, while, at Carrara in Tuscany, a network of wires runs throughout the mountain quarries, guided by a pulley system which directs the wire to the rock face. The principle of cutting by wire in quarries is the same as that in stone-yards where abrasive powder and water assist the process. In granite quarrying, a thermal lance is now used to cut the stone. This consists of a jet of flame, generally paraffin, boosted by compressed air, which forms a cut by melting the rock and blowing away the molten material.

Stone, while having great strength under compression, has comparatively little tensile strength. Very hard stones can split simply, as the hardness of the material assists the splitting action. Wedges force the rock apart by directing pressure from a line on the surface deep into the stone. The division is helped by drill holes which can sink down to a level of 3 or 4 feet (about 1 metre) in certain stones. Granite usually requires shallower holes. Nowadays drilling is mechanical; 'feathers' or split sleeves of iron are set in the holes, and wedges are driven between them in a rhythmic sequence. If the stone is sound, and the wedges are carefully aligned, a clean break can be made.

Lifting plays an essential part in quarry work, and, although the tackle is heavier than most masonry kit, the techniques have much in common. Wire hawsers and chains of appropriate calibre are used according to the weights and materials. For limestone, grips called 'nips' and 'pincers' are still used, following centuries of tradition. A fixed crane is normally on hand to lift the blocks and swing them out to be trimmed and then numbered for the stockpile. Mobile cranes are also used.

HANDLING

When organizing masonry or carving, the first consideration is to be able to move and turn the stone, and to set it in a convenient position for work. The general principle is always to let the weight of the stone assist rather than counter the move.

Small stones up to roughly 1 cubic foot (0.03 cubic metres) can be lifted carefully by hand, but keep your back as straight as possible. There is little point in straining to lift a stone when the job can be comfortably done with an assistant. Several techniques have been developed to manhandle heavier stones. Iron levers are commonly used to move large stones short distances. A wooden block can be placed between stone and iron to prevent crushing. Rollers, made of wood or iron and sometimes clad in rubber, are a great help. Small trolleys or waggons make good, simple transporters.

Medium sized stones can be lifted several feet by cantilevering onto support stones, which are graduated in height up to the the final platform. Where stones of more than about 300lb (136 kg) are regularly being moved, a hoist is indispensable. A block and tackle capable of lifting much heavier weights is useful, but must be supported in various ways above the work area. Common supports are shear legs and gantries.

Nylon straps, 2½in (6.25cm) broad, support the stone. In special cases, an expanding bolt, known as a Lewis bolt, can be inserted into the block. This technique is traditionally used for altar stones and foundation stones of buildings.

CHOOSING STONE

The sculptor's choice from the vast range of stones with different qualities of hardness, consistency and colour is guided by many personal preferences. Other basic concerns which must be considered are the soundness of the block, the possible size of the block in a given material, the durability of the stone, its relationship to the site and the type of working methods available to or preferred by the sculptor. There are many factors which make a particular stone more suited to some forms than others. Some stones are brittle, others erode quickly. Distinctive veins or graining may work with or contradict the sense of the sculptural form. Availability and cost are also important considerations.

SETTING UP A STONE

A stone is most conveniently worked at waist or elbow height and should certainly not be at knee height or lower. This usually means a stout wooden bench, known as a 'banker', or sometimes another substantial stone is necessary as support. It is essential to place soft material underneath the stone, since the blows of the chisel on the top of the stone reverberate against the base. Sacking or soft boarding are useful. Straw is also a good material, but not if water is being used.

Small stones can be worked on a container of fine sand, or sometimes a very small stone is fixed to a base by plaster of Paris. Such stones can also be clamped into a vice with softening over the jaws, but, as with the plaster method, any carving can only be delicate. Heavy blows can fracture the stone.

Preparation for stone work Before beginning work on stone, it is important to set the stone up correctly and to be aware of the correct posture and clothing. Some points to be remembered are listed (**below**). Similarly, the hammer and chisel should be held correctly (**left**).

Place the chisel against the stone at the appropriate angle, depending on the type of cut desired.

Hold the hammer firmly but not too tightly.

For the best results, the hammer should strike the head of the chisel at 90°.

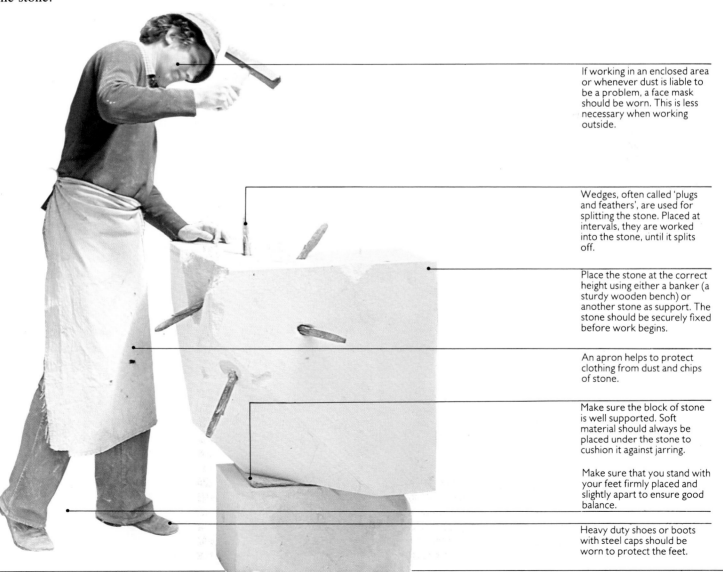

If working in an enclosed area or whenever dust is liable to be a problem, a face mask should be worn. This is less necessary when working outside.

Wedges, often called 'plugs and feathers', are used for splitting the stone. Placed at intervals, they are worked into the stone, until it splits off.

Place the stone at the correct height using either a banker (a sturdy wooden bench) or another stone as support. The stone should be securely fixed before work begins.

An apron helps to protect clothing from dust and chips of stone.

Make sure the block of stone is well supported. Soft material should always be placed under the stone to cushion it against jarring.

Make sure that you stand with your feet firmly placed and slightly apart to ensure good balance.

Heavy duty shoes or boots with steel caps should be worn to protect the feet.

SAWING

There are many kinds of saws for stone, ranging from industrial plant to simple handsaws. It is useful for the sculptor to know about the larger saws, but, in practice, the smaller disc saws and tenon types are more likely to be used. In industry, traditional wire saws are still used for primary cutting. The wire is drawn across the block by distant pulleys, while water and abrasive dust (formerly sand, but now carborundum grit) is directed into the cut. Lateral saws like giant hacksaws are also used. These too originally used sand as a cutting agent, but now the blades are tipped with industrial diamonds, set in tungsten. Multiple blades of this type are used to cut several slabs at once, rather like producing a sliced loaf of bread.

Large disc saws, higher than a man, are known in industry, but usually about 3 feet (around 1 metre) radius is the maximum. Monumental masons often have a disc which can cut up to 5in (12.5cm). Most of these saws are diamond tipped and used with water to carry off the waste material or slurry. Hand-held disc saws can be used by experts, but these are extremely dangerous.

Tenon and cross-cut saws are traditionally used in shaping soft stones such as some limestones. Tungsten-tipped saws are now available, although formerly steel and forged iron proved very successful with such soft stones. 'Drags' with saw teeth are commonly used to smooth the surface of softer stones such as limestone.

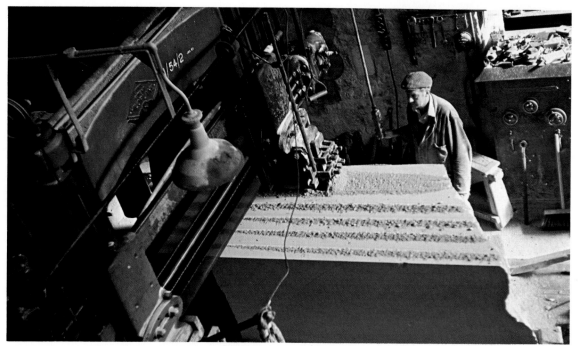

Right Huge machines are needed for cutting stone commercially. Here a guillotine is being set up ready to cut through some stone. As in all aspects of stone working, safety is of prime importance.

_ SPLITTING AND COPING _

The simplest way to remove large pieces of stone is to split them off. This is generally cheaper than sawing, as less energy and time is used. The disadvantages are that the surface may need dressing after the split, and, of course, it is not possible to make a partial split into a block. Masons use the plugs and feathers employed in quarries, but also may use a simple method, known as coping, for removing small amounts. No drilling is needed. A series of small, sharp punches, 'coping punches', are used as primitive wedges. They are nested into holes cut out by punch or fine chisel, and then treated like 'plugs', being hit in a rhythmic sequence, until a crack appears between them, and a lump is split away.

Far left Stones are stored commercially in a stockpile. The quarried blocks may be split into smaller pieces. These slabs of granite have been made into slabs using a multiple-blade saw.
Left The wedges in this stone are the 'plugs and feathers' used to split stones. Although this is a good method of splitting off large pieces of stone, it cannot be used for smaller pieces. In addition the surface may need dressing after the stone has been split.

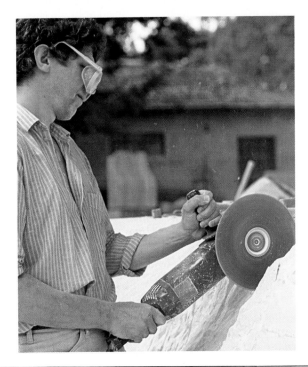

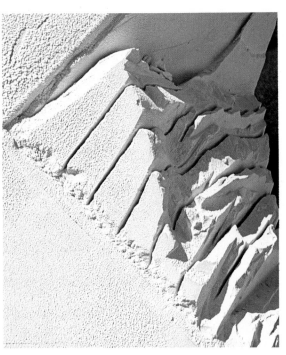

Centre left A hand held diamond disc saw is an extremely efficient way of cutting through stone. However, it is very dangerous and should only be used under strict supervision. When using any power tools, always wear safety clothing – goggles, mask (especially if working inside), stout shoes and a protective apron.
Left These saw cuts have been made by a power saw. The depth of the indentations makes it easier to smooth out the surface of the stone.

Pitching 1. The tools needed for pitching are the pitcher and a mason's hammer.

2. Gradually work along the edge of the stone with the pitcher. Start from one end and work to the middle.

3. Work in a similar way from the other end.

4. The purpose of pitching is to remove excess stone so that the more detailed work can begin. Like many carving processes, it involves gradually reducing the size of the stone block so that the broad outlines of the work emerge.

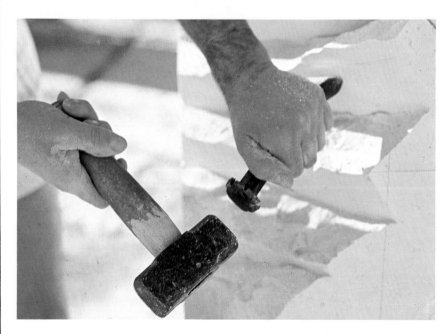

5. The amount of stone which is removed can be varied by altering the angle of the pitching tool. After pitching, chips of stone can be removed with a stiff brush.

ROUGHING OUT

The basic tools for roughing out are the pitching tool and the punch, both normally hit by suitable hammers. The job of the hammer is to deliver energy to the tool with a minimum of jarring to the wrist and arm of the mason or carver. The shape of the hammer head varies greatly. Simple cubic heads ranging from ½lb (0.25kg) to 3lb (1.5kg) or 4lb (2kg) deliver a deadened localized blow and are used in marble work. The smaller lump hammers of this type are common for letter cutting, where the weight of the head is firmly set at the top of the straight, simple shaft. The blow is directional but very controlled. The 'dummy' is a round-headed hammer which is normally used for very close work. The head can be iron or even brass or lead. This type of hammer is not directional and delivers a very specific local tap.

For stones such as limestone or sandstone requiring a heavy blow which follows through, the hammer head can be as much as 6in (15cm) long with a slightly carved top and ends angled downwards. The haft bulges slightly below the head, and the wood narrows into the metal. Granite hammers have very delicate hafts with heads almost oval in shape. Here the springing quality of the haft absorbs the jarring of the hammer head against intransigent stone. A series of lighter blows achieves more than one great swipe.

Pitching The function of the various stone tools is to convert the energy delivered by the hammer into specific forms for different jobs. The pitching tool is shaped to strike a shock wave into the stone in order to make a localized split. It is not literally a cutting tool. One side of the tool is virtually straight, and the blow is directed down this line. The other side is shaped towards the striking edge. The tool is most effective working from a smooth surface. A succession of blows side by side can multiply the shock wave and split a stone in two. Large corner pieces can be struck off by pitching, while smaller blows directed into the mass can help to prepare stone for punching.

Punching The punch is the simplest yet most widely used tool for broad work. Basically a pointed or near pointed implement, its length varies from long Portland punches which can measure 18in (45cm) down to thick waisted granite punches about 4½in (11cm) in length. Most punches have forged points. They are more drawn out for softer stone and stubbier for granite. Nowadays, tungsten-tipped punches are available.

The punch should be held fairly loosely and set at an angle to the stone. The most effective way is to follow blows along a series of parallel paths, so that each strike reinforces the next. It is counter-

productive to try to hit individual blows too deep, as the punch burrows into the stone and stops removing material.

With marble and granite, great care should be taken to stop punching just above the finished surface, since the blows make stun marks deeper than the actual cut, and these appear as whitish areas on a hard stone surface. A general rule in punching and most chisel work is to avoid hitting away from the central mass of the stone, especially at a corner, where it is a good idea to stop about 2in (5cm) short and then work inwards from the edge in the opposite direction. Following these instructions, work over the surface several times, gradually reducing the amount of stone.

Punching The punch is a traditional stone carving tool, it was much used by Michelangelo. It is a long pointed tool which makes a series of parallel strokes along the stone. Do not hit too deeply, as the punch will simply penetrate the stone and not remove any material. Do not work right to the edge of the stone. Stop the punch about 2in (5cm) above the edge and work back from the other side.

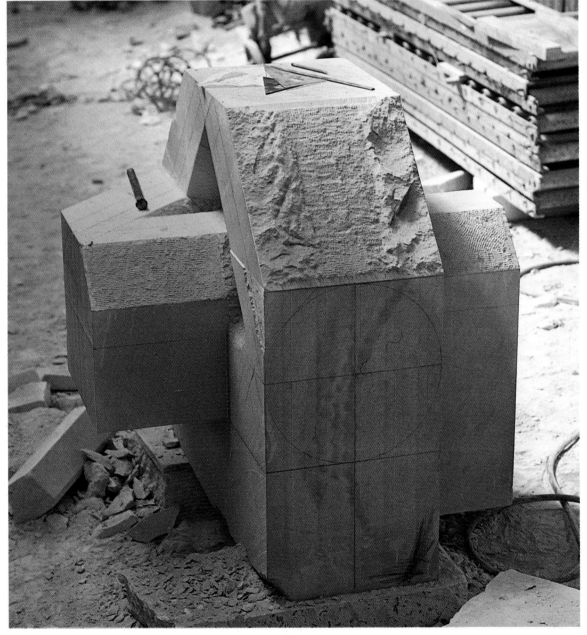

Left Stone carving is a process of gradually working away excess stone to achieve the general shape of the work, and then refining and smoothing the surface. Different tools—the pitcher, punch and also power tools—create very varied surfaces. This picture shows one surface of the sculpture after initial roughing out. The different stages can be seen clearly.

Stone carving 1. First clear away broad areas of stone to rough out the shape. Tap down the stone with a pitching tool.

2. The initial taps weaken the stone. Hit the pitching tool hard with the hammer to split and break off sections of stone.

3. Continue roughing out with a punch. Holding it at a shallow angle against the stone, make parallel cuts down the surface.

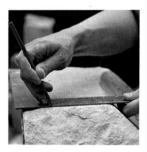

4. Use a scribe to mark out a sharp edge for cutting. Guide the scribe along a metal ruler or square held on the stone.

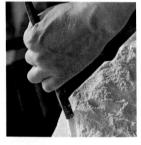

5. Cut a draft along the scribe mark with a flat tungsten chisel. Define the edge sharply and smooth down the plane.

6. Shape the stone with a claw chisel, hit with a lignum vitae mallet. The claw leaves hatched marks on the surface.

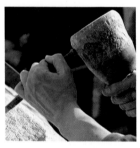

7. Work down to the final shape with a flat chisel. Do not dig right into the block.

8. The flat chisel is used to remove claw marks and define the finished form of the carving.

9. Use a rasp to file down remaining chisel marks. On soft stone, the rasp can be used as a shaping tool.

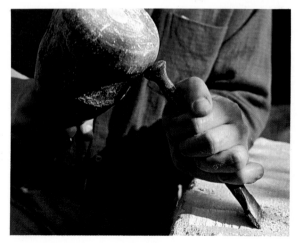

Boasting a surface Hold a wide-tipped chisel at an angle to the stone surface and apply rapid taps of the mallet to push it along, forming a series of shallow, ridged marks.

CHISEL WORK

After roughing out, the stone is worked with chisels and mallets. This stage may be repeated many times with different sizes or combinations of chisels until the desired surface is achieved.

Mallets Round wooden mallets provide a more muffled blow than a hammer, and are gentler to use. The most common wood is beech, although heavier mallets are made of the extremely hard wood lignum vitae, which has to be treated carefully to avoid undue surface splitting of the wood. Mallets have a 'beat' which is determined by the grain. In practice, carvers tend to rotate a mallet in use to avoid undue wear on one part.

Chisels There are many varieties of chisel, but the main groups are hammer-head types which have a small hitting end, and mallet-head which have a broadened, rounded hitting end. The cutting ends may be tempered steel or tungsten. Between the punch and the normal chisel is a type of chisel known as a 'claw', which consists of a row of fine punches combined into one tool. Claw chisels are made in different widths and can be found with detachable claw heads which wedge into a patent claw holder. Although a little heavier to use, these are very practical, since the teeth of the claw wear out and need replacing.

The flat chisel is very commonly used for defining and finishing a surface. In practice, a 1in (2.5cm) chisel may be found much more useful than bigger chisels, even for large, flat areas, and a ½in (1.25cm) chisel is a convenient size for the early defining of form. Letter cutters use very fine chisels which can sometimes be very useful to carvers. It is usual for masons to follow regular punch work with claw treatment to establish a surface ⅛in (3mm) proud, and then remove the final stone with steady chisel blows in controlled sequence. However, carvers may tend to work in a freer, more random way, where they are finding a form by eye rather than working to a previously calculated shape. Here, the claw is most useful, as it can work around a form without giving the emphasis of a series of flat planes. Round-ended chisels are made for special jobs, but both these and gouge-shaped chisels are uncommon in stonework.

Right Chisel attachments are available for use with pneumatic tools. A power tool can deliver more rapid and consistent force than can be delivered with a hand-held mallet but the sculptor has less sensitive control of the cutting edge. Flat chisels (**1, 4** and **5**) of various weights can be used to shape the stone. The claw chisel (**2**) is also a shaping tool, but leaves striated marks on the stone, owing to the toothed blade. A boucharde (**3**) is a heavy tool which bruises and wears away the stone. Power driven chisels may be used where they will suit the quality and resistance of the stone, but the rapid action should not obscure the gradual development of form.

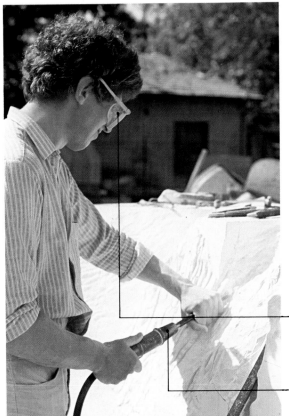

Pneumatic tools Industrial procedures led to the introduction of a range of tools powered by compressed air. Drills with hammer and twist action are widely used, and there are several systems of air hammers, which can be used to drive both punches and chisels. The Italians have developed a sophisticated range of cylinder-shaped hammer appliances which are standard industrial equipment for working marble and granite. Pistol-type air hammers are used on limestone with much longer chisels. The great advantage of air tools is the series of rapidly delivered hammer blows which are very suitable for trimming surfaces. The disadvantages are noise and possible vibration hazards, and, for some sculptors, the fact that the action of the chisel can become too insensitive. They are also more suitable for a stoneworker with some experience than for the beginner. Nonetheless, it is always essential to find procedures which are at one with the sculptor's intentions.

Power tools Power tools can be of great service to the stone sculptor. However, they should, like all electrical equipment, be used with great care. Power tools are not really suitable for the beginner; they are better for the sculptor with a little more experience. Among the advantages of power tools are that they work much quicker. Because they work by delivering a series of rapid hammer blows, they are especially good for trimming surfaces. There are several types of power tools. Of especial use to the sculptor are the power hammer and power chisel. The amount of stone removed varies according to the type and size of the tool being used.

Safety goggles

Marks of regular hammer blows

Power chisel

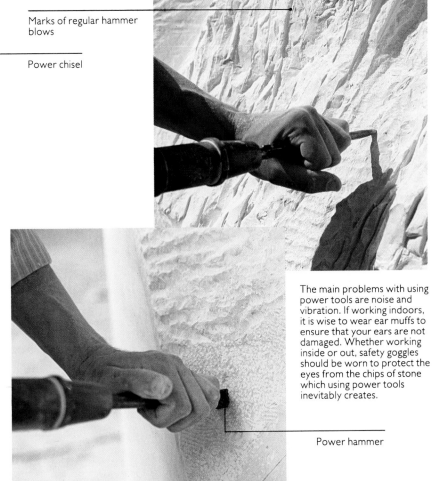

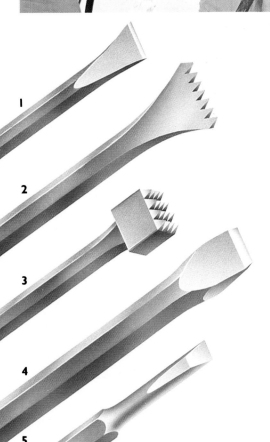

The main problems with using power tools are noise and vibration. If working indoors, it is wise to wear ear muffs to ensure that your ears are not damaged. Whether working inside or out, safety goggles should be worn to protect the eyes from the chips of stone which using power tools inevitably creates.

Power hammer

1

2

3

4

5

RUBBING AND POLISHING

There are craftsmen whose sole activity is rubbing or polishing, and for them the monotony of this stage of the work is lost in the recognition of how important a specific surface can be. Pacing the work is essential. It cannot be hurried, even when power tools are used. The basic materials are abrasive stones, usually carborundum grit in a range of thicknesses, bonded in shellac. The procedure is to work from coarse to fine, either dry, which is more laborious but more controlled, or, usually, with water to aid the cutting by removing the eroded stone. Silicon carbide paper, commonly called 'wet and dry', can also be used especially at the later stages.

Electric disc sanders are common in the trade, but, when used dry, they create a lot of dust, and, when water is used, there is a problem of keeping the water away from the power supply. Dust extraction should be considered when stones with a high silica content are being ground. One solution may be to work in the open wearing a face mask.

Above Abrasive stones come in various grades of hardness. Work with the stones, which consist of carborundum grit bonded with shellac, begins with the coarse stone (**top**), continues with the medium grade (**centre**), and the smoothest grade (**bottom**) is used for the final smoothing.

Finishing 1. Fine chisels may be used for delicate work in final shaping and trimming of the stone, and sharpening angles.

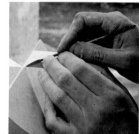

2. To avoid the risk of cutting into stone at the final stages, use a riffler to file down and work into the detail.

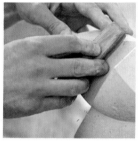

3. Finish the surface by rubbing with abrasive stones. This work may be done wet or dry.

4. Finally, use wet-and-dry or carborundum paper to achieve the final smooth surface.

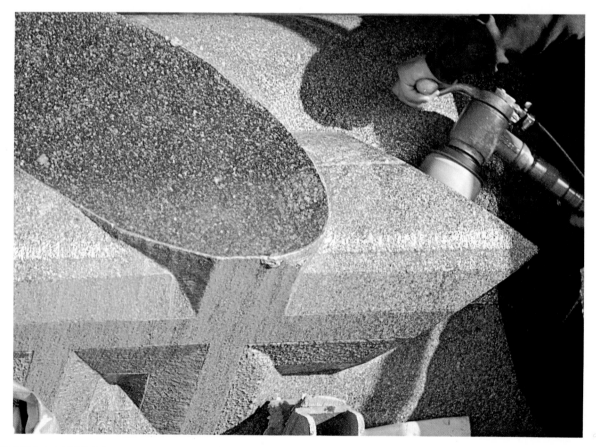

Right Power tools take much of the heavy work out of working with stone. Here a compressed air abrasive wheel is being used on granite. The shine which is produced during finishing can be seen. The work in progress is *Prism* by John Maine.

FIXING

If possible, stones are best fixed when dry, although the way separate stones sit next to each other should take potential frost damage into consideration. Drilling and pinning is a standard way of joining stone. There are electric drills specially designed for stone, some even have a hammer-drill action. Pins must be of non-ferrous metal, since iron rusts and will eventually burst the stone. Epoxy adhesives specially made for stone are usually used in a two-part mix. They are either white or 'transparent' and can be coloured by powder paint. These are usually very quick acting, and are best used out of direct sunlight. White cement is sometimes used with stone, but mortar is preferable.

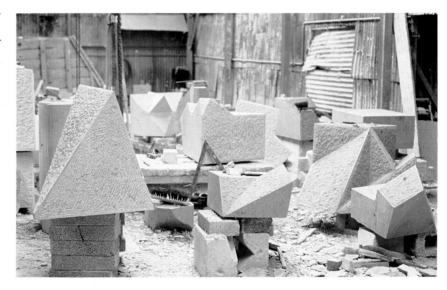

Above This studio shows work in progress on *Pyramid* by John Maine. The work took two years, from 1978 to 1980. Several of the pieces were worked on at the same time.

Left This shows the completed sculpture, *Pyramid* in its final site in a park. It is made from Portland stone, weighs about 20 tons and consists of 28 interlocking pieces. The work was assembled on site. The final surface texture is shown on the insert.

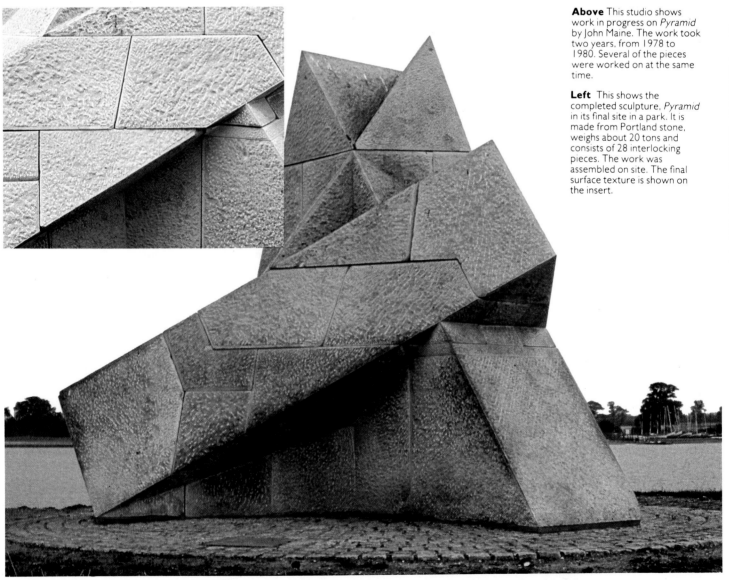

CONSTRUCTIONS

In recent years, many younger sculptors have become interested in using stone in conjunction with other media. Raw blocks of stone or slabs of slate, for example, may be stacked or set out in particular relationships. To overcome the gravity force in stone, the material has been used in conjunction with steel or wood in assemblages which seem like reorganized nature or primitive structures. The implications from the range of different approaches to the medium is that stone is seen with new vitality as a material with many qualities that can be developed for a broad range of sculptural expression.

POINTING AND SCALING UP

These are methods of reproducing a given form in stone, either as a facsimile, or larger in strict proportion. First, the form is made in a convenient material (often plaster of Paris).

'Pointing' is virtually a three-dimensional method, using the principles of triangulation, that is to say, given two known points, a third can be found by using the distances from each of these basic points. In 'pointing', these positions are established in space, using an apparatus called a pointing machine, which has adjustable arms that can be set to given points on the original model. When the machine is removed and then set up around the stone block, these arms can be pushed against the surface of the stone. As the stone is punched away, the arm is set deeper until eventually the prescribed point is established.

'Scaling up' can be achieved by the use of a scaling board, which simply converts lengths taken from the model according to the ratio of increase required. The scale on the board should be established first.

These are traditional procedures, still widely understood and used in Italy. Reproduction in this way is felt by many sculptors to overlook aspects of interpretation which should accompany the transfer of a form to a different material. However, methods themselves cannot be right or wrong, but should be used with imagination.

Starting with the simple devices of a compass, a right-angled iron and a straightedge, masons have developed a way of understanding very complex volumes. The skill has developed over centuries, and is passed on to apprentices through simple procedures, which become second nature just like the practical use of the masons' tools. In some ways, the process is like 'pointing', in that there is a logical development from known to unknown, in order to make a specific volume. The main differences are that usually no model exists to copy, and, secondly, planes rather than points are used to establish the volume. Special measuring tools—'shift stock' for angles, and 'sinking square' for depths—are more robust versions of similar tools used in carpentry. These tools may also be useful to certain carvers.

Traditionally, masons are seen as craftsmen in a succession from quarrymen through to carvers in a stoneworking hierarchy. But for the sculptor, each stage of handling stone presents its unique problems, and may have a direct bearing on the sculptor's approach. It is no longer adequate to separate preparatory work from the finishing touches.

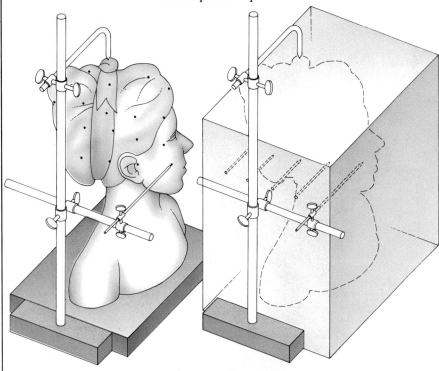

DIRECT CARVING

Any method which does not use a model of the proposed form is called direct carving. However, this title was devised to describe a kind of carving where the form of the block or boulder gave rise to ideas about the form of the sculpture. The carver changes the form somewhat, and, then, responding to the way the stone is going, he or she develops the idea further. This is perhaps the least prescriptive method of carving.

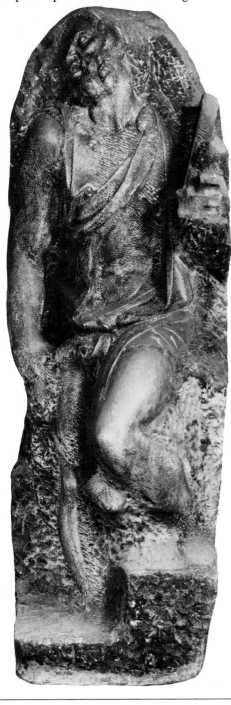

SAFETY

The main danger areas in stone sculpture are hazards associated with weight, dust, eye protection and noise.

Lifting Lifting is very much a question of common sense, but certain rules apply to tackle. Never stand beneath a block, however confident you may be in the straps or chains. Particular caution with Lewis bolt lifting is advisable. Always allow for a stone to fall and roll, and especially take account of the possibility of a chain breaking and spinning away from the block. Steel-capped shoes are advisable.

Dust Any dust is an irritant to the respiratory system, but dusts with high silica content, such as granite and especially sandstone, are highly dangerous. A safety mask should be worn, and good ventilation is essential. Vacuum systems are helpful in conjunction with power tools. Goggles with safety glass should be worn when punching hard stones, and always when grinding. Remember the abrasive grit can scar the eye even when grinding soft stone.

Noise The worst noise hazards are associated with certain pneumatic tools and industrial saws. Take sensible account of noise levels and wear ear protectors when extreme conditions prevail. Remember that constant exposure to comparatively medium levels of noise can damage your hearing after a long period.

Quarry work In quarries and on site it may be appropriate to wear protective headgear. Procedures for blasting are normally clear, but a degree of unfamiliarity with the rules or simply being preoccupied create extra danger.

General However, with reasonable experience and awareness stoneworking can be perfectly safe. Problems usually only occur through being overtired or taking undue risks.

Left The statue of *St Matthew* by Michelangelo was begun in 1506. From the unfinished work, it is easy to see how the figure is emerging from the block of stone. It is interesting that this piece seems to show that Michelangelo worked from one face of the sculpture, rather than in the round. Those parts of the figure which jut out most are almost complete, while the virtually raw stone block is still visible around the outline of the figure.

PLASTER

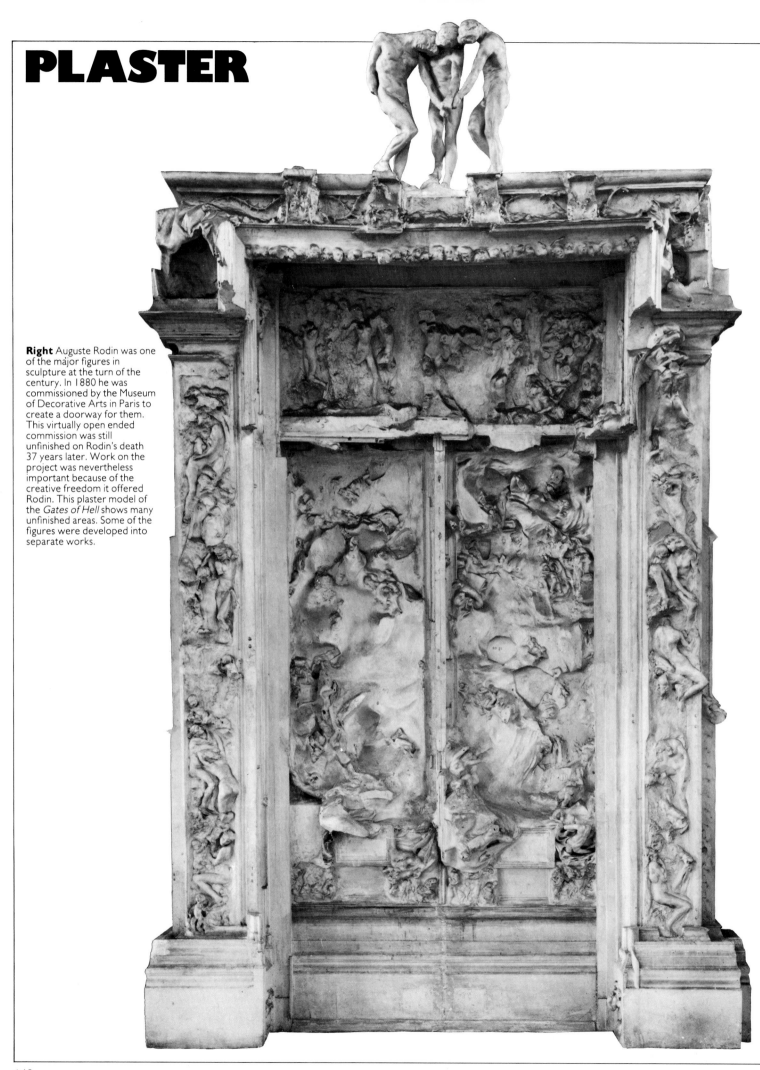

Right Auguste Rodin was one of the major figures in sculpture at the turn of the century. In 1880 he was commissioned by the Museum of Decorative Arts in Paris to create a doorway for them. This virtually open ended commission was still unfinished on Rodin's death 37 years later. Work on the project was nevertheless important because of the creative freedom it offered Rodin. This plaster model of the *Gates of Hell* shows many unfinished areas. Some of the figures were developed into separate works.

HISTORY

Plaster was used by the ancient Greeks to make casts from statues. The early Greek sculptor Lysistratos is credited with developing the process in the fourth century BC. However, it is now known that the Egyptians used plaster for making death masks and casting from parts of the human body as early as 2400 BC.

Despite its use by the great classical civilizations, plaster seems to have fallen into disuse as a medium for sculpture after the decline of the Roman Empire. It was not revived until the Renaissance. The first main Renaissance exponent of plaster sculpture was the Italian Andrea Verrocchio (c 1435–1488). He frequently used plaster for making casts from life. Verrocchio's techniques were vividly described by his contemporary Vasari in his influential work *Lives of the Artists*. This provides a fascinating glimpse into the practice of sculpture with plaster, which, because of the nature of the medium, has changed little over the years. Vasari wrote: 'Andrea was very fond of making plaster casts, for which he used a soft stone quarried in the districts of Volterra and Siena and in many other parts of Italy. When the stone is baked in a fire and then crushed and made into a paste with tepid water, it becomes so soft that it can be fashioned into whatever shape is wanted, and, then, when it has dried out, it sets so hard that whole figures can be cast from it. In the moulds he has made from this stone, Andrea used to cast various natural forms, such as knees, legs, arms and torsos, which he kept by him for copying purposes. Then during Andrea's lifetime the custom started of doing inexpensive casts of heads of those who died, and so one can see in every house in Florence, over the chimney-pieces, doors, windows and cornices, endless examples of such portraits, so well made and natural that they seem alive. This practice has continued until the present day and has proved extremely useful in making available to us the portraits of many of those who appear in the scenes painted in Duke Cosimo's palace. For this we are indebted to the talents of Andrea who was one of the first to make such casts.'

This description illustrates much that is relevant for plaster sculpture today. The medium is cheap, readily available and relatively easy to use. Vasari praises Verrocchio's practice of casting from life because of the naturalness which he achieves.

The pursuit of naturalness at the expense of other sculptural values led to a relative decline in the art of sculpture which continued until the time of Rodin. The Frenchman Auguste Rodin (1840–1917) surrounded himself with plaster casts of his sculptures or parts of them. Using these casts, he could assemble figures from the fragments and thus achieve the freedom with anatomical form which is characteristic of his work.

When Rodin exhibited his first major work, *The Age of Bronze* in 1878, first in Belgium and then in Paris, he was accused of casting it from life. These allegations were disproved, but they did bring to light that casting from life was a frequent practice among sculptors, and one which had reduced the vitality of sculpture as an art form.

Since the days of the ancient Greeks, the main use of plaster has been as a transitory medium for finalizing a shape, before it is cast into a more permanent material such as bronze. This tradition has continued in the twentieth century. However, in recent years, sculptors such as the Americans George Segal (born 1924) and Claes Oldenburg (born 1929) have produced permanent figurative works in plaster. Plaster has also recently been used as part of a mixed media approach to sculpture. Its main use, however, remains that of a transitory material.

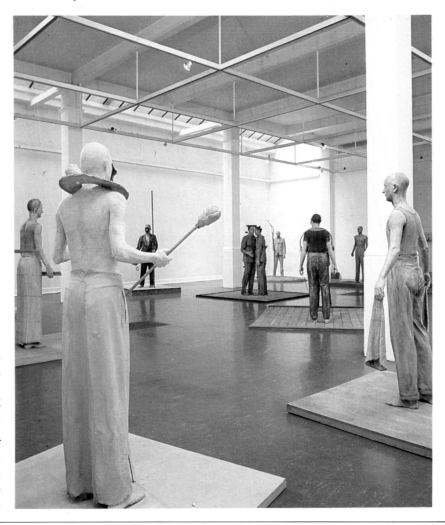

Below This picture shows an exhibition of work by the young British artist John Davies. Plaster plays an important role in his works, although they also include other materials. The figures are life size. The figure in the foreground is called *Old Enemy* and was made between 1973 and 1975.

TECHNIQUES

Hydrated calcium sulphate $CaSO_42H_2O$ (gypsum), when heated to 350°F (117°C), loses 75 per cent of its water to form $CaSO_4\frac{1}{2}H_2O$, which is known as plaster of Paris. It is named after the Paris region in France, which has an abundance of gypsum. Commercially, the plaster is more often called dental or superfine casting plaster and this is the grade most often used by sculptors.

Bought plaster comes in the form of a white powder which, when mixed with water, recovers the water it had prior to being treated by heat, and sets to a uniform mass with the same composition as the original gypsum.

Gypsum is found in a variety of forms, alabaster being one which is well known to sculptors as a soft and easily carved stone. Most of the gypsum deposits which occur widely are believed to have been formed by the slow evaporation of sea water, resulting in a mineral concentration which formed the gypsum.

PREPARATION AND TOOLS

Work surfaces and the areas around them should be as simple as possible, so that cleaning down can be relatively easy. Plastic sheeting can be used to cover or surround the work space, as plaster easily cracks off plastic once it has set. The sink used for cleaning bowls and tools should be equipped with a plaster trap to prevent drains from being blocked.

Even allowing for an adequate drainage system, surplus plaster should be scraped into a waste bin, and the bowls and tools wiped clean with old newspapers, before being washed at the sink. Plastic bowls are excellent for mixing plaster in, as dried plaster can, if necessary, be easily cracked away from the surface by flexing the bowl. However, it is preferable not to have to resort to this practice too often or the bowl will be weakened. Sharp or metal instruments should not be used for cleaning bowls as the scratches they cause will tend to form a key for future plaster

Below *Balustrade* by Barry Midgley is a mixed media work featuring plaster for the balustrades. The small trees visible above the landscape are made of lichen. Many artists have worked with plaster either as a transitional medium or as a component in a mixed media work.

mixes, making cleaning the bowl progressively more difficult.

If no plaster trap is fitted, a tin bath or large bin can be used to clean bowls and tools while work is in progress. When the work is complete, the plaster should be allowed to settle, the water poured away and the sludge that has settled at the bottom of the container disposed of.

Apart from mixing bowls, other items that should be available in the work area include paint scrapers, old or cheap wood chisels for carving or prising open moulds, wooden wedges for splitting moulds or tightening ropes holding mould sections together, a tyre inner tube cut into rings for holding smaller moulds together, surforms, rifflers, plaster rasps and perhaps an old cheese grater for rough forming work. Finally, a mallet, hammer, pair of pliers, general purpose saw, junior hacksaw and a pair of scissors are useful. Experience and the type of work being undertaken will expand this list.

STORAGE AND CARE OF TOOLS

Plaster is usually bought in 1cwt (51kg) paper sacks which should be stored in a dry area and raised from the floor on a wooden pallet to avoid contact with moisture. It is best to use fresh plaster when possible, but, if it has to be ordered in bulk and stored for a time, the paper sacks should be placed in large plastic bags and made airtight. This will keep the plaster in good condition for long periods.

Mixing bowls and tools should be cleaned during and after use, and metal tools rubbed with an oily rag to prevent rusting. Wooden formers can be scraped down with a paint scraper and surforms should never be left clogged with damp plaster. Although most tools used in working plaster are relatively cheap to purchase, they should, nevertheless, be treated with respect.

MIXING PLASTER

A clean plastic or enamel bowl should be used for mixing plaster. Clean, cold water is added to the bowl first, and plaster is sifted through the fingers into the water. Any lumps which are found in the dry plaster should be removed. The plaster is sprinkled into the water until it begins to stand above the surface of the water, forming a 'desert island', while the water soaks up through it. Once all the plaster is wet, tap the bowl to dislodge any dry plaster sticking to the sides of the bowl, and now mix it thoroughly. The mixing should not be carried out until this stage. Mixing is best done by placing an outspread hand into the bottom of the

TOOLS

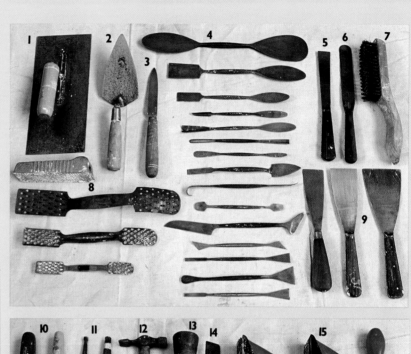

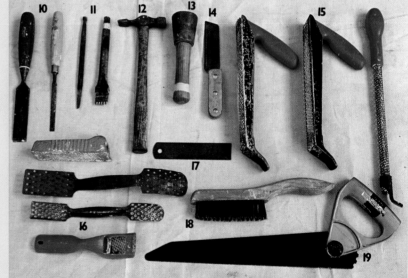

The great variety of tools used for working with plaster are usually not very expensive, but should still be treated with care, as clean tools are important for good results. The tools pictured here are for carving and shaping, and the same tools can be used whether the plaster is being worked for casting or being used in its own right. A few of the tools which are available for plasterwork include: a float (1), pointing trowel (2), parting knife (3), assorted modelling tools (4), scraper (5), spatula (6), wire brush (7), plaster rasps (8), assorted larger scrapers (9), flat chisels (10), claw chisels (11), hammer (12), dummy (13), knife (14), surforms (15), plaster rasps (16), scraper made from a broken hacksaw blade (17), wire brush (18), and a general purpose saw with an adjustable blade (19). Other useful items would be rifflers, wooden wedges, an old cheese grater for creating rough work, a mallet, pliers, a pair of scissors and plastic bowls.

Plastic bowls are the best possible containers for mixing plaster. Metal tools should never be used for cleaning these bowls, because they will leave scratch marks which will eventually make the bowl impossible to clean thoroughly. After metal tools are cleaned they should be rubbed with an oily rag to prevent rusting. Remember that surforms must never be left clogged with damp plaster.

Mixing plaster 1. Fill a plastic bowl with clean water. With dry hands, sprinkle plaster evenly around the bowl.

2. Continue sprinkling plaster until it stands in small islands above the surface of the water.

3. Place your hand flat in the bowl and move it briskly from side to side to mix the plaster and water to a cream.

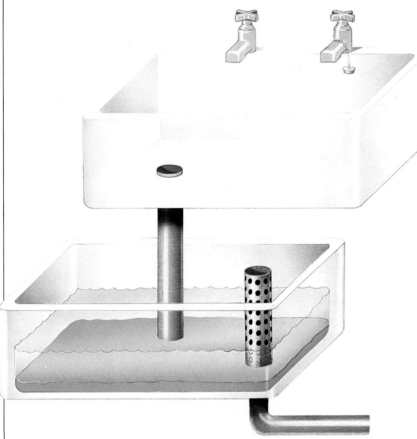

Plaster trap This diagram shows a sink fitted with a plaster trap. One of the problems of working with plaster is that it inevitably creates a certain amount of mess. As plaster is relatively quick drying, frequent washing of tools, bowls and hands is necessary to prevent equipment becoming clogged, and dried plaster mixing with fresh. However, this vigorous activity can cause blockages in the sink pipes or drains, so, if you intend to use plaster often, or over a long period of time, it is well worth fitting a plaster trap to the sink. This is a second sink underneath the main basin, into which the water flows. The flow is interrupted and passes through a second outlet pipe which is a filter. The water runs through freely into the main drainage system, but small bits and pieces of plaster cannot enter the filter pipe and they gradually collect in the trap, forming a thick sludge which can be scooped out and disposed of elsewhere.

bowl and shaking the mix from side to side. The result should resemble thin cream and be of a uniform consistency. If care is taken in following these procedures, fresh plaster in good condition should give about 15 to 20 minutes working time before the chemical reaction which is taking place makes it too thick to use. Old plaster will tend to thicken quickly, and, if it is too old or has not been stored properly, it will set but not harden.

To test plaster, pinch some dry plaster between your fingers. If it retains its shape, it is useable but, if the shape disintegrates, the plaster is old or has been exposed to damp.

When making a plaster mould to be used for slip casting or press-moulding, it is advisable to measure the water and plaster, so that the parts of the mould absorb moisture from the clay at the same rate and thus do not cause distortion in the moulded item. The measurements for this are equal volumes of water and plaster or approximately 2¾lb (1.25kg) of plaster to 2 pints (1.1 litres) of water.

ACCELERATING AND RETARDING PLASTER

The setting of plaster rarely needs to be speeded up, as its normal time of 15 to 20 minutes is usually fast enough. However, when it is thought necessary to accelerate a mix, it is probably simplest to use warm water. Alternative means of acceleration include the addition of salt, approximately ½oz (12g) to two pints (1.1 litres) of water. Increasing the amount of plaster in the mix and vigorously agitating the plaster also accelerate setting, although this would be unsuitable for fine work, as the agitation would trap air bubbles in the mix and cause pinholes in the final surface of the set plaster.

Retarding setting is more often desirable, particularly when working on large sculptures or when modelling complex works, as the extra time allows the surface to be more carefully controlled. The addition of glue size to the mixing water is the best retardant and also increases the strength of the plaster. Mix the glue size as normal and add a 1oz (25g) to every 2 pints (1.1 litres) of mixing water. To lengthen the setting time, increase the amount of glue size. The addition of acetic acid, approximately 5 per cent, to the mixing water will also retard a mix. A further method is to add plaster to the water as normal but, instead of mixing, leave the plaster and water to stand for 10 minutes. The mix will thicken and remain plastic for longer than a normal mix, but it will also be weaker in strength. This method of retarding is, however, particularly useful when modelling direct with plaster or when doing final work such as filling surface blemishes.

SEPARATORS

When using plaster for mould-making or casting, it is necessary to use a separating agent between the parts of a mould, between the mould and the material from which it is being taken, or even between a plaster mould and the material being cast from the mould.

Slip A thin clay slip, made by mixing clay and water to a thin creamy consistency, is a simple separating agent, which is suitable for use on mould walls or to separate plaster from a wood casting box or baseboard. It would not be suitable for use as a barrier between a mould face and a cast, as it would tend to fill in fine detail. To produce a barrier between a plaster cast and a plaster mould, brush soft soap vigorously onto the damp mould surface until a foam appears, dab off excess soap and repeat the process until a sheen appears. This separator allows very fine detail to be reproduced.

Oil Another separating agent that can be used on simple geometric forms is thin oil. When making a mould from a hand or when life casting, petroleum jelly should be used to allow release and prevent the skin being dried.

ARMATURES

When modelling with plaster, it is necessary to build an armature onto which the plaster can be applied. As when modelling clay, care should be taken when designing the armature to ensure that it is the correct size and proportion and that it is rigid enough to support the weight of plaster to be applied and to withstand the handling and modelling. For small-scale works, square-section aluminium wire may be adequate, whereas, for larger work, mild steel rod or tubes welded or bolted together may be necessary to support the work. Experience will help in the choice of armature.

Steel If mild steel is used to make an armature, it should be painted with either shellac or metal primer to prevent rust marks staining the surface of the plaster. Galvanized binding wire should then be bound around the main tubes to help the plaster key onto the armature.

Wood Wood is generally not very suitable for armatures, particularly for complex forms, as it will soak up water from the plaster, causing it to swell and crack the sculpture unless it has been well sealed with shellac. Also, if it is necessary to alter the armature after work has started, it is easier to bend a steel rod into the new position than to reorganize a wooden support.

Wire netting For a large volume model, wire netting is often used to help reduce the amount of plaster needed. After building an armature in wood or steel, wire netting is wrapped around it and attached with galvanized binding wire. The netting should be shaped as far as possible to the profile of the sculpture being made and supported internally with crumpled newspapers, cardboard or polystyrene chips. Onto this framework layers of scrim—an open weave fabric—soaked in plaster are built up to the final shape, and a layer of neat plaster used to make a 'skin' for the form. This allows surface detail to be worked with a chisel, file or spatula.

Polystyrene For very large work, a more flexible working method is necessary. A block or blocks of polystyrene are stacked to the required height and then carved with saws, hot wire cutters or rasps to the required profile. This is then covered with a layer of plaster and scrim in the usual manner. The advantage of this working method is that it gives infinite room for changes of design, is light, strong and a rapid building method. The finished work can then, if necessary, be cut into manageable sections for casting or transporting.

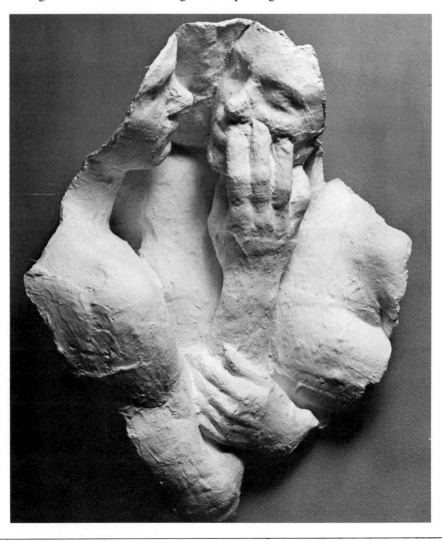

Below In *Lovers* by George Segal, no attempt has been made to smooth away the modelled texture of the plaster. The theme of two figures touching is emphasized in the tactile quality of the actual material.

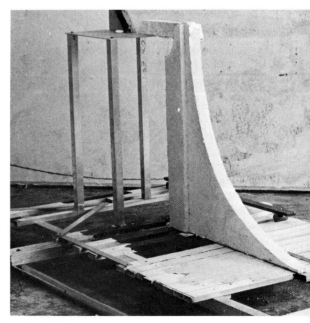

Above Using plaster, Brancusi achieved the clean lines and simple definition of form in *The Tortoise*.

MODELLING

Having built an armature, the choice of plaster modelling technique is very much a personal one. However, some rules must be observed if the sculpture is to be successful.

When adding more plaster to plaster that has already set, it is essential that the latter is saturated with water to prevent it from sucking water from the new mix and, in so doing, affecting its strength. Failure to do this will cause the new plaster to crack away from the older plaster and prevent a proper bond. Until the final surface is reached, keep the layers of plaster roughened where possible, so as to form a key onto which additional plaster can be placed.

Organize the work so that the build-up of plaster is as continuous a process as possible, without long periods when the work is left to dry out. Should this happen, then the work already carried out must be saturated with water before any more plaster is added.

If it becomes necessary to cut the surface back and scrim appears on the surface of the work, it is usually better either to cut it out or to knock the supporting wire netting in with a hammer and plaster over the hole rather than attempt just to hide the scrim with a thin layer of plaster. If the latter course of action is taken, the scrim invariably makes a reappearance at a later stage.

Modelling tools Tools used for modelling or shaping plaster include metal modelling tools, plaster rasps, surforms, paint scrapers, rifflers (for dry plaster only), old wood saws or general purpose saws with replaceable blades, and broken hacksaw blades.

Modelling with plaster 1. Make a suitably shaped armature with square-section aluminium and chicken wire.

2. Pad out the armature with rolls of newspaper bound to the stem with wire.

3. Block out the base with clay if appropriate. If the armature is well padded, the weight of plaster will be reduced.

4. Cover the whole shape with scrim soaked in plaster to form a reinforcing layer before modelling the surface.

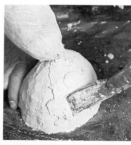

5. Add more plaster with fingers or using metal modelling tools. Develop the form, keeping plaster rough to provide a key.

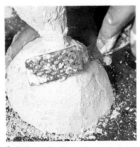

6. When the form has taken shape, smooth down the surface and refine the contours with surforms and scraping tools.

CARVING PLASTER

As an introduction to the carving process, plaster affords a cheap and economic material to practise on. However, plaster does not have the same resistance as or the permanence of stone, so it should not be considered as requiring exactly the same technique.

To make a block of plaster suitable for carving, use a strong cardboard box, sealed with tape and greased to prevent water penetration, and pour a plaster mix into it. Once it has set, the cardboard can be stripped away and the carving begun.

When carving plaster, it is preferable to keep the area being worked on *damp*, as this helps prevent fractures occurring by absorbing impact. However, when using a rasp, surform, riffler, drill or sandpaper, the plaster should be kept *dry* as this will not clog the teeth of the tools.

Surforms and plaster rasps are more useful than conventional rasps when it is necessary to work the plaster damp, as their design prevents clogging or at least makes it easy to clean them.

The carving can be either left in a state that shows the carving process or it can be filed or sanded to a smooth finish. If the plaster is still damp, wet-and-dry paper can be used to achieve a smooth finish. If the plaster is dry, sandpaper should be used. In both cases, coarse grades should be used first, followed by finer grades.

Carving tools Tools required for carving a plaster block include both wood chisels and stone chisels, mallet, rasps, rifflers and sandpaper. When using chisels for roughing out, they should not be driven too far into the block or they will act as a wedge and may split the block.

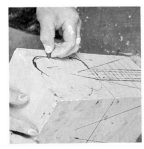

Carving plaster 1. Make a solid plaster block in a casting box. Draw up rough guidelines to the design on the faces.

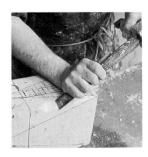

2. Rough out the basic form with a flat chisel. Work in towards the centre of the block to avoid breaking off the edges.

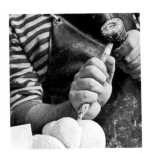

3. Shape rounded forms with a claw chisel. Push the chisel carefully with a small mallet, developing the carving slowly.

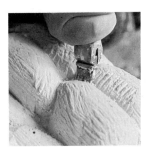

4. The claw chisel makes small criss-cross marks on the surface. It is a stone carving tool, but wood chisels can be used.

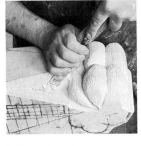

5. Plaster is not a very resistant carving material, so the chisels may be pushed with the hand rather than hit with a mallet.

6. To eliminate chisel marks and produce a clean rounded surface, finish off the carving with a plaster rasp.

Right This detail comes from a large sculpture by Henry Moore called *Internal and External Forms*. It shows the texture of carved plaster in a work formed for casting in bronze. Marks left by chisels and rasps make the surface as active and exciting as the form itself.

Left Plaster is frequently used as a component in mixed media sculpture as it is versatile and relatively cheap. It can be cast or formed if a geometric shape is required, or more roughly modelled or carved. In this large construction, *Black Virgin* by Michael Kenny, plaster is combined with wood and metal.

Forming a hemisphere I.
The quarter circle template fits to a metal rod set in the centre of a wood base.

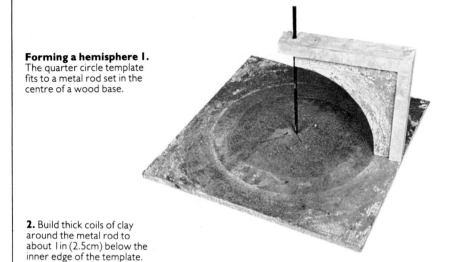

2. Build thick coils of clay around the metal rod to about 1in (2.5cm) below the inner edge of the template.

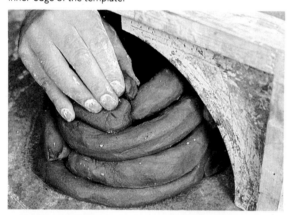

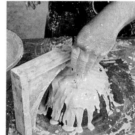

3. Throw a coat of plaster over the clay core. Cover it completely with plaster.

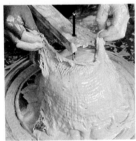

4. Reinforce the plaster coat using scrim soaked in plaster wrapped around the circular form.

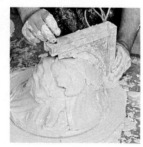

5. Build up a thick coat of plaster over the scrim. Rotate the template to scrape away surplus plaster.

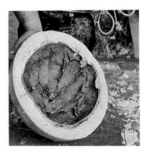

6. Complete the shape and let the plaster dry out. Remove the hemisphere and clean out clay from the inside.

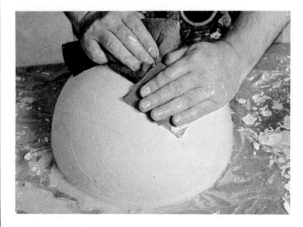

7. Fill the small hole left by the rod with fresh plaster. Soak the surface and smooth it with wet and dry paper.

SIMPLE FORMING DEVICES FOR REGULAR SOLIDS

A hemisphere can be constructed by setting a vertical axle into a baseboard and constructing a hemisphere using wire netting, or, for small shapes, clay. The netting or clay core should be made smaller than the desired final size in order to allow for the thickness of the scrim and plaster to be used. The axle should be greased to prevent sticking and should project higher than the radii of the finished hemisphere. Next, a template is attached to the axle in such a way as to allow for its easy removal.

With the template removed, the inner core of wire or clay is covered with scrim dipped in plaster—two coats are usually enough. Large-scale items may need the addition of mild steel reinforcing rods which should have been pre-formed and sandwiched between the coats of scrim. The template should be cut from a zinc-plated mild steel sheet attached to a wooden frame for reinforcement. However, depending on the intricacy of the shape to be formed, even hardboard could be used if suitably sealed and reinforced.

The template should occasionally be fitted on the axle, and a check made that the scrim and reinforcement are kept below the surface of the required shape. Plaster should then be poured over the scrim, and the template turned around the axle until it scrapes the plaster surface and, in so doing, forms the finished shape. The template will need to be removed and cleaned at regular intervals to avoid any build-up of plaster which may score or mark the surface of the form. Once the form is complete it can be removed from the axle and the inner clay core taken out.

Linear plaster shapes of any reasonable length can be formed by attaching a wooden batten, which is the length of the required shape, to a baseboard. Make sure again that the baseboard is greased to prevent the shape which is being formed from sticking. Make a template so that it slides against the batten. The shape required should be blocked out with clay or netting if necessary. Scrim reinforcement and plaster can be added in the same way as when turning the hemisphere until the shape is achieved by scraping the template along the length of the form.

The thickness of plaster and reinforcement necessary are very much a matter of experience. If the object is to be long and reinforcement added along the length, then it should be rigid enough not to flex too much. This will probably affect the thickness of the plaster used, as the reinforcement should not be placed too near the

final surface of the plaster. Templates should be designed so as to eliminate undercuts which would prevent their removal from the completed work, or so that they can be run off the end of the shape being formed.

FORMING

Plaster shapes to be used either as forms for carving or as parts of a larger work can often be created by simply pouring plaster into a prepared former, such as a plastic bag or cardboard box, and leaving it to set.

A useful and versatile device for forming plaster is a casting box which, together with a baseboard, enables rectangular solids to be produced quickly and easily. The rectangularity of shapes cast in this way can be altered by filling parts of the box with clay or other suitable materials to create negative shapes between the casting box and the plaster. Wood should be screwed down, either to the base or to the walls of the casting box, to prevent it from floating when plaster is added. It would also need the application of separator, as would the casting box.

A baseboard may be either sealed wood or ¼in (6mm) glass laid on a pad of polystyrene. When using a casting box regularly, it may be desirable to construct the sides out of wood faced with formica to make cleaning and release easier.

The sides of the box should be smooth and the ends cut at precisely 90° to the edges. At one end, an L-shaped bracket should be attached so that it projects downwards against the end, at the same distance away from the end of the box as the thickness of the wood. The box is assembled so that each L-shape links one board to the other, forming a square that can be adjusted to a rectangular shape of any proportion.

Simple cylindrical forms can be cast using a tube made from tin-plate, lightly oiled, tied and sealed around the bottom against the baseboard using clay. If more accurate or complex cylindrical forms are required, then a turning box may be more useful.

Spheres and spherical shapes can be cast using a turning box or, for rough shaping, a balloon, plastic bag or two halves of a ball, which has been cut in half, can be used. A turning box can also be used for forming regular plaster cylindrical shapes that do not include undercuts. Its basic construction is a box without a top or bottom. A metal shaft is fitted across the top of the box, which has one end cranked to form a handle. To one side of this shaft, a wooden plate onto which a template can be added is attached. The design should enable the top plate assembly to be removed easily. Now cut a template of the desired profile from zinc-plated mild steel or some other suitable

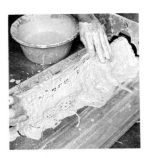

Forming a linear shape 1. The former consists of a metal template supported upright against a batten fixed to a flat board. Make a clay core for the shape.

2. Mix a bowl of plaster and throw it onto the clay to form a covering coat. Eliminate any air bubbles.

3. Build up the plaster layer and apply scrim soaked in plaster as reinforcement along the whole shape.

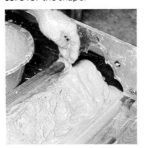

4. Completely cover the scrim with fresh plaster, working up towards the inner curves of the template.

5. When the plaster layers are sufficiently thick, brace the template against the batten and draw it along the form.

6. Add more plaster and scrape it down again with the template. Repeat until the linear form is smooth and perfectly shaped.

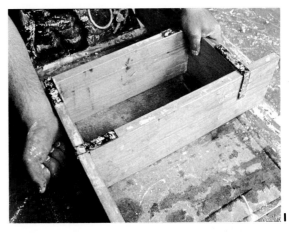

Casting box This can be used to form solid plaster blocks which can be carved. It is constructed of four pieces of wood, each having an angle iron set at one end (**2**). The irons hold the sections together but, as each is movable, rectangles of different proportions can be cast by altering the lengths. When the box is assembled (**1**) the irons are secured with wedges (**3**). The box is set on a wooden base, coated with a release agent and sealed around the base (**4**). Plaster is poured in and left to set hard.

thin sheet material. The template is half the diameter of the shape being turned, less the radius of the shaft.

When working on a small scale, make the box so that it fits over a bowl, as this will help with collecting and recycling the liquid plaster. When the template has been put in place, scrim soaked in plaster or string is bound around the shaft to bulk out the volume. The shaft should be turned occasionally to make sure the scrim is not catching on the template. New plaster is built up by pouring over this core while turning the handle. As the shape builds up, it begins to scrape against the template and the required shape is formed. The template will need to be removed frequently so that the plaster can be cleared off it. When the turning operation has been completed, the template can be removed and any final smoothing down carried out using wet-and-dry paper. Continue to turn the handle during this process. The shaft should then be removed from the shape and the operation is complete, apart from filling the hole which has been left by removing the shaft.

Turning box The principle here is similar to that of forming a shape, but the plaster is built up on a spindle and rotated against the template, which remains fixed.

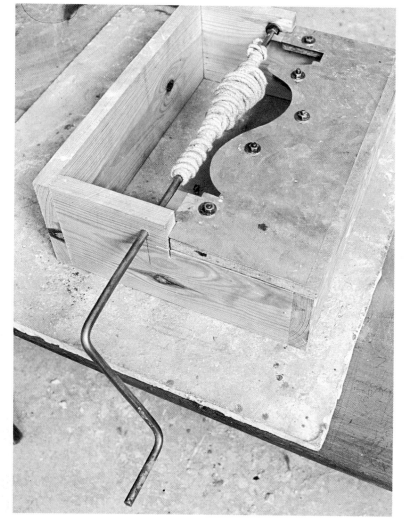

MAKING A HOLLOW REGULAR SOLID USING PLASTER

As well as being moulded, modelled or carved, plaster can be used as a sheet material can be built into regular solids such as cubes or pyramids.

Cubes To build a cube, make a former using a baseboard of chipboard or plywood and softwood battening, chamfered to an angle of 45°. The battens should be fixed to the baseboard using screws, so that they can be released and relocated as necessary. The depth of the battening should be the depth required for the final plaster panel. After applying a releasing agent to the former, a quantity of plaster is poured in and allowed to stiffen. More plaster is then mixed, and scrim is dipped into this and applied to the back of the plaster in the former. Take care not to allow the scrim to come into contact with the edge of the former or be pushed through to the surface of the panel. Any additional reinforcement thought necessary is now added, and more plaster and scrim applied over this. Finally, the thickness is made up by pouring plaster over the reinforcement and the whole is levelled by scraping excess plaster off with a piece of wood pulled across the top of the battens. Once set, the shape can be removed from the former and the other five panels cast.

As each panel is cast, it should be laid flat on top of the others until ready for assembly. To assemble the cube, the panels are first soaked with water and the edges scratched to form a key. Five panels—four sides and a base—are fixed together by applying plaster as a cement between the chamfered edges and tying the side panels together using rope and wedges or corner clamps. If rope is used, the corners must be protected with packing to avoid damage. The sides are assembled over the fifth bottom panel, and the corners are reinforced internally using plaster and scrim down and along each seam. Finally, the sixth panel is fixed in place using the method described, although, of course, these seams cannot be strengthened from the inside. The edges can now be cleaned and the shape is complete.

Quite large, surprisingly strong and rigid box shapes can be formed in this way, without the need for metal reinforcement. Although this type of shape could be made simply using wood, plaster may be more appropriate, and the surface can be subjected to a different and interesting range of treatments, such as fresco paintwork, staining or inlaying of objects and marks. In this way, a wide variety of effects can be achieved. Plaster is a surprisingly versatile medium.

Building a hollow solid I.
Make a rectangular former for plaster slabs by attaching a framework of chamfered battens to a base.

2. Assemble the former and apply a release agent to all the inner faces. Petroleum jelly is suitable for this.

3. Mix up plaster and pour enough into the former to make a layer about ¼in (6mm) thick.

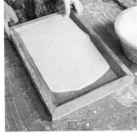

4. Spread the plaster evenly by tilting the mould and tapping it gently on the worktop, forcing out air bubbles.

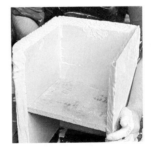

5. Reinforce the first layer by laying on scrim soaked in plaster. Keep it away from the edges of the shape.

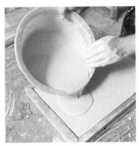

6. Pour in more plaster until the former is completely full. Make sure that the scrim is completely covered.

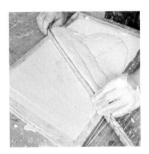

7. Level off the surface of the plaster by pulling a wood batten evenly across the top. Allow the plaster slab to dry out.

8. Make as many pieces as are required for the final form. Soak them with water and scratch the edges to provide a key.

9. Pour plaster along the edges of each shape to act as adhesive for the joints.

10. Assemble the pieces into shape. Use a thick wood section to guide them into place or if possible use corner blocks.

11. Tie the hollow form with string to keep the pieces in place until the plaster has set.

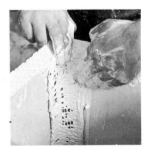

12. Reinforce inside seams with thick plaster and scrim soaked in plaster.

13. Stand the form upright on a greased base and seal the bottom with clay. Pour in plaster to form a base.

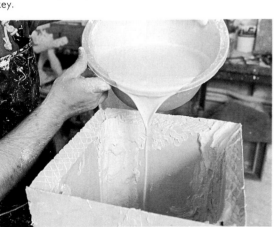

14. When the whole piece has set, fill the outer joints with fresh plaster. When dry, rub them down to a smooth finish.

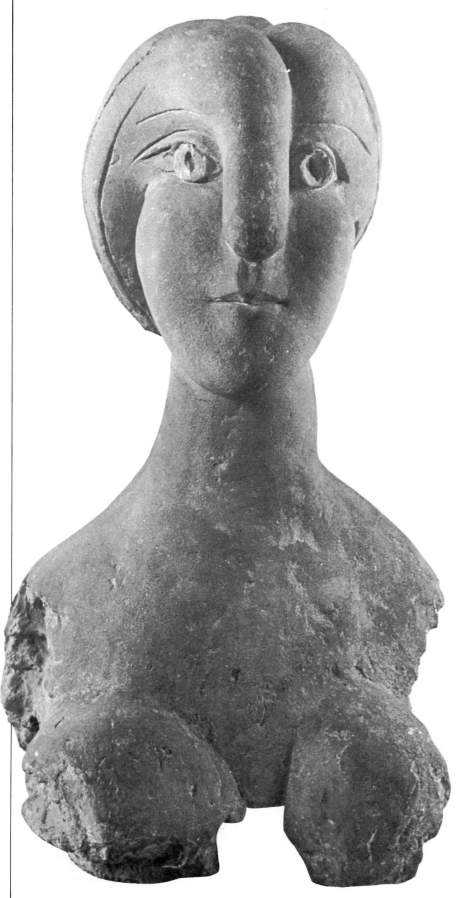

FINISHING

A plaster sculpture may need to have its surface sealed to prevent dust and dirt building up in the pores. When plaster is still damp, it appears more dense than when it has dried out, at which stage it takes on a more 'dusty' appearance.

Waxing If a dense appearance is desired, then the old technique of waxing will help the surface retain some of this quality.

The plaster should be warmed prior to treatment so as to allow the wax to impregnate the pores. The wax, which should be stearin wax if possible, should be melted in a double boiler to which liquid turpentine is added in the proportions 1oz (25g) wax to 8oz (200g) turpentine. Care must be taken that the wax is not too hot, otherwise the turpentine may combust. Also, the turpentine should not come into direct contact with the heat source.

The solution is then applied to the plaster with a large, soft bristle paintbrush, starting at the top. Several coats will be needed, depending on the finish required. The work should then be allowed to cool and, if a polish is wanted, the whole work should be rubbed with a pad of cotton wool and talcum powder. This process produces a surface resembling ivory.

Shellac Another method of sealing plaster is to coat it with shellac. Make sure the surface is free of dust and grease, and paint the shellac onto the work with a large, soft paintbrush. After one coat, the surface will be sealed, and subsequent coats are used to build up the degree of polish, although too many will fill in detail and darken the plaster. Indeed, this method has even been used to give work an 'antique' quality. When the polish has been applied and allowed to harden, a little dry powder colour, such as yellow ochre, raw umber or light red, can be mixed with methylated spirit in a saucer and painted into the hollows and creases on the work to darken and 'age' it. Any colour that runs can be wiped clean using cotton wool and methylated spirit.

Left *Bust of a Woman* by Pablo Picasso is one of the plaster heads which the artist made in 1932. The main feature of the head is the unusual treatment given to the nose, while the eyes, eyebrows and hair appear rather roughly incised and modelled. The shoulders seem almost untouched. Plaster is only one of the many sculptural media in which Picasso worked.

Right The *Column of the Kiss* shows the artist's work in plaster. The piece relates to Brancusi's famous work *Gate of the Kiss* (1937) in which the circle motif reappears. In some ways, the *Column* is itself an abstraction from the artist's early work, *The Kiss*, of 1910. This can be seen in the division of the column into two and the proximity of the two halves of the circle like two heads kissing.

Another method used to colour a work is to paint the whole work with a colour and spirit mix, and then remove the unwanted colour, again using a pad of cotton wool and spirit. Care should be taken not to dissolve the shellac sealing coat by rubbing too hard.

Linseed oil Another medium used for sealing the surface of plaster is linseed oil, but this tends to darken with age and may, therefore, tend to defeat the purpose of sealing. However, it does give a mellow quality to the plaster and could be used to advantage. Where possible, immerse the warmed plaster sculpture in linseed oil for several hours, or, failing this, paint on the oil until the surface is saturated. The sculpture should then be allowed to drain and, when dry, rubbed carefully with a soft rag to produce a polish.

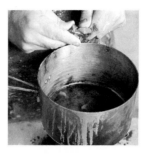

Finishing with wax 1. Heat a mixture of wax and turpentine in a pan. Meanwhile warm the plaster block in an oven.

2. Brush the liquid wax over the plaster surface, working first in one direction, then across to form a thin layer.

Adding surface colour 1. Draw into the surface with a sharp metal tool. Lay on plaster coloured with powder paint.

2. Scrape away the coloured plaster with the flat edge of a knife, leaving colour only in the engraved lines.

Below The casting box for this work, *Settlement* by Barry Midgley, forms the frame for the finished work. The shapes were created using sand, placed on top of the layer of glass in the bottom of the box. The stones were placed in the sand and the plaster poured on. After the plaster had set, the sand was poured out.

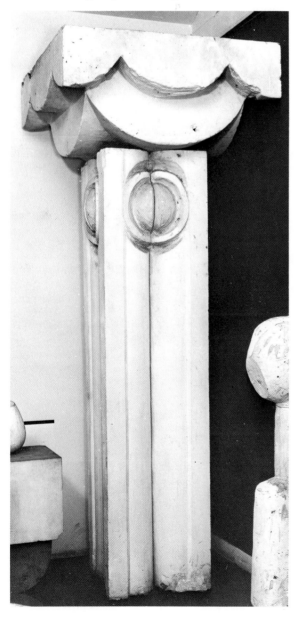

Right This very naturalistic plaster figure, *Linda on Dais* by Barry Midgley, was made using a three-piece mould. When the cast was complete, it was painted with acrylic colours. One advantage of using acrylic or emulsion paints is that no sealing coat needs to be applied to the plaster first.

Below This humorous piece is called *Pain Pied* (*Bread Foot*) and is by the contemporary French sculptor Claude Lalanne. It is made from plaster using casts. It shows how an apparently traditional technique can still produce some unusual and innovative images.

COLOURING PLASTER

Powder colour added to the water prior to mixing in the plaster can be used to produce a coloured plaster, although too much powder may affect the setting or the strength of the plaster. The earth colours are safest.

This method should be used for making a plaster mould, from which a plaster cast is to be made. The coloured plaster is the first coat of the mould, the subsequent coats being a normal mix. When chipping away the mould to reveal the cast, the colour shows when the mould is nearing the cast and very great care should be taken to prevent damage to the surface of the cast. If colour is used in a finished plaster work then no work should be carried out on it after casting, if surface changes of colour are to be avoided.

If colour is to be applied to the sculpture on completion of the forming or casting process, then the surface will need sealing if gloss or enamel paints are to be used. Shellac is the quickest means of sealing the surface, as paint can be applied within approximately 30 minutes, when the shellac has dried. Emulsion or acrylic paints can be applied directly onto the plaster without the need for a sealing coat.

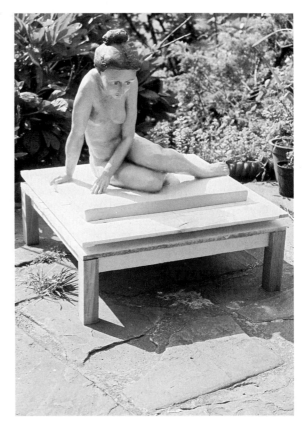

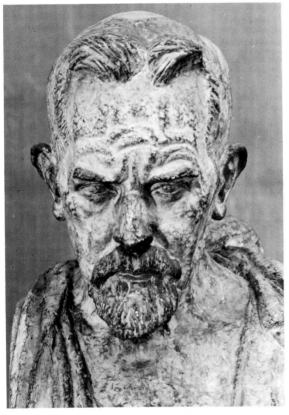

JOINING, REPAIRING AND FIXING

Because plaster cannot absorb shock through sudden pressure, it can easily be broken. Therefore, careful handling is always necessary. When a work is broken or cracked, repairs can be difficult.

Simple blemishes on a work such as cracks, or pinholing, caused by air bubbles being trapped against the surface, can be removed by filling with a weak mixture of plaster, after first thoroughly wetting the plaster which is to be repaired. If the work to be repaired is old and dry, the whole object should be immersed in water until air bubbles stop rising to the surface. If this is not possible, water should be poured over the work until it stops absorbing water in the repair area. Dirt and grease should be removed and a key for the new plaster formed by scraping the surface of the parts to be repaired. After application of the new plaster, the repair can be gone over with a damp brush to blend it with the surrounding area. The surface should then be left to dry.

Should the repair require two parts that have dried to be joined, the fractured faces of each can

Left This striking portrait head of Sir James Frazer is an example of the work of the French sculptor, Antoine Bourdelle. Bourdelle worked for a time with Rodin who was a great influence on Bourdelle's work. This head conveys an impression of great concentration. Traces of the tools the artist used can still be detected on the surface.

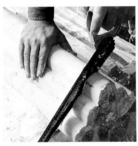

Joining plaster forms 1. Trim the sections to the same size by cutting through them with a general purpose saw.

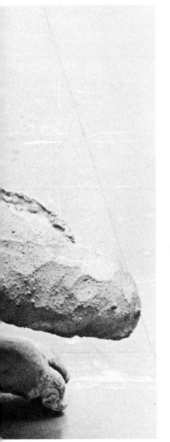

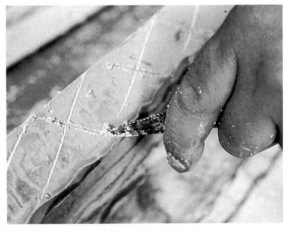

2. Provide a tooth on the seam lines by scratching across them with a knife or metal tool.

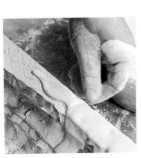

3. Wedge one section with seam edges upwards and horizontal. Pour fresh wet plaster along each seam.

4. Put the second section in place and press the two halves firmly together.

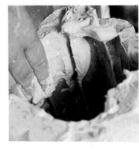

5. Reinforce the inside seams by reaching into the form and laying on more plaster.

6. When the joints are firmly set, smooth down the outer seam lines with a surform.

be painted with shellac and, when dry, a second thickly mixed coat of shellac used as a glue to fix the parts together. Alternatively, carpenter's glue, the type that is melted in a double boiler, can be used. The parts should be held firmly together while the shellac hardens and the excess that has been squeezed from the joint removed with a sharp knife or scalpel. To help hide the joint, it can be scraped carefully with the knife to create a surface crack along the joint. This can be filled with a weak plaster mix in the way already described.

PVA (polyvinyl acetate) woodworking adhesive is also useful for repair work and has the advantage of drying to a clear finish. Surfaces that are to be joined should be absolutely free from dust and grease before the adhesive is applied.

A joint that will be under stress is best reinforced with metal rods. These should be fixed with plaster into holes drilled into one piece, so that half the rod protrudes, and, when set, should fit into holes drilled into the second piece. The joint can then be completed by pouring plaster into those holes and onto the face of the break. The pins should be placed into their respective holes, and the joint squeezed firmly until a bond has been made.

Right *Spring* by the French sculptor Aristide Maillol is made from plaster washed with blue. The figure is typical of Maillol's interest in simplicity of form and massiveness of volume. For much of his work, he concentrated on drawing and modelling the same type of female figure.

Below This small sculpture, *Female Vine Leaf*, by Marcel Duchamp was created in 1950. It is made of galvanized plaster. Duchamp's wide ranging talents were exercised in many different media.

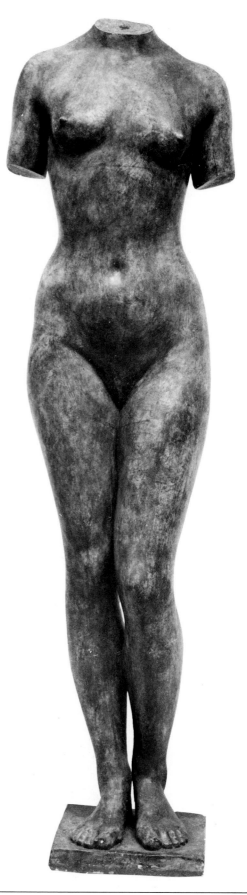

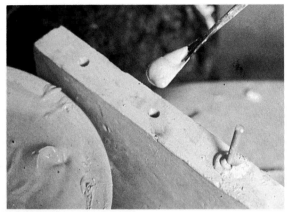

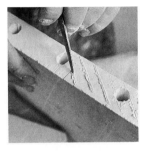

Reinforcing a joint I. Drill holes along both edges to be joined and cut small metal rods of suitable size. Make sure holes are correctly aligned.

2. Fill the holes on one section with fresh wet plaster and insert the rods.

3. Roughen the edge of both sections by scratching the face with a metal tool.

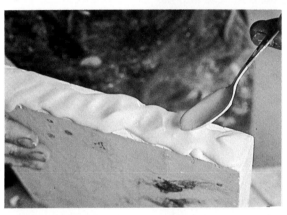

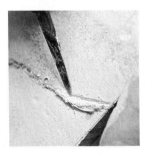

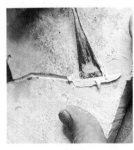

4. Pour wet plaster along the roughened edge. Make quite a thick layer to cover the whole surface of the joint.

5. Set down the plaster slabs on a flat surface and locate the rods in one section to the holes in the other. These should be a little larger to help with fit.

6. Press the two halves firmly together. Wait until the wet plaster has dried and then rub down the seam with a surform.

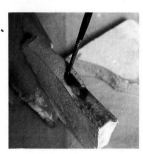

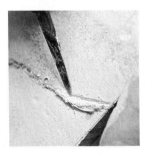

Mending a break I. With a soft brush, coat the faces of each broken piece with a thin layer of shellac to seal them.

2. Apply a thicker coat of shellac to both surfaces to act as adhesive in the repair.

3. Press the shellacked faces firmly together and leave them for about I hour or until the joint feels quite firm.

4. Cut a shallow V-shaped groove along the surface of the plaster, centred on the seam line.

5. Fill the groove with plaster applied with a flat spatula. When this has dried, rub down and finish the surface.

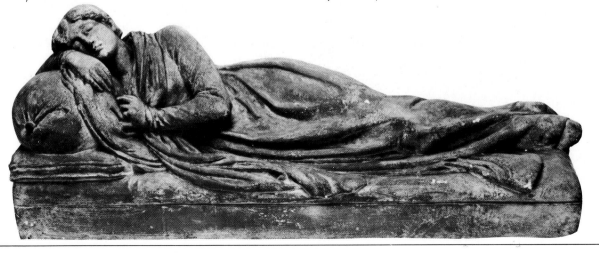

Left This plaster model for a monument by John Flaxman shows one of the main possible uses of plaster, as a medium for making models of work which will be executed on a larger scale.

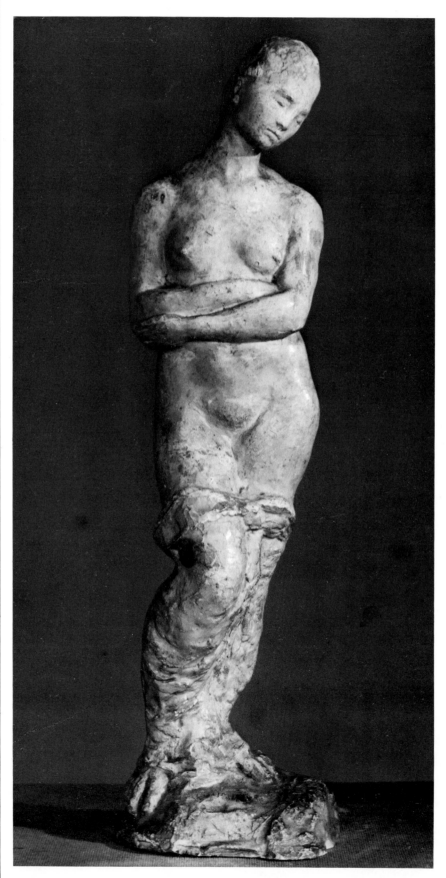

A hole in a hollow form, such as a portrait head, can be mended simply by filling the form with damp newspaper and pouring plaster into the hole against the paper. Another method is to fix a piece of string to the centre of a piece of card by piercing it, and tying it to a nail. The card is then pushed through the hole in the form and held firmly against the inside of the hole by pulling the string tight. Plaster can then be used to complete the repair, and the string removed after the plaster has set.

Bolts can be used to join plaster sections together, either by drilling the sections to be joined and bolting in the usual way, or by setting the bolt head into the plaster when casting, so the thread is exposed once the former or mould is removed. If this method is used, the bolt should be primed to prevent rusting, which may stain the surface of the plaster, and the exposed thread should be greased to prevent plaster adhering.

Left German born sculptor Wilhelm Lehmbruck created most of his work from artificial stone and bronze. But he was also capable of creating expressive work using plaster. Lehmbruck's work often produces an air of inner contemplation, as does this small work in coloured plaster completed in 1911.

Filling a hole 1. Cut a piece of card large enough to cover the hole and attach a piece of string through the centre.

2. Push the card through the hole and pull it back against the inner surface. Start to pour plaster into the hole.

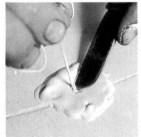

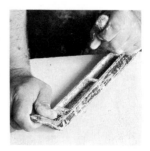

3. Continue pouring slowly until the hole is filled. When the plaster has set, cut off the string at the surface.

4. When the plaster has dried, work over the repair with a surform to finish it flush with the original surface.

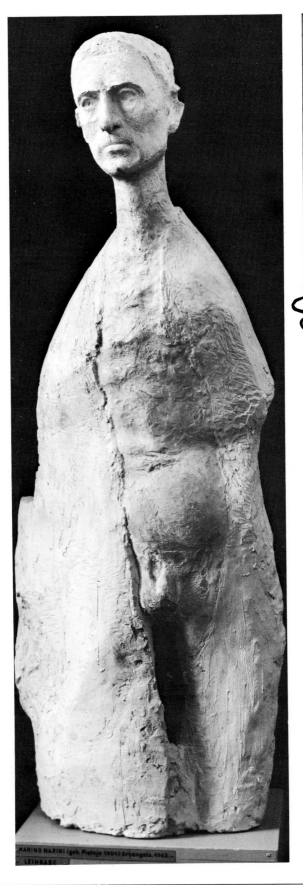

SAFETY

Dust Plaster dust, like all dust, should be kept to a minimum. **Skin** Contact with the skin should be avoided by rubbing petroleum jelly or a barrier cream well into the hands. Plaster dries out natural oils from the skin and excessive contact can produce serious skin complaints. When working with plaster, hands should be washed after each mix before the plaster hardens, a problem that can be quite painful for plaster mixers with hairy arms. **Lifting** You should take the usual precautions which should be observed when lifting heavy weights.

General Plaster is a relatively safe, stable and cheap material to use and well suited to the needs of an inexperienced sculptor.

Far left The quick-setting properties of plaster can be used to create interesting effects of roughness in texture, as evidenced here in *Archangel*, sculpted here by the Italian painter and sculptor Marino Marini in 1943. Marini was greatly influenced by the techniques of Rodin.

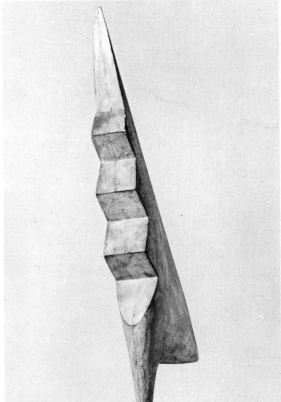

Left The Romanian born artist Constantin Brancusi worked in many different media. He often worked on the same subject in different media. For example, *The Cock* was originally carved from a single piece of wood. Plaster was just one of the many media Brancusi used.

CONCRETE

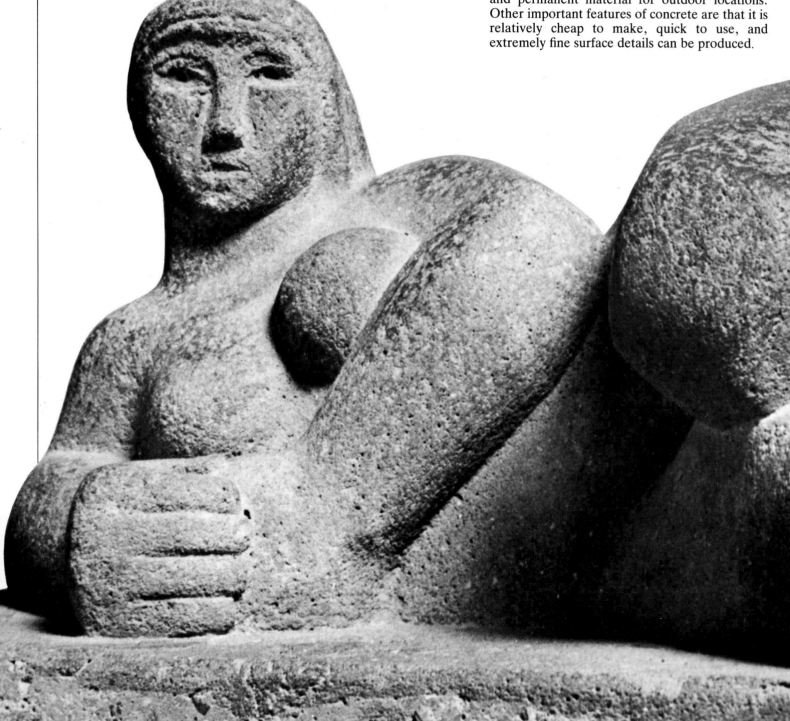

HISTORY

Concrete is a relatively new sculptural medium, although it has been used in architecture for some time. Its use has been limited partly because it has been considered a poor substitute for stone, lacking stone's inherent character and historic importance in the development of sculpture.

However, its popularity has grown with the development of architectural techniques which employ concrete for forming a building's external skin. These developments have led to the realization that the processes of shaping and forming concrete give the medium a unique quality that can be exploited by the sculptor.

Since the 1950s, sculptors have developed a technique by which they can hollow cast ciment fondu, a grey-black type of concrete, and this has done much to popularize concrete as an economic and permanent material for outdoor locations. Other important features of concrete are that it is relatively cheap to make, quick to use, and extremely fine surface details can be produced.

Concrete is a mixture of cement, aggregate—a substance that adds body to the cement—and water. There are two types of cement. Portland cement is composed of calcium aluminium silicate and is similar in appearance to Portland stone, and high alumina cement or ciment fondu. This is composed of alumina and is grey-black in colour.

Cement is made by grinding the raw material to a fine powder and heating it in a furnace to form a clinker. This is finely ground to create a powder that, when mixed with water, forms a paste that will remain workable for a reasonable time before setting to form a dense mass. The act of mixing with water triggers a chemical reaction that will occur even if the mixture was placed under water.

To increase the strength and durability of the cement mixture, aggregates are added to form the paste. There are two main groups of aggregates—fine and coarse. Fine aggregates include stone dust and silver sand. Coarse aggregates are normally granite or marble chippings. The basic criteria for an aggregate are that it should not be liable to structural weakness, nor should it react chemically with cement. Furthermore, it should be clean, pure, inert and strong. Aggregates can give a concrete mix a wide variety of qualities, depending on the combination of aggregates used. These vary from a fine cast stone appearance to an open, exposed aggregate surface, like that used on many modern buildings.

Sculpturally, concrete is used in one of three main ways. It can be cast solid from a mould, in which case a combination of fine and coarse aggregates may be used and the mixture vibrated to ensure good surface reproduction and the elimination of air pockets. Concrete may be hollow cast from a mould. For this, only fine aggregate is added to the cement, and strength is provided by the use of pieces of fibreglass. Concrete can also be worked by direct modelling. This process is not very popular, but it does provide a means of working on a large scale relatively cheaply. This use is perhaps best illustrated in making yacht hulls. If a concrete mixture is to be applied directly onto a supporting armature, lime can be added (approximately three parts cement to one part lime) to give the mixture greater plasticity.

Below This is one of the fore-runners of Henry Moore's famous reclining figures. It was made in 1927 of cast concrete and is 25in (62cm) high. The position and style of the figure was influenced by Moore's visits as a student to the British Museum in London, where he was particularly drawn to non-European art, to the African and ancient Egyptian exhibits as well as to the pre-Columbian art of Mexico. The coarse effect of the concrete emphasizes the massive shaped arms and legs which give such strength to this sculpture. The interest in strong massive line can be seen in the works of other English and European sculptors of this period, including the French sculptor Gaudier-Brzeska and the Russian-American artist Archipenko.

Above This modern concrete sculpture called *Artigas* by J. Gardy shows how well the medium can blend with a natural setting. The reflections in the lake add to the work's appeal.

EQUIPMENT AND TOOLS

A mixing box is a useful item to have when working with concrete, as is a measuring box into which the dry ingredients can be poured so that volume can be measured accurately. This ensures that consistent proportions can be achieved should more than one mix be needed and helps avoid changes in colour and density in the work being undertaken. Having mixed the constituents of the concrete dry, water is added to make the mix plastic. This should be added a little at a time, until the required consistency is reached. Sand and aggregate, when purchased from a builder's yard, will probably contain a high percentage of water, and allowance must be made for this when calculating ratios of sand to cement.

Apart from mixing and measuring boxes, useful tools include a spade and an old brush for cleaning tools and work area, a paint brush to apply the 'goo' coat when hollow casting, sacks to keep work damp during curing, a bucket and assorted trowels and scrapers to apply or work the mix. A stick of wood is useful as a 'rod' for puddling concrete that is to be solid cast. When vibrating concrete for solid casting, a wooden mallet is useful for tapping the side of the box containing the concrete.

Generally, because concrete is either modelled onto an armature or cast from a mould or former, it is rarely necessary to cut into a concrete mass, but, should this be necessary, special carbide discs specifically designed for the purpose can be fitted to an angle grinder. However, when using such equipment, care must be taken to follow the manufacturer's instructions, safety goggles should be worn, and adequate safety precautions taken.

Some finishing work can be carried out on concrete with other tools. These include stone chisels, files and carborundum papers or wheels, although it should be borne in mind that, on a cast surface, further working tends to show up as a different colour or texture.

Concrete can be drilled using a masonry drill bit and a hammer drill. However, an alternative method suitable for more delicate works or large diameter holes is to include a wooden dowel in the mould or armature, so that it can be drilled out using a hand drill, leaving a clean hole of the correct diameter.

Slabs of concrete may be joined using conventional methods of fixing, such as bolts. They can also be designed to slot together or to be joined with dowelling. Such considerations may be of more importance on large works where, for reasons of weight or to protect vulnerable projections, the work needs to be assembled on site. These possibilities should always be borne in mind.

Tools for concrete

Many of the tools used with concrete are identical to those used in and around the home. These include a bucket (**1**) for mixing or holding the concrete, a spade (**5**) for mixing, a selection of trowels (**4**) and scrapers (**11**) for applying the concrete to the work. If casting solid, tap the box with a wooden mallet (**2**) to help eliminate air bubbles. A paintbrush (**8**) is a convenient implement for applying the thin goo coat.

Sacking or hessian (**3**) is handy for keeping the concrete damp while it cures. The concrete can be smoothed with a float (**10**). For finishing, use a file (**9**), stone chisels (**7**), carborundum discs (**12**) attached to an electric drill (**14**). For drilling, a masonry bit (**13**) should be used with the drill. Working with concrete can be messy. It is best to keep your tools and work area clean. A scrubbing brush (**6**) is indispensable.

TECHNIQUES

The strength of concrete depends on several factors. The first is the water content of the mixture, basically, the more water in the concrete the weaker it is. The second factor is the type of aggregate used, as strength is related to the strength of the individual components. A third important element is the curing of the mixture. Curing is the process in which the mixture dries. It is very important that the drying time is controlled, so that the concrete does not harden too quickly. If it hardens too fast, it will not be uniformly strong. To ensure a good curing, keep the concrete damp. The best way to keep ciment fondu moist is to wrap it in damp rags or sacks for at least eight hours, and preferably 24 hours. In the case of Portland cement, the concrete should be kept damp for about 10 days after being removed from its mould.

The strength of concrete is also related to the use of steel reinforcement. If concrete is properly mixed and cured, it has good compressive strength but relatively poor tensile strength, in other words it would crack easily. To provide steel reinforcement, incorporate mild steel rods or mesh into areas that will be subjected to tensile stress. If steel reinforcement is used, it should be completely encased in concrete or sealed in order to avoid rust stains on the surface of the work.

Strips of fibreglass, known as glass fibre mat, are often used either in direct modelling or for reinforcing hollow cast shapes. This can be employed either as supplementary to or as an alternative to reinforcement with mild steel bars. Glass fibre mat can be shredded and mixed with cement to form a binder or impregnated with cement and tamped—or forced—into place against the surface coat of the hollow cast section.

Concrete as a sculptural medium has many advantages, particularly if it is to be used out-of-doors. It can withstand various climatic conditions and is resistant to scratches and knocks, and, if properly reinforced, can be moulded or modelled into almost any shape. A large number of textured finishes are also possible. It is relatively cheap to work with and few specialist tools are needed.

The main disadvantage of concrete is that it is difficult to add additional material to concrete that has already cured. If concrete is added after a work has been finished, some cracks may appear between the old and new areas of concrete. Because of this, it is best to plan the work well, making sure that the work is supported by a well designed armature, so that the sculpture can be completed before the concrete cures. So sculpture in concrete requires good planning and timing.

PREPARATION

When mixing cement and aggregate, the ratio of each will vary depending on the type of work being undertaken. The main considerations are whether the concrete is to be poured solid, laminated in a mould or applied directly onto an armature.

To make a hollow fondu casting, first mix neat cement with water to form a creamy paste, usually referred to as 'goo'. Apply a layer of this with a brush to the wall of the wet mould, and then lay a mix in the proportion of one part cement to two parts sand over this, followed by a similar mix reinforced with glass fibre mat.

If the concrete is to be poured into a mould, then a coarse aggregate can be used in the mix. A good general mixture would be one part cement, two parts sand and four parts coarse aggregate, such as granite chippings. The size of coarse aggregate which can be used will depend on the volume of the sculpture, as the greater the volume, the larger the aggregate size that can be incorporated in the mix.

Below This piece by Martin Ives shows how concrete can be combined with other media. The ring of concrete, which is almost 6 feet (2 metres) tall, has pieces of straw in it. The centre of the ring is filled with hazel twigs.

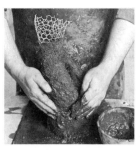

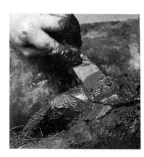

Modelling 1. Mix up concrete to the consistency of a stiff paste and add shredded glass fibre matt for the first coat.

2. Model this onto the armature with your fingers. Use barrier cream to protect skin when handling concrete.

3. Allow the first layer to stiffen slightly and then model over the surface with a smooth paste of concrete only.

MODELLING CONCRETE

Working concrete directly onto an armature requires a good understanding of the final shapes wanted, as the armature must be designed to withstand the weight of concrete applied. To help keep the amount of concrete used to a minimum, it is best to construct the armature from welded mild steel bar or tube with expanded metal, which can be used to form the 'skin' of the shape being created. If the armature is well designed, the amount of concrete needed will be greatly reduced.

Having constructed the armature, it should be covered with a stiff concrete mixture reinforced with glass fibre matting to help bind the concrete into a homogeneous mass. Work should be continuous until the entire armature has been covered. If work has to stop for a few hours, the edges should be roughened and water applied before continuing. If more concrete is to be joined to some that has set, the surface which is to be worked on should be roughened to form a key, and a proprietary sealant applied before the fresh concrete is added. The final surface should be applied while the first is still wet, in order to ensure that the two surfaces bond. If this is not possible, the same procedures for starting work again must be carried out.

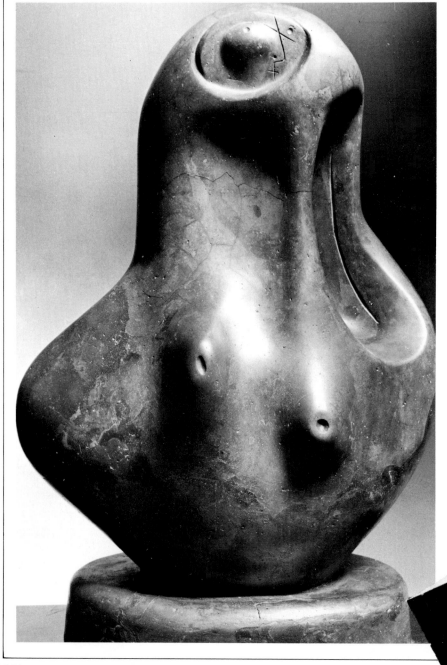

Left *Composition* by Henry Moore was made of carved concrete in 1933. It is 23in (57.5cm) high. Moore used this unusual way of working with concrete to explore and integrate Surrealist influences into his work. The use of hollows and contrasting curved forms are characteristic of his work.

SOLID CASTING

When casting concrete from a plaster mould, the mould should be soaking wet or sealed to prevent water being absorbed from the concrete mix, as this would adversely affect the final strength of the concrete. If the mould is wet, a bloom will be picked up on the surface of the concrete. In both cases, the mould should be kept damp while the concrete cures. The concrete mix should be as stiff as possible, while still being workable. The reason for keeping the concrete stiff when solid casting is that this prevents the larger aggregate particles from settling to the bottom of the mould, which would create a mass that varied in density. The concrete should be 'puddled'. This process ensures a good surface reproduction and eliminates air bubbles. Puddling involves pushing a rod up and down in the mix to compact it. Concrete can be added in several stages when this method is used. Care needs to be taken not to agitate the rod too rapidly or the mould will get damaged and air bubbles will form. As the mould is filled, it should be vibrated by being gently tapped by a wooden mallet; this also ensures an even density of mix.

Apart from plaster moulds, wooden formers or shuttering can also be used in concrete work in much the same way as in plaster work. These need to be sealed with grease or oil, and the whole work should be covered with damp sacks while the cure is achieved.

Below Wendy Taylor's *Brick Knot* (1978) uses brick and concrete to achieve an effect of lightness which belies the medium she is working in. The abstract geometric forms are typical of her established style.

Solid casting 1. Construct a mould or former for the cast. Coat all inner surfaces with a release agent.

2. Drop a layer of stiff wet concrete into the mould. Use a rod or batten to puddle it but do not create air bubbles.

3. Bang the mould repeatedly on the bench top to settle the concrete and spread it evenly.

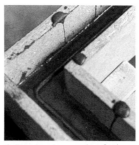

4. Bend an iron rod to fit the mould and place it into the concrete layer to provide reinforcement.

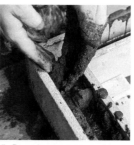

5. Drop in more concrete over the reinforcing rod and fill the mould right to the top.

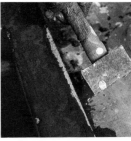

6. Make sure the concrete is evenly distributed in the mould by tapping round the outside with a mallet.

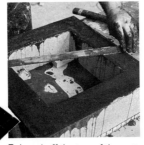

7. Level off the top of the wet concrete by drawing a wood batten across the mould.

8. Cover the mould with damp sacking and leave it to cure.

Below *Meeting Place* by Spanish sculptor Eduardo Chillida was finished in 1973. This sculpture typifies the austerity of form that Chillida brings to his work. The wide sweep of the solid block forms are served well by the medium of concrete in this striking piece which measures 8 feet (2.50 metres) by 14 feet (4.4 metres). This differs from his earlier work which was characterized by jagged or twisted ribbons of metal.

HOLLOW CASTING CIMENT FONDU

Generally, a plaster waste mould is used when making a hollow casting. This should be strong enough to absorb the compacting process and the soaking. If the plaster mould is dry, it should be sealed with two layers of shellac and a thin coating of oil. Any metal reinforcement that may be necessary to strengthen the concrete should be bent and cut to shape. Prepare a 1½-oz (42g) glass fibre mat by cutting it into manageable sizes and splitting it into two thinner layers in order to facilitate handling when laying up the mould.

A coat of neat cement or 'goo' is applied with a brush to the surface of the mould. The thickness of this coat will be about ⅛in (3mm). A second coat composed of one part cement to one part aggregate (silver sand), mixed to a slightly stiffer consistency, is applied immediately over the 'goo' to form a thickness of approximately ¼in (6mm). It should be pressed well into the mould in an even layer, using a spatula or fingers, and care should be taken to ensure all projections are fully covered, while, at the same time, ensuring it does not displace the 'goo'. If a piece mould is being

worked on, only one part at a time should be completed, the caps first. Into this second layer, glass fibre is stippled using an old paint brush to ensure complete impregnation of the fibres. A second layer of the sand and cement mix is applied, and any steel reinforcement placed in this layer. The steel should be completely covered with cement or it will corrode.

A second layer of glass fibre is added, and a further layer of sand and cement mix used to build up the final thickness. It can be stiffer than the previous layers and used to ensure that any possible weak spots are adequately strengthened. The seams should be cleaned and the edges of the concrete slightly angled back to allow close contact between the mould sections.

When all the mould pieces have been laid up, they can be left to form an initial set. This takes approximately three hours. However, the parts should be joined as soon as practicable after this time. If they are left unjoined until they harden, a sealant should be used on the seams before the parts are joined.

The caps of the mould are joined by applying a layer of 'goo' around the seams and squeezing against the main mould section. Where possible

Below *Barriera* by Mauro Staccioli made in 1971 measures 2 feet 8in (80cm) on all sides. It is made of cement and iron. He uses his solid square and triangular forms with protruding spikes to make an impact on the environment and act as a contrast to the surroundings.

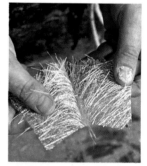

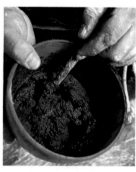

Hollow casting 1. Mix up a creamy paste of ciment fondu and water, and brush it into the mould to about ⅛in (3mm) thick.

2. Cut glass fibre matt into small pieces and separate each piece into two thin layers by pulling it apart.

3. Mix up a quantity of concrete, using equal parts of cement and silver sand. Use a stiff mix.

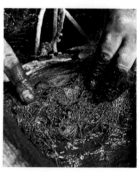

4. Press the stiff cement into the mould, making a layer of about ¼in (6mm) thickness. Add extra weight in the corners.

5. Pat in a reinforcing layer of glass fibre matt soaked in the concrete. Cover the mould with damp sacks and leave it to cure.

6. Chip away the plaster mould and brush off the cast surface. The plaster leaves a soft bloom on the surface.

the joint should be reinforced from the inside by laminating a layer of glass fibre over the seams. On completion, the mould should be covered with damp sacks and allowed to cure.

FINISHING

When a concrete sculpture is released from its mould, in particular a plaster mould, it has a bloom which it picks up by dissolving minerals from the plaster. This is often considered to be an attractive feature which is retained. If the work demands a polish, then it can be treated with a shoe polish. In the case of ciment fondu, a bronze patina can be produced by brushing the surface of the sculpture with ordinary black shoe polish, using a suede brush which has brass bristles. Finishes that imitate other materials should be used with caution as they may well work against the structural quality of the material, but this kind of decision must be made using experience.

Colour can be incorporated either as an addition to the original mix or rubbed into or painted on the sealed surface of the concrete. Materials for sealing and colouring concrete are produced by specialized firms and can be purchased at builder's and plumber's merchants.

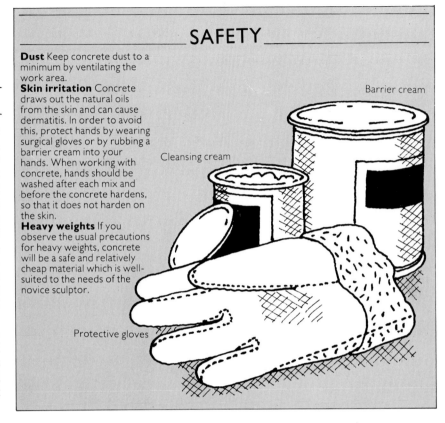

SAFETY

Dust Keep concrete dust to a minimum by ventilating the work area.

Skin irritation Concrete draws out the natural oils from the skin and can cause dermatitis. In order to avoid this, protect hands by wearing surgical gloves or by rubbing a barrier cream into your hands. When working with concrete, hands should be washed after each mix and before the concrete hardens, so that it does not harden on the skin.

Heavy weights If you observe the usual precautions for heavy weights, concrete will be a safe and relatively cheap material which is well-suited to the needs of the novice sculptor.

Barrier cream

Cleansing cream

Protective gloves

Surface finishes Cast concrete picks up surface qualities from the material which forms the mould. The three examples (from **left** to **right**) show blocks cast against glass, wood and creased polythene. The block on the right has been treated with boot polish to give it a heavy black sheen.

PLASTICS

Right Naum Gabo created his work *Column* in 1923. It is about 4 feet (1.04 metres) high. It is made from a variety of media – perspex, glass, metal and wood. One of the founders of Constructivism in Russia, Gabo was one of the major innovators in sculpture in the twentieth century. During the 1920s, Gabo used transparent materials such as perspex extensively. This example shows how the materials have been combined to produce an apparently simple sculpture with clean lines.

Below Claes Oldenburg's *Giant Ice Bag* is an example of the artist's use of plastics to create images which are startling because of their scale and soft texture. Oldenburg's approach turns quite everyday objects into soft collapsing structures which can both amuse and fascinate.

HISTORY

Plastic is generally considered to be a modern material, although, surprisingly, the first public announcement of its invention came in London at the International Exhibition of 1862. The material concerned was the cellulose nitrate-based substance 'Parkesine', developed by Alexander Parkes and D Spill, two English metallurgists. Parkesine was primarily a substitute for existing materials, such as ivory, hard woods and tortoiseshell, which were already in short supply. It was never really exploited, and it was left to two Americans, John Hyatt and his brother, Isaiah, to patent a similar plastic, 'Celluloid' in 1869 and to begin commercial manufacture.

The next 70 years produced a chemical revolution. The phenol-formaldehyde-based 'Bakelite', developed by Leo Hendrik Baekeland (1863–1944), came in 1907; 'Polythene' was created in Britain in 1933; 'Plexiglas' acrylic sheet was patented in America during the same year; while 'Perspex' appeared in Britain in 1936. The same 70 years also saw important changes in the arts. Plastic played a part in some of these. In Moscow in 1920 the Soviet brothers Antoine Pevsner (1886–1962) and Naum Gabo (1890–1977) published their *Realistic Manifesto* in which they attacked the current principles of art and declared a new direction, which became known as Constructivism. They rejected solid, heavy masses and volumes in sculpture, introducing light, airy forms constructed with transparent sheets, initially celluloid, which were intended to demonstrate static forces and kinetic rhythms

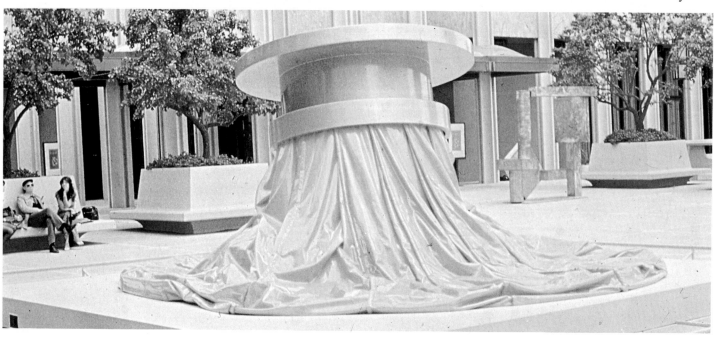

within particular areas. Gabo in particular pursued the use of plastic, developing complex non-figurative inter-penetrating acrylic constructions during the 1930s and 1940s while in England.

One of the founders of the Bauhaus, the Hungarian László Moholy-Nagy (1895–1946), with the famous *Light and Space Modulator* series used acrylic sheet in combination with other materials and projected light. The light was partially absorbed, refracted and reflected to generate new fields of visual experience around and within the basic structures.

The use of natural and artificial light provides the clue to the main directions taken by plastic sculpture in the last 20 years. Sculptors have explored many of the avenues opened by the early pioneers in kinetics and light sculpture. Electronics have given the sculptor the means to control the levels and hues of light in their structures. Industrial processes have added the use of heat and pressure to generate new and exciting forms in the sculptor's vocabulary. Plastic has recently found its way outside the confines of the studio and the object. It is widely used by artists working on temporary environmental or installation ideas, becoming an integral part of many performance events, such as the silver inflatables made by American Andy Warhol (born 1930) which floated freely in the gallery space. The Bulgarian Jachareff Christo (born 1935) has wrapped objects, buildings and even whole sections of coastline in synthetic sheet. The polymer chemist, from Parkes' early beginnings, has now provided a range of colours and types of plastic to satisfy many of the sculptor's needs. This medium still has great potential for the sculptor.

Right Claes Oldenburg's *Giant Soft Fan* (1966–67) is about 10 feet (over 3 metres) tall and is made of vinyl filled with foam rubber, wood, metal and plastic tubing. The gigantic size of the fan gives it a surreal effect while the softness and looseness of the material supplies a humorous comment on the 'value' of the fan in society. In the same period Oldenburg created other gigantic versions of household objects and foodstuffs.

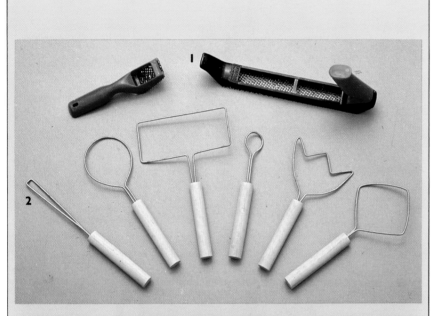

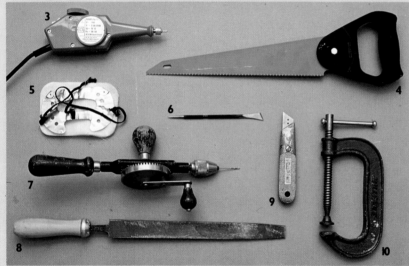

TYPES AND TECHNIQUES

There are two general families of plastics—rigid plastics, which include acrylics and polystyrenes, and flexible plastics, such as the PVC (polyvinyl chloride) and polythene families. Plastics are extremely versatile materials and different techniques can be applied to them. They are mainly used in construction, but carving and turning are also possible. However, they are expensive, so it is important to plan the piece carefully. First, make detailed drawings and designs, and decide the scale of the work. Also, think about the most appropriate fixing method for the work and whether plastic is the most suitable medium for it.

The best results are achieved with plastics which are worked in a clean and dust-free area. Make sure that bench tops and other working surfaces are free from nail heads, dried glue or other foreign matter likely to scratch the surface of the plastic. Work tops can be covered with soft cotton cloth or felt. Unfortunately, once marked, plastic will never fully regain its original quality. It is advisable, therefore, to leave any backing paper or protective coating in place until the last possible moment.

Plastics generate an electrostatic charge, particularly when being handled or machined. This attracts dust to the surface very quickly. When a piece is finished, it should be washed with warm water and a mild detergent. Then the surfaces should be dried with a soft cotton cloth or chamois leather, and finally an antistatic agent applied. These can be obtained at most record shops and come as liquids and, for large areas, as aerosols. Smaller areas can be treated with an antistatic pistol.

RIGID PLASTICS

Acrylics Acrylics are available in four different forms: as sheets, blocks, rods or tubes. They all come in transparent form, although sheet acrylics are also sold in opal and opaque, and rods of acrylic are sometimes sold in different colours. They come in a range of thicknesses and diameters. Sheet acrylics are sold in ⅛–¼in (3–6mm) thicknesses; blocks come in 1–5in (25–125mm) thicknesses and rods and tubes in diameters of ¹⁄₁₆–1in (1.5–25mm).

Acrylics, such as perspex or oroglas, are light, strong, homogeneous materials with no grain or irregularities. They will pipe light internally even when the plastic has been bent or shaped, transmitting the light from the cut edge or rod end.

Tools for plastics
Different tools are required depending on whether rigid plastics or flexible plastics are being used. For expanded polystyrene, a selection of wire tools (**2**) are useful. It is important to heat the heads of the tools in a gas flame. The tools have wooden handles, which should, of course, not be placed too close to the flame. The various shapes of the tools determine the amount of polystyrene and the shape which can be created. For filing down the polystyrene, use surforms (**1**). These come in a variety of shapes and sizes. Before

cutting rigid plastics, make sure that all tools are very sharp. This will help ensure a neat, clean cut. A general purpose saw (**4**) is useful, as is a craft knife (**9**). A metal file (**8**) In order to achieve a surface texture, use either an electric engraving tool (**3**) or a scribe (**6**). A drill (**7**) is necessary for making holes before pieces of plastic are joined, while a G clamp (**10**) is handy for keeping work steady. Safety is an important consideration when working with plastics. A face mask (**5**) should always be worn if dust is likely to occur. A small amount of cutting oil or

coolant will be useful to stop the tools overheating during use. Working with plastics tends to generate heat. You should be careful that it does not become excessive.

Acrylics are relatively easy to work. They can be sawn, drilled, routed, turned and milled in much the same way as non-ferrous metals. Standard hand and machine tools are suitable. All tools should be very sharp, and, if possible, tungsten carbide tipped. A blunt drill or saw quickly causes overheating and binds. Use a little cutting oil or coolant to help prevent this.

When drilling, always clamp work firmly to a wooden backing sheet to stop vibration which might cause the edges to chip. High speed twist drills are used, their cutting heads being ground to a zero or negative rake. Circular saws with thin, hollow ground blades of 8 to 14 teeth per inch (2.5cm) are best for cutting straight lines. Jigsaws and band saws are preferred for curves and more complex shapes. In general, high machine speeds and slow feeding are the rule for acrylics.

Acrylics can be joined with self-tapping screws, bolts or adhesives. Care should be taken to match the drill size to the screw or bolt size. Under or oversize holes can lead to stress and possible cracking. Soft leather or rubber washers will help to ease the stress around the holes.

Solvents such as chloroform and ethylene di-chloride can be used for simple joints. However, the best general adhesive is a two part cement which can be used for up to 20 minutes after mixing, and produces a strong and durable bond, which is resistant to water and weather. The adhesive can be applied by brush, glass rod or syringe. It may, however, attack acrylic surfaces, so care should be taken to avoid unwanted spillage.

Acrylics are thermoplastics and so, if heated to 318°F (150°C), soften and become rubbery. They can be stretched and formed into three-dimensional shapes. On cooling, they become rigid again and retain their new shape. For large sheets, hot-air or infra-red ovens are used. On a smaller scale, domestic ovens can produce a successful result. Localized or edge bending is possible with hot-air blowers in combination with simple wooden formers. These blowers may have special attachments for heating rods and tubes. The use of vacuum and air pressure with heat is also suited to acrylics. Blow forming can produce particularly spectacular results.

Polystyrene The two main types of polystyrene are toughened and expanded. Both of these are available in sheet form, but expanded comes in blocks or granules as well. Toughened polystyrene comes in a number of colours, including black and white and in various thicknesses. Expanded polystyrene comes in a range of sizes.

Toughened polystyrene sheet can be readily used for small box or plane forms. It is cut easily with a guillotine, scissors or a modelling knife and

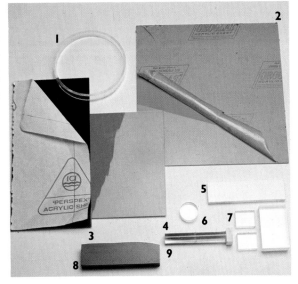

Types of acrylic
Available in four different forms, acrylics also come in a wide range of translucencies and colours. The forms include cylinders (**1**), rods (**9**) and sheets (**6,7**). All of these forms can be purchased in a range of thicknesses or diameters: sheets range from 1/8–1/4in (3–6mm), blocks from 1–5in (25–127mm) and rods come in diameters of 1/16–9/10in (1.5–23mm). Colours available include turquoise (**2**), brown (**3**), orange (**4**), opaque white (**5**) and black (**8**). All these forms of acrylic can be sawn, drilled, turned and milled in a very similar method to that used for non-ferrous metals. The colour is obtained by the addition of pigments or dyes which do not affect the workability of the material.

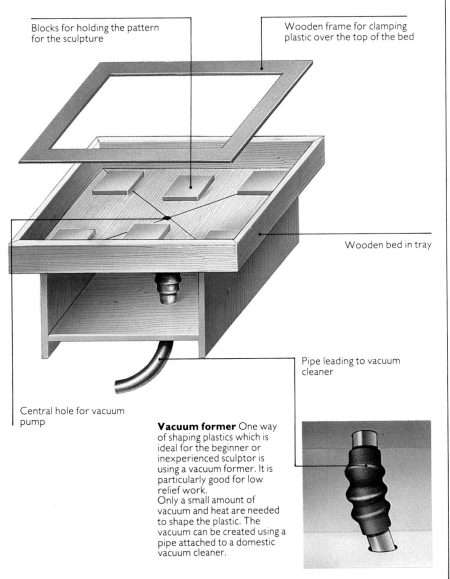

Blocks for holding the pattern for the sculpture

Wooden frame for clamping plastic over the top of the bed

Wooden bed in tray

Pipe leading to vacuum cleaner

Central hole for vacuum pump

Vacuum former One way of shaping plastics which is ideal for the beginner or inexperienced sculptor is using a vacuum former. It is particularly good for low relief work.
Only a small amount of vacuum and heat are needed to shape the plastic. The vacuum can be created using a pipe attached to a domestic vacuum cleaner.

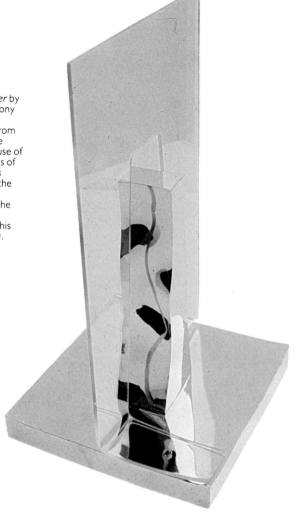

Right This work is *Tower* by the British sculptor Anthony Benjamin. About 2 feet (60 cm) high, it is made from bronze and perspex. The work makes interesting use of different planes and areas of reflection. The work was created in 1966. During the 1960s, there was considerable interest in the potential of plastics as a sculptural medium, and this has continued until today.

can be scored and folded in a similar way to card. Standard polystyrene adhesives of the type used for model aircraft kits bond the sheet.

This is perhaps the most useful material for use with a home-made vacuum former. Its softening point is 176°F (80°C), and only a small reduction in air pressure is needed to stretch the sheet. For the beginner, vacuum forming is best used as a means to develop low relief work. Professional results can be obtained with this process.

With the vacuum former, patterns can be made cheaply and easily using combinations of wood, clay, modelling clay, card and metals. The main point to be aware of is that the draft of the pattern is limited by the depth of the vacuum box, there should be no undercuts on the pattern. Small holes should be drilled through the pattern wherever air might be trapped between forms. These will allow the air to vent freely, drawing the plastic into the hollow. The deeper the draw the thinner the sheet becomes. But excessive draw will rupture the sheet and the forming will be ruined.

Expanded polystyrene has altogether different uses and characteristics. It has a cellular structure and a low weight to volume ratio, making it ideal for large-scale work. Surface finishes, though versatile, are generally visually unpleasant. Polystyrene is, therefore, recommended mainly as a

Cutting acrylic sheet 1. Draw around a paper template, marking the required shape on the backing paper of the acrylic.

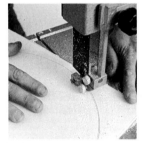

2. Cut out the shape on a band saw, working fractionally wide of the mark. Use a metal cutting blade as acrylic is very tough.

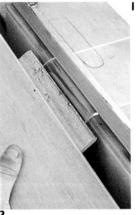

3

2

1

Bending acrylic sheet
Clamp the acrylic under a thin strip of metal on a wooden jig. Hold the protruding end between asbestos and wood, so only a narrow line is exposed along the width. Direct the hot air blower onto this area (**1**). The metal strip helps to spread the heat. As the plastic heats, work it gently up and down and when it is ready to bend put aside the blower and form the bend evenly with both hands (**2**). By varying the angle and direction of each bend you can form a complex shape (**3**). As the edges may flare when heated it may be advisable to cut the original sheet over the required size and trim it when bending is completed.

3. Grind down the edges to finish accurately on the mark, using a bench grinder. Saw cuts cannot give the necessary precision.

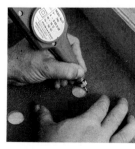

4. To make marks on the surface of acrylic sheet, peel away backing paper and draw with an electric engraving tool.

base material to which more interesting surfaces built up. For example, plaster, resins and adhesive sand and sawdust mixes can be applied. Cutting and carving can be done with single-edged razor blades, hand saws, knife-bladed bandsaws, rasps and surforms.

Heated carving tools for working with expanded polystyrene can be made cheaply from thick metal wire bent to the required shape and mounted in a wooden dowel handle. These are then heated over a gas flame before cutting. Regular cleaning of the tool will prevent melted plastic deposits building up. Abrasive paper is ideal. These tools are useful for cutting away internal volumes. Hot-wire cutters are another alternative and are available in small battery operated and larger tabletop models.

Joining polystyrene with adhesives can present some problems. Solvent-based types can corrode the material. If in doubt, try a test sample. Generally, latex and PVA-based adhesives are the safest and produce strong bonds.

Corrosion can be used to give textural effects to surfaces. Liquids, such as cellulose thinners, carbon tetrachloride and nail polish remover, when sprayed will etch the surface of polystyrene. They can be difficult to control, but paper templates or stencils will protect those areas not to be treated. Never use mouth sprays for these liquids.

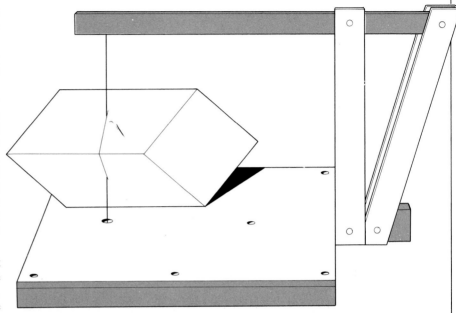

Table top hot wire cutter
Although a hand-held wire cutter will suffice for most jobs, for large-scale work a table top cutter may be more appropriate. With a hot wire cutter, it is possible to cut more intricate shapes with the hand-held model. Electric cutters work on the principle that an electric current passes through the wire, softening and cutting the material. The wire should be made of nickel chrome.

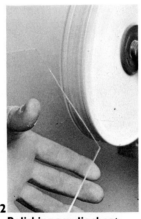

Turning acrylic rod Turn the sawn end of acrylic rod on a lathe to give it a clean edge. Set the lathe to a negative rake, so it cannot dig into or chip the acrylic.

Polishing acrylic sheet
The polishing wheel is made of layers of canvas which hold together in a tight mass when in motion. Canvas abrades as well as polishes the acrylic, removing any scratch marks. Set the wheel in motion and apply polish from a block (**1**). Peel away all backing sheet from the acrylic and hold the edge lightly against the wheel, moving it gently up and down (**2**). Stand slightly to one side of the polisher and avoid trapping corners of the acrylic between the canvas layers of the wheel.

Joining acrylic sheets at a right-angle 1. Clamp the sheet and cut two pieces, using a sharp general purpose saw.

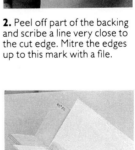

4. Turn the sheets over and apply adhesive along the V-shaped groove formed by the two mitres. Use a small syringe or dropper.

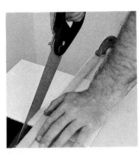

2. Peel off part of the backing and scribe a line very close to the cut edge. Mitre the edges up to this mark with a file.

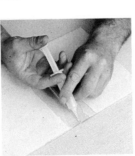

5. Support the acrylic sheets in a wooden jig to hold them at a 90° angle while the joint sets firm.

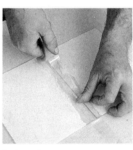

3. Butt the two mitred pieces together, angled edges down, on a flat surface. Put clear adhesive tape along the join and rub it down.

6. Avoid removing all backing paper for as long as possible, so most of the acrylic is protected while you work. The final result will be clean, firmly jointed sections.

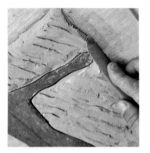

Vacuum forming 1. Make up a relief pattern for the work using wood and clay. The underside must be absolutely flat.

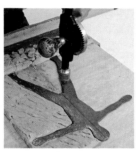

2. Drill small vent holes in the baseboard to ensure tight forming. The pattern must have no undercuts or right-angles.

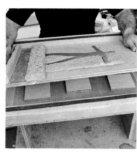

3. Place the pattern into the bed of the vacuum former. It should rest below the top edge with ⅛in (3mm) free surround.

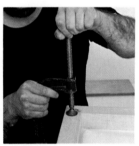

4. Lay a sheet of toughened polystyrene over the bed. Clamp it down firmly under a wooden frame with G-clamps.

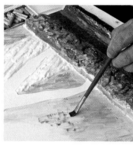

5. Turn on the vacuum and heat the plastic with a hot air blower until the suction draws it down over the pattern.

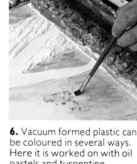

6. Vacuum formed plastic can be coloured in several ways. Here it is worked on with oil pastels and turpentine.

Cutting and joining expanded polystyrene 1. Mark the block with a felt tip pen. Cut along the mark with a hot wire cutter.

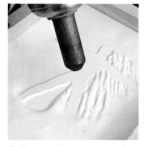

2. Cut all the sections needed for the sculpture. In this example they are interlocking shapes and there is no wastage.

3. To shape a curve, cut off surplus material with a saw or hot wire and use a surform to round off the edges and corners.

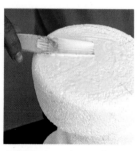

4. On each section apply a latex based adhesive to the faces which are to be joined.

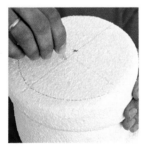

5. Locate the shapes and press the glued surfaces together. Insert a thin wooden peg to secure them while they are drying.

6. A wood glue mixed with acrylic pigment and sawdust is used here as finish. Two coats are needed and it is sanded when dry.

FLEXIBLE PLASTICS

Polythenes and PVCs are both flexible plastics. They can be bought as flexible sheets, although polythenes come as tubes and bags as well. Both are available in clear colours, while PVCs come in opaque colours also. PVCs and polythenes also come in a variety of sheet sizes and gauges.

Flexible plastics are mainly used by the sculptor as 'containers'—to contain air with inflatables, kapok or cotton waste for soft sculpture. Dyed liquids, polystyrene granules, sand, soil and various aggregates have all been used to create fluid and organic forms.

When marking out designs, use paper templates as a guide. Ballpoint pens or tailor's chalk mark clearly. Cut with scissors or modelling knife. Take care the blade does not slip.

There are a number of ways of joining flexible plastics. Special adhesives are made for PVC. Non-solvent types are particularly recommended for inflatables. No permanent adhesive is available for polythene.

PVC can also be sewn together on a standard sewing machine. Use strong thread and 10 to 12 stitches per inch (2.5cm), six to eight stitches per inch (2.5cm) for polythene. A useful tip is to place tracing paper underneath the sheets being

Blow forming The blow forming table has a clamping ring in the middle surrounded by toggle clamps. A hole at the centre of the ring admits the compressed air supply and is covered by a loose felt pad to prevent a direct blast of air onto the plastic. Acrylic sheet is cut in a circle slightly larger than the clamping ring. With the backing paper removed, it is heated in an oven and, when rubbery, it is taken from the oven and clamped down on the table under the clamping ring. This must be done very quickly before it cools. Asbestos gloves are used as protection from the hot sheet. Compressed air is released slowly into the ring and the sheet inflates into a dome shape, the height controlled by the amount of air let in.

sewn. This aids the movement of the sheets under the machine foot. If sewn seams are backed with clear adhesive tape, they must produce seals which are fairly airtight and satisfactory for most purposes.

Welding is the most permanent method of joining flexible plastics. A number of electrically heated hand irons are made for polythene welding; and there are also larger table models. Heat welding is very much a matter of trial and error, welding times vary according to the gauge of plastic being handled.

Hot-air blowers with specially designed nozzles and a small type of pressure roller can be used to weld PVC. This method requires considerable practice, but gives excellent results when it has been mastered.

High-frequency welding techniques can also be used with PVC. This is the most sophisticated method, but demands high capital outlay for the equipment. The welding electrodes are made of copper or brass, and can be bent into any flat profile pattern, limited only by the size of the machine's welding bed. This is, therefore, not so suitable for the beginner.

Plastics are a relatively recent sculptural medium. However, they have great potential, as scientists invent new substances. One of the most interesting aspects of work with plastics is the way some plastics, especially the rigid variety, can interact with light.

SAFETY

Manufacturers of the different types of plastic supply detailed literature dealing with specific hazards of their products. Read these carefully before starting work. Safety notes with solvents and adhesives must also be observed. There are five general areas of safety:

Fire All the plastics described here are inflammable. The temperature at which they ignite and the ferocity with which they burn varies, but all release toxic fumes as they decompose. Never leave material on or near paraffin stoves, central heating boilers, gas rings or open fires of any kind. Try and store plastic away from living areas. Outside in a garden shed is ideal. Always keep a fire extinguisher or at least a sand bucket in the studio.

Toxic fumes In addition to fire, many plastics release toxic fumes when overheated during machining. Use a coolant to help avoid this. Harmful styrene fumes are released in small quantities when cutting polystyrene with heated tools. It is essential to ventilate your work area adequately. Extractor fans can be fitted to your studio windows at reasonable cost. Solvents and adhesives can also produce potentially dangerous fumes. Chloroform is an obvious case. Fumes can cause nausea, irritability, drowsiness and, in extreme cases, coma. Fume masks help reduce these risks.

Dust Acrylic machining is the main dust producer. Liquid coolant helps absorb dust in certain processes, but, with grinding, filing or hand-sawing, this is not practical.

Dangerous solvent

Safety mask

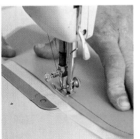

Joining PVC I. Seam two pieces on a sewing machine using strong thread and needle. Run tissue through under the PVC.

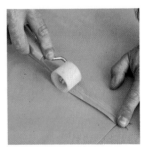

2. To make a seam suitable for use in inflatable sculptures, flatten down the seam with a wallpaper seam roller.

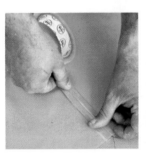

3. Lay adhesive tape down the seam covering both edges of the PVC. If curves are required in the seam make darts before taping.

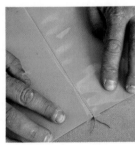

4. Turn over the PVC and smooth it out along the seam line. This is strong and airtight.

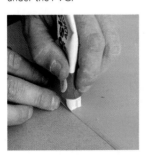

Run and fell seam I. This is for PVC sculptures which will hold water. Apply adhesive along the edges of each piece.

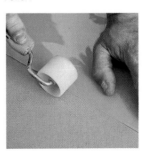

2. Align the pieces together and rub down the seam with the roller to seal it quite flat.

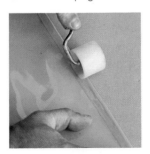

3. Apply glue to one side of the seam and turn it down to form a double thickness. Flatten it down again with the roller.

4. Unfold the PVC and smooth out the seam. The strength of the adhesive and doubling of the seam make it watertight.

Hot air blower The hot air blower is used to form plastics using a mixture of heat and air. The tool is electric powered and comes with a variety of possible attachments. It is extremely useful when working with plastics.

CONSTRUCTED METAL

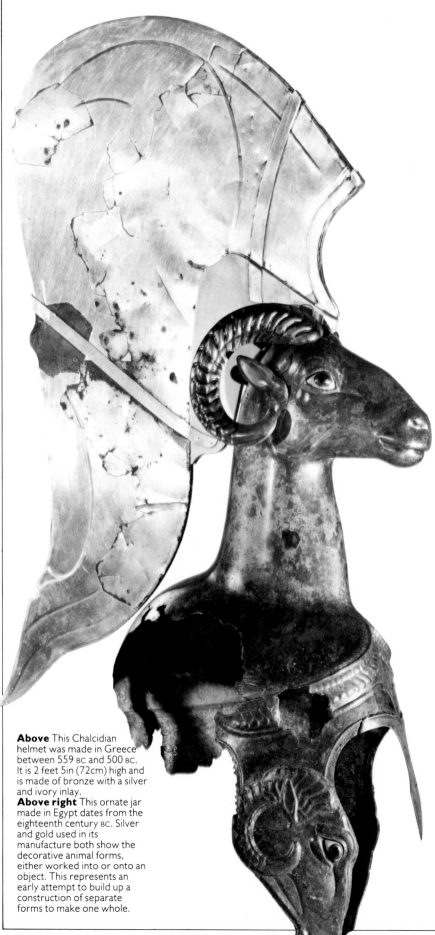

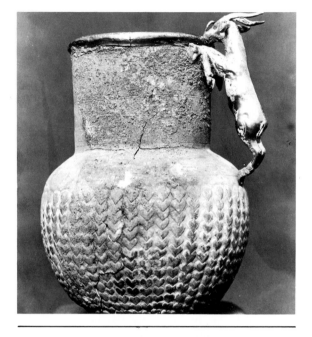

Above This Chalcidian helmet was made in Greece between 559 BC and 500 BC. It is 2 feet 5in (72cm) high and is made of bronze with a silver and ivory inlay.
Above right This ornate jar made in Egypt dates from the eighteenth century BC. Silver and gold used in its manufacture both show the decorative animal forms, either worked into or onto an object. This represents an early attempt to build up a construction of separate forms to make one whole.

HISTORY

Metal as a medium in which to construct rather than cast sculpture only developed in the twentieth century. It is, in many ways, a product of industrialization and the processes developed in industry. The first important all-metal constructed sculptures were made by the Spanish artist Pablo Picasso (1881–1973) just after 1900. These were influenced by metal masks made by his compatriot, Pablo Gargallo (1881–1934). Picasso's *Guitar* of 1912, which was made from sheet metal and wire, constituted a major break with the tradition of cast sculpture. Picasso's inventiveness imbued the medium with a freshness and vitality which is still evident today— some 70 years later. The mood of change around the turn of the century and heavy industrialization all brought about the kind of atmosphere in which traditional sculptural values no longer seemed adequate. Sculpture, especially through this new medium of constructed metal, began to reflect the vigour of the industrial age.

In Russia, where revolution was transforming the thoughts of the people and the make-up of the country, the Contructivist sculptors were trying to create a movement in line with the cult of the engineer. Vladimir Tatlin (1885–1953) had met Picasso and seen his small relief sculptures. Mixed with Tatlin's own ideas, this new use of material led to the Constructivists producing the first abstract sculpture, free of any representation. In 1919 Kasimir Medunetsky constructed his *Abstract Sculpture, Construction No 557* from tin, brass and iron. This piece shows complete abstraction, but also reveals a certain awkwardness,

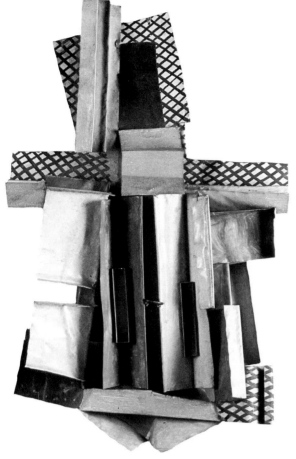

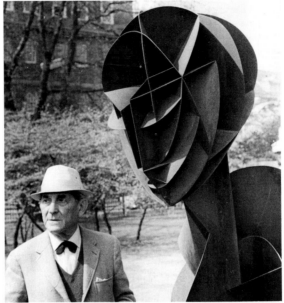

Far left *Construction: Metal Violin* is an example of Picasso's early work in metal. It was created in 1915. The metal was painted in several colours. Some of the surfaces of the work were painted in plain colours, while others were given a pattern. In its many different surfaces and textures, this work shows the influence of Cubist ideas about form and space.

Left This is one of the early abstract heads of Naum Gabo, the Russian Constructivist which was made following Cubist ideas. The iron planes used in this sculpture are surprisingly evocative and give a certain strength and presence to the whole sculpture. The edges of the plane delineate the form and there is no barrier between internal and external space. Gabo—who is standing by the work—saw Constructivisim as a 'general view of the world, an ideology that is grounded in life'.

as if it was an engineer's model rather than a sculpture.

In 1930 Picasso made *Construction in Wire*, a totally open space frame, which, although figurative in content, was a radical change from the attitude that sculpture was only about mass and solid form. This elevation of materials, which previously would only have been considered for maquettes or models, to the stature of sculpture paved the way for the adventurous use of metal in constructional sculpture. Picasso began to supplement his materials by selecting metal scrap which could aptly convey his ideas. About this time, Picasso was joined in Paris by fellow Spaniard, Julio Gonzalez (1876–1942). Gonzalez came from a background of silversmithing, and introduced Picasso to forging and welding techniques. Hammered surfaces and spikes gave Gonzalez's sculpture an aggressive feel, which can be seen in the *Cactus* figure pieces (1939–1940). He dealt with shapes based on masks and armour, and, although aggressive, they are very lyrical.

Towards the middle of this century, many sculptors felt that it was important to convey in their work their attitude to man's position in society, and feelings of alienation and anxiety. This was a broad phenomenon involving many media, but metal sculpture became one of the most appropriate. Such was the case with Theodore Roszak (born 1907) who created bird-like forms in welded steel. His *Night Flight*, created between 1958 and 1962, conveys a feeling of impending evil.

The general mood manifested itself in an interest in mythology. In Britain, the Scottish-Italian sculptor Eduardo Paolozzi (born 1924) welded preformed aluminium and bronze industrial shapes into god-like pseudo machines as in the 1962 work *Hermaphroditic Idol No 1*. The French sculptor Cesar Baldaccini (born 1921) used found metal objects to construct welded winged figures with elaborate surfaces. In some instances, the found objects provided a direct reference back to the industrial society that the sculptor was parodying, as was also the case with the large motor-like sculptures by the American Jason Seley (born 1919) which were made entirely from chrome-plated automobile bumpers.

More significant in the development of sculpture generally was the American artist David Smith (1906–1965). His early forged steel sculptures, such as the 1951 *Hudson River Landscape*, were open and calligraphic in form. His wit and inventiveness were prodigious, as even left-over cut-outs were transformed into sculpture. By the early 1960s, his work had become more abstract, simple, and contemplative, as can be seen in the box structures welded together into the columns or arch formations of the *Cubi* series. The process of welding is central to the make-up, visual balance and sense of form in these last pieces by Smith. Another central figure in constructed metal sculpture is the Englishman Anthony Caro (born 1924) whose use of industrial metal beams and simple treatment of steel has done much to further abstract sculpture. In Caro's *Early One Morning*, for example, the simple steel units actually describe their own environment into which the spectator can physically enter.

The development of constructed metal sculpture has been one of liberation, thanks to its flexibility and durability. This, coupled with its direct links to the rise of industrial society, has made it a part of sculptural advancement.

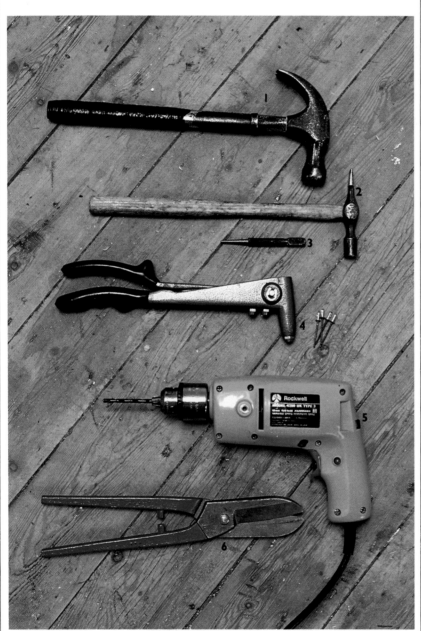

MATERIALS

Not all of the wide variety of metals available to the sculptor are practical for general use, for a number of reasons. To the student, with limited workshop facilities and little money, cost and ease of working are especially relevant. The expensive metals—gold, silver and tin—are not really suitable for sculpture, except on a small scale, and will more often be used by a silversmith or jeweller. The metal generally called tinplate is, in fact, thin, mild steel coated with a thin layer of tin for protection against rust. Aluminium, bronze, and brass are available in various forms and can be fixed mechanically. However, they present some problems in welding, as they need specialized equipment.

Copper is very malleable, and therefore is ideal for beating into shape or riveting, and it is easily soldered. However, bronze, brass and copper are too expensive to experiment with on a large scale, and none of these materials can compare with the versatility of mild steel for construction purposes. Mild steel can be soldered, brazed and welded quite simply, if it is thin enough. This is only one of the alloys of iron. Another alloy, stainless steel, has been used by many sculptors. However,

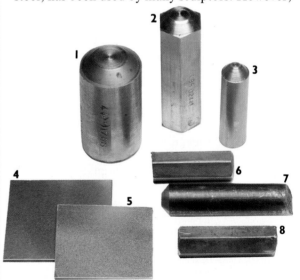

Tools for metal sculpture
A certain number of specialized tools are required when working in metal. Pictured here are a large claw hammer (**1**), a small ball hammer (**2**), a punch (**3**), a pop riveter (**4**), an electric drill (**5**) and tinsnips (**6**). A choice of chisels and wrenches are often used, and an engineer's vice is an essential piece of equipment. Most of the work involved in metal construction falls into two categories—cutting and bending or shaping. For cutting, power or hand tools or heat is used. Heat cutting requires oxyacetylene equipment. Harder metals also have to be heated before bending and shaping. Thinner metals do not require such treatment and can be shaped with hammers like those pictured above. When working with metals safety precautions should be strictly observed, especially when metal is being cut. Protective clothing, including gloves and a dust mask, is essential. Steel-capped shoes should be worn for protection in case any metal is dropped. Oxyacetylene equipment is highly specialized and should only be used under strict supervision. Pipe benders should also be used with great care and supervision.

Types of metal
Although not all of the forms of metal available to the sculptor are suitable for the amateur who must pay attention to cost and ease of working, it is important to be aware of the qualities of—and the availability of—metals before choosing a medium. Aluminium can be obtained as a cylindrical bar (**3,1**) or a hexagonal bar (**2,6**). Copper (**4**) and brass (**5**), here in sheet form, are two of the most popular metals. Steel generally comes in the same form as aluminium—cylindrical (**7**) or hexagonal bars (**8**)—but it is also available in sheets.
Tin offcuts As well as flat metal sheets hammered out from the walls of the cans, thin strips of metal are obtained by trimming off seams and rims. You may also find a use for the round sections of the top and bottom of the can. This is a cheap and easy way to find a source of metal.

this metal is rather impractical for the beginner.

There are four basic sources of metal. It can be bought new in all forms from commercial stock-holders, builder's merchants, and much interesting metal can be found in industrial scrap or rescued from household waste. Both the Swiss sculptor Jean Tinguely (born 1925) and the Frenchman César (born 1921) extensively used old industrial components from scrap yards, and the American John Chamberlain (born 1927) used crushed cars which came straight from the breaker's yard.

An almost overwhelming variety of material can be found in this way and this method is, of course, much cheaper than obtaining new material. Any form of metal of useable size—whether sheet, plate, bar, tubing, mesh or I-beam—is costed by its weight of metal. In addition, very small scrap will often be sold for a nominal sum to artists. Scrap metal offers a large number of interesting shapes which lend themselves readily to construction methods. In the home, the sort of materials available will be on a much smaller scale, but nevertheless very useful things are often found. Tin cans, for instance, can be opened up with metal cutters or tinsnips to provide a good source of thin steel suitable for soldering or riveting.

Left Julio Gonzalez's *Tunnel Head* (1933–1935) is a construction in sheet steel. With an economy of line, using curved, bent and flat surfaces, he creates total darkness within a continuous surface by the almost complete sealing-off of the void in *Tunnel Head*. He achieves a striking effect through the use of strong bold lines.

Below The French sculptor César is renowned for his work with found objects, particularly cars which he crushes with a hydraulic press. He calls his works *Compressions dirigées* (directed compressions). He is interested in the surface textures created.

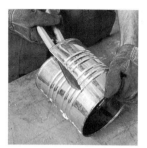

Cutting and flattening a tin can 1. Remove the top and bottom of the can, and cut down one side of the seam with tinsnips.

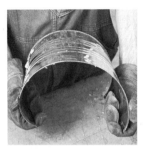

2. Using gloves to protect your hands, grasp each edge of the metal and pull out the can to flatten it.

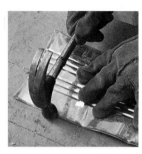

3. Place the metal down on the work bench and hammer it out along the edges to ease the buckling.

Cutting metal on a guillotine 1. Place the metal flat on the bed of the machine, positioned under the blade. Press down the foot pedal.

2. The foot pedal activates a toothed grip which holds the metal in place and then draws down the blade.

Safety The importance of safety cannot be overstated when dealing with metal cutting machinery. It is vital for you to pay attention to all safety procedures. Always have the machine's safety guard in position, as the manufacturer suggests. Also it is important to wear gloves, so that your hands and fingers are not cut by the sharp edges of the metal or the blade.

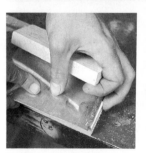

Bending metal 1. Place a wood block at the edge of your work bench, and position the metal sheet to overlap the wood.

2. Align a second block with the first to hold the metal in place, and clamp them firmly to the worktop.

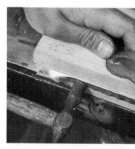

3. Hammer along the overlap of metal to flatten it down against the lower block, making a clean sharp bend.

MARKING OUT

Before undertaking any sculpture in metal it is important that all the processes—such as shaping, fixing, and drilling—should be well planned and marked out, especially if the sculpture is going to be an awkward shape, which may make drilling or cutting difficult. Ordinary blackboard chalk will prove a useful item of equipment for marking out on steel prior to cutting. The chalk line will remain easily visible when using oxyacetylene cutting gear. Where precision is required, an engineer's scribe should be used. To make this more visible, a marker usually called 'engineer's blue' is painted onto the metal and the line scribed through it.

Where a completed sculpture is very heavy and therefore needs to be split into sections for ease of transport and reassembly, cutting lines should be envisaged during construction. Where two pieces have to be bolted and holes drilled, accuracy is essential, and it is useful to mark the centre of the hole with a punch. If a large hole is required, it is best to drill a pilot hole of a smaller size first.

CUTTING

Cutting is an important operation which also needs careful planning and thought. It is important to consider the physical properties of the material which determine how it can be cut. In addition, the type of cut may influence the impact of the sculpture and the effect it achieves.

There are three main means of cutting—using hand tools, power tools, and heat. The hand tools are the cold chisel, hacksaw, tinsnips and manually operated guillotine. The most commonly used power tools are the power guillotine, bandsaw and mechanical hacksaw. Heat cutting requires oxyacetylene gear. This should not be attempted by a beginner, as it requires both specialist equipment and strict supervision.

Hand tools can only be used effectively on thin metals and short runs. The hacksaw is useful for cutting tubes, bars, and rods, as long as their diameters are not greater than the depth of the saw. However, it is not so practical for sheet metal as the saw's frame prevents it from going in deep enough. A sheet saw may be used to cut sheet metal by hand. The manual guillotine can only be used with thin sheet metal, unless it is geared. It will only make straight cuts, although external curves can be achieved by snipping off small bits at a time. Both guillotine and tinsnips will affect the shape of sheet metal. If this is not desirable, the sheet must either be flattened after cutting or a different method employed.

The mechanical hacksaw and bandsaw are only

useful for taking the hard work out of cutting. The power guillotine, on the other hand, is a very useful piece of equipment, as it can chop through thick section steel.

However, the most versatile method for cutting metal is oxyacetylene equipment. This uses a forced flame of oxygen and acetylene, which heats the metal to melting point. Then an extra blast of oxygen oxidizes the metal, forming a hole. The advantage of this method to the sculptor is obvious, because, using different cutting tips, it can cut anything from the thinnest sheet to very thick plate. With practice, a smooth and even cut can be achieved. Unlike the other methods of cutting, it can cut from the centre of a sheet of metal without the cut having to be started at the outer edge. However, the equipment is specialized and should only be used under strict supervision. It is also vital to follow all safety regulations or advice when using this equipment.

_ BENDING AND SHAPING _

There are various ways of bending and shaping metal, ranging from the simple process of hammering to the precise process of box bending, all of which produce different results. Non-ferrous metals should be annealed before shaping. With copper, copper alloys and silver, this means heating the metal to a dull red and quenching it in water. Aluminium is annealed to a much lower temperature. It can then be hammered out, using soft mallets and concave wooden formers or sandbags. Very thin mild steel sheet can be shaped without heat, using steel hammers which will produce a more rugged surface than that of a wooden mallet.

Thicker steel sheet and plate needs to be forged. This means heating the metal to red heat and hammering while it is still hot. This involves using a forge, which is an open coke fire raised to a high temperature by a forced jet of air. The metal is held in tongs and beaten out on a stout anvil. Julio Gonzalez used this technique to produce vigorous sculptures. However, this is not a practical technique for the beginner.

A rolling mill can be used to produce smooth curves in one direction only on thin sheet metal. One of the rollers has a series of grooves running around it which enables rods and bars to be curved evenly.

The effect of expansion due to heat may be used to bend thicker plate in one direction. A controlled line of heat applied on one side of a plate by an oxyacetylene torch will cause the metal to expand, thus curving the plate the other way.

Angled folds in thin sheet metal can be made on a box bender. If more than one fold is wanted,

these must be carefully planned to allow easy removal from the machine.

In his sculpture *Open Bound*, the British sculptor Phillip King (born 1934) used a box bender to produce square boxes of steel to reinforce the honeycomb structure of the piece visually. The box forms are used in combination with expanded steel mesh.

Another useful piece of equipment is the pipe bender for bending tubes and bars. The most common type has a long lever which is pivoted about a grooved wheel. The tube or bar is held in the concave part of the wheel and is bent around it by a corresponding grooved block set in the lever. To prevent the tube collapsing during the process, a spring can be inserted into the tube, but this is not necessary if it is bent in gradual stages. A hydraulic bender will do the same job with less effort and is a smaller piece of equipment. Much of this equipment is specialized and expensive. Great care should be taken when using it and expert supervision is essential.

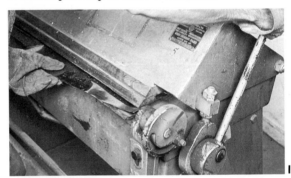

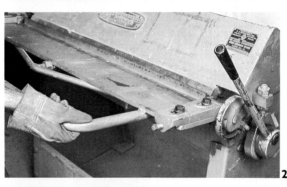

Metal bending machine
This produces a clean, angled bend along the edge of thin metal sheet. The metal is pushed into the jaws of the machine with the edge overlapping the machine bed (**1**). The top section of the machine is clamped down on the metal and the bottom section drawn up over it (**2**). The two parts lock tightly together and trap the metal to form the bend (**3**).

Joining metal 1. Interlock the trimmed and bent edges of two flat sheets of metal. The edges must be absolutely straight.

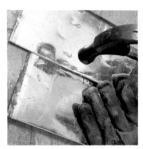

2. Hold the pieces in place and hammer down the seam. Work from each end towards the centre. Make the seam line quite flat.

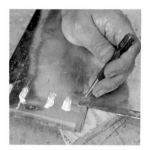

3. Mark out holes for rivets at each end of the seam. Place a punch on the metal, hold it vertical, and tap it with a hammer.

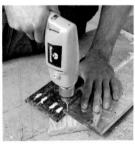

4. Place the metal sheets on a wood block and drill through the punched marks to make rivet holes.

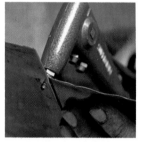

5. Fit an aluminium rivet into a pop riveter and secure the seams.

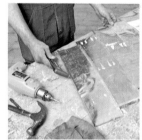

6. Continue to work in the same way, joining the sheets to make the shape required.

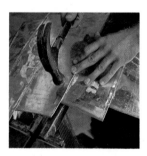

7. To join two ends of a flat sheet to form a cylinder, find a support which will fit inside the curve, on which the seam can be drilled and hammered.

Right *Metal column* is a constructed metal piece by the British sculptor Andrew Fyvie. It stands several feet high and is entirely constructed from jumbo size tin cans by the processes described in the step by step sequences. The form derives from the artist's interest in the simple, powerful solidity of tree trunks. The spirals of the tin sheets suggest organic growth. The sculpture is hollow and, in fact, relatively fragile, but at the same time evokes the strength of a heavy, old tree.

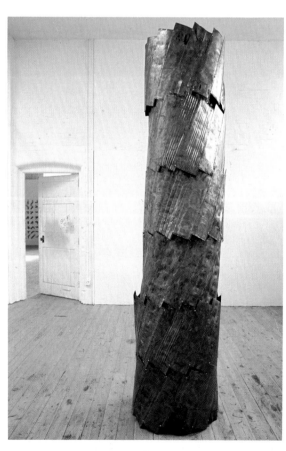

In metal sculpture, the fixing or joining processes are more important even than cutting processes in determining the approach to the work. Therefore, it is important to consider, for example, whether the joins should be concealed or should form an integral part of the sculpture. For example, when arc or oxyacetylene welding is used, the weld line can be left as an obvious join between two areas, or it can be ground down to produce one continuous surface. Oxyacetylene welding utilizes a forced flame of oxygen and acetylene which brings the metal up to red heat. For joining, a filler rod of the same material is placed in front of the flame to help fuse the metal. Although a weld can be achieved without the filler rod, it helps to fill any slight gap between the pieces of metal and prevents any tendency for the metals to run away from each other when the right heat is reached.

An arc weld is made by producing a powerful, localized electric current through the pieces to be welded. A negative cable is clamped to the work and a circuit is made by the positive electrode (the filler rod) being introduced to the point of the weld. As in oxyacetylene welding, the filler rod is made of the same metal as those being joined. This means that only identical metals may be joined by these methods.

Different metals can, however, be joined by brazing. This is similar to welding, but uses a lower heat and a copper-zinc brazing rod. The metals must be cleaned and fluxed to obtain a good join. Fluxing is a method of ridding metal of

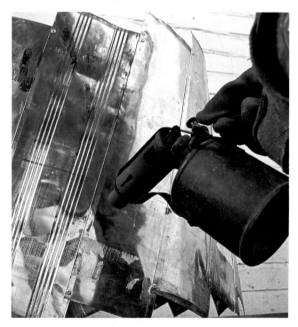

Blueing metal The surface of the metal is heated continuously with a blowlamp until it changes colour. If using tin cans to provide the metal, this process will also clean off any dirt or scraps of labels.

impurities using chemicals which coagulate any impure substances. With practice, both welding and brazing can be used to fix metals of different thicknesses and sizes. This can greatly add to the vitality of a sculpture.

For reasons of convenience, it may be necessary to make a piece of sculpture that is easily dismantled. In this case, bolting would be preferable to welding as a means of joining. Used thoughtfully, bolts may also add to the effect of the finished work.

Bolting and riveting are also suitable for joining thin materials, as they eliminate the distortions caused by joining methods which use heat. The only extra piece of equipment needed is a drill to make the holes for the rivets or bolts. For very thin metals or wire construction, soldering may be necessary. This relatively simple method requires only a heating element and solder. The join does not have great strength but is adequate for small work.

Left *Orion* is an example of the metal sculpture of the French artist Hajdu. Completed in 1968, the work was constructed from polished aluminium. Much of Hajdu's sculpture features pierced forms with jagged edges. As well as using aluminium, he also works frequently in marble, copper and lead.

FINISHING

The surface of metal sculpture may be painted or treated in various ways to change its appearance and make it suitable for an outdoor site. Paint will prevent steel from rusting, but it is also generally used to unify an image by covering a sculpture with a single colour.

Parts may be emphasized by introducing more dominant colours, or made to recede by painting in a way which contradicts the original contours. One possible disadvantage of painting steel sculpture is that the raw quality of the steel may be lost. In some cases, it is preferable to paint the bare metal with clear varnish. To overcome the problem of the outside durability of metal sculpture, some sculptors have used stainless steel, which has a distinct individual character. For instance, David Smith has used stainless steel which he polished or burnished with a grinder, giving the pieces a dazzling, reflective surface.

It is possible to achieve an overall dense surface on mild steel by allowing a coating of rust to develop. This process can be accelerated by wetting the metal with a weak acid. Any surplus or flaking rust built up must be brushed off and then varnish may be applied. This will tone down the rust colour and keep it stable for some time. To prevent any rusting at all there are several proprietary brands of rust inhibitor and converter. Once applied, these can be covered with paint or varnish.

Weather proofing only has to be taken into account when sculptures are going to be placed outside. For smaller indoor pieces, more liberties may be taken, and it is possible to experiment with a wide variety of different finishing techniques.

SAFETY

Hazards abound in any area where sculpture is being made, and this is especially so with metal sculpture. Therefore all possible precautions should be taken to lessen the risks.

Clothing Generally, stout clothes are advisable but, where specialist operations are carried out, protective clothing is essential. Goggles should be worn to guard against sparks or chips of metal entering the eyes; earmuffs will deaden excessive noise; and hard hats will protect the head from falling objects. Leather aprons, caps, gauntlets and thick trousers will prevent the danger of burns when cutting, welding or grinding, as sprays of molten metal are created when cutting with oxyacetylene torches.

Footwear It is important to wear appropriate footwear. When handling heavy objects that are likely to fall, it is vitally important that the toes are protected with heavy shoes, preferably with metal toecaps.

Eyes and skin Apart from these obvious dangers, extreme care is needed when arc welding, as the light produced by the arc will seriously damage the retina of the eye. Overexposure can cause skin cancer, so the proper face guard must always be in place before applying the electrode, and work must be screened from other people.

Ventilation There should be good ventilation at all times, as a build up of the fumes produced by the arc are toxic.

Electricity Arc welding will not result in electric shocks as long as neither the work nor your hands are wet.

Gas When welding with gas, common sense should ensure that nothing goes wrong. The cylinders must be placed away from the work and from any source of heat, and the hoses kept tidy and off the ground.

Safety instructions These are only general safety precautions. All pieces of equipment have particular rules for usage with which the user must be familiar and which should be adhered to.

Safety goggles

Safety gloves

Safety spectacles

KINETICS

HISTORY AND BACKGROUND

The representation of movement in sculpture and painting has always been a definite aim of many sculptors, but it has made itself felt in static form. The background to the beginnings of kinetic or moving sculpture also has other roots including the interests of scientist engineers as well as artists. From the early experiments in clockwork mechanisms in the sixteenth century to the complex mechanical toys of the eighteenth century, there has been a desire to create the novelty of independently moving objects.

The situation where movement could become an art form was helped when sculpture was freed from traditional restraints by artists such as Marcel Duchamp (1887–1968). While working on changing people's ideas as to what constituted a work of art, Duchamp created his *Bicycle Wheel* (1913), which was the first mobile 'art' piece. As the name suggests, this was just an upturned bicycle wheel which was mounted upon a wooden stool. Although the reason for producing the piece was not that of making moving sculpture, the wheel would have moved if anyone pushed it.

Since Duchamp, movement has been used in sculpture in widely diverse ways. It has been used to multiply the compositional variations of a piece, to comment on the mechanical nature of society, and to introduce an element of time in a work. Ideas ranging from simple to very complex have been employed by kinetic sculptors. The Russian Constructivist sculptor Naum Gabo (1890–1977) made his *Kinetic Construction, Standing Wave* in 1920. Powered by an electric motor, it is a single oscillating metal rod, which is transformed into a seemingly solid volume when in motion. In contrast to the simplicity of Gabo's construction, *Light Space Modulator* by László Moholy-Nagy (1895–1946), which was conceived in 1922 and made in 1930, consisted of an arrangement of polished metal plates and screws rotating in a synchronized motion, powered by the same motor. Designed to stand alone on a theatre stage during the interval of a show, the surfaces of the sculpture reflected 116 different coloured light bulbs onto surrounding walls. In addition to the elements of movement and light, Moholy-Nagy envisaged a suite of music to accompany the action, but this was never brought to fruition. This type of complex visual display was taken to an extreme later by the Hungarian-French artist Nicolas Schöffer (born 1912). He built large towers of moving and reflecting surfaces and flashing lights. His work was financed by commercial sponsorship.

In the work of both Moholy-Nagy and Schöf-fer, the motor was a means to an end; its sole function being to drive the moving parts of the sculpture. It therefore remained hidden from view. As a contrast, the Swiss sculptor Jean Tinguely (born 1925) based his major work on the motor-machine itself. His earlier pieces were mobile shapes, powered by hidden motors, but, in the work for which he is best known, the emphasis is on the often useless and wayward nature of mechanical hardware. In the *Metamatic* series, produced in the late 1950s, petrol motors mounted upon freely moving, wheeled tripods drive mechanisms which produce continual abstract drawings on rolls of paper. In the larger sculptures such as *Hannibal No 1*, the mechanism becomes the sculpture, creating aimless motion, with rusting wheels and cams which gradually wear themselves out. Most bizarre of all was the *Study No 2* for an *End of the World* (created in 1962), which, after being set up in a desert in America, was exploded in a ritual-like 'happening'.

As with Gabo's kinetic construction, some of the most evocative images have come from the use of natural forces or simple mechanical movement. The American sculptor Alexander Calder (1898–1976), best known for his invention of the term 'mobile', first used motors to power his moving sculptures, but soon relied solely on air currents to set them in motion. The mobiles use simple counter-balanced weights, usually rounded flat metal shapes suspended from elegantly poised rods with very simple wire joints. Another American, George Rickey (born 1907), makes groups of slender needles balanced near their thicker ends. In some of the smaller versions, the needles lie horizontally at rest, while in the larger ones they are in equilibrium vertically. In the large examples, Rickey developed elegant pivoting arms radiating from central columns upon which the needles rest in a cluster. In a strong wind the needles fan out to produce endless variations of composition.

In the 1960s and 1970s sophisticated electronic sensing devices were developed prompting the emergence of increasingly clever 'toys' which go beyond the realms of sculpture, in some cases going back to the eighteenth century concept of mechanical novelties. Two artists, however, whose sculptures are interesting because of their straightforward simplicity, are the Greek sculptor Takis (born 1925) and the French painter and sculptor Pol Bury (born 1922). Takis used electromagnetism to motivate slender antennae, tipped with discs of metal, which quiver when an overhead electromagnet is turned on and off. The significance of these very minimal pieces lies in the magical quality of the movement created by the invisible force of magnetism. Bury's work is

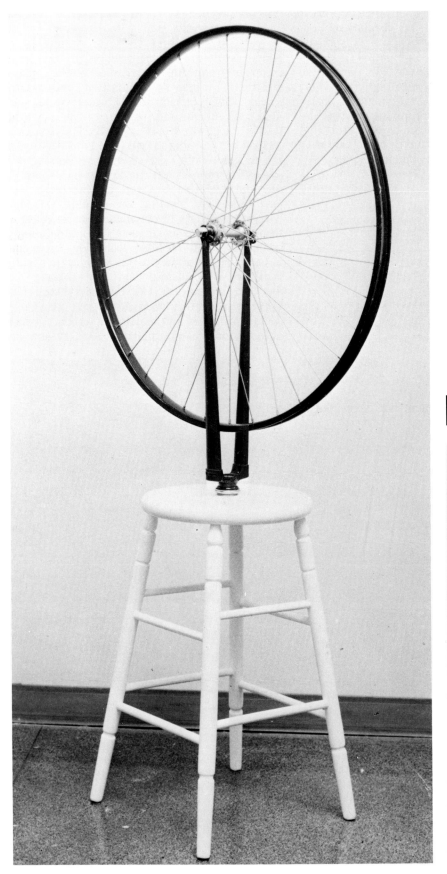

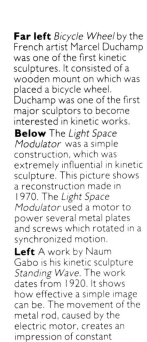

Far left *Bicycle Wheel* by the French artist Marcel Duchamp was one of the first kinetic sculptures. It consisted of a wooden mount on which was placed a bicycle wheel. Duchamp was one of the first major sculptors to become interested in kinetic works.

Below The *Light Space Modulator* was a simple construction, which was extremely influential in kinetic sculpture. This picture shows a reconstruction made in 1970. The *Light Space Modulator* used a motor to power several metal plates and screws which rotated in a synchronized motion.

Left A work by Naum Gabo is his kinetic sculpture *Standing Wave*. The work dates from 1920. It shows how effective a simple image can be. The movement of the metal rod, caused by the electric motor, creates an impression of constant movement. One of the main features of kinetic work has been a willingness by the artists to experiment with widely different forms and materials.

very different as the movement of the sculpture is so minimal that in fact it looks virtually motionless. Wooden cubes and balls in a rack twist and shift almost imperceptibly, and matted strands of nylon mounted through boards switch around in minute amounts which seem to imply stretching and growing rather than movement in space. Even though kinetic sculpture has become increasingly sophisticated, simple interpretations have often been the most successful in capturing the essential quality of movement.

Below This ceramic work by the Spanish artist Joan Miro is an example of the use of water in sculpture. The green ceramic gargoyle, made in 1968, epitomizes Miro's zany approach to his art.

Below This kinetic sculpture entitled *Fountain* is by Pol Bury, one of France's leading kinetic sculptors. The work measures about 12 feet (4 metres) across and is made of stainless steel. It is in a lake near a French art gallery. The work revolves very slowly, different parts of it dipping into the water. Slowness of movement is one characteristic of Bury's work.

Right *Le Cyclograveur* is an example of the work of Jean Tinguely, the Swiss sculptor. His works often feature jagged pieces of mechanized metal. In this work, which dates from 1960, a needle draws arbitrary lines on a screen.

Left *Antennae with Red and Blue Dots* (1960) by the American artist Alexander Calder illustrates one of the main types of kinetic sculpture, the mobile. Mobiles can either rely on wind to rotate them or can be powered by motors. This example does not have a motor and is made from sheet aluminium and steel wire.

TECHNIQUES

Kinetic sculpture can be achieved by two basic means of propulsion—mechanical power, such as electricity or internal combustion, and natural forces, which include falling water, wind, gas, heat, magnetism, and solar energy. The natural sources of power are often used when ecological factors are considered and a definite decision is taken against the use of motors. Among the sculptors who do use motors there is also a division between those working with technology and those commenting on it. For example, Nicolas Schöffer's towers make conscious use of technology, whereas Tinguely's sculptures make a comment about machine technology from the outside. His attitude to the machine is slightly anarchic and disrespectful; by making his machines 'un-machine like' he draws attention to the importance of machines today.

Circumstances ultimately determine which power source can actually be used. Where no

This sculpture (**centre**) demonstrates quite a complex pattern of movement, but is made using readily available materials, simple construction techniques and a single natural source of power – the wind. The base of the sculpture consists of two flat wood sections set at right angles to each other. The long tail fin anchors the sculpture. The vanes (**1**) are constructed by stretching plastic over a thin wood frame, cut with a jigsaw. They are fixed to the spindle by lengths of metal rod. These are attached to the vanes with wire bound through small drilled holes in the top of the wood frames. A wire is also run between the spindle and the bottom of the vane to keep it at a fixed angle.

The yellow and black paddles are mounted on stakes driven into the ground (**11**). A piece of mild steel rod through a drilled hole in the shaft allows free movement around a fixed point.

The polythene vanes are mounted on the central spindle. They activate the movement in the construction as they catch the wind and rotate (**2**, **3**). Attached to the central spindle is a circular section of wood (**4**, **5**), which transmits the movement to other sections of the sculpture. The shaped edge of the wooden wheel knocks against a metal spring, pushing the red panel back and forth between the two green flaps (**6**).

To balance the paddles, they are tied loosely with strings to wire hooks driven into the ground (**8**). Small curved pieces of wood are mounted on the flat surface of the wheel. Yellow and black paddles balanced on this move up and down over the wood as the wheel rotates (**9**, **10**).

The baseboard is fitted with small hoops of rod driven through holes drilled in the wood. The spindle slots into these and rests on a small section of angle iron screwed to the wood (**7**). The central spindle is held vertical by a wire hook halfway up. The hook attaches to a wooden stake driven into the ground.

Power sources This series of diagrams shows a number of ways movement can be created from a simple motor. The motor (**1**) turns a rod. By attaching another rod with a belt, two rods (**2**) or more (**3**) turned by one power source. Different speeds of rotation can be achieved by attaching belts to a wheel to give slower motion or by using the perimeter of a wheel to give quicker motion (**4**). Gears can create reverse motion (**5**) and cam wheels up and down movement (**6**).

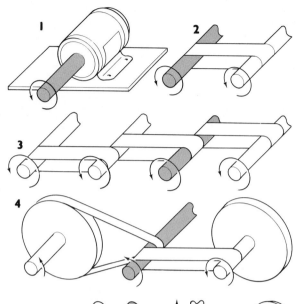

Below *Two lines – Temporal 1* is an example of George Rickey's kinetic sculptures. Created between 1964 and 1977, this huge work is over 35 feet (10.5 metres) high. It consists of two stainless steel mobile blades on a stainless steel base.

motor power or proper mechanical components are available, many scrap materials can be used to rig up some kind of system. An electric motor suitably fixed to a firm base can be used to motivate several simultaneous actions with the help of an arrangement of gears and belts. Belts will transfer the power from the drive of the motor to where the movement is needed, and the gears, if interlocked with other gear wheels, will transfer the direction of the drive. The gear cogs can be made simply from either scrap wood or metal by cutting out V-shapes for the teeth with a hacksaw, and, even if rather crude, they will serve the purpose. The gear wheels can be set together at any angle, so that a wide variety of changes can be made. If the speed of the motor is not correct for any particular action, it can be changed by gearing. A small wheel driven by a larger one, in turn driven by the motor, will speed up the motion. The opposite effect will be achieved if a large wheel is driven off a smaller one. In this way a number of different actions can be obtained from one motor, as in Moholy-Nagy's *Light Space Modulator*, where the different rotations of the plates create a kaleidoscope of reflection from the given light source.

To produce a series of connected movements from a motor, a rigid framework will be needed in which the moving parts can be set up. As long as this requirement is attained, the moving parts can be made up from the kind of scrap found in a scrap yard. Old bicycle or pram wheels are excellent, and car wheel inner tubes cut to size make very good drive belts. If these are not available, string knotted to form a chain can be used with a toothed wheel just as effectively. Plywood will make very light useable gear cogs as the criss-cross layering of the wood prevents the teeth from breaking, which may happen with ordinary wood.

A petrol engine would enable a construction to be set up independently in the open, but it is obviously too noisy and fume-producing for reasonable use indoors. Furthermore, as it is potentially more violent if left unchecked, a much more robust and rigid frame is needed than when using an electric motor. The sort of petrol motors which are ideal for an outside kinetic sculpture can be taken from old mopeds, as these are light, easy to handle, and have a small engine capacity of about 50cc, which is the best size. Secondhand electric motors are often stocked by scrap dealers. These motors, usually taken from old washing machines, are very cheap and easily fitted into a framework. Alternatively, complete washing machines can be bought from secondhand shops, and the fabric of the machine can then be used as well as the motor.

Natural power sources greatly increase the

scope of kinetic sculpture and encourage inventiveness. In the studio, water falling on a wheel fitted with paddles will provide a limited amount of power. Of course, the time the system runs is dependent on the size of the water supply and the rate at which it is falling. Obviously the container supplying the water and that receiving it should be watertight and strong enough to hold the volume of water. Water can also be used in a less active way but nevertheless one which allows movement to take place as in the case of *Floating Sculpture* (1961) by the Hungarian-French artist Marta Pan (born 1923). This is a large upturned rounded form floating gracefully on a pond. On top of this, joined by a swivel joint, is another rounded form which turns independently from its partner. The sculpture is made from polyester resin, an extremely light material, so the hollow moulded form easily responds to any wind. The sculpture sits in the middle of the lake by the Kröller-Müller Museum, at Otterlo in the Netherlands, surrounded by superb scenery. It is, of course, chained loosely in the middle so that it does not get beached at the side of the lake.

Air movements have been used by themselves in the mobile sculptures of Calder and Rickey to produce variations in groups of balanced objects. As long as the parts of a sculpture are finely balanced and free to move easily they will need very little breeze to move them. In both Rickey's and Calder's sculptures the same basic principle is used to catch any available breeze. Calder's mobiles are generally thin, flattish plates, and Rickey's needles are light open cross-section pieces rather than being solid.

Most of the other natural sources have been used by sculptors at one time or another, including solar energy and magnetism. However, the former requires advanced technology to make it useful and it is not really a suitable source of power for the beginner.

Electro-magnetism can be achieved in the studio with only a basic knowledge of electronics. Turning an electric current on and off produces alternate pulsations which will allow limited variations of movement. In his sculptures, Takis uses this method of turning an electric current on and off to alternately attract and repel magnets mounted upon thin rods which quiver accordingly.

Most of the power sources mentioned provide only limited possibilities for use which have been fully exploited by artists in the past. Unlike other sculptural media, kinetic techniques are usually inseparable from the idea, so further development must rely on new inventions. Nonetheless, the exploration of kinetic sculpture is still valuable in providing an understanding of real and implied movement.

Above This sculpture by the Hungarian-French sculptor Marta Pan shows her use of organic form. In its modern architectural setting, the steel column in the sculpture echoes the perpendicular lines of the building's design.

Left Signal, also by Marta Pan, is another example of her interest in forms derived from nature. The superimposed discs bear some resemblance to the petals of a flower. Again, the artist combines curving shapes with vertical rods.

LIGHT

Light is a relatively new medium in the history of art. As a fundamental stimulus of life forms, light has always had a magical or mystical status and is an important symbol in many religions. The movement of the sun was a determining factor in the construction of monumental edifices such as the Pyramids and Stonehenge. Medieval stained glass windows projected the sun's rays into beautiful coloured patterns to highlight architectural or sculptural features inside the building. The Italian sculptor Bernini (1598–1680) paid careful attention to the effect of light on his work, both in the individual sculptures and the settings in which they were displayed.

However, the technical ability to create particular images and effects using light itself as the medium has only become available to artists during the twentieth century. Previous experiments, such as the colour organs of the eighteenth and nineteenth centuries, were unsuccessful. These attempted to link music and colour systematically. Illumination was originally provided by candles, glowing through translucent coloured tapes, later by arc lamps projecting coloured light. The illuminations were linked to the keys of a musical instrument, and the pattern of colour related directly to the musician's playing. Colour organs were both technically and visually disappointing and met with little public response. Displays of colour projection devised by the American Thomas Wilfred (born 1889) in the early years of the twentieth century were more favourably received. These could be aptly described as paintings in light, although the images in his later work suggested three-dimensional space.

The Bauhaus artists in Germany during the 1920s made a number of constructions incorporating movement and light. Laszlo Moholy-Nagy (1895–1946) became interested in patterns of light and shade, arising from his recognition of the sculptural potential of the image of cityscape at night. The *Light Space Modulator* created between 1922 and 1930, was a large metal construction, set in motion by an electric motor. Displayed in a dark room, under a changing pattern of spotlights, the effect of a fluid environment of light and shade was produced.

Effective technical advances in the use of light owe a great deal to work on lighting for the theatre and for commercial display. The development of such equipment as lighting consoles and machines for bending neon tubes has given painters and sculptors the means to approach their traditional preoccupations with form, light and colour in a new and exciting way.

Since 1945, artists have applied new technological developments with great sophistication and have met with a far more favourable public response than did the pioneers of light art. One of the most influential figures has been the Italian Lucio Fontana (1899–1968). Writing his *White Manifesto* of 1946, he defined clearly the traditional importance of light as a factor affecting works of art, and proceeded both theoretically and practically to lay the ground for a positive use of light in their design and construction. Sources of light, such as lamps and neon strips, were incorporated in his sculptural environments as vital and undisguised components of the work.

During the 1950s and 1960s, the medium of light was explored with the same confidence and skill which has characterized other developments in the visual arts. The German Otto Piene (born 1928) interpreted the sensations of his wartime experiences in work known as *Light Ballet*, which used hand-held or mechanized apparatus to form images within a given space. The Hungarian-French sculptor Nicolas Schöffer (born 1912) constructs kinetic works, of which emitted or reflected light forms an integral part. A more recent work detects the surrounding light level and atmospheric conditions, systematizes the information through a computer, and projects related images. The Italian sculptor Danti Leonelli uses light to enhance the volumetric form of his moulded perspex sculptures, changing the colour and mood at intervals. Chryssa (born 1933) and Dan Flavin (born 1933) both work with neon, but in different ways. Chryssa's free standing sculptures are linear drawings in neon, enclosed in transparent boxes. Flavin uses straight tubes in simple groups, but places them around the floor and walls of a room to structure the space in terms of light.

Laser technology is currently being explored by artists, but as yet this work is not fully developed or documented. Artists working with this medium include Billy Apple and Robert Whitman. This is a medium with considerable sculptural potential.

Below Bruce Naumann's neon tubing sign (1967) measures 59in (148cm) 54in (135cm) and demonstrates the flexibility that this medium can achieve. Bending the tubes is difficult and exacting work, which should be done by an expert. Gentle bends are easier to produce than sharp ones. Several tubes will be used to make one work.

Bottom The use of neon is an exciting departure in light sculpture. Closely connected to the use of neon in advertising, neon can create amusing and eye-catching images. Here three colours—green, blue and red—have been used to portray the 'click' of the fingers. It is possible to see where the individual tubes occur.

Left The north rose window in Chartres Cathedral was built in the thirteenth century. This classic example of stained glass craft and painting is famous for its blue glass which is the result of copper being added to the molten glass. The extraordinary quality of this glass has not been repeated in modern times.
Right Nicholas Schöffer's *Tour Cybernétique de Liège* is an example of his highly inventive kinetic work. The reflected light forms an integral part of the sculpture as it cuts through the space around.

SOURCES OF LIGHT

Natural light This is the most obvious, cheap and available source, but the quality is, of course, uncontrollable. A sculpture with reflective surface planes goes through an infinite number of changes in a day. Light through a window could also be incorporated in a sculpture, directed by mirrors or through stencils.

Light bulbs and fluorescent tubes The common apparatus of domestic lighting can be used to make quite complex effects. Bulbs and tubes are available in a range of colours and provide lighting of different intensities. They may be concealed within a construction to provide subtle, fixed effects, or their shapes may be positive elements in the design of the work.

Neon tubes Neon offers a greater brilliance and variety of colour than fluorescent tubes, and can be bent into gently curving shapes. Such work must be done by a professional glass bender, working from an artist's drawing, as it requires expert technical knowledge. Neon tubes are high voltage and must be carefully installed,

with good insulation in the fittings.

Strobe lights The strobe light gives intense, white light in rapid pulsating flashes. Normal movement patterns are given a slow, eerie quality under strobe lighting.

Projectors A projector throws a strong beam of light which can be focused at a distance or close to the lens. It can be used to project white light, coloured light, or photographic images.

Laser beams A laser projects an almost parallel beam of light on one coherent wavelength. The visual effect is of a rod of pure light passing through space, which may be white or coloured. Laser beams are used to create interwoven linear patterns in three dimensions and environments of pure light.

Laser holography This is a means of creating a three-dimensional image with light on a special photographic plate. The image is recorded on the plate by one laser, transferring information from an object. The image is not visible in normal light but must be reconstituted, in effect, by another beam. Holography is very complex and is not yet common as an art form.

Light bulbs Even ordinary light bulbs can provide the sculptor with material if used imaginatively. This type of light can be used to advantage when the sculptor wishes to exploit the reflective properties of light. The positioning of the lights shining onto a mirror sculpture, for example, will greatly affect the impression which the work gives. Some of the types of light bulb which can be used include an ordinary domestic bulb (**1**), semi-silvered (**2**), spotlight (**3**) and tinted (**4**).

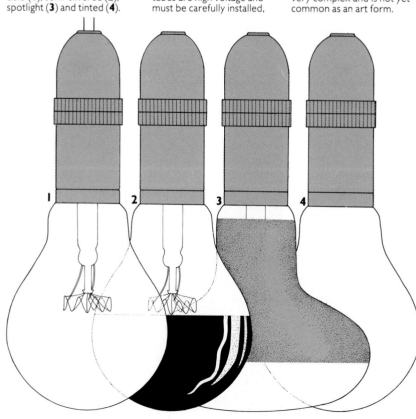

MATERIALS AND TECHNIQUES
REFLECTION

Reflective surfaces react to any available light, therefore no electrical work need be necessary in producing a sculpture with quite complex visual effects. Pieces of mirror, glass or polished metal can be glued to a basic wood construction, or set in resin.

Mirror glass is usually silvered on the back, and the thickness of the glass cuts across between the object in real space and the reflected image. Front surfaced mirror, which may be glass, plastic or stainless steel, eliminates this break. A solid object, such as a half cube, placed against the mirror, connects directly with its reflection and the image of a whole cube is created.

A semi-silvered mirror is reflective under normal lighting, but becomes translucent when lit from the back. It is possible to set up a semi-silvered mirror, with controlled light falling down

each side, in such a way that a reflected image mixes with a view of an object on the other side of the mirror. Thus, two people looking at each other through the mirror can each see their own reflection superimposed on the other's face. A single object placed between a semi-silvered mirror and a back-surfaced mirror is seen as an infinite number of objects in a line receding in space, owing to internal reflections back and forth between the mirrors.

A multi-faceted reflective surface can be obtained by setting small rectangles of mirror side by side, each at a slightly different angle to the flat plane. A curved, reflective surface gives a distorted image.

Water can also be used to provide a reflective or refractive surface, though it is no use if a given effect must be fixed or accurately repeated. Refraction is a term referring to a slight change in the direction of light rays as they pass from one medium (air) into another (water). The most common illustration of this phenomenon is that a straight stick pushed into clear water appears to bend at the surface of the water.

Materials for making coloured slides Slides on which a variety of colours move when they are projected can be made with a simple selection of materials. These include coloured inks (**1**) glass slides (**2**), ether (**3**) and a dropper (**4**).

Making slides with coloured inks 1. Lay out three glass slides and drop a small puddle of ink onto each one.

2. Using a clean dropper, add a little ether to each patch of different coloured ink.

3. Place the slides one on top of the other, finishing with a clean one so all liquid is contained between them.

4. Put the slides into a projector and throw the image onto a white screen. The ether forms transparent patches in the ink and moves towards the edge of the slides to evaporate out. This causes the inks to flow inside the glass in constantly changing patterns.

Right When projections of the primary light colours – red, blue and green – are made by using a coloured filter on each of three projectors, and combined, they form the secondary colours – yellow, magenta and turquoise or cyan – where two overlap. White light is created in the centre where all three colours overlap.

Left Larry Bell's coated glass screens incorporate the spectator into the sculpture. Each pane of the glass acts as mirror, window and screen at the same time, and this unusual effect can only be demonstrated by the presence of the spectator.

_ PROJECTION OF COLOUR _

White light is composed of a spectrum of coloured light waves. When a beam of white light is directed through a prism, it is refracted, but each colour in the spectrum is refracted at a slightly different angle, so the beam fans out into a rainbow effect. If this is then passed through a lens and a second prism, it combines back into white light.

Colour properties in light are different from those in pigments. The primary colours in light are red, blue and green. These can be mixed in pairs to produce secondary colours. Red and blue combine into magenta, blue and green form turquoise or cyan, and red and green mix into yellow.

Filters for an ordinary slide projector can be simply made by sticking coloured cellophane into a cardboard slide mount. Working with three projectors, the primary colours can be made to overlap on the screen, producing the secondaries, and white light where all three primaries come together. An object placed in front of this white area casts coloured shadows. The colours change across the shadow area, according to which primary is blocked by the object at any point on the screen. The shadow is black only in the centre where all three projections are blocked.

Projections of moving colour can be produced simply. Trap a small puddle of coloured ink and a drop of ether between two clear glass slides. When this is put into a projector, the ether moves towards the edges of the slide, to evaporate out. The ether projects as a transparent 'hole' in the ink, so the effect is of a mass of colour constantly

Below This photograph shows the hologram *Portrait of a Woman*, created by Harriet Casdin-Silver. It measured 1 foot (30cm) by 4 feet 8in (140cm). This is a pulse laser hologram. The pulse laser emits a brief flash of light and 'freezes' the action. This means that this type of laser can be used to record moving objects which otherwise would have obliterated the image.

Polarizing 1. Make a pattern on a glass slide by rubbing down overlapping strips of adhesive tape across the surface.

2. Cut polarizing film to the size of the slide, and sandwich it between the taped slide and a clean one.

3. When the taped slide with polarizing sheet is projected, it shows a delicate grey tracing of the pattern. A second sheet of polarizing film held in front of the projector lens causes the light to break up, forming different colours in each section of the pattern. As the film is rotated through 360°, the colours change with each new angle.

changing shape. Two or three colours projected in this way form a complex shifting pattern of pure and translucently overlaid colours.

Polarizing film interferes with the pattern of light waves and can be used to project colours. A design made with strips of clear adhesive tape on a glass slide is backed with a sheet of polarizing film. When this is projected, the design is seen as a faint, grey image. A second piece of polarizing film held in front of the camera lens divides the light, and the pattern is seen in colour. If the film is rotated 360°, the colours keep changing.

CONSTRUCTION

Sculpture which emits light may be very simple, such as a light box with an on-off switch, or highly complex, with interdependent sequences of light and movement. A simple construction can easily be made with readily available electrical components. A basic wooden framework, for instance, can be drilled to allow wires and light sockets to be set in place.

Complicated kinetic devices with light can be designed in careful drawings, and technical advice should, if necessary, be sought on making the sculpture. Many artists now incorporate computer or microprocessor systems to control the activity of a work. A simple device which gives a good effect is the pressure mat. This consists of two surfaces which are electrical conductors, held apart by insulating strips. When the viewer treads on the mat, the pressure forces the conductors together and completes the circuit, activating the sculpture.

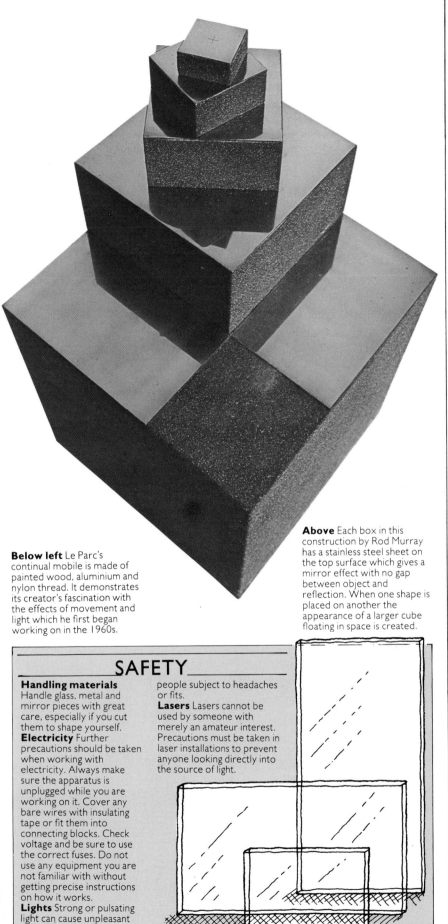

Above Each box in this construction by Rod Murray has a stainless steel sheet on the top surface which gives a mirror effect with no gap between object and reflection. When one shape is placed on another the appearance of a larger cube floating in space is created.

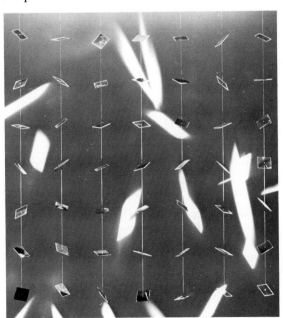

Below left Le Parc's continual mobile is made of painted wood, aluminium and nylon thread. It demonstrates its creator's fascination with the effects of movement and light which he first began working on in the 1960s.

SAFETY

Handling materials Handle glass, metal and mirror pieces with great care, especially if you cut them to shape yourself.
Electricity Further precautions should be taken when working with electricity. Always make sure the apparatus is unplugged while you are working on it. Cover any bare wires with insulating tape or fit them into connecting blocks. Check voltage and be sure to use the correct fuses. Do not use any equipment you are not familiar with without getting precise instructions on how it works.
Lights Strong or pulsating light can cause unpleasant effects, particularly in people subject to headaches or fits.
Lasers Lasers cannot be used by someone with merely an amateur interest. Precautions must be taken in laser installations to prevent anyone looking directly into the source of light.

Glass

MIXED MEDIA

HISTORY AND TECHNIQUES

It is nothing new for a work of art to be made from a combination of materials or objects. However, artists in the twentieth century have explored a wide range of ways of using combinations of materials or objects in sculpture. The prominence today of sculpture using mixed media, or assemblage as it is also called, seems to be the product of changing attitudes to art in the twentieth century. For the purposes of mixed media work, the technique is inseparable from the artists's approach and its content.

FORERUNNERS

Throughout the history of sculpture, examples of work using a variety of media are so common that it seems, in fact, that it is the unmixed use of a medium in the period since the Renaissance which is exceptional. For instance, bronze statues with ivory eyes made in ancient Greece still exist, and most other sculpture of that time was often brightly painted. The many different folk arts of the world also show a tendency to the use of different media in an amusing and inventive way.

In addition, the decorative arts and architecture have always concerned themselves with using a variety of materials and techniques in combination. While, in early and folk examples, the different media have mainly been used in a representational way, more contemporary mixed media works have tended to call into question the nature of art and to challenge the viewer's assumptions and existing ideas about the world.

DADA AND SURREALISM

The interest in using mixed media in the twentieth century stems, perhaps, from the use of 'real' materials by Pablo Picasso (1881–1973) and Georges Braque (1882–1963) in their revolutionary Cubist collages, which incorporated materials such as newspaper and oilcloth. The first major mixed media work, however, was one of modern art's landmarks, the *Fountain* of 1917 by the French artist Marcel Duchamp (1887–1968). Duchamp's up-ended, signed porcelain urinal caused a furore when it was exhibited at an art exhibition. It was the combination of the object and the 'art' context which contributed to the outraged reaction. This type of shock has been a repeated feature of mixed media works. A par-

Below Pablo Picasso was one of the first artists to use everyday objects and materials in his works. This *Still Life*, made from many different materials, dates from 1914. One of the aims of many mixed media artists has been to shock their audiences.

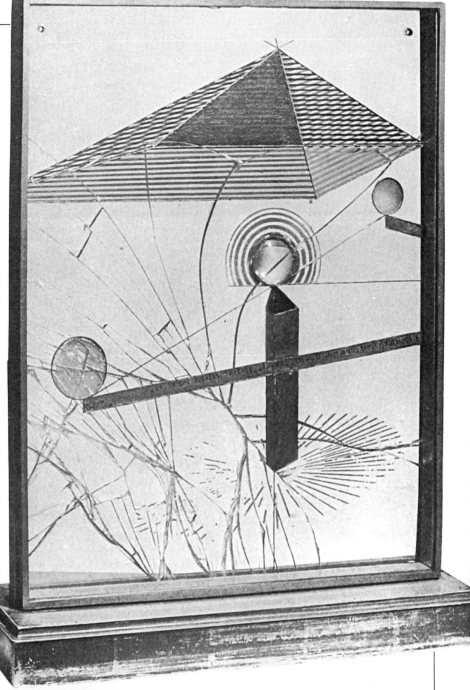

Marcel Duchamp was one of the main exponents of mixed media work. His *Secret Noise* (**above**) was made in 1916. Having used string and metal in *Secret Noise*, he turned to very different materials for a 1918 work (**right**). This consists of oil paint and silver sheet with lead wire and a magnifier placed between two sheets of glass. Duchamp made the visually striking ready-made *Why not Sneeze, Rose Selavy?* in 1921(**below**).

ticular feature of much mixed media work is the way in which it reflects the artist's particular enthusiasms and interests, whether these are visual or not. Duchamp's works reveal his great sense of humour and his interests in literature and philosophy, as well as his interests in art.

Another facet which has characterized much mixed media work is the use of objects in ways which remove them from their normal contexts or present them in new or unconventional ways.

The important *Object* of 1936 by the German-Swiss artist Maeret Oppenheim (born 1913) showed everyday objects—a cup, saucer and spoon—made out of fur. The idea behind the work was related to the anti-art ideas of the Dadaists, such as Duchamp. However, Oppenheim's *Object* achieves its effect because the material—fur—works against ordinary ideas about cups, saucers and spoons. In addition, the artist tried to use a substance which seemed as far removed as possible from any idea of sipping. The idea of drinking from a fur cup makes the viewer's mouth pucker.

Above *Object* by Maeret Oppenheim was made in 1936 and was an important example of one area of mixed media work. The fur is such an unexpected material in which to make a cup, saucer and spoon that it achieves its aims of surprising and shocking the viewer. The piece is approximately life size.

POTENTIAL AND POSSIBILITIES

There is literally no limit to what material or combination of materials can be used in mixed media sculpture. Duchamp's urinal was only the beginning. For instance, the American artist Joseph Cornell (1903–1973) is best known for making enclosed constructions consisting of various objects and clippings in picture-frame boxes. Cornell's work in some ways follows on from the collages and assemblages of the Dadaists and is a precursor of the later large scale assemblages of artists such as Robert Rauschenberg (born 1925).

Rauschenberg and his fellow American Jasper Johns (born 1930) used a wide variety of materials in their work. These included stuffed animals, rubber tyres, plaster casts, paint and pillows. Against the eclectic background of Abstract Ex-

pressionism, the predominant artistic movement in America during the 1950s, Rauschenberg's work is characterized by his use of associative leaps and fascinating juxtaposition. The close links between early and contemporary ideas on mixed media sculpture are epitomized by what happened when, in the late 1950s, Rauschenberg was one of the prizewinners in an international exhibition of painting and sculpture. His construction incorporated, among other things, an alarm clock. One of the jurors was Marcel Duchamp, who smiled benignly most of the way through a public question-and-answer session following the judging. Several members of the audience directed slightly outraged questions to the jurors about Rauschenberg's construction, and it was becoming difficult for them to make coherent replies. Finally, one of the audience stood up and asked Duchamp if the alarm clock actually told the time. Duchamp smiled a little

Left Robert Rauschenberg's untitled 1967 work is an example of his use of collage. Collage has been one of the main approaches to mixed media work since Picasso and Braque first used newspaper in their works in 1912. This example of Rauschenberg's work measures about 6 feet 6 inches (2 metres) square. However, collage can be done on any scale, and lends itself to both two- and three-dimensional work.

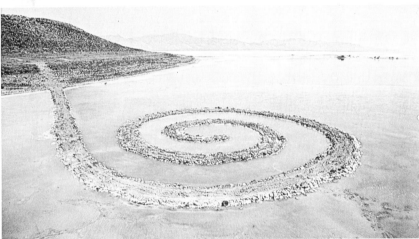

Left *Spiral Jetty* by the American artist Robert Smithson is an example of sculpture which uses the whole environment. It consists of a spiral of rock and salt crystal in the Great Salt Lake, Utah. This approach to art became popular during the late 1960s and early 1970s. The works are also called earthworks.

more broadly and replied 'No, I tried it'.

This anecdote illustrates one of the main factors in mixed media work. More than any other kind of sculpture, assemblage demands a preparedness on the part of the spectator to enter openly into the spirit of the work, and it also requires an informed awareness of important issues in contemporary art if the viewer is to gain the most from what such work offers.

Another feature of mixed media work is the use made by artists of materials new to the world of art. For instance, one of the great artistic innovators of the twentieth century, the Hungarian Lázló Moholy-Nagy (1895–1946) used perspex and metal discs in his *Light-Space Modulator.* Another example is the work of the German Dada artist Kurt Schwitters (1887–1947). His various *Merzbau* constructions, created throughout his career after 1919, used many everyday household objects.

CONSTRUCTIONS AND ENVIRONMENTS

The *Merzbau* constructions created by Schwitters can be seen as forerunners of the extension of mixed media work into 'total' or environment art. This idea takes the notion of a work of art and extends it to take in the whole environment around the work.

For example, the American artist Ed Kienholz (born 1927) created a series of detailed environments. With scrupulous research, he produced works of uncanny realism—with surrealistic touches. His *State Hospital* had the viewer look through a peep-hole into a hospital ward which contained two bandaged figures on beds. The heads of the figures, however, were goldfish bowls with black fishes swimming in them.

Taking the idea of using the environment to an

extreme, the Bulgarian-born sculptor Christo (born 1935) put a curtain across the Grand Canyon and, on another occasion, wrapped a stretch of Australian coastline in plastic.

USING SCALE

As well as placing everyday objects in unusual contexts and making works in unconventional materials, mixed media artists have manipulated the idea of scale to create new and surprising juxtapositions. The influential American Claes Oldenburg (born 1929) has produced huge, soft sculptures of small, everyday objects. For example, his *Giant Soft Fan*, made in 1966 and 1967, consists of vinyl filled with foam rubber, wood, metal and plastic tubing. The soft version of an electric fan is some 10 feet (3 metres) high and, including the attached cord and plug, about 24 feet (8 metres) in extent. The huge scale and deflated appearance create an amusing image.

CREATING MIXED MEDIA WORKS

Many artists have used the possibilities offered by mixed media as a way of getting away from the traditional sculptural media, such as stone and wood carving or metal casting. While it is very difficult to suggest any specific techniques, because, literally, any technique can be used, certain approaches have become associated with mixed media work.

Collage Developed by the Cubists early in the twentieth century, collage used many kinds of objects including newspaper cuttings and photographs, to create a three-dimensional form on a flat surface. Gradually, collage developed away from its two-dimensional basis and came to include almost any work assembled from different sources. One of the names for mixed media work—assemblage—comes from this idea of assembling different elements.

Objets trouvés Another popular mixed media technique is using ordinary objects and juxtaposing them. Both natural and synthetic materials can be used—wood, shells, tin cans, pieces of commercial packaging and any other object from everyday life can be put to good use.

The idea of using many different media in sculpture originated partly in an attempt to break away from traditional conventions. Much early mixed media art was a form of mockery, but this approach to sculpture has played an important role in gaining acceptance for a large variety of new and exciting materials which are now a recognized part of the sculptor's repertoire.

Below The American artist Ed Kienholz is known for his painstaking reconstructions of scenes. This picture shows a detail from *The Portable War Memorial*, completed in 1968. The level of detail results from extensive research by the artist, who uses a wide variety of material.

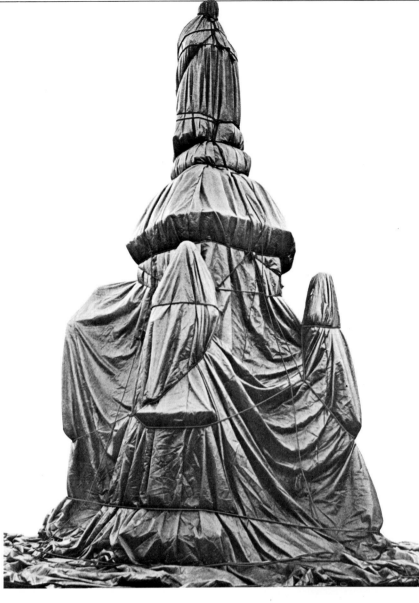

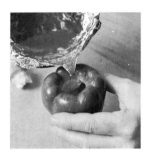

Making a wax cast inside a pepper 1. Cut around the stalk and scoop out the core of the pepper. Pierce holes in the top.

2. Melt down the wax in a pan lined with tinfoil. Pour it slowly into the pepper.

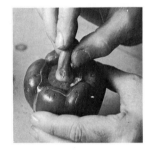

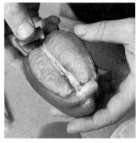

3. The pepper is quite full when a little wax escapes from the holes. Replace the stalk and leave it to cool.

4. Slit open the pepper skin with a sharp knife and peel it away in sections to free the wax cast.

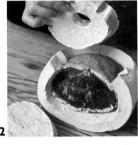

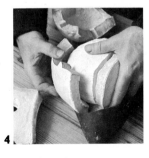

Making a plaster cast from a stone A mould can be made from an interesting found object, such as an oddly shaped stone, if more than

one representation of the object is required. The stone should first be thoroughly greased (**1**), and a plaster piece mould formed around it

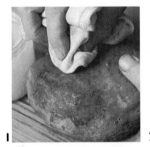

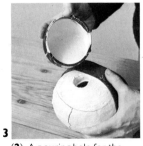

(**2**). A pouring hole for the plaster must be made in one of the mould sections (**3**). When the plaster has set, the cast is released from the mould (**4**).

Above *Wrapped Monument to Leonardo* is an example of mixed media work by Christo, an important contemporary exponent of this type of sculpture. His other works have included wrapping a stretch of Australian coastline in plastic.

Right *Ghetto*, a construction by the American artist George Carter illustrates one way of using found objects. The American flag and eagle are juxtaposed with numerous everyday objects, particularly bells and padlocks. The boxes are different sizes and this contributes to the overall variety of the image.

PRESENTATION AND DISPLAY

It is important that sculptures are displayed to their best advantage, whether they are positioned inside or out-of-doors. This applies whether you have made the sculpture or bought it. There are several basic considerations. These include how to mount or fix the sculpture so that it is stable, where to position it and how to light it. When displaying sculpture it is vital to consider not only the space which the piece itself occupies, but also the space around it.

PLINTHS

Plinths can be used to steady a sculpture or raise it to the correct height for viewing. A plinth should always complement the piece of work which it supports, so they vary greatly in size, shape and colour from one piece to another. Materials commonly used for making plinths include simple

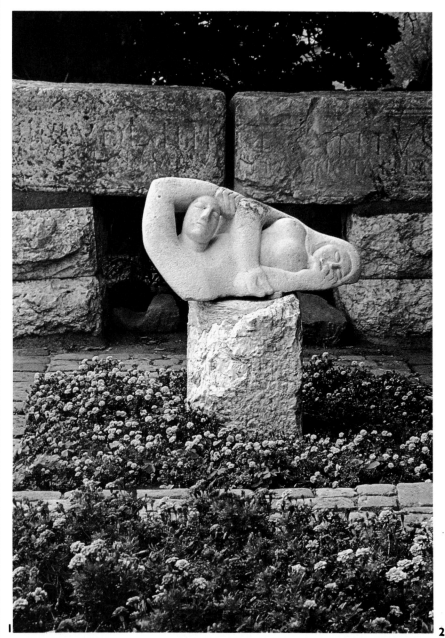

In a private garden
In this instance, the advice of the sculptor should be obtained wherever possible. Consideration should be given to whether the work is to be seen from a distance or close to, or both. The selected site should provide a complementary—but not intrusive—setting for the piece. Modern sculpture can be displayed to great advantage, even in small town gardens, if sufficient care is taken in matching piece and site as can be seen with this Picasso piece set among flowers (1). Purchasers considering particular pieces can get some idea of scale by

placing garden canes to the height of the sculpture in position on site. As with interior display, the property owner must take steps to ensure that the sculpture will not injure family or friends, or vice versa. Particular care must be taken about safety in the garden in darkness; lighting or careful siting should solve this problem.
In a public outdoor location
Most of the points discussed in the section on setting in a private garden are relevant when installing a sculpture in a public exterior location. However, attention must also be given to the sculptor's

relationship with the owners of the piece as well as the site on which it is to be displayed. If the sculptor is selling the piece, but wishes to be consulted about the display arrangements, a provision to this effect should be written into the contract of sale. If the sculptor owns the piece, but is displaying it permanently or temporarily on a public site, every possible effort should be made to check that the piece is installed securely, and is adequately protected from vandals. Sculptors should take independent legal advice on the relationship between themselves and the owner or controller of the land, and on

liability should the piece cause injury to a member of the public. Here *Aston Cross* (4) by John Maine is displayed at the University of Aston, Birmingham, England.
In a gallery
The gallery will usually be able to provide plinths, but sculptors may wish to provide their own if those available are inappropriate. It is unlikely that a gallery would meet the cost of this, although organizers of touring shows are sometimes able to reimburse artists who provide specially constructed plinths. Gallery directors will be able to give much valuable advice on display, as they will be

thoroughly familiar with the gallery space and lighting system. It is normal for the gallery director and artist to work together on the installation of a show, but many gallery directors will expect to have the final say, and this may be specified in the exhibition contract if one is used. Galleries will usually only suggest the use of display cases for sculpture in particular circumstances. This applies, of course, to work which is particularly delicate, has special requirements (such as temperature control or special lighting) or is made of precious or semi-precious materials. This photograph of

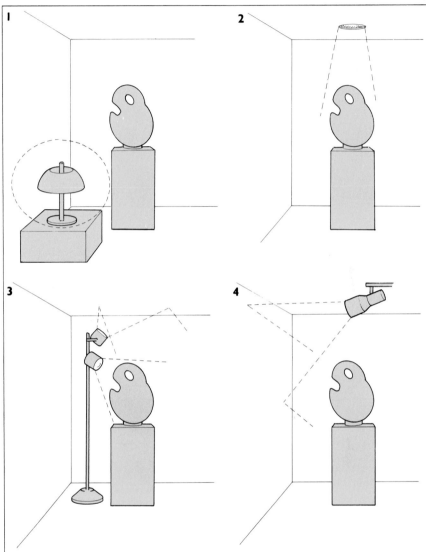

London's Hayward Gallery (**2**) shows how works by Anthony Caro were exhibited in 1969.

In a domestic setting
Whenever possible, owners should seek the advice of the sculptor on siting a piece of work in a domestic interior. The work should be placed so that it can be seen to advantage, without being confused by being too close to other objects, such as paintings, lamps and curtains. The owners should consider whether the work will be viewed mainly from a standing or sitting position, and site it at an appropriate height. The space around the sculpture is an important element in the

work, and it is sometimes difficult to achieve adequate surrounding space in small rooms. The balance between space, sculptures and furniture can be clearly seen in this interesting arrangement (**3**).

Common-sense precautions must be taken in considering whether the piece could be damaged by any movement through the room, or whether it could cause injury, either in position or if it is dislodged. Particular care must be taken if children are likely to visit the house. Normal domestic lighting can be augmented with floor or ceiling spotlights.

Lighting a sculpture How the form of a sculpture is perceived is crucially affected by the way it is lit. Light thrown from one angle tends to accentuate curves, hollows and angles, defining changing planes. Indirect lighting from a table lamp (**1**) is directional but very soft. A downlighter (**2**) sheds a broad, clear light over the whole sculpture, illuminating the form

without exaggeration or distortion. With a combination of two spotlights on an adjustable stand (**3**), one can be thrown directly on the sculpture while the other softens the light by bouncing it off the ceiling. The glare of a ceiling mounted spotlight could be too harsh, but if the lamp is angled to bounce light off the wall (**4**), it gives a pleasant illumination.

Lighting fitments A recessed downlight (**5**) is set in the ceiling. A broad cone of clear light is shed from its fixed position. Multiple spots on a rail (**6**) can be mounted on ceiling or walls and angled to give a particular direction. Clip-on spotlights (**7**) can be attached to wall or ceiling tracks and to shelves and tables to give direct or diffused light.

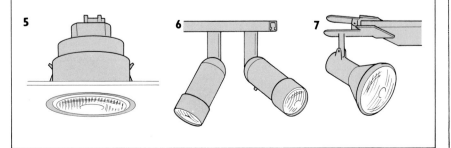

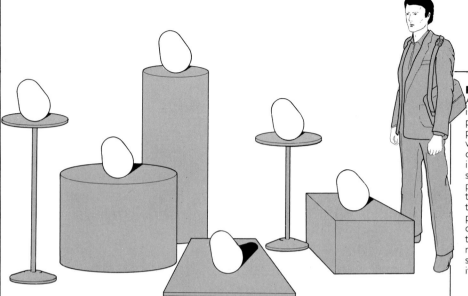

Photographing sculpture An up-to-date record of work is vital, and, since slides and photographs will be sent to people who are not familiar with the sculptures, the quality of the pictures is important. If the works are small, they can be photographed adequately in the studio without much trouble. A large sheet of paper or card provides a clean, plain background for the sculpture. The camera must be mounted on a tripod so that its position is fixed and it is steady throughout the exposure. A pair of anglepoise lamps provides enough light. If the light seems glaring it can be softened and diffused by placing a sheet of tracing paper in front of the bulb on each lamp. Harsh shadows on or around the sculpture may obscure the form and cause difficulty for the viewer in understanding the nature of the work. If the sculpture is in the round, it should be photographed from several angles, each view placed carefully within the viewing frame and accurately focused.

Photographing a relief sculpture A relief is best photographed placed flat on the floor, the camera fixed directly above it and lights on either side.

Plinths A plinth for a sculpture (**top**) should always complement the work. The plinth may be a solid, heavy base or a tall, narrow stand. It should be carefully chosen to place the work at the correct height and angle within the viewer's line of vision. An elaborate plinth may not be suitable unless specifically designed in conjunction with the sculpture. Plain cubic or cylindrical plinths are often used in gallery displays. Many modern sculptures, such as *Cross Bow* by Wendy Taylor (**above**) are designed to be placed directly on the floor, without a base. This is particularly common if, as in this case, they are large works with a pronounced horizontal emphasis.

painted or unpainted chipboard boxes, solid timber, stone bricks, marble, perspex, metal, concrete and paving stones.

Sculptors can profitably study the use of plinths by other artists. Look at the many different ways in which works are displayed. Note what they are made of, whether the plinth was in fact made as an integral part of the piece, whether the material harmonizes or contrasts with the work. Sculptures can also be displayed without plinths, which should, in any case, only be used if they fulfil a specific function.

PHOTOGRAPHING SCULPTURE

Slides The quality of colour slides is important, and, if the sculptor is not a competent photographer, it is advisable to ask a friend or professional photographer to do this work. Slides should be constantly updated. It may be necessary to produce photographs of recent work at short notice. At least three sets of slides are required. One set is the sculptor's master record and should never be sent out, and the remaining two sets are for submission to galleries, competitions and award schemes. This type of assessment can take some time, and slides will not be returned until all decisions have been made.

Slides may be taken either in studio, gallery, outdoor or domestic locations. Alternatively, the sculptor may wish to have pieces recorded in a photographic studio setting which might offer many options in terms of background and lighting effects. When slides are not taken in a photographic studio setting, a number of points should be considered. Check that lighting is adequate, and select the correct type of film for the lighting

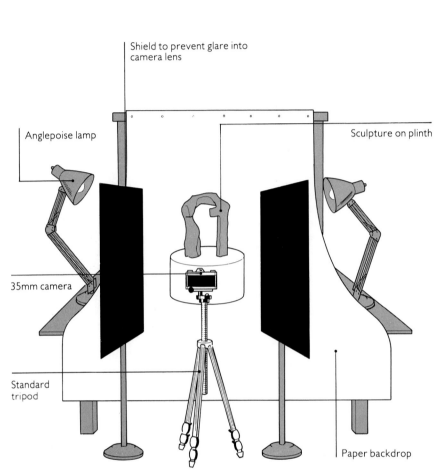

Shield to prevent glare into camera lens

Anglepoise lamp

Sculpture on plinth

35mm camera

Standard tripod

Paper backdrop

Top lighting— single spot

¾ lighting— single spot

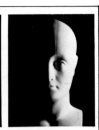
Side lighting— single spot

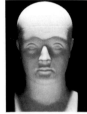
Top lighting— stronger fill-in light opposite

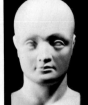
¾ lighting— stronger fill-in light opposite

Side lighting— stronger fill-in light opposite

Frontal lighting— single light

Soft side lighting— stronger fill-in light opposite

Soft ¾ light— light reflected from white wall opposite

Photographing a small sculpture A suitable area for photography can be set up in the studio. A paper backdrop pinned to the wall and draped over a table provides a clean background. Two anglepoise lamps, placed one on either side, give clear, strong light. A simple shield or screen should be erected to prevent glare from the lamps entering the lens. It is necessary to steady the camera on a tripod.

Lighting a sculpture There are many ways of lighting a sculpture to obtain a particular effect. A single, strong light produces a dramatic heightening of tonal contrasts. This can be countered by filling in the shadows with a second light from a different angle, or by reflecting back the light with white paper or card.

to be used. Place the work to be photographed against a plain background; plaster walls, brick walls, grass, trees, yards and playgrounds are all suitable. Photograph the work from several angles if this is necessary to give a sense of the piece. Give special attention to the placing of the work within the camera frame, and accurate focusing. Harsh shadows which may confuse the reading of the slide should be avoided. Consider including some clue as to scale—brick walls, windows, doorways, floorboards and objects of known size such as matchboxes may be helpful. One or two 'scale' slides can usefully be included in a presentation which is going to people unfamiliar with the work. In addition, installation shots, studio shots, slides of work in progress and pictures showing the artist at work can all be useful in certain circumstances, and should be taken when the sculptor feels it is appropriate.

Black and white photographs The general points about colour slides also relate to black and white photographs, but greater care must be taken in selecting backgrounds which will not become confused with the work. Consideration should be given to how the tonal relationship between the sculpture and the background will translate into black and white. It is helpful if sculptors have black and white photographs available to give to the press, catalogue compilers and for other publicity purposes. Artists should not rely on getting these prints back again.

RECORDING WORK

It is advisable to maintain a complete record of all the work you do. This is usually done on slide or through the use of photographs.

35mm colour slides This is the most commonly

used system for recording work. Most galleries are equipped with a light box and/or projector for viewing slides, and most competitions and schemes are geared to assess work initially from slides. Some artists worry that their work does not translate well onto slide, but most administrators involved in the assessment of work are experienced in 'reading' slides carefully. 35mm slides can be mounted in glass to protect them from scratching and damage from the heat of a projector. The card mounts supplied by photographic processors sometimes do not engage properly in a carousel projector, and thicker plastic mounts are preferable. Simple colour prints can be made directly from 35mm slides in certain types of photocopying machine, and high quality colour prints can be made from transparencies. Full colour printing, for instance for catalogues, books and private view cards, is also originated from colour slides.

35mm black and white slides Some artists are attracted by the use of black and white stock for photographing sculpture. Monochrome slides are acceptable as an alternative to colour slides in almost all circumstances.

2¼in square slides Slides with a 2¼in square format give excellent definition. Because of their large size, they should always be mounted in glass. Some galleries and evaluation schemes may not have ready access to a projector for this type of slide, which may be a minor disadvantage.

Black and white prints Photographic prints should be big enough to show the work to advantage— 8in × 10in (20cm × 25cm) is a popular size. Prints are often used in conjunction with slides to record work, and are necessary for press, publicity and catalogues. It is possible to make black and white prints from colour slides, but black and white photographs give better quality reproduction of sculpture in magazines and catalogues. Prints supplied to press and printers should be sharply focused and have good overall contrast. Photographs should never be reproduced without permission being obtained in advance from the owner of the copyright. Negatives should be filed for possible future use.

Card index Some artists find it useful to make up a card index record of completed work. This is particularly useful when a lot of work is either being sold or loaned. Large index cards should be compiled for each piece to record basic details. These include title of the work, size/dimensions, date completed, and materials. In addition, it is useful to note down the history of the piece including the slides available (numbered for reference), prints available (numbered for reference), the buyer, buyer's address, number of invoice or bill of sale, details of any resale, loans to exhibitions, other loans and details of press coverage. Information about any repair, restoration or insurance claims should also be recorded, as should the location of the piece, if it is in store.

GALLERIES

Sculptors wishing to exhibit their work in a gallery can gain much background information at the outset by analyzing their reasons for wishing to show. Knowledge of what the artist wants out of the show provides a good starting point in looking for a gallery. For instance, if the aim is to make work available to others, think about the people who visit different types of galleries and approach those which can offer exposure to the most appropriate audience.

Local galleries are usually a good starting point. Useful information about galleries in any area of the country can be obtained locally. Galleries should be researched fully before any approach is made about showing. A gallery which an artist visits frequently because it shows interesting work may be the one which will eventually offer a show. Most galleries are either publicly funded or run as a commercial venture; this may affect the extent to which applications for exhibitions must be evaluated in terms of potential sales. A public gallery is often in a better position to exhibit non-commercial work than a small

INSURANCE

If a sculptor works on an amateur or freelance basis, it may be possible to insure work, materials and equipment by taking out or extending a normal household policy. When work is being carried out on a professional basis, or is being carried out in premises which are not already covered by a domestic insurance policy, it is necessary to take out a separate policy on the studio contents. This should cover completed work, work in progress, tools, equipment and materials. An insurance broker experienced in placing work of a fine art nature may be of assistance, as, in the event of a claim being made, an insurance company experienced in this area would be familiar with the nature of the goods. As with an ordinary domestic policy, substantiation of the value of the items lost as well as photographs would probably be required.

Work should also always be insured during exhibitions. If an artist organizes an exhibition in a place where the work will not be covered by an existing exhibition insurance policy, it would be wise to take out appropriate cover for the period of the exhibition. Most large insurance companies are willing to quote for such cover, or, as above, a specialized broker could help. Comparative estimates should be obtained. If the sculpture is already covered by a 'studio' insurance policy, it may be possible to obtain temporary extended coverage under the same policy to insure the work whilst on exhibition elsewhere.

When work is being shown at the invitation of another person or organization, the artist should make careful enquiries about all aspects of the arrangements offered, including what insurance cover will be effected. The sculptor needs to know whether the gallery or organizer is insuring the work, what the maximum amount claimable on each piece is, whether there is a maximum sum claimable on the whole exhibition, what period the insurance covers, which premises or locations are covered by the insurance, and whether the insurance covers all risks—theft, accidental damage, vandalism, and damage by fire and water. It is also wise to check whether there are any exclusion clauses in the policy.

Confirmation of the insurance cover offered by the organizer, together with details of all other administrative arrangements should always be obtained in writing, preferably as an exhibition contract. If the insurance cover offered is unsatisfactory to the artist, it is wise either to reconsider the exhibition arrangements or to take out separate insurance cover. If a carrier or hired van is involved in moving the work between studio and gallery, the artist should make equally thorough enquiries about insurance arrangements while the work is in transit.

When work is to be exhibited in a public place, such as a park or garden, it is important that the artist checks that suitable arrangements are made for public liability insurance. For instance, if a child was injured as a result of falling from a piece of outdoor sculpture, the artist could be faced with a sizeable claim for damages. Advice on these and other legal and insurance matters should be obtained.

Recording work It is useful to keep a comprehensive photographic record of all work. 35mm slides are the most convenient form. These can be assembled in transparent viewing sheets which are kept in a file (**1**).

Administrators of galleries and exhibitions will have access to a suitable projector (**2**) or light box (**3**) for viewing the slides. A sheet of slides must be carefully packed for submission by post. If you are attending a gallery in person,

the file is a neat way of carrying the slides while they remain easily accessible and visible. It is sensible to take several slides of each work, and from all angles, as you may wish to apply to two or more places at once.

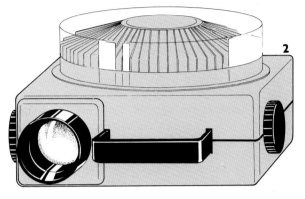

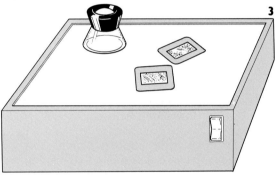

Name of artist —— S. PILKINGTON 5.10.79. —— Date of work

DANIELS DEN. —— Title of work

5' —— Dimensions of work

←— 11' —→

CHORLEYWOOD, HERTS, UK• —— Location

Medium —— BRONZE 81/C. —— Number of slide

Labelling slides Although the mount of a slide is small, a great deal of information about the work can be neatly recorded on it. If each slide is clearly numbered and the details are also kept in a card index, you will have an invaluable record of all work.

If slides are sent to a gallery, it is essential that they are clearly marked with the artist's name and the title and date of the work. The medium and dimensions of the sculpture also help to make it clear whether or not the work is suitable for a

particular location or purpose. If the work has been sold or is on exhibition, it is also helpful to know its location. This information is of as much help to the artist as to anyone viewing the slides. It is surprisingly easy to forget such details once a few months or years have passed.

private operation. Some galleries plan their programmes months or even years in advance, and may not have exhibition space available at a time to suit the artist applicant. Sculptors should also find out what application procedure the gallery uses, and comply with this. Common procedures include personal recommendation, submission of slides or photographs, a formal or informal studio visit and completion of an application form.

If an application is unsuccessful, there is no reason why the artist should not ask the gallery to enlarge upon the reasons for this. The gallery may be able to redirect the artist to a more appropriate establishment, or indicate that they would consider a further application when the work is more developed. Many exhibition applications fail because artists are aiming too high too soon, or have simply approached a gallery which has no interest in their type of work.

UNCONVENTIONAL VENUES

Sculptors suffer from a lack of conventional exhibition opportunities because showing sculpture tends to require more space and more

complex administration than displaying other types of work. One way to redress this balance is by seeking out non-gallery locations in which work can be shown. Sculpture could be exhibited in a public building such as a library or hospital, in houses open to the public, parks, gardens, offices, shops, restaurants and in the artist's own studio.

COMPETITIONS AND EXHIBITIONS

Information about competitions and exhibitions can be obtained from the many newsletters and magazines aimed at practising artists. Local public libraries or national organizations are good sources of information. In addition, many local or regional arts' associations publish newsletters which carry this type of information. Furthermore, opportunities of special regional interest would usually also be advertised in the local press.

For open exhibitions and competitions, great care should be exercised in putting together a detailed application. It is important to assess the field at the outset, follow the submission instructions carefully, and not to be discouraged.

Mounting slides under glass Plastic slide mounts with glass windows are available and they provide far better protection for slides than the usual cardboard type. The thickness of the plastic keeps the slide rigid and gives extra weight to engage it in an automatic projector. Make sure the slide is clean and free of dust before clipping the halves of the plastic mount together, as any specks will show up badly when the slide is projected.

Transporting sculpture
Sculptures must be moved with great care. A small fork lift (**1**) is useful for moving large or heavy works. A simple trolley can be made from casters (**2**) mounted on a strong piece of wood (**3**).

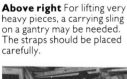

Above right For lifting very heavy pieces, a carrying sling on a gantry may be needed. The straps should be placed carefully.

PACKING

Packing a piece of sculpture well requires almost as much effort as went into making the piece, but good packing not only protects the work but also makes the handler's job easier and underlines the professionalism of the artist. Certain general points on packing should always be assessed. Consider the function of the packing and plan accordingly. Inspect the work carefully, checking its condition and noting any points needing special attention. Photograph the work before it leaves the studio, not only for record purposes, but also in case the work is lost or damaged. If the work will be dismantled and put together again by others, compile clear assembly instructions and diagrams which will travel with the work. Keep a copy in case the original is lost. Make up loads which require no more than two people to handle them. Special arrangements must be made for heavier work.

For short-term packing, the sculpture should be wrapped in soft absorbent material, such as foam rubber, wood wool, shock absorbent 'blister' polythene, shaped polystyrene blocks or cotton waste, and placed within a rigid outer container. If necessary, braces or internal supports can be used to keep the piece in position within the outer case. There should be at least 4in (10cm) clearance between the sculpture and the outer case. Second-hand crates can be used for the outer packing.

If work is included in a touring show, loaned or travelling in circumstances where it will be re-packed by someone other than the artist, it is important to provide strong, clearly marked packing materials. Slatted outer crates, as described above, can be made from sturdy softwood, assembled with screws and fitted with padded internal braces. Alternatively, solid crates can be built from panels of softwood boards, plywood or marine ply, within a strong timber frame. Crate lids should be screwed on and marked to show which screws are to be removed for opening. If a crate is to be continually re-used, the lid should be fitted with captive bolts or hinges and a lock. Cases for long term packing should also be reinforced with cleats and riding battens, but not so as to make them unnecessarily heavy. Wooden battens or metal handles may make handling easier; avoid ropes as they burn hands. Painting the outside will prolong the life of a case, and also help with identification if it forms part of a composite load.

Most big galleries and firms of carriers will provide a hand trolley and a set of piano wheels for handling heavy pieces. Carrying slings may also be available. In smaller or temporary venues, the sculptor may have to make special arrangements in advance if this equipment is required.

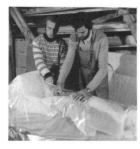

Packing a sculpture for transport
1. A crate is specially made to a suitable size. The sculpture is first wrapped in tissue paper.

2. The sculpture is then wrapped completely in polythene sheeting which is firmly secured with adhesive tape.

3. Corrugated cardboard is laid in the crate and then padded cushions of paper stuffed with straw are laid in as a bed.

4. Thick layers of foam rubber are placed over the bed and are allowed to hang over the sides of the crate.

5. The wrapped sculpture is placed in the crate on the foam rubber bed. Using waste pieces and offcuts can save expense.

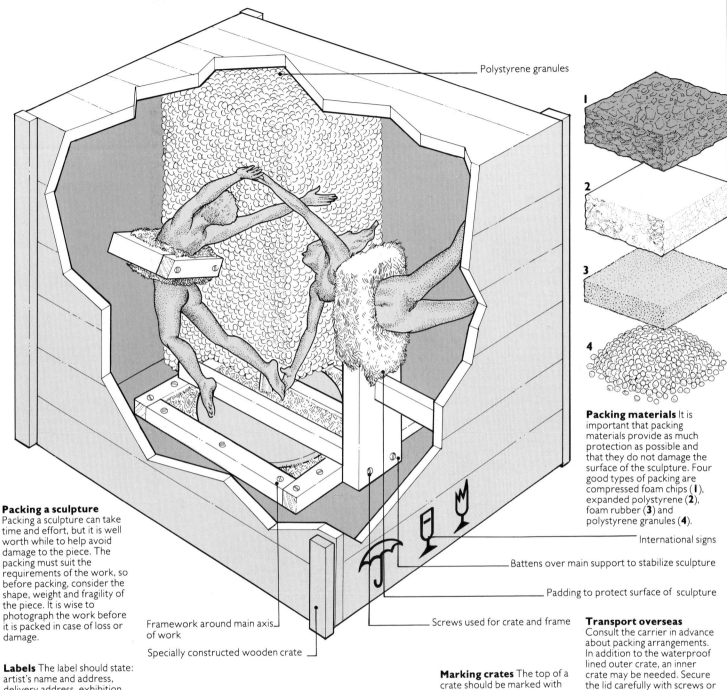

Polystyrene granules

Packing materials It is important that packing materials provide as much protection as possible and that they do not damage the surface of the sculpture. Four good types of packing are compressed foam chips (**1**), expanded polystyrene (**2**), foam rubber (**3**) and polystyrene granules (**4**).

International signs

Battens over main support to stabilize sculpture

Padding to protect surface of sculpture

Screws used for crate and frame

Framework around main axis of work

Specially constructed wooden crate

Packing a sculpture
Packing a sculpture can take time and effort, but it is well worth while to help avoid damage to the piece. The packing must suit the requirements of the work, so before packing, consider the shape, weight and fragility of the piece. It is wise to photograph the work before it is packed in case of loss or damage.

Labels The label should state: artist's name and address, delivery address, exhibition title (if applicable), title of work and, if appropriate, the case number. Mark in paint, felt marker or stencils. Mark the top clearly.

Marking crates The top of a crate should be marked with the international symbols of an open umbrella or wineglass. Mark 'fragile' or with the broken wineglass symbol where necessary.

Transport overseas
Consult the carrier in advance about packing arrangements. In addition to the waterproof lined outer crate, an inner crate may be needed. Secure the lid carefully with screws or bolts. Label the crate carefully, but do not specify the nature of the contents on the outer crate to reduce the risk of theft.

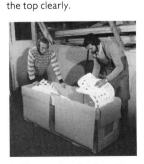

6. The overhanging foam is tightly packed around the sculpture in the crate and another layer added on top and tucked into the sides.

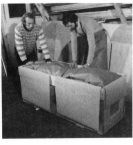

7. More paper parcels stuffed with straw are laid on top and pressed firmly. Corrugated cardboard is laid over the packing and folded in to the sides of the crate.

8. The lid of the crate is put in place and nailed down around all four sides so that the crate is quite solid and secure.

9. Metal bands are passed round the reinforcing battens and tightened firmly. Instructions for handling and transporting must be clearly shown on the outside.

10. The finished package is quite secure and strong, clearly marked with instructions and given added protection by the metal bands.

GLOSSARY

A

Abrasion A technique of shaping stone, wood or plaster by rubbing the surface with an abrasive material to wear it down.

Accelerator A substance which speeds up a chemical change. An accelerator is added to polyester resin to promote curing.

Acetone A flammable solvent used to remove uncured polyester resin from tools and work surfaces.

Acrylics A range of rigid, lightweight plastics, used commonly in the form of sheets or rods. Acrylics may be transparent or opaque and are available in a range of colours.

Adze A tool used in wood carving to rough out a form. It is similar to an axe but the blade is set horizontally in the handle, sloping downwards.

Aggregate A body of granular material such as sand or gravel which is mixed with cement to make concrete.

Alloy A metal produced by combining two or more metals.

Angle grinder A heavy motorized tool with a cutting wheel, commonly used to cut or abrade the surface of metal or stone.

Annealing A process of heat treating metal to remove internal stresses and make it easier to work when cool. Mild steel and brass are allowed to cool slowly whilst other metals, such as copper, may be quenched in water. Aluminium is annealed by a slightly different process.

Armature A framework to give rigid internal support to a modelled sculpture. A basic linear form in wire can be bulked out with chicken wire or padded with wood or paper if appropriate. The medium is modelled directly onto the armature.

Assemblage A sculpture constructed from various materials not originally manufactured for artistic purposes, often including whole found objects.

Auger A tool for drilling deeply into wood, an auger is a long metal shaft with a spiral drill and cutting blades at one end.

B

Back iron A metal frame set on a wooden base, which is attached to an armature and supports the weight of the modelling material.

Ball clay An ingredient in a number of clay bodies because of its plasticity, ball clay may be black or grey in colour, but fires almost white. It contracts considerably as it dries and when fired.

Ballpein hammer A hammer which has one side of the head flattened for striking, and the other rounded for flattening rivets or forming a dome.

Bandsaw A narrow, power driven blade set in heavy machinery, used to cut shapes from wood, metal or plastic sheet.

Banker A heavy wooden bench to support work being carved or modelled. The top may be fitted with a turntable so the work can be easily rotated.

Baroque This term refers to a dramatic or highly ornate style of work, originally the characteristic style of seventeenth and eighteenth century art in Europe.

Base A plinth or podium on which a sculpture is displayed, or the portion of a sculpture on which its weight rests.

Bat A thick plaster slab on which wet clay is left to lose sufficient moisture to make it workable.

Bighead bolt A threaded bolt with a broad, flat head, useful in joining two hollow cast resin sections in a resin construction.

Biscuit firing The preliminary firing of ceramic ware before a glaze is applied.

Blind mould A mould which, when fitted together, gives no access to the internal space.

Block A body of material for carving. The term is also applied to a piece of wood used to beat and consolidate large masses of clay.

Bloom A fine cloudy film which forms, for example, on the surface of melted wax or concrete cast in a plaster mould.

Blow forming A method of shaping acrylic sheet. The plastic is heated until pliable, then clamped and subjected to a blast of air which inflates it like a balloon.

Blueing Colouring the surface of metal by applying concentrated heat from a blowlamp or oxyacetylene torch. Oxidization gives the metal a blue tinge.

Boasting Dressing or shaping the surface of a stone block with a broad chisel.

Body A term used to refer to a mass of clay formed from a mixture of clays or clay and ceramic materials.

Brazing A method of joining two pieces of mild steel by heating to red heat and using a copper zinc alloy as a solder in the joint. This is known as hard soldering. A flux such as borax is necessary to aid the flow of the alloy.

Bronze Bronze is an alloy of copper, tin and zinc sometimes with the addition of other metals. It is commonly used in casting.

Bust peg An armature on which a portrait bust is modelled. A framework of metal loops is mounted on a central support of wood or metal.

Butterfly Two pieces of wood bound together to form a cross, suspended from an armature as an extra internal support for the weight of the modelling material.

C

Callipers An instrument used to measure a three-dimensional object, consisting of two metal arms with curved, pointed ends, hinged together.

Carbide disc An abrasive disc attachment for a power tool.

Carborundum Another name for silicon carbide, this is a hard crystalline substance used as an abrasive and in refractory compounds.

Carving Carving is the technique of cutting and abrading the surface of a block of material to shape it into a particular form.

Cast, casting A cast is a sculpture produced from a mould. There are various casting processes by which an original sculpture can be reproduced exactly in a different material, or several copies can be made.

Catalyst A substance which provokes a chemical reaction in other materials without itself changing. Specifically, in resin sculpture, an additive which causes the resin to harden. An accelerator, usually already added to the resin, reacts with the catalyst and heat is generated which sets off the hardening process.

Celluloid One of the earliest invented plastics, a cellulose nitrate which is tough and inflammable.

Cellulose A substance obtained from plant cells which is one of the basic materials used in the manufacture of plastics.

Cement A powdered substance made from calcium aluminium silicate, or alumina, which is the binding ingredient in concrete.

Ceramics Pottery or hollow clay sculpture which is hardened and finished by firing.

Chamfer To cut through the thickness of a material at an angle, giving a sloping edge.

Chasing The process of finishing and refining the surface of a metal sculpture, for example, removing the protuberances on a bronze cast which necessarily form in the casting process.

Chisel A cutting tool consisting of a metal shaft bevelled at one end to form the cutting edge. A chisel is specially designed for cutting a particular material—wood, metal or stone.

Ciment fondu A grey-black alumina cement, relatively quick-drying, used in concrete sculpture and as an ingredient in refractory compounds.

Circular saw A circular toothed blade which is power driven. A bench circular saw is used for cutting timber by feeding the wood into the blade, to cut across or down the length.

Cladding A technique of construction with wood. A solid shape is formed by bending thin sheets of hardboard or plywood over a wooden framework.

Claw chisel A stoneworking chisel with the blade fashioned into small teeth. It is used for shaping and leaves striations in the stone surface.

Claw hammer The head of a claw hammer has a flat striking face on one side and two heavy metal prongs on the other used to trap and lever out nailheads.

Clay wash A thin liquid made by dissolving a little clay in water, used to coat the seams in a plaster mould to prevent adhesion.

Clear casting A solid cast made from clear casting resin.

Coiling A pottery technique in which a pot is built up by coiling thin rolls of clay into the required shape.

Cold chisel A toughened steel chisel used to cut metal when it is cold.

Collage An image assembled on a flat plane by gluing scraps of paper, fabric and found materials to a ground such as canvas, paper or board.

Collaring Part of the ceramic technique of throwing a pot on a wheel. Collaring means constricting the top of the pot to prevent the wet clay from flaring out.

Concrete An extremely heavy, durable material when set, concrete is made from a mixture of sand, aggregate and cement.

Coning When a mass of clay is worked on a potter's wheel, it is repeatedly drawn up into a cone shape and then flattened down to centre it on the wheel and shape the mass. This process is known as coning.

Construction A term referring to a sculpture made by joining together various components of different materials or of the same substance.

Constructivism A modern art movement developed in 1917 by the Russian sculptor Tatlin. The aim was to construct abstract sculpture suitable for an industrialized society and the work pioneered the use of modern technology and materials such as wood, glass, plastic and welded metal. Constructivism was introduced to Western Europe by Pevsner in Paris, and Gabo in Germany. The principles of Constructivism were highly influential in twentieth century European art, although for political reasons its influence was over in Russia by 1921.

Coping A method of splitting away stone from a block preliminary to shaping a carving. Small punches are driven into a block and hit in sequence until the stone splits between them.

Core A hollow wax sculpture to be cast in metal is filled with refractory material to give it a solid core. The wax can be modelled directly over a preformed core.

Corner clamp A device which holds together two strips or slabs of solid material at a right-angle while the joint is secured.

Countersinking A method of keeping the head of a bolt or screw, used to join sections of a sculpture, below the outer surface of the materials.

Crank mixture A textured stoneware body suitable for modelling terracotta sculpture. Ceramic materials mixed with stoneware clay give it the correct texture.

Crosscut saw A saw with fine teeth set and angled to cut transversely through the grain of a dense material.

Crucible A heatproof receptacle in which metal is made molten for pouring into a mould.

Cubism An influential style of art pioneered by Picasso and Braque in the early twentieth century. The form of an object was analyzed as a series of geometric units and interlocking planes describing both volume and surface.

Cure The hardening process of a material which is worked in a moist or liquid form, such as resin and concrete.

D

Dada An 'anti-art' movement which embraced sculpture, painting, theatre and literature, which emerged during the First World War. Dada artists produced works which were nihilistic or reflected a cynical attitude towards social values.

Direct carving A carving technique in which the form of the sculpture evolves as the artist works into the block, or is suggested by the shape of the block.

Dolly A low platform on wheels used to move sculpture or heavy materials.

Dowel A wooden peg, which is circular in cross section, used instead of nails, bolts or screws to secure a joint.

Drawtool A metal blade with a wooden handle at either end used to strip wood.

Dummy A hammer with a rounded head, usually of iron, for striking stone carving tools.

E

Earth colours Natural pigments such as ochres, umbers and siennas, derived from metal oxides.

Earthenware Red earthenware is a clay deposit given its red colour by the presence of iron oxide. A clay body based on ball clay is known as white earthenware.

Engineer's blue A blue liquid painted on metal to give a thin coating in which a scribed line can be clearly seen.

Epoxy resin A thermosetting plastic resin, used for resin casting. Epoxy is also used in the manufacture of adhesives which bond firmly.

Exothermic A material which gives off heat as it cures is described as exothermic.

F

Fettling The process of cleaning and finishing the surface of a metal sculpture, especially the seam lines on cast metal caused by the form of the mould.

File A metal tool with a rough surface used to smooth, shape or cut materials by abrasion.

Filler A powdered or ground substance added to sculpture material to give extra bulk or body. Fillers for resin also make the material opaque.

Filling compound A paste which can be spread into a break or indentation in a surface. The compound can be filed down and smoothed when hard.

Firing Baking pottery and ceramic ware in a kiln to harden it and, subsequently, to fuse decorative glazes to the surface of the ware.

Flaming A process for finishing and hardening a wax model by passing a candle flame over the surface.

Flange A metal ring which flares at the base so it can be screwed to a flat surface. A rod inserted in the flange is held at right-angles to the surface.

Flat chisel A chisel with a straight cutting edge used for shaping and finishing in wood or stone carving.

Fluxing A chemical method of cleaning impurities from metal to assist fusion when metals are welded or brazed.

Former A construction usually of wood, or wood and metal, in which blocks of plaster or concrete can be formed or cast.

Futurism A movement in modern art originating among Italian artists in 1909. Futurism was a celebration of the machine age. Futurist painting and sculpture were concerned with expressing movement and the dynamics of natural and man-made forms. Some of these ideas, including the use of modern materials and techniques, were taken up later by the Constructivists.

G

Galvanized Galvanizing is a process by which steel is coated with zinc to prevent rusting.

Gantry A rigid framework which supports tackle for lifting heavy objects and materials.

G-clamp A rounded metal clamp, used to clamp materials together by adjusting a screw thread.

Gearing In Kinetic sculpture, a means of transmitting motion from a power source to the moving parts of the sculpture, utilizing either levers or interlocking gear wheels.

Gel, gel-coat When polyester resin is mixed with catalyst it begins to harden, or gel. The gel-coat is the first coat of liquid resin applied to a mould or surface when casting or laminating. It sets into a tough, plastic skin.

Gesso A mixture of whiting and glue size, gently heated. Gesso is applied with a brush to the surface of wood sculpture, forming a ground for painted decoration.

Glass fibre A light but durable sculpture material used to reinforce resin and hollow cast concrete. Thin filaments of glass are bonded into thin, flexible sheets called mats, strips of tape, or a fine, loosely stranded rope known as roving.

Glaze A transparent or coloured coating which decorates and seals ceramic ware. Glazes are applied in liquid form hardened and fused to the ware by baking in a kiln.

Glue size Size crystals or powder mixed with water form a gelatinous solution which forms the binder for gesso. Glue size added to plaster retards the drying process, giving the plaster a longer working time.

Goo A creamy paste of cement mixed with water. Goo is the first coat applied to a mould in making a hollow cast concrete sculpture and forms an even surface layer for the finished cast.

Gothic A term referring to Medieval art, principally architecture, in Europe. Sculpture and architecture were closely linked during this period in monuments, tombs and church decoration.

Gouge A wood carving chisel with a curved cutting edge. A V-tool for engraving the surface of wood is a variation of the gouge.

Graphite A black mineral substance, a form of carbon, available as powder or in a stick form.

Green A term which refers to the state of wood which is unseasoned or clay before it is fired.

Grog Grog is fired clay ground into fine granules, used as an ingredient in a clay body or as a base on which clay is worked or fired which allows the form to contract freely as it dries.

Grout A liquid or paste cement mixture used to fill and seal a joint.

Guillotine A mechanical cutting apparatus with a heavy moveable blade, worked by a lever or foot pedal.

Gypsum Gypsum is calcium sulphate which is found in a variety of forms as natural deposits. When heated and deprived of its moisture it forms the substance known as plaster of Paris.

H

Hacksaw A multi-purpose saw with a narrow blade fixed at each end in a rigid curving frame.

Hardwood Certain deciduous trees yield wood which is very tough and durable when seasoned. Mahogany and oak are examples of hardwoods.

Hollow building A ceramic technique for terracotta sculpture in which the form is built up from slabs and tubes of damp clay in such a way that it is hollow throughout.

Hollow casting Casting in a mould by lining the walls of the mould with layers of the sculpture material rather than filling up the mould. The technique varies with the medium being used.

Hot air blower A hand-held electrical tool which produces a powerful jet of hot air. It is used to heat and soften acrylic rod or sheet to make it pliable.

Hot wire cutter A tool for cutting expanded polystyrene. A wire is held taut in a frame and heated, enabling it to pass cleanly through the polystyrene without undue pressure being applied. A hand-held tool or bench model may be used.

I

Indirect carving A carving technique in which the sculpture is made by copying the proportions of a small scale model.

Inflatable A sculpture made from polythene sheet or PVC which achieves its intended form when filled with air.

Investment A thick jacket of refractory material built around a wax model. This forms the mould in lost wax casting.

K

Key A small interlocking device in the seam of a mould, enabling the mould to be precisely reassembled. The term also means the slight roughening of a surface which allows a painted finish to adhere effectively.

Kiln An oven in which clay objects are baked at high temperatures, to harden them or to set surface glazing.

Kinetics A kinetic sculpture is one which moves or has moving parts. Movement may be provoked by a natural force such as wind or water, or by a motor built into the sculpture.

L

Lacquer A varnish which can be painted on a surface to produce a glossy finish.

Laminating Building up a rigid surface over a framework by applying thin layers of material. Laminating is a technique used in sculpture with wood or resin.

Latex A rubber substance used as a cold cure moulding compound and also as the basis of certain adhesives.

Leather-hard This term describes the state of clay which has lost a good deal of moisture but is not yet hardened completely.

Lewis bolt An expanding metal bolt, consisting of two angled metal arms fixed on a pivot, which is used for lifting stone blocks.

Lost wax casting This is the traditional technique for producing a cast in bronze from a wax model. The wax model is jacketed in a refractory mould and fired to melt out the wax. Molten bronze is poured into the resulting space in the mould and left to set. When it is cool, the mould is broken away and the bronze sculpture cleaned and finished.

Ludo mould The refractory

mould used in lost wax casting.

Lump hammer A hammer with a heavy, rectangular head, usually made of iron, used to strike stone cutting tools.

M

Majolica A type of pottery glaze which produces the effect of a rich, enamelled surface.

Mallet A wooden hammer used to apply force to chisels in wood carving.

Maquette A small sculpture, often a clay, wax or plaster model, made as a preparatory study for a full scale work.

Mat A thin, flat sheet or strip of glass fibre material, used to reinforce laminating resin, hollow cast ciment fondu and modelled concrete sculpture. Surface mat is quite fine, chopped strand mat is a coarse, loosely woven fabric.

Maul A wooden club used to strike a wood carving chisel. A maul is shaped from a single piece of wood taken from the base of a young tree.

Measuring box A box devised to measure the proportions of the dry ingredients for concrete so it is possible to calculate the total volume of the mixture.

Medium, media A medium is the particular material or technique with which a sculptor works. Mixed media sculptures, therefore, are those in which several materials or processes are employed.

Melamine A synthetic resin or the material manufactured from that resin. Melamine can be bought in the form of a tough, non-porous sheet.

Mild steel Steel which contains only a small proportion of carbon. This is the type of steel most commonly used for constructional purposes.

Minimal art A style of abstract art developed, particularly by sculptors, during the 1960s. Minimal sculptures are simple, unembellished forms, often geometric. The sculpture material is undisguised and no attempt is made to represent or symbolize any other object or experience.

Mixing box A shallow wooden box, open at the top, in which concrete is mixed. A mixing box may be sealed inside to make it waterproof.

Mobile A type of kinetic sculpture, first explored by Alexander Calder. Mobiles are often constructions of flat metal shapes suspended on wires or fixed to flexible rods. The parts of the sculpture move in response to draughts of air, wind or motor power.

Modelling A process of making sculpture by building up a form in a malleable material such as clay, wax or wet plaster or concrete. The material is shaped with the fingers or with pointed and spatulate tools.

Modelling stand A turntable mounted on a tripod which can be raised or lowered, giving the sculptor access to the work from all angles. A modelling stand is only suitable for work on a small or medium scale, such as a figure under life size or a portrait bust.

Mould A negative form or impression taken from an original sculpture, in which a cast is made to copy the sculpture or reproduce it in another material.

N

Neoclassical The dominant style of European art in the late eighteenth and early nineteenth centuries. Neoclassical artists took the dignity and grandeur of ancient Greek and Roman civilizations as their model, celebrating their heroes and legends and the beauty of classical art and architecture.

O

Oilstone A stone used for sharpening and honing metal cutting tools.

P

Paddle A flat piece of wood used to beat damp clay, to remove air pockets and consolidate the mass.

Palette knife A knife with a flexible, spatulate blade, for applying or scraping off a plastic material. It is also a convenient tool for loosening a rigid layer of cured resin from a mould.

Pallet A large flat board on which materials may be stored to protect them from damp. It may be slightly raised from the floor by battens on the underside.

Paper rope Lengths of tightly rolled paper used to reinforce hollow cast resin. The paper rope is wetted out with resin and dries completely rigid.

Patina A coloured coating which forms on the surface of metal sculpture owing to chemical changes induced by natural elements. These changes can also be stimulated artificially. The best known example is verdigris, the bright green deposit which forms on bronze through oxidation.

Perspex An acrylic plastic available in sheet or rod form. Perspex may be transparent or brightly coloured.

Piece mould A mould made up in interlocking sections which can be used to make several casts since the mould is easily removed each time without being damaged.

Pinching A pottery technique which involves pressing the thumb into a ball of clay and drawing the clay out into a pot shape between thumb and fingers.

Pins Long, flat headed pins which connect the core to the investment in a mould for lost wax casting. When the wax is burnt out the pins hold the core in position.

Pitching tool A broad, heavy stone carving chisel, used to strike off large pieces of stone in roughing out a carving.

Plaster of Paris A fine white powder made from heat treated gypsum, which sets hard when mixed with water and allowed to dry out, forming again as gypsum.

Plaster trap A receptacle fitted under a sink to provide a filter in the drainage system. Waste plaster is strained off when tools and mixing bowls are being cleaned.

Plasticity The quality of a material which can be modelled, moulded or pressed into shape. Clay is an example of an extremely plastic material.

Point A simple metal tool with a pointed end used to rough out the basic shape of a stone carving.

Pointing A mechanical means of reproducing or scaling up a three-dimensional form in correct proportion. The pointing machine is a framework of metal arms which can be fitted around a sculpture to measure the relationships between given points on the surface.

Polarizing An effect of light waves produced by limiting their normal pattern, by means of a filter. The projection of a design with changing colours is possible by this means.

Polychrome A term describing sculpture finished in or decorated with several colours, usually referring to painted decoration.

Polyester resins Synthetic plastic resins in liquid form are made to solidify by the addition of a catalyst. Resin, reinforced with glass fibre, is commonly used as casting material but may also be modelled when thickened with an inert filler such as powdered chalk. It can be cut and abraded when hard.

Polystyrene A plastic which is available in two forms—toughened polystyrene is a rigid plastic in sheet form while expanded polystyrene is a light, granular mass, usually worked in sheets or blocks but also available as loose granules.

Polythene Flexible plastic sheeting which can be sewn or welded to make the outer skin of inflatable or stuffed sculptures. Polythene may be transparent or opaque and coloured or colourless.

Pop Art A dominant style of art during the 1960s, Pop Art originated in Britain and the USA when artists began to represent the many transient products of a consumer society, revelling in bright colours and the elevation of objects such as comics and junk food to a new scale and status.

Porcelain A clay body consisting mainly of china clay, porcelain is white and often translucent when fired.

Pour The process of filling a mould with the material which will form the actual sculpture, for instance, molten bronze in lost wax casting.

Pouring ring A circular metal band attached to a long handle which holds a crucible full of molten metal for pouring in lost wax casting.

Press moulding A method of making ceramic ware by pressing a sheet of clay into an open plaster mould.

Primer An undercoat applied to the surface of a sculpture to seal it and provide a ground for a painted finish.

Puddling A technique of creating even density and eliminating air bubbles in a mix of wet concrete by pushing a rod up and down through the mass.

Pug mill A machine with revolving blades which chop and mix clay. The pug mill is used to process and consolidate clay masses.

Punch A broad, pointed metal tool used in roughing out a stone carving.

PVA An abbreviation for polyvinyl alcohol. PVA is a thick white liquid which dries to a tough clear plastic skin. It is an adhesive and may also be used diluted with water as a release agent or sealant.

PVC An abbreviation for polyvinyl chloride. PVC is a flexible sheet plastic which can be sewn, glued or welded. Shapes made from PVC may be stuffed, inflated or filled with water.

Pyrometric cones Ceramic cones placed inside a kiln before firing. At a certain temperature, the cones will bend, so by constant observation it can be determined at what point particular temperatures are reached in the kiln.

R

Rasp A coarse abrasive tool made of metal. The abrasive surface has many pointed teeth shaped like tiny pyramids.

Refractory A refractory material is one which is resistant to high temperatures. Refractory materials are used for moulds in lost wax casting and for kiln furniture on which ceramic ware stands while it is fired.

Release agent A substance applied to the interior or seams of a mould to prevent the adhesion of two surfaces.

Relief A sculpture developed into or on a flat plane surface. The forms of a relief sculpture are not fully rounded, but they vary from low relief, which may be only shallow undulations or incisions in the surface, to high relief in which there is considerable expression of the three-dimensional form.

Riffler A metal tool with a small filing surface at the end of a rounded shaft. The riffler is used in delicate shaping and finishing of a carving. Rifflers are made in different shapes and sizes for work in wood, metal and stone.

Ripsaw A long-bladed hand-held saw with teeth designed for cutting down the grain of the material.

Risers In lost wax casting, risers are channels through the mould which allow air to escape as molten metal is poured into the mould.

Riveting A method of joining sheets of metal using short bolts with flattened heads.

Rodding The process of attaching wax rods to the surface of a wax model in lost wax casting. The rods form the runners and risers in the mould.

Romanesque The style of art and architecture dominant in Europe in the eleventh and twelfth centuries. Like the later Gothic style, Romanesque art was mainly applied in buildings and monuments for religious purposes.

Roving A light rope made of loosely bonded glass fibre, used as reinforcement for resin sculpture.

Rubbing compound An abrasive paste used to rub down the surface of a resin sculpture to give it a polished finish.

Runners In lost wax casting, channels in the mould through which the molten bronze flows into the mould.

S

Sand moulding A method of casting in metal in which a mould is made by packing layers of damp sand firmly around a sculpture. When the original is removed an exact impression is left in the sand.

Sash clamp A straight clamp with adjustable fixings, used in wood construction.

Scaling up A mechanical method of copying a small sculpture on a larger scale by increasing all the measurements proportionately, using such measuring devices as a scaling board or callipers.

Scraper A tool with a broad metal blade which is fairly rigid, but not honed to a cutting edge.

Scribe A metal tool with a sharp point used to draw fine, accurate lines on a rigid material such as metal or plastic sheet.

Scrim A coarse, loosely woven hessian fabric which acts as reinforcement for plaster models and casts.

Sculpture in the round Sculpture which is free standing and fully developed from all points of view.

Seasoning The long process of drying out most of the natural moisture in wood to make it stable and workable for carving or construction.

Separator A substance applied to the interior of a mould to prevent the adhesion of a casting material.

Setting The hardening process of plaster of Paris, concrete or resin.

Sheet saw A saw for cutting sheet metal which has no support along the top of the blade that would hinder its movement on a long cut.

Shellac A varnish made from a natural resin secreted by the lac insect.

Shim A thin brass strip used to divide the surface of a modelled sculpture into sections for a waste mould.

Silica A hard mineral substance found in various natural deposits. Silica ground to a granular form is a component of ceramic bodies and abrasives.

Silicone rubber A cold cure moulding compound which can withstand the heat of molten lead. Silicone rubber is only used for small scale casting. It is mixed from a rubber base solution and a catalyst.

Slabbing A pottery technique in which a form is built up by joining shapes cut from thick sheets of damp clay.

Slip, slip casting Slip is an opaque, creamy liquid made by mixing finely ground clay with water. To form a slip cast, slip is poured into a plaster mould and left until a thick skin forms inside the mould. The excess slip is poured out and the hollow cast left to harden.

Slipstone A small abrasive stone used to sharpen the inside curve or angle of a gouge or V-tool.

Softwoods Woods from coniferous trees, some of which are suitable for carving, for example, yellow pine.

Soldering A method of joining pieces of metal by melting an alloy of tin and lead

into the joint to fuse the two edges together. A soldered joint will not withstand much stress.

Solvent A substance which is able to dissolve another substance.

Spatula A simple rounded or blunt modelling tool in a flat, elongated shape. Spatulas are made from wood or metal.

Spokeshave A small planing tool for wood consisting of a blade with a handle at either end. The spokeshave is drawn across the surface of wood to smooth or shape it and can be used on a flat or curved surface.

Stoneware A smooth buff, grey or brown clay which is mixed with other clays and ceramic materials to make a dense, highly plastic clay body. The term stoneware also refers to the body and objects made from it.

Superrealism A style of figurative painting and sculpture in which forms are represented in exact detail. Paintings may be copied minutely from photographs, while the sculptures usually take the form of lifesize resin or wax figures dressed in real clothes and carrying real objects.

Surform A metal abrasive tool fitted with a replaceable blade, like a grater, so that small particles of material pass through and do not clog the cutting teeth. Surforms are available in a number of shapes—flat, curved and rounded.

Surrealism A movement in fine art, literature and theatre which was extremely widespread in the period between the two World Wars. Surrealist artists aimed to free themselves from the traditions of art and pursue images born of fantasy and free association of thoughts. The work included both figurative and abstract styles.

Tamping Consolidating a fibrous or granular material such as resin-soaked glass fibre, concrete or damp sand by pressing or packing it into shape in a mould.

Tapping Cutting a thread inside a drilled hole so it will accept a screw or plug in which a corresponding thread has been cut. Tapping is done with a tap drill. The process is used to fill pin holes in a bronze cast with fine bronze rod.

Template A pattern cut from a thin sheet of rigid material which is used as a guide for forming or cutting the shape as a three-dimensional solid.

Tenon saw A saw with a short, rectangular blade which is supported along the side opposite the cutting edge by a narrow metal grip. It is used for cutting with accuracy through small sections of wood.

Tensile strength The ability of a material to withstand the stress imposed upon it when it is stretched.

Terracotta This term means baked clay, and is generally applied to any sculpture made in clay and fired. In a more specialized sense, terracotta specifically refers to red earthenware bodies used for modelling or building hollow sculptures which are then fired to give them permanence.

Thermoplastics Plastics which soften when they are heated and harden as they cool without changing their basic properties. Acrylics are an example of this type of plastic.

Thermosetting A term which refers to plastics, such as polyester and epoxy resins, which require the presence of heat in a forming process, but which then set hard and cannot be remoulded.

Throwing In pottery, throwing means forming a pot from a ball of clay on a rotating wheel.

Tinsnips Shears with short blades used to cut through thin sheets of metal.

Turning A pottery technique by which the base of a pot is trimmed and finished on the wheel. The pot is first allowed to dry to the leather-hard stage.

Turning box An open box fitted with a metal spindle used for forming a rounded solid in plaster. A metal template is attached to the top of the box and the shape is formed by applying wet plaster to the rotating spindle which is gradually shaped as it dries and scrapes against the template.

Twist drill A drill with a straight shaft incised with spiral cutting edges for boring a hole.

Undercut A recess or awkward angle in the surface or form of a three-dimensional object which would prevent easy removal of a cast from a mould. Moulds are designed to eliminate this problem.

Vacuum forming A method of shaping plastic sheet over a solid relief pattern. The plastic is heated until it is pliable and when a vacuum is created under the form the plastic is drawn down onto the pattern like a skin.

Vinyl moulding compound This is a type of rubber moulding compound which is heated to a liquid form and contained around the original model where it sets into a flexible rubber mould. When the mould is no longer needed, it can be melted down and the rubber used again.

Ware A collective term for pottery and ceramic objects.

Washer A flat metal or rubber ring fitted to a bolt head or nut which helps to secure the bolt and distribute its pressure.

Waste mould A mould from which only one cast can be taken as the mould must be broken away to release the cast and is thus wasted.

Wedge A piece of wood or metal tapered at one edge, used to split wood along its grain.

Wedging A technique by which clay is thoroughly kneaded before use in modelling or pottery, to make it the correct consistency and remove air pockets.

Welding The process of joining metals by fusing them together under direct, intense heat. A commonly used source of heat for welding is an oxyacetylene torch. A metal rod may be applied to the joint which melts into any gaps and strengthens the bond.

Wet-and-dry paper Paper with a coating of silicon carbide, used as an abrasive. Its common name derives from the fact that it can be used wet or dry, as suitable for the materials used and the surface finish required.

MANUFACTURERS AND SUPPLIERS

Sculpture involves such a wide range of media and equipment that often one supplier will not sell all the equipment and materials required for a particular work. For most media, especially stone, wood and metal, it is always worth looking for suppliers locally – wood yards, scrap metal merchants, foundries and stone quarries or yards. Many local hardware, do-it-yourself, craft and hobby stores stock a selection of materials and tools, such as chisels, hammers or mallets, which are suitable for sculpture. Similarly, smaller, more specialized stores may also sell tools which are of use to the sculptor. These include, for instance, ships' chandlers, which may also supply fibreglass and flexible moulding compounds. These lists give the names and addresses of some of the main manufacturers who are normally extremely helpful and may be able to give details of local retail outlets. Many manufacturers and suppliers also produce their own catalogues which, as well as listing retailers, often gives useful information on using materials and tools.

UNITED KINGDOM

General sculpture tools and suppliers

Brickhouse Crafts,
Cock Green,
Felsted,
Essex.

Buck and Ryan,
101 Tottenham Court Road,
London W1.

Alec Tiranti Ltd,
70 High Street,
Theale,
Reading,
Berks.

Alec Tiranti Ltd,
21 Goodge Place,
London W1.

Wengers Ltd,
Garner Street,
Etruria,
Stoke-on-Trent,
Staffs.

Clays, ceramics and pottery supplies

Deancraft Ltd,
Lovatt Street,
Stoke-on-Trent,
Staffs.

English China Clay Co,
John Keay House,
St Austell,
Cornwall.

The Fulham Pottery Co Ltd,
184 New King's Road,
London SW6.

Harrison-Meyer Ltd,
Meir,
Stoke-on-Trent,
Staffs.

Kilns and Furnaces Ltd,
Keele Street,
Tunstall,
Stoke-on-Trent,
Staffs.

Potclays Ltd,
Brickkiln Lane,
Etruria,
Stoke-on-Trent,
Staffs.

Podmore and Sons Ltd,
Shelton,
Stoke-on-Trent,
Staffs.

Podmore Ceramics Ltd,
105 Minet Street,
London SW9.

Wengers Ltd,
Etruria,
Stoke-on-Trent,
Staffs.

Wax

Candlemakers' Supplies,
28 Blythe Road,
London W14 0HA.

Brownings of Hull,
65 Aberdeen Street,
Hull,
Humberside.

Duffek Campbell Ltd,
Thames Road,
Crayford,
Kent.

Duffek Campbell Ltd,
New Hive Works,
Bury,
Lancs.

Wood

For supplies, try local timber yards or stockists and for tools a hardware, craft or do-it-yourself shop. Contact the Timber Trade Federation for advice on local stockists of particular woods.

Afro Timber & Plywood Co Ltd,
Englemere Sawmills,
London Road,
Ascot,
Berks.
(hardwoods)

D.W. Beattie & Co Ltd,
Dalhousie Estate,
Bonnyrigg,
Midlothian EH19 3HY.

Brownlee & Co Ltd,
City Saw Mills,
Port Dundas,
Glasgow.

Wm Brown's Saw Mills Ltd,
John Street,
Darlington.

Wm Brown & Co (Ipswich) Ltd,
Greyfriars Road,
Ipswich.

J.S. Fisher Ltd,
Newry Saw Mills,
Buttercrane Quay,
Newry, Co Down, NI.
(softwoods)

Gregor Bros Ltd,
Beaufort Road,
Plasmarl Industrial Estate,
Swansea,
West Glam. SA6 8HQ.

Mallinson-Denny (Scotland) Ltd,
Kalvinaugh Saw Mills,
Kalvinaugh Street,
Glasgow G3 8PG.

Montague L. Meyer Ltd,
North Dock,
Alexandra Dock,
Newport,
Gwent.

Montague L. Meyer Ltd,
Timber Terminal,
King George Dock,
Hull HU9 5QT.

Montague L. Meyer Ltd,
Western Dock,
Southampton SO9 3RT.

Vincent Murphy & Co Ltd,
74-76 Derby Road,
Liverpool L20 8LT.

George Rankin & Co Ltd,
Dock Saw Mills,
Milewater Road,
Belfast 3, NI.
(hardwoods)

Rudders & Raynes Ltd,
Studley,
Nr. Redditch,
Worcs.

The Sabah Trading Co Ltd,
Long Reach Road,
Barking, Essex.

Sabah Timber South East
(Merchants) Ltd,
1 Central Road,
Worcester Park,
Surrey KT4 8DN.

John Sadd & Sons Ltd,
Station Road Wharf,
Maldon, Essex.

The Timber Trade Federation,
47 Whitcomb St,
London WC2.
(for advice on local suppliers)

Henry Venables Ltd,
Castletown Saw Mills,
Doxey,
Stafford, Staffs.

Fibreglass and resin casting

Architectural and Industrial GRP,
400 Ewell Road,
Tolworth,
Surrey.

Dufaylite Developments Ltd,
Cromwell Road,
St Neots,
Huntingdon.

Falcon Glass,
75 Maltby Street,
London SE1.

Strand Glassfibre Ltd,
Brentway Trading Estate,
Brentford,
Middlesex.
Branches in Ashford (Kent),
Birmingham, Brentford, Bristol,
Derby, Dublin, Glasgow, Ilford,
Leeds, Norwich, Plymouth,
Portsmouth, Reading,
Southampton, Stockport,
Stockton-on-Tees.

Metalwork and casting

Local foundries, iron- and steelworks and scrap metal dealers are always worth investigating as a source of supply for metal casting and also for advice and help on where to obtain suitable materials.

Vinatex Ltd,
Station House,
North Street,
Havant,
Hants.
(flexible moulding compound)

Park and Patterson,
Rose Hill Works,
Croft Lane,
Manchester.
(metals)

Plastics

British Industrial Plastics,
Sheet and Film Division,
Manningtree,
Essex.

B. Brown (Holborn) Ltd,
Warriner House,
32-33 Greville Street,
London EC1N 8TD.

Evode Ltd,
Common Road,
Stafford,
Staffs.
(adhesives)

Expanded Polystyrene Suppliers
Assoc,
PO Box 103,
Haywards Heath,
West Sussex.

ICI Plastics Division,
Welwyn Garden City,
Herts.

Lennig Chemicals Ltd,
Lennig House,
2 Masons Avenue,
Croydon.

Margros Ltd,
Monument Way West,
Woking,
Surrey.

Parnall and Sons Ltd,
Plastics Machinery Division,
Lodge Causeway,
Fishponds,
Bristol.

Transatlantic Plastics Ltd,
Garden Estate,
Ventnor,
Isle of Wight.

Welwyn Tool Co Ltd,
Stonehill House,
Welwyn Garden City,
Herts.

Stone and marble

For supplies, contact a local stone
yard or quarry and for tools try a
hardware or craft shop.

Ashby and Horner Masonry Ltd,
195 London Road,
Thurrock,
Essex.

Kingston Minerals Ltd,
Bumpers Lane,
Wakeham,
Portland,
Dorset.
(Portland stone)

Marble and Slate Consolidated
Stone Ltd,
1a Harpenden Road,
London SE27.

Noirell Ltd,
Kent House,
Regent Street,
London W1.

C.A. Pisani,
Transport Avenue,
Brentford,
Middx.
(marble, granite, tools)

The Stone Firms Ltd,
20 Manverse St,
Bath BA1 1LX.
(limestone)

The Stone Firms Ltd,
Portland,
Dorset.
(limestone)

UNITED STATES

General sculpture and suppliers

Alexander's Sculpture Services,
117 E 39 St,
New York, NY 10016.

Arlene's Artist Materials and
Ceramic Supply,
57 Fuller Road,
Colonie, NY 12205.

Art and Hobby Center,
3177 Poplar Ave,
Memphis, TN 38111.

Art Hardware,
1135 Broadway,
Boulder, CO 80302.

Buffalo Ceramic and Art Supply
Center Inc,
437 Franklin St,
Buffalo, NY 14202.

Crafts Distributing Inc,
227 NW 63 St,
Oklahoma, OK 73112.

The Craft Tool Co Inc,
2323 Reach Rd,
Williamsport, PA 17701.

ETT Studios Inc,
Byram, CT 068 30.

Kemper Mfg Co,
Box 545,
Chino, CA 91710.

Frank Mittemeier Inc,
3577 E Tremont Ave,
Bronx, NY 10465.

Pacific and Home Foreign Trade,
1336 Harrison St,
San Francisco, CA 94103.

Sax Arts and Crafts,
316 N Milwaukee St,
Milwaukee, WI 53202.

Sculpture Associates Ltd,
114 E 25 St,
New York, NY 10010.

Sculpture House,
38 E 30 St,
New York, NY 10016.

Sculpture Services Inc,
9 E 19 St,
New York, NY 10003.

Western Sculpture Supply,
2855 W Eighth Ave,
Denver, CO 80204.

The Woodshed,
No 5 Ave A,
New York, NY 10009.

Clays, ceramics and pottery supplies

American Art Clay Co,
4717 W 16 St,
Indianapolis, IN 46222.

Binney and Smith Inc,
1100 Church Lane,
Box 431,
Easton, PA 18042.

Blair Art Products Inc
3540 Summer Ave,
Box 22381,
Memphis, TN 38122.

Kilns Supply and Service Corp,
38 Bulkey Avenue,
Box 1071,
Port Chester, NY 10573.

New England School Supply,
Spring Field, MA 01101.

Newton Pottery Supply Co,
Main St,
Waltham, MA 02154.

Paragon Industries Inc,
Box 10133,
Dallas, TX 75207.

Poly Form Products Co,
9420 W Byron St,
Schiller Park, ILL.

Potter's Supply Co,
PO Box 799,
11 Washington,
East Liverpool, Ohio.

Stewart Clay Co Inc,
400 Jersey Ave,
New Brunswick, NJ 08902.

Fiberglass and resin casting

Adhesive Products,
1660 Boone Ave,
Bronx, New York, NY 10460.

Crescent Bronze Powder Co Inc,
120 W Illinois St,
Chicago, ILL 60610.

Palmer Paint Products,
1291 Rochester Rd,
Troy, MI 48084.

Stafford Reeves Inc,
622 Greenwich St,
New York, NY 10014.

Thermoset Plastics Inc,
65th at Nickel Plate RR,
Indianapolis IN.

Metalwork and casting

Airco Welding Products,
Box 486,
Union, NJ 67083.

Allcraft Tool and Supply Co,
100 Frank Rd,
Hicksville, NJ 11801.

Bartlett and Co Inc,
5 S Wabash Ave,
Chicago, ILL 60603.

Casting Supplies House Inc,
62 W 47 St,
New York, NY 10019.

McEnglevan Heat Treating and
Mfg Co,
700-708 Griggs St,
Danville, ILL 61832.

Mason Renshaw Ind,
123 Gray Ave,
Santa Barbara, CA 93101.

Plastics

Foamed Plastic Sales,
Indian Point Lane,
Riverside, CT 06830.

Fome Board Service Center,
2211 N Elston Ave,
Chicago, ILL 60614.

Poly Products Corp,
28150 Hayes Ave,
Box 42,
Roseville, MI 48066.

Stone and marble

For supplies try a local stone yard
or quarry, and for tools try a
hardware or hobby store.

New York Marble Works Inc,
1399 Park Ave,
New York, NY 10039.

The Woodshed,
No 5 Ave A,
New York, NY 10009.

Wax

Bartlett and Co Inc,
5 S Wabash Ave,
Chicago, ILL 60603.

The Crafttool Co Inc,
2323 Reach Rd,
Williamsport, PA 17701.

Frank Mittemeier,
3577 E Tremont Ave,
Bronx, NY 10465.

Wood

For supplies try a local wood yard
or stockist and for tools try a
hardware or hobby store.

Allway Tools Co,
1513 Olmstead Ave,
Bronx, NY 10460.

Loew Cornell Inc,
131 W Ruby Ave,
Palisades Park, NJ 07650.

Sander Wood Engraving Co Inc,
212 Lincoln St,
Porter, IN 46304.

The Woodshed,
No 5 Ave A,
New York, NY 10009.

INDEX

ACKNOWLEDGEMENTS

pp. 8 W. Rawlings/R. Harding Agency. 9 R. Sheridan. 12 Fogg Art Museum. 13 Christie's/Bridgeman Library. 17 Errol Jackson. 18 Iraqi Government/Visual Arts Library. 18/19 Victoria & Albert Museum/Visual Arts Library. 27 New York, Museum of Modern Art, A. Conger Goodyear Fund. 33 (tl) Victoria & Albert Museum/Visual Arts Library. 33 (tr) Bridgeman Library. 34 (tl) Bridgeman Library. 34 (bl) Visual Arts Library. 34 (r) Stoke-on-Trent Museum. 35 (t) Visual Arts Library. 35 (l) Visual Arts Library. 35 (r) Jos. Wedgwood and Sons Ltd. 36 (l) Visual Arts Library. 36 (r) Victoria & Albert Museum/Visual Arts Library. 41 Royal Doulton Tableware Ltd. 44 Visual Arts Library. 50 Victoria & Albert Museum/Bridgeman Library. 55 Victoria & Albert Museum. 58 Tate Gallery/Bridgeman Library. 60 Victoria & Albert Museum/Visual Arts Library. 61 Statens Museum for Kunst, Copenhagen. 64 (l) Visual Arts Library. 64 (r) Visual Arts Library. 65 University College/Visual Arts Library. 76 (l) Bridgeman Library. 76/77 Scala. 77 (t) Visual Arts Library. 78 (l) Victoria & Albert Museum/Visual Arts Library. 78 (r) Paris, Musée Picasso/Visual Arts Library. 79 (l) Sean Rice. 79 (r) Paris, CNAC/Visual Arts Library. 86 (l) Visual Arts Library. 86 (r) Bridgeman Library. 87 Leo Castelli/Visual Arts Library. 95 New York, Museum of Modern Art, gift of Ch. & A. Blatt. 96 (l) British Museum/Bridgeman Library. 96 (r) British Museum/Visual Arts Library. 97 (bl) Chicago Art Institute/Visual Arts Library. 97 (t) Mansell Collection. 97 (br) Victoria & Albert Museum. 98 (l) Leipzig, Karl-Marx University/Visual Arts Library. 98 (r) Bridgeman Library. 99 (l) London, Museum of Mankind/Visual Arts Library. 99 (m) New York, Museum of American Indian/Visual Arts Library. 99 (r) Paris, Musée Picasso/Visual Arts Library. 99 (b) David Nash. 111 Visual Arts Library. 112 Visual Arts Library. 114/115 Visual Arts Library. 115 Tate Gallery/Visual Arts Library. 116 (t) Victoria & Albert Museum/Visual Arts Library. 116 (b) Paris, Musées Nationaux. 117 Paul Neagu. 119 British Museum/Visual Arts Library. 120 Bridgeman Library. 121 Victoria & Albert Museum/Visual Arts Library. 123 Tate Gallery/Bridgeman Library. 139 Mansell Collection. 140 B. Jarret/Paris, Musée Rodin. 141 Visual Arts Library. 145 Visual Arts Library. 146 Paris, Musées Nationaux. 146/147 Visual Arts Library. 147 Henry Moore Foundation. 152 Paris, Musée Picasso/Visual Arts Library. 153 Paris, Musées Nationaux. 154 Visual Arts Library. 155 Tate Gallery. 156 (l) Visual Arts Library. 156 (r) New York, Metropolitan Museum, Marquand Fund, 1951. 157 (b) University College/Visual Arts Library. 158 Wilhelm Lembruck Museum, Duisburg. 159 Paris, Musées Nationaux. 160/161 Errol Jackson. 162 Visual Arts Library. 163 Dan King. 164 British Council. 164/165 John Donnat/Visual Arts Library. 166 Visual Arts Library. 168 (t) Guggenheim Museum/Visual Arts Library. 168 (b) Los Angeles County Museum/Visual Arts Library. 169 New York, Museum of Modern Art, S. & H. Janis Collection. 176 (l) St Louis Art Museum/Visual Arts Library. 176 (r) Paris, Archives Photographiques/Visual Arts Library. 177 (l) Paris, Musée Picasso/Visual Arts Library. 177 (r) Tate Gallery. 179 (t) Tate Gallery. 179 (b) Galérie Mathias Fels/Visual Arts Library. 183 Visual Arts Library. 185 (l) Visual Arts Library. 185 (tr) Tate Gallery. 185 (br) Visual Arts Library. 186 (tl) A. Campbell. 186 (bl) Tate Gallery/Visual Arts Library. 186 (tr) A. Campbell. 188 (br) New York, Museum of Modern Art, Mrs S. Guggenheim Fund. 189 Visual Arts Library. 190 Sonia Halliday. 191 (r) Rapho. 191 (tl) Visual Arts Library. 192/193 Tate Gallery. 194 (b) Visual Arts Library. 196 Tate Gallery. 197 (tl) Philadelphia Museum of Art/Visual Arts Library. 197 (tr) New York, Museum of Modern Art/Visual Arts Library. 197 (b) Philadelphia Museum of Art, L. & W. Arensberg Collection. 198 New York, Museum of Modern Art. 199 (t) Leo Castelli/Visual Arts Library. 199 (b) Visual Arts Library. 200 Visual Arts Library. 201 (t) Visual Arts Library. 201 (b) Visual Arts Library. 202 John Webb. 204 John Donnat/Visual Arts Library.

Key:
(t) – top
(tl) – top left
(tr) – top right
(m) – middle
(b) – bottom
(bl) – bottom left
(br) – bottom right
(r) – right
(l) – left